To Mother from Bill
— November, 1990

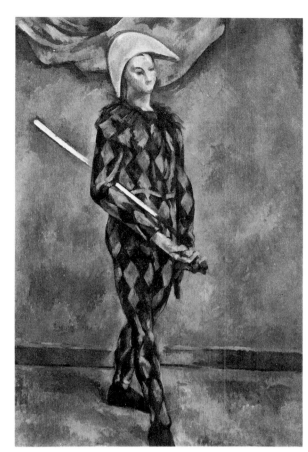

CEZANNE

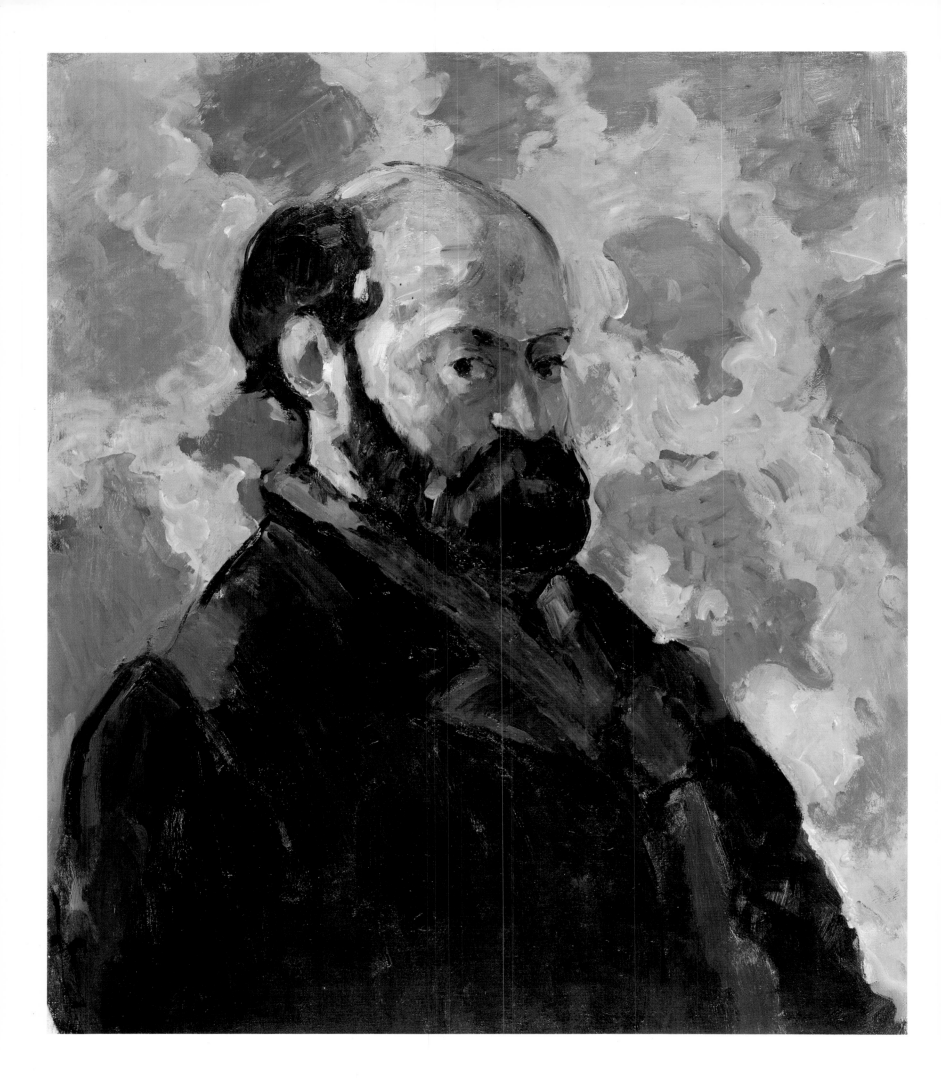

CEZANNE

A Biography

JOHN REWALD

ABRADALE PRESS
HARRY N. ABRAMS, INC.
Publishers, New York

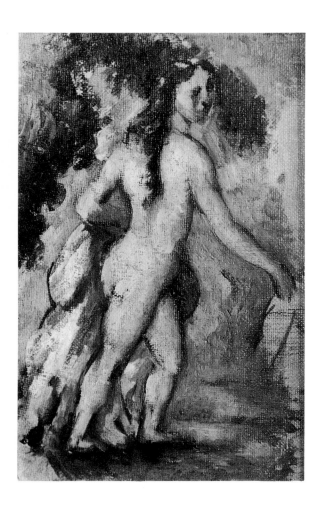

PAGE ONE:
Harlequin. 1889–90
FRONTISPIECE:
Self-Portrait with Rose Background. c. 1875
LEFT:
Female Bather. 1872–74
OPPOSITE:
Still Life, Two and a Half Apples. 1873–77

PROJECT DIRECTOR: Robert Morton
EDITORIAL ASSISTANT: Harriet Whelchel
DESIGNER: Judith Michael

LIBRARY OF CONGRESS CATALOGING-IN-PUBLICATION DATA

Rewald, John, 1912–
Cézanne: a biography / John Rewald.
p. cm.
Thesis (doctoral)—Sorbonne.
Includes bibliographical references (p.).
ISBN 0-8109-8100-9
1. Cézanne, Paul, 1839–1906. 2. Painters—France—Biography.
I. Title.
ND553.C33R37 1990
759.4—dc20
[B] 90–33369
 CIP

Printed and bound in Japan

Contents

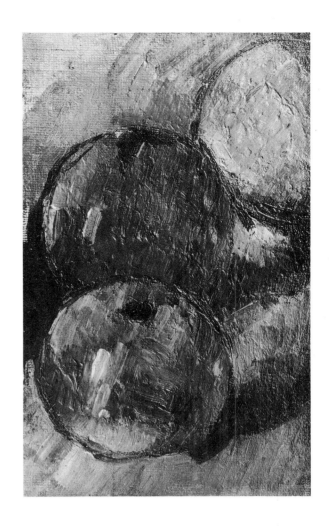

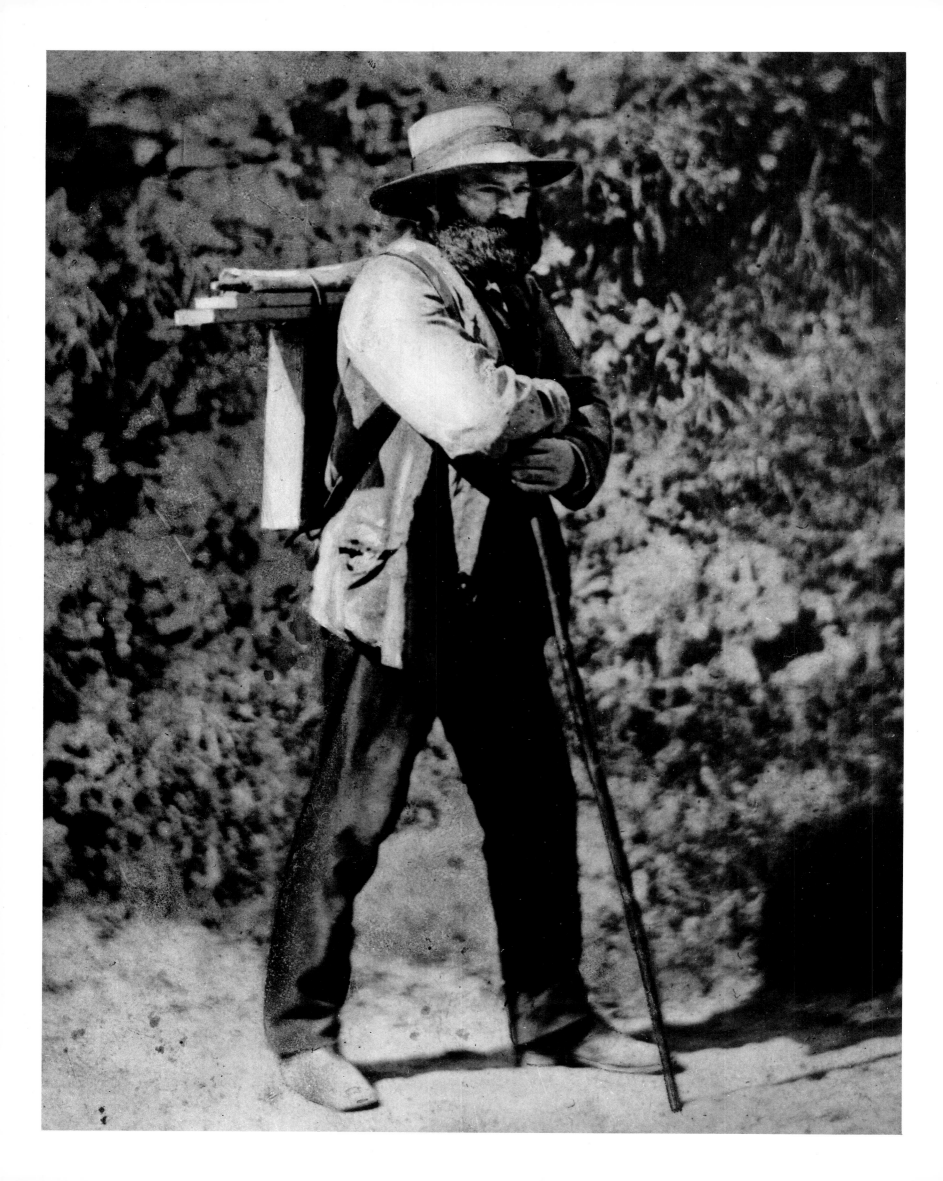

Introduction

IN *The History of Impressionism,* first published in 1946, I endeavored to give a detailed account of the artistic movement of which Cézanne was, at least for some time, a member. The present biography may be considered as a subsequent attempt to detach a single figure from the general background described in the larger book. Actually, however, this life of Cézanne was written more than half a century ago. After several years of research, it was published in 1936 in Paris as a Sorbonne thesis, under the title *Cézanne et Zola.* A second edition, expanded to almost twice its original size and with a slightly different title, appeared in 1939 on the occasion of the one-hundredth anniversary of Cézanne's birth. Since then I have been able to add new material to the book and to reshape it into its present form; from a study of the friendship between the painter and the novelist the emphasis has been shifted to Cézanne alone.

The method by which this biography has been put together over a period of years does not differ from that adopted for *The History of Impressionism.* It presents another attempt to let the facts speak for themselves, to rely chiefly on documents and witness accounts, to quote from the originals wherever possible, and thus bring the reader into direct contact with the historic evidence. It again assigns to the author mainly the role of coordinating this evidence and of presenting it in the most effective and also the most scrupulously exact way.

Not all the documents assembled here are new, of course. Since this book first appeared, the collected *Letters of Cézanne* have gone though various editions both in French and in English. The several score letters that Cézanne addressed to Zola during almost thirty years have thus been made available to the public. Yet Zola's papers, now at the Bibliothèque Nationale in Paris, have also yielded numerous documents that had escaped the attention of Cézanne's biographers. They include, for one thing, the notes the novelist made for his books, notes that often contain the name of Cézanne. Even more important, however, are the letters received by Zola from a number of friends, mostly companions of his youth, which furnish a great wealth of information about the painter.

For having been allowed to consult these all-important sources, I am deeply indebted to Zola's daughter, Denise Le Blond-Zola, and to her husband, Maurice Le Blond, who in every possible way facilitated my research. I am equally grateful to Cézanne's son, Paul Jr., for the warm sympathy with which he assisted me. I was also fortunately able to gather some firsthand information from Paul Signac, Ambroise Vollard, Maxime Conil (Cézanne's brother-in-law), Maurice Denis, Paul Gachet (the son of Dr. Gachet of Auvers), and Hermann-Paul, as well as from Blanche Hoschedé-Monet, Marie Gasquet, Louis Le Bail, Charles Camoin, Rodo Pissarro, and Albert André. My friend, the painter Léo Marchutz, assisted me with enlightened advice over many years and shared with me his profound insight into the work of Cézanne. They are all gone now, who were so patient, generous, and selfless when it came to helping a very young student in his quest for information and documents.

Only in one respect did I meet with resistance: my art history professor at the Sorbonne felt that Cézanne was not yet "ripe" and that I should have selected a thesis subject that did not go beyond Delacroix. I won out in the end, but it was perhaps only because I was a foreigner whose doctoral title did not seem to endanger either French culture or the prestige of the Sorbonne. But I must add that Henri Focillon had shown me exquisite courtesy—to which, as an alien, I

OPPOSITE:
Paul Cézanne on the way to his motif
in the region of Auvers. Photograph c. 1874

7

was not accustomed—and that at the public defense of my thesis, Zola's daughter and son-in-law sat in the first row of the amphitheater. After I fled France in 1941, the French Academy, without my knowledge, awarded the *Prix Charles Blanc* to my thesis.

In America I received encouragement and help from a few colleagues, such as Meyer Schapiro; and especially from my friend the late Gerstle Mack, himself the author of the first comprehensive biography of Cézanne published in English; from Mrs. Adelyn D. Breeskin, to whom I owe the communication of a then unpublished letter by Mary Cassatt on her meeting with Cézanne at Giverny; and from Margaret Scolari and Alfred H. Barr, Jr., who discovered and published the invaluable correspondence between Marion and Morstatt. But my indebtedness to Alfred Barr goes much deeper since without his active support, I could never have written my *History of Impressionism* (nor would it have been published by the Museum of Modern Art). That volume led—in some unforeseeable way—to the publication of the English translation of my Cézanne biography.

At a time when there appear every few months—if not weeks—more or less well assembled and selected albums or volumes of reproductions of the works of the French Impressionists in "full" color (often much too full) or in black and white, there seems to be no need of acquainting the reader with the major paintings of Cézanne. The illustrations in this volume have therefore been assembled, at least in part, from a documentary point of view and with emphasis on less well known works, some of which have never been reproduced in color before. Rather than to show once more Cézanne's most famous paintings—though some of these have been included—the illustrations were selected to supplement the text with visual references. For their presentation a strictly chronological sequence (as far as the chronology of Cézanne's work can be established) has been abandoned in favor of one that would facilitate juxtapositions that, it is hoped, reveal better than words could the artist's creative process: how he used the same objects for completely different still-life compositions; how a small study, apparently done from a model, reappears as a minor element in various groups of bathers; or how he approached subjects while working side-by-side with his friends Pissarro, Guillaumin, or Renoir. The illustrations also include photographs of landscapes that were so dear to him, most of them taken by the author some fifty years ago and representing sites that have changed completely since the days of Cézanne, if they have not disappeared altogether.

The belief that the average reader dislikes footnotes has led to the almost complete suppression of these. Notes have been limited in general to documents culled from sources not previously explored or available. The student will find more complete references in the two earlier French editions of this book, especially the one of 1936. A systematic bibliography has been provided by *The History of Impressionism*, periodically brought up-to-date in successive editions. The bibliography appended here has been limited to the more important among the several hundred books and articles on Cézanne; above all, it includes publications of documentary interest and those from which material here presented has been gathered.

I wish to express my profound gratitude to the late Miss Louise Salm for the patience and skill with which she assisted me in the final revision of the translation from the French. I am also greatly obliged to my editor, Robert Morton, for the discretion and enthusiasm with which he readied this manuscript for the printer, to the designer, Judith Michael, who turned the vast material of illustrations into a beautiful and cohesive ensemble, and to Harriet Whelchel for her extremely careful and competent proofreading.

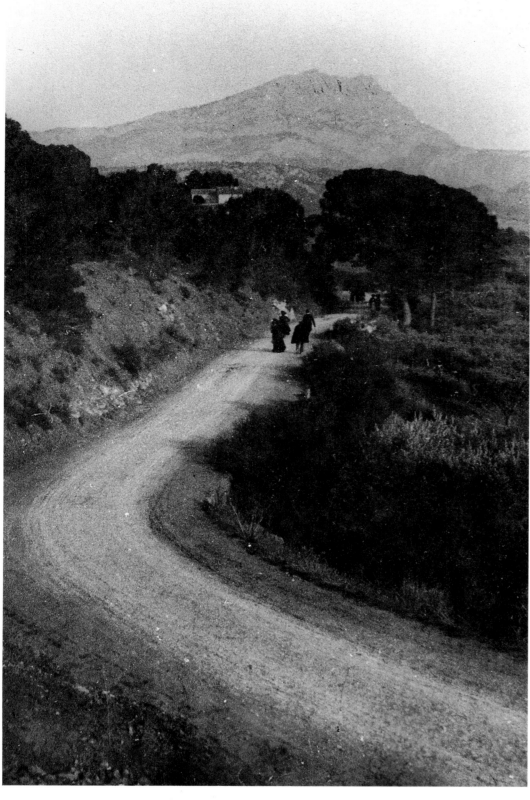

The road to Le Tholonet and Mont Sainte-Victoire.
Photograph c. 1900

I am of course extremely grateful to the many collectors and museums that allowed me to reproduce works they own and who frequently even provided me with transparencies for colorplates. The public institutions are named in the captions, but most of the private owners have insisted on anonymity. Among those who put at my disposal colorplates (often of works they did not even own) were William Acquavella, New York; Heinz Berggruen, New York; Ernst Beyeler, Basel; Christie's, New York; Marianne Feilchenfeldt, Zurich; Peter Nathan, Zurich; Sotheby's, New York; Eugene Victor Thaw, New York; and Daniel Wildenstein, New York. I owe several black-and-white photographs, among them some hitherto unpublished Cézanne drawings, to Pierre Berès, Paris; Philippe Cézanne, Paris; Denis Coutagne and Bruno Ely, Aix-en-Provence; and Peter Nathan, Zurich.

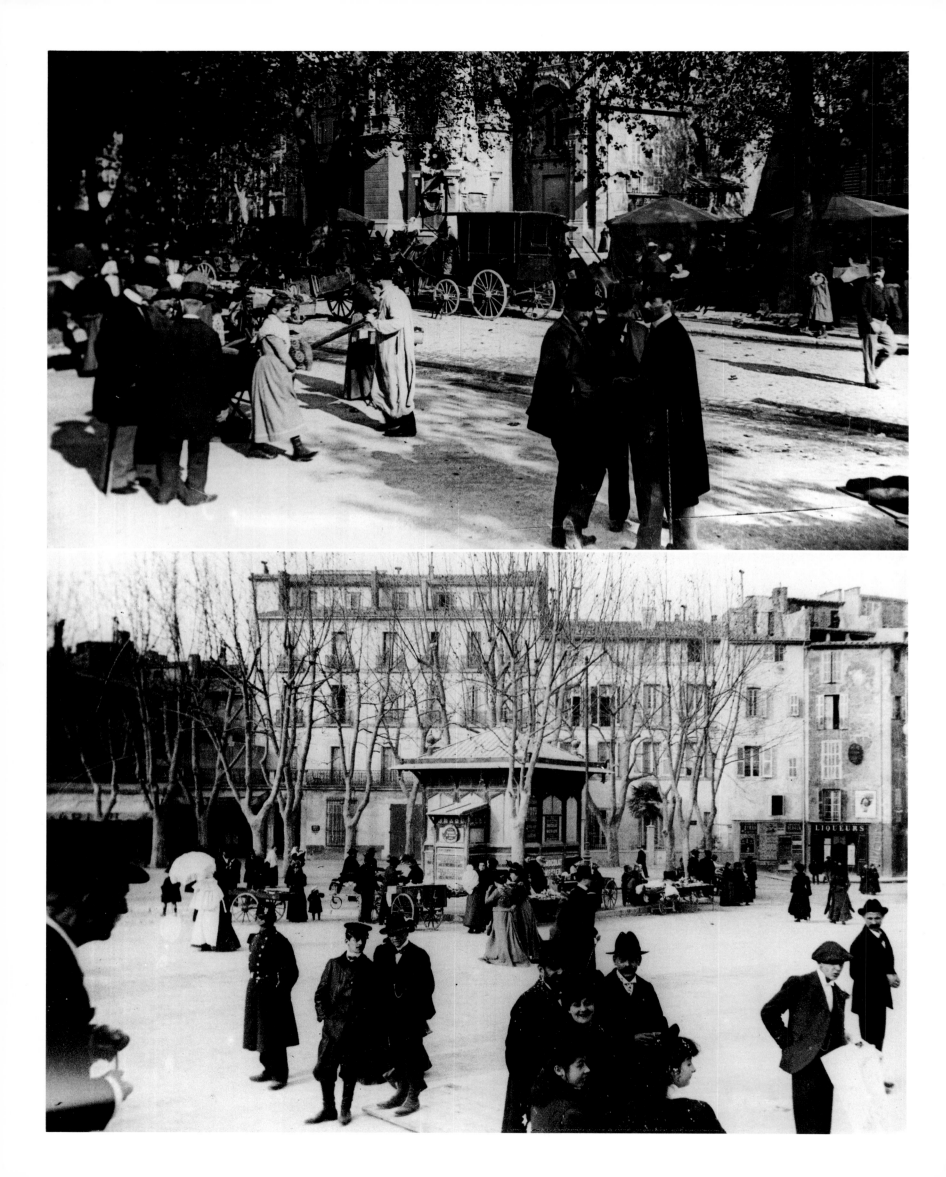

Youth in Aix

AIX-EN-PROVENCE is a small town in southern France that, even some fifty years ago, still seemed to have been completely bypassed by progress. Time appeared to have stood still there for many decades, and life was almost as peaceful and quiet as it was a century and more ago. No large highway touched the town then; yet even today the express from Paris to nearby Marseilles continues to pass by its old and sleepy station. A few buses and an obsolete train connect Aix with the outer world, but their incredible slowness discourages what traffic might disturb the pace of the town.

Nothing ever seems to happen in Aix, and even the seasons succeed each other without much altering its aspect. The countryside with its pines and cypresses remains green throughout the winter and the many warm springs that cascade over mossy stones or run into baroque basins at practically every street corner never interrupt their flow the year around. The town is rich both in beautiful fountains and in churches, whose often clumsy towers or picturesque belfries dominate the yellow and red tiled roofs. Crowded together so as to provide cool shadows, the old houses, with their shuttered windows, stone caryatids, and graceful ironwork, have seen few changes during the past one hundred fifty years. The people who live in them were born there and will die there, ignorant of the world at large, perfectly contented with their retired existence.

Although most of the streets are no longer cobblestoned, nearly every one of them leads into the open, into a beautiful country of hills and vineyards, crossed by rivulets that often dry out in the summer's heat. Wherever one finds oneself, there appears in the distance the large and gray wall of Mont Sainte-Victoire, rising abruptly above the undulating valley. At its foot Marius defeated the Teutons one hundred years before Christ, and the reddish earth of the fields is said to have retained its color from the blood with which it was drenched. Since then, however, eternal peace has reigned over the valley; grapes, olives, and almonds ripen in the torrid sun and even clouds seem banned from the blue sky. No sooner do they appear than a violent sirocco, blowing from the Mediterranean, chases them beyond Sainte-Victoire.

In the rocks near Sainte-Victoire lies hidden a large dam, designed by one François Zola in order to provide the town with water during the summer months. And not far from there is a strange old quarry from which a warm-colored, soft stone has been extracted since Roman times. Most of the houses in Aix are built of this stone and seem to retain some of the yellow glow of the sun. The Collège Bourbon, however, is not one of them; it is one of the few buildings that do not partake of the silent charm of Aix.

In this quiet, sun-filled town, remote in its own concerns, and behind the austere walls of this school, two young boys met in 1852. Paul Cézanne was then thirteen and a boarder in the sixth grade; Emile Zola, who was a year younger, was a part-time boarder in the seventh. Both were unconventional in different ways, and a close friendship immediately grew up between them. "Opposites by nature," as Zola later remembered, "we became united forever, attracted to each other by secret affinities, the as yet vague torment of a common ambition, the awakening of a superior intelligence in the midst of the brutal mob of dreadful dunces who beat us."

The Fontaine des Quatre Dauphins, Aix-en-Provence. Photograph c. 1939. In the background is the steeple of Saint-Jean-de-Malte.

OPPOSITE, ABOVE:
Place des Prêcheurs,
Aix-en-Provence.
Photograph c. 1900

OPPOSITE, BELOW:
The bandstand, Place Jeanne d'Arc,
Aix-en-Provence.
Photograph c. 1900

11

Paul Cézanne, who was big and strong, took the somewhat puny Zola under his
protection when the younger boy was sneered at as "Parisian." Born in Paris and
brought up in Aix, Zola was an orphan. His father, Italian by birth, was an
engineer and a former officer of the Foreign Legion. He had died in 1847, soon
after beginning the construction of the dam, and his young widow lost her whole
fortune in lawsuits concerning the estate. She lived in straitened circumstances
with her parents and her son Emile.

Cézanne, too, was probably of Italian ancestry. His forebears came from a
small town near the French frontier and had moved to Briançon.[1] His father,
born in a village in the Var, set up business in Aix as a dealer and exporter of
hats. In 1848 he was rich enough to buy the only bank in town, and by this
means gained a considerable fortune.

At the Collège Bourbon, Cézanne and Zola extended their friendship to include
a third schoolmate, Baptistin Baille, who later became an engineer. The three
friends found themselves closely drawn together by a number of unusual interests
and ambitions, and at school they came to be known as the "inseparables." They
took long walks together over the countryside around Aix, and passed the time in
fishing, swimming, and reading verses by Homer and Virgil. They felt, as Zola
told Cézanne, "all three rich in hope, all three equal by virtue of our youth and
our dreams." Artistic questions particularly absorbed them and they discussed
everything that was on their minds, persuading each other that they had a great
and extraordinary destiny. Zola wrote poetry, which he read to his friends, and
they in turn wrote verses. Zola found Cézanne's more poetical than his and
encouraged him to continue his efforts. "What we were seeking," Zola later wrote
to Baille, "was richness of heart and spirit, and especially the future, which our
youth made us see as so brilliant."

It is impossible to say who was the most enthusiastic and animated of the
three, but it is certain that Cézanne was the least sure of himself. He lost his
temper easily and was prone to deep depressions that alarmed his two friends.
Nevertheless they did not bear a grudge against him when he insulted them
during his fits of rage; Zola, always conciliatory, told Baille: "When he hurts
you, you must not blame his heart, but rather the evil demon that beclouds his
thought. He has a heart of gold and is a friend who is able to understand us,
being just as mad as we, and just as much of a dreamer."

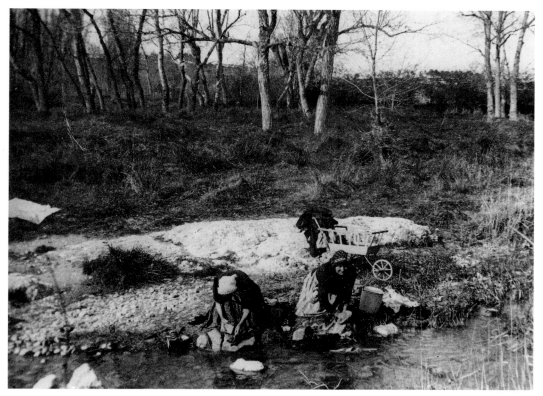

Washerwomen on the bank of the Arc River, Aix-en-Provence. Photograph c. 1900

When this "demon" haunted him, Cézanne would say: "The sky of the future is very dark for me!" When, on the other hand, he was lighthearted, no reasoning could prevent him from carrying out some crazy ideas. For example, whenever he had some money he usually hastened to spend it before going to bed. When Zola questioned this extravagance, Cézanne replied: "By Jove! If I died tonight, would you want my parents to inherit from me?"

The interests of the friends were many: According to Henri Gasquet, a schoolmate at the Ecole Saint-Joseph, where Cézanne had studied before entering the Collège Bourbon, Cézanne and Zola used to serenade a pretty girl of the neighborhood whose only fortune consisted of a green parrot. Zola played the cornet, Cézanne the clarinet, both with more enthusiasm than skill, and the parrot, driven crazy by their cacophony, made an indescribable racket. The two friends also belonged to a musical club that participated in all local ceremonies and gave a warm reception to every official who returned from Paris with the red ribbon of the Legion of Honor. Occasionally they played in religious processions.

On the third floor of Baille's house the friends had found a large workroom full of old newspapers, pictures lying on the floor, chairs with broken straw seats, and rickety easels. There they exercised their talents still further and made chemical experiments, heated retorts, and wrote three-act comedies in rhyme.

Later on they indulged in "the healthy debauchery of the fields and of long walks. . . . In the morning we left before daybreak," as Zola used to tell. "I went under your windows to call you in the middle of the night, and we hurried out of the town, game bag on back and gun in hand. . . . The game bag was empty on our return, but the mind was full and so was the heart."

Zola later recollected with emotion this happy period of their youth:

It was around 1856; I was sixteen. . . . We were three friends, three scamps still wearing out trousers on school benches. On holidays, on days we could escape from study, we would run away on wild chases cross-country. We had a need of fresh air, of sunshine, of paths lost at the bottoms of ravines and of which we took possession as conquerors. . . . In the winter, we adored the cold, the ground hardened by frost, which rang gaily, and we went to eat omelettes in neighboring villages. . . . In the summer all our meetings took place at the riverbank, for then we were possessed by the water. . . . In the autumn, our passion changed, we became hunters; oh! very innocuous hunters, for the hunt was for us only an excuse to take long strolls. . . . The hunt always ended

13

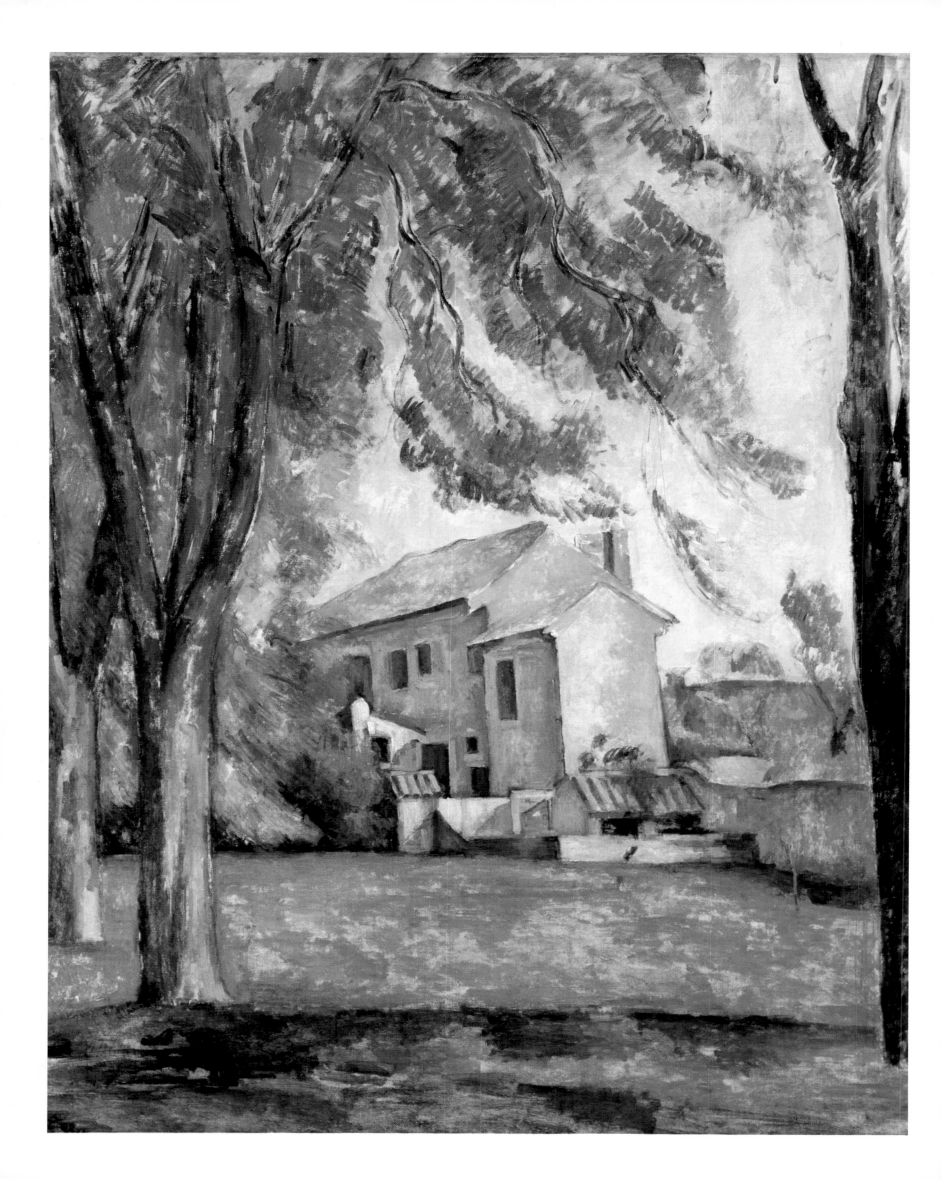

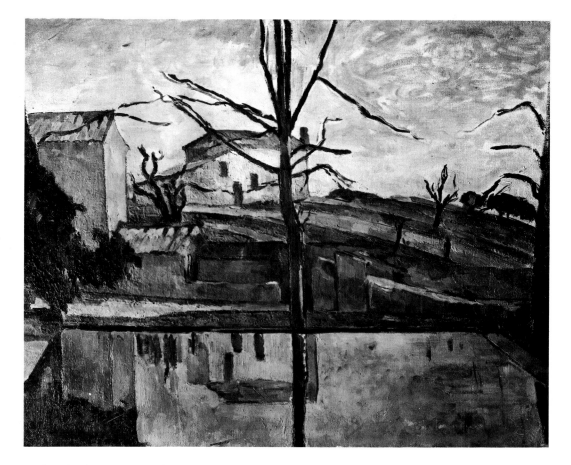

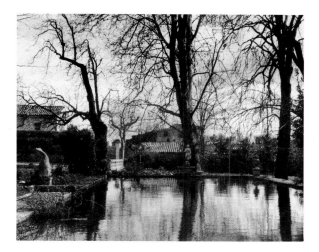

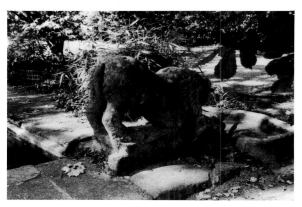

The Pool at the Jas de Bouffan in Winter. c. 1878

The pool of the Jas de Bouffan with a view
of the farm complex beyond the chestnut trees.
Photograph c. 1935

One of two waterspouting lions at the corners
of the pool, close to the allé of chestnut trees,
Jas de Bouffan. Photograph c. 1950

in the shade of a tree, the three of us lying on our backs with our noses in the air, talking freely about our loves.

And our loves, at that time, were above all, the poets. We did not stroll alone. We had books in our pockets or in our game bags. For a year, Victor Hugo reigned over us as an absolute monarch. He had conquered us by his powerful demeanor of a giant, he delighted us with his forceful rhetoric. We knew entire poems by heart and when we returned home, in the evening at twilight, our gait kept pace with the cadence of his verses, sonorous as the blasts of a trumpet. . . .

Victor Hugo's dramas haunted us, like magnificent visions. When we came out of classes with our memories frozen by the classical tirades we had to learn by heart, we experienced an orgy replete with thrills and ecstasy when we warmed ourselves by memorizing scenes from *Hernani* and *Ruy Blas*. How often, after a long swim, the two or three of us performed whole acts on the bank of the little river!

Then, one morning one of us brought a volume of Musset. . . . Reading Musset was for

François-Marius Granet. *View of an Italian Town.* n.d.

The Aix painter François-Marius Granet (1775–1849), a friend of Ingres, left his entire estate to the museum of his hometown, which in 1861 opened a room devoted exclusively to his work. There Cézanne must have seen Granet's many exquisite small landscapes, mostly of Italy. These were the first spontaneous, freely brushed, and tenderly observed studies of nature he had an opportunity to study.

*Farmhouse and Chestnut Trees
at the Jas de Bouffan.*
c. 1884

15

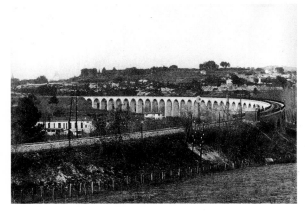

The railway viaduct painted by Cézanne,
Aix-en-Provence. Photograph c. 1903

us the awakening of our own heart. We trembled. . . . Our cult of Victor Hugo received a terrible blow; little by little we felt ourselves grow chilled, and his verses escaped our memories. . . . Alfred de Musset alone reigned in our game bags. . . . He became our religion. Over and above his laughter and schoolboy buffoonery, his tears won us over, and he only became completely our poet when we wept on reading him.

Those were strange hunting parties, indeed. Paul Alexis, another schoolmate, gives this description of the three friends' expeditions:

At three in the morning, the first to awaken threw pebbles at the shutters of the others. They left immediately, their provisions having been packed in their game bags the previous day. By sunrise they had already walked several kilometers. About nine o'clock when the sun became hot, they sat in the shade of a wooded ravine. And lunch was cooked in the open air. Baille lighted a fire of dead wood in front of which a leg of mutton seasoned with garlic hung from a string, which Zola flipped from time to time. Cézanne fixed the salad in a damp napkin. Then they took a nap. Then they set off again, their guns on their shoulders for a great hunt, perhaps to shoot a snipe. A league farther on, they put down their guns and sat under a tree, taking a book out of the game bag. . . .

"Sometimes," Zola remembered later, "when an inquisitive bird perched at a suitable distance, we thought ourselves obliged to take a shot at it; fortunately we were wretched shots and almost always the bird shook its feathers and flew away. This barely interrupted the one of us who was reading aloud, perhaps for the twentieth time, *Rolla* or *Les Nuits!* I have never had any other conception of the hunt. . . ."

Back in town the irrepressible interests of the three friends did not lag. During the Crimean War, when numerous regiments passed through Aix on their way to the Orient, the "inseparables" rushed on to the Cours Mirabeau, the main avenue of the town, as early as four o'clock in the morning to watch the departure of the troops and accompany the soldiers for a little way on the road to Marseilles.

Their excursions did not make them neglect their studies, however. Cézanne was a diligent student, especially interested in dead languages. For two sous he would turn out a hundred lines of Latin, and during his school years he frequently won prizes for calculus, Greek and Latin, science, and history. Several times he won the prize for general excellence, but only once, in 1854, did he receive an award in painting. In the same year, however, he attended Professor Gibert's classes at the Ecole Spéciale et Gratuite de Dessin de la Ville d'Aix (Free Municipal School for Drawing, Aix), where he won second prize. Zola distinguished himself more easily in drawing and won a prize for it each year.

In February 1858 the life of the friends together, with its excursions, painting, music, and poetry, was suddenly interrupted by Zola's departure for Paris to join his mother, who had been forced to go there for financial reasons. Although Zola regretted abandoning Aix, he felt a sense of adventure in leaving for Paris and thought his new life would hold promise for the future. Both Cézanne and Baille promised to come to Paris as soon as their examinations were over, and to resume their life together. Deep in their hearts the two friends who remained in Aix envied Zola, who left "to find the reward and the lover that God keeps for us at twenty."

THEIR letters exchanged after Zola's departure show how much Cézanne and Zola suffered by their separation. Not being sociable, neither succeeded in making new friends, and as a result they missed each other more keenly than might otherwise have been the case. In one of his very first letters, Cézanne complains to Zola: "Since you left Aix, my dear friend, a deep melancholy weighs upon me; I do not lie about this—I no longer recognize myself; I am heavy, stupid, and slow."

Cézanne's letters contain long poems, short bits of rhyme, Latin verses, an occasional rebus, drawings, and watercolors, as well as detailed and often ironical accounts of school and local events, of his examinations, studies, and personal adventures. The handwriting is full of verve, there is little space between the lines, many words are scratched out, and the margins are filled with comments that often have no bearing on the rest of the letter. The tone of these letters is not always the same. Sometimes they are full of vitality, sometimes frivolous, sometimes melancholy, and only seldom completely serious. As one of his friends remarked, Paul wrote letters only when he felt depressed. Thus a gay letter ends resignedly: "When something new occurs, I will write you. Until now a habitual and regular calm envelops our dull city in its sullen wings."

There is no evidence in his letters that Cézanne felt attracted at that time either to painting or to writing. Only once, in June 1859, did he say that he dreamed of pictures and of a studio in Paris; in general he did not even employ the words "painting" and "poetry," and if he painted and wrote verse it was more or less as a pastime. "Are you swimming?" Zola asked him in one of his letters. "Are you going on sprees? Are you painting? Are you playing the horn? Are you writing poetry? In sum, what are you doing?" In truth, Cézanne seems to have been doing nothing that was purposeful.

The poems Cézanne sent Zola nearly always contained some mocking lines, even if only at the end. Although Zola admired his friend's verses and found his soul "tenderly poetic," Cézanne refused to take his literary production seriously, and it is apparent that he wrote verse only to please himself and Zola. Convinced of Cézanne's talent, Zola tried to make him stop being a dilettante and to guide him toward serious artistic effort:

You sing for the sake of singing, and carelessly use the strangest expressions, the most facetious locutions of Provence. Far be it from me to call this a crime; on the contrary, it pleases me, especially in our letters. You write for me and I thank you for it; but the herd, my dear old friend, is more demanding; it does not suffice to express, it is necessary to express well. . . . I have asked myself what this good Cézanne lacks for becoming a great poet. Purity? He has good ideas; his form is vigorous and original, but what spoils it and the whole thing are the provincialisms, the solecisms, etc. . . . Yes, old man, you are more of a poet than I. My verse may be purer than yours, but yours is certainly more poetical, more true; you write with the heart; I, with the mind. . . .

But Cézanne was not moved by Zola's advice, or concerned with the demands of the herd. That which he lacked "for becoming a great poet" was chiefly the will to become one. The sheer pleasure of making rhymes and giving play to his ironical wit inspired his pen and his letters in verse, but these were unimportant to his ambitions.

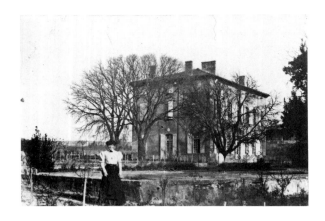

TOP:
The Jas de Bouffan. Photograph c. 1900

ABOVE:
The trees along the western border of the Jas de Bouffan, with a view of the neighboring properties, which have since made room for a highway. Photograph c. 1935

A large part of the friends' correspondence deals with love, and though Zola's opinions appear to be based on numerous experiences, he nevertheless admits: "I have never loved except in dreams, and I have never been loved, even in dreams." Cézanne's life in this respect was no doubt similar, as can be seen in one of his first letters to Zola: "Your letter not only gave me pleasure but even a feeling of well-being. A certain inner sadness fills me and, by God, I do nothing but dream of the woman I spoke to you about. I know not who she is; sometimes I see her passing in the street on my way to the monotonous seminary. I have reached the stage of heaving sighs, but sighs that do not betray themselves externally—they are mental sighs."

Later Cézanne wrote his friend: "The love known to Michelet, pure, noble love, may exist, but you must admit that it is very rare." And Zola, far from discouraging him in this platonic love, advised him to persevere. He even wrote him: "I am glad to know you, you who do not belong to our century, you who would invent love were it not a very old invention."

In one of his letters to Zola, Cézanne speaks at length about a new love as enthusiastic as it was fleeting:

I felt a passionate love for a certain Justine who is really *very fine*; but as I have not the honor to be *of a great beautiful*,[2] she always turned her head away from me. When I cast my peepers in her direction, she dropped her eyes and blushed. And I thought I detected that when we were in the same street she made as if it were a half-turn and dodged away without looking backwards. I am not happy *quanto a della donna* [*sic*] and to think that I run the risk of meeting her three or four times a day! And better still, dear fellow: one fine day a young man accosted me—Seymard, whom you know. "My dear friend," he said, taking my hand, and then hanging himself on my arm and continuing to walk toward the Rue d'Italie, "I am about to show you a sweet little thing whom I love and who loves me!"

I confess that instantly a cloud seemed to pass before my eyes. I had, so to speak, a presentiment that fortune was not going to smile at me, and I was not mistaken, for midday having just struck, Justine emerged from the dressmaker's shop where she works and Seymard, as soon as we caught sight of her, said to me, "Here she is." At this point I saw nothing more, my head was spinning, but Seymard dragging me along with him, I brushed against the little one's frock. . . .

Since then I have seen her nearly every day and often Seymard has been following her. . . . Ah! what dreams I have not built up, the maddest ever, but you see, things are like that. I said to myself, if she did not detest me, we should go to Paris together and there I should become an artist, we should be happy. I dreamed of pictures, a studio on the fourth floor, you with me—how we should have laughed! I did not ask to be rich; you know how I am—with a few hundred francs I thought we could live contentedly. By God, it was really a great dream, and now I, who am lazy, am happy only when I have drunk; I can hardly go on, I am an inert body, good for nothing.

My word, old man, your cigars are excellent! I am smoking one while writing you. They taste of caramel and barley sugar. But oh! look, look, here she is, she, how she glides and sways. Yes, it is my little one; how she laughs at me; she floats on the clouds of smoke; there, there, she rises, she descends, she frolics, she turns over, but she is laughing at me. O Justine, at least tell me that you do not hate me. She laughs. Cruel one, you enjoy making me suffer. Justine, listen to me! But she is disappearing, ascending, ascending, ever ascending until at last she fades away. The cigar drops from my mouth, whereupon I fall asleep. For a moment I thought I was going mad, but thanks to your cigar my mind is reasserting itself. Another ten days and I shall think of her no longer, or else I shall see her only on the horizon of the past as a shadow of which I dreamed.

Zola went to Aix in the summer of 1858 to spend his vacation with Cézanne and Baille, and despite Cézanne's project of writing a five-act drama to be entitled *Henry VIII of England*, no work of any kind was undertaken because their time

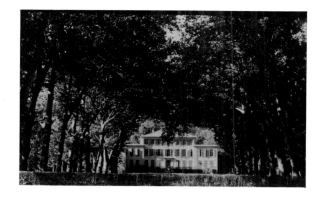

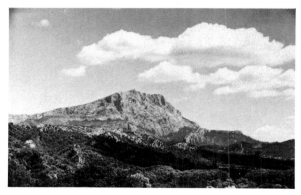

Sheet with legal texts from Cézanne's law studies, with various pen and ink sketches. c. 1859

was consumed by walks and talks. Once again they read, they spent hours bathing and lying in the sand, "wrestling, throwing stones at posts, catching frogs in their hands." They passed entire days on the banks of the Arc, not far from the Jas de Bouffan, an estate rented by Cézanne's father.

After Zola's return to Paris, Cézanne and Baille prepared for their baccalaureate examinations, which worried Cézanne a great deal. Baille had already passed his examinations when Cézanne, who had failed in July, passed his on November 12, 1858, with the mention "fair."

Complying with his father's wishes, Cézanne now registered as a student at the law school of the University of Aix; but his studies did not appeal to him at all; bitter references to this subject are found in his letters. He devoted a minimum of time to his law study and used his leisure to draw and to write poetry as before. Painting attracted him increasingly, and he began to feel vaguely that it was his real vocation. He was not yet concerned about the future and continued

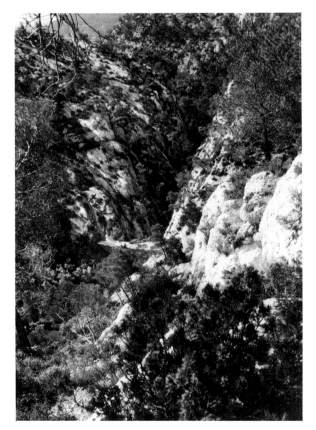

to have fantastic dreams and to compose interminable poems on historical or eerie themes.

In Paris, Zola, too, continued to write verse. He began the outline of *La Chaîne des Etres* in three cantos: Past, Present, Future. He wrote long poems, *L'Aérienne, Paolo*, etc. Whereas Cézanne was not at all concerned with form, Zola cultivated a gentle and flowery language, but the result was what de Maupassant later tactfully described as "poetry without definite character."

When Zola read his verses to his classmates in Paris, he received small praise. This roused Cézanne's ire, and he wrote his friend: "I am hurling this apostrophe, the terms of which are all too feeble to characterize these boasting, abortive, literary penguins, these asthmatic mockers of your honest rhymes. Pass on my compliment to them if you think it wise and add that if they have anything to say, I am here ready for them all as long as they are ready, waiting to box the first who comes within striking distance of my fist."

On his return to Aix in July 1859, Zola needed a rest after the strain of his baccalaureate examinations; he had passed the written ones but failed in the orals in German, history, and literature. He, who had suffered in Paris from his isolation, was happy to return even though he found Cézanne complaining about his law studies. Forgetting all their troubles, they went on outings with Baille and his young brother. They went to the dam, to Sainte-Victoire, whose gray wall rises above the village of Le Tholonet, and to the Pilon du Roi, a peak near the small town of Gardanne. Cézanne brought his paintbox and at Les Infernets, between the dam and Sainte-Victoire, his friends, rigged out in rags, posed for a picture of *The Brigands*, which was retouched by Cézanne twenty times. The painter was in a contagiously gay mood and would recite verses by Alfred de Musset.

The relationship between the friends had somewhat changed, however. Zola, though the youngest, had had a considerably harder experience of life and he was perforce the most earnest of the three. On his return to Paris after his stay in Aix, his life continued to be not only lonely, but also poor. Already he was beginning to look for a way to earn his living. In the meantime, he was again studying for his examinations, but when the time came he even failed in his written ones, and in discouragement he gave up trying for his baccalaureate. He was filled with the desire to work and to become independent so that he might devote himself entirely to literature. Several years later when he wrote his first novel, *La Confession de Claude*, he recalled this last summer spent with his friends in Provence:

Brothers, do you remember the days when life was for us a dream? We had friendship, we dreamed of love and glory. . . . The three of us let our lips say what our hearts felt and, naively, we loved queens, we crowned ourselves with laurels. You told me your dreams, I told you mine. Then we deigned to touch earth again. I told you about my pattern of life, devoted to work and struggle, and about my great courage. With a sense of the richness of my soul I liked the idea of poverty. Like me, you climbed the staircase to the attics; you hoped to nourish yourself on great thoughts. Because of your ignorance of reality, you seemed to believe that the artist, in his sleepless nights, earns the morrow's bread.

I N 1859 Cézanne's father bought the Jas de Bouffan, thus following the custom set by so many of the rich bourgeois citizens of Aix who had a country place where they passed the summer as well as a house in town. The Jas de Bouffan, about two kilometers west of Aix, was a thirty-seven-acre estate with a farm and a large, beautifully proportioned eighteenth-century manor that still stands. The wide facade, with tall and regular windows, overlooks a big garden set with ancient trees. It was originally the residence of the Governor of Provence, but when Cézanne's father bought it, for 90,000 francs, the house was in a deplorable state. A large salon on the ground floor and several rooms in the upper stories were in such a dilapidated condition that they were uninhabitable. They were locked up, and at first nothing was restored.

Garden facade of the manor house of the Jas de Bouffan. Photograph c. 1935

The purchase of this property was generally considered ostentatious, "the whim of a parvenu." This was not a surprising reaction in the local citizens who had several reasons for prejudice. One must not forget that the banker, Louis-Auguste Cézanne, was not a native of Aix; he had come there in 1825 at the age of thirty. He had started as a dealer and exporter of hats, for the felt industry was flourishing in Aix at that time. On January 29, 1844, he had married Anne-Elisabeth-Honorine Aubert, one of his employees, but by her he had already had a son, Paul, born January 19, 1839, and a daughter, Marie, two years younger. Ten years after their marriage another daughter, Rose, was born. The humble beginnings of the elder Cézanne, his marriage to a working girl, and the illegitimacy of his first two children were reason enough for society in Aix to keep him at a distance. Because these people did not associate with him, they did not know him. Some thought of him as a sort of Père Grandet: authoritarian, shrewd, and stingy. Others considered him, on the contrary, a man of great humanity. But Zola, who knew him well, later described him in the preparative notes for his novel *The Conquest of Plassans* (published in 1874) as "mocking, republican, bourgeois, cold, meticulous, stingy. . . . He refuses his wife any luxury, etc. He is, moreover, garrulous and, sustained by his wealth, doesn't care a rap for anyone or anything." The banker did, however, take an interest in public affairs, and after the fall of Louis-Philippe in 1848 had tried for election to the municipal council of Aix, as twenty-second on a list of twenty-seven candidates running on a ticket of "fusion of classes and parties." He obtained only a very few votes and was defeated.

The kind of ostracism to which his family was subjected left its mark on Paul, who was proud and sensitive, and accentuated his introspective tendencies. Later, when he reached manhood, Cézanne avoided society and found it very difficult to make friends.

The Jas de Bouffan was to play a great part in the life of Paul Cézanne. Nowhere else did he work as often. In a great many of his paintings one can recognize the big house, the two rows of chestnuts, the square pool with its stone dolphin and lions, the farm, and the low walls surrounding the property. Yet in his letters to Zola, written in the year the "Jas" was acquired by his father, Cézanne makes no allusion to the place.

Although Cézanne did not discuss painting in his letters, it is apparent from

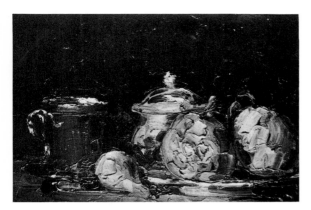

Still Life with Sugar Bowl, Pears, and Cup. c. 1865.
This still life hangs on the wall in Cézanne's portrait
of his father, reproduced on the opposite page.

those written by Zola after December 1859 that he had decided to become a
painter. The desire to devote his life to art appears to have developed slowly,
however, and he had not yet obtained the consent of his father, who urged him to
"think of the future, for one dies with genius but one eats with money."

At that time Cézanne often worked at the Aix museum, where he made various
copies. Cézanne also painted a large mural in the salon of the Jas de Bouffan, a
fishing scene at sunset. To satisfy his father Cézanne continued his studies, but
he hated law. His desire to paint grew and made him dream of going to Paris and
dedicating himself to art. Meanwhile he enrolled at the municipal drawing school
of Aix for the school year November 1858 to August 1859. He enrolled again in
November 1859 and 1860, and thus copied plaster casts or studied the living
model (always male) from 1858 to 1861. At the school he met Achille Emperaire,
Numa Coste, Jean-Baptiste Chaillan, Joseph Huot, Honoré Gibert—son of the
drawing master and curator of the museum—as well as Joseph Villevieille,
Auguste Truphème, Philippe Solari, and many others.

Life classes took place in the summer from six to eight in the morning and in
the winter from seven to nine in the evening. They were held on Mondays,
Tuesdays, Wednesdays, and Fridays. During the winter months the classroom
was lit by gas lamps and heated by stoves, near which the shivering model held
himself; in 1859 the model earned one franc per session. Besides life classes,
the students were also engaged in a number of other exercises, such as painting
in oils and in natural size the heads of living models (as opposed to plaster
casts), meticulously drawing moldings and ornaments, faithfully copying
sentimental lithographs, etc. In 1859 Cézanne obtained his only award: a second
prize in the class for painted figure studies, the first prize having been given to
one Eugène Grange, who chose not to otherwise encumber the history of art with
his name. An honorary mention went to Jean-Baptiste Chaillan, a comrade a few
years older than Cézanne, in whom Cézanne appreciated a certain poetic strain
whereas Zola had a rather negative opinion both of his gifts and his character.

In 1859, Chaillan was obviously the outstanding pupil of the municipal
drawing school. Besides the honorable mention, he won a first prize for a figure
study after an antique sculpture (read: plaster cast), as well as for drawings after
plaster ornaments. How the jury distributed these prizes is a mystery, since the
works submitted by the students that have been preserved show a distressing
sameness and a total absence of any venturesome spirit. Were it not that the
authors had to sign their works, it would be impossible to distinguish Cézanne's
boring studies from those of his classmates, the more so as they all represent the
same models in static poses. It is quite evident that their teacher, Joseph Gibert
(1806–1884), taught them only the technical tricks of placing shadows and lights
and of a carefully dull execution, which was obviously all he himself knew how
to do.

Whether the students, most of whom had known each other since childhood,
had any fun during these uninspiring classes has not been recorded, but it is
known that in 1868, several years after Cézanne had left the school, there was
unrest among the pupils, which old Gibert suppressed with great vigor even
though vigor was otherwise absent from his production.[3]

The one thing that was not taught at the Aix school was the study of nature,
and this in spite of the fact that the museum owned since 1849 a rare treasure of
spontaneous outdoor sketches. Indeed, the painter François-Marius Granet
(1775–1849) had bequeathed to his hometown not only an excellent portrait that
Ingres had done of him in Rome (one of Ingres's finest), and a good many of his
own then still highly regarded compositions, mostly of monks and church
interiors, but also numerous small, vividly brushed landscapes of great charm

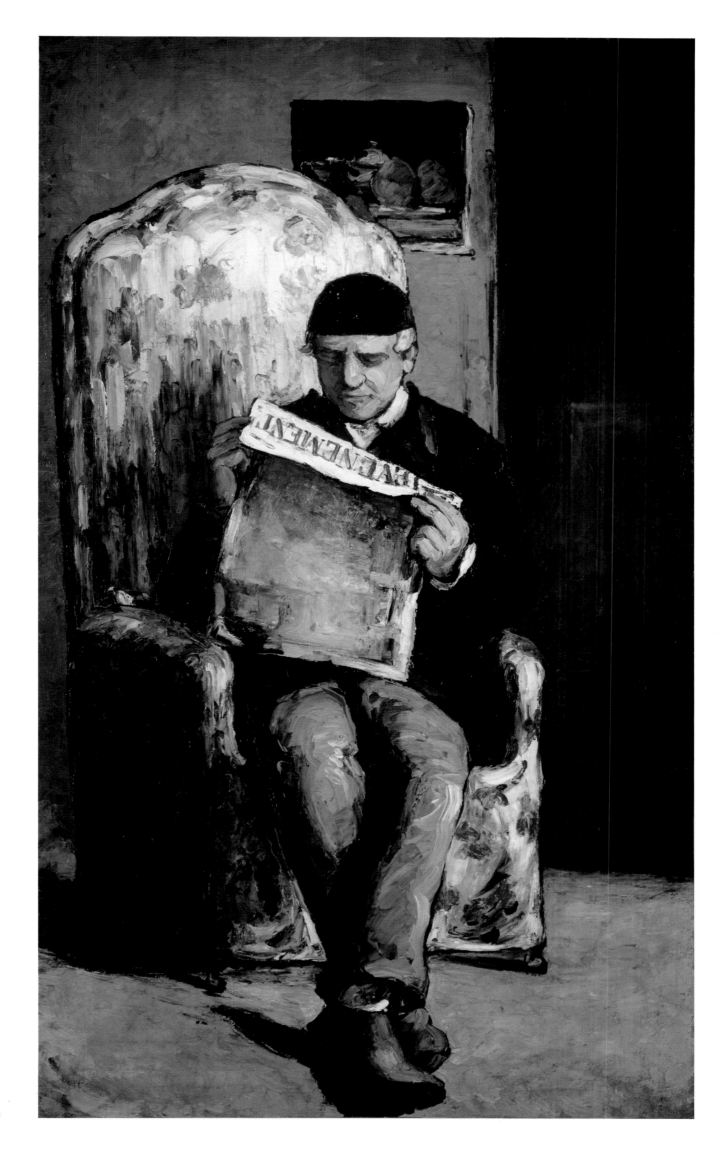

Portrait of Louis-Auguste Cézanne
Reading L'Evénement
(The Artist's Father). Autumn 1866

Male Nude. 1862.
Drawn at the municipal drawing school in Aix-en-Provence

and luminosity that rivaled similar works by Corot or Constable. In addition he had left countless watercolors of such innovative freedom of execution, such exquisite colors, and such keen observation of nature that they cannot have failed to impress Cézanne. But these watercolors were still little appreciated and it appears unlikely that Cézanne became acquainted with them until decades later.

On the other hand, in 1866 Joseph Gibert invited Cézanne to see the Bourguignon de Fabregoules collection of old masters (generally of second rank) recently willed to the museum and still temporarily installed in a chapel. Cézanne reported to Zola that he found everything bad.

As far as contemporary works were concerned, the Aix museum had nothing to boast about, depending as it did on government handouts, which is not to say that it might have fared better if Joseph Gibert and some municipal counselors had been allowed to let themselves be guided by their absence of taste and discrimination. One way or the other, masters like Delacroix or Courbet would never have found their way to Aix. It is true that in 1835 Paris had shipped to Aix Ingres's huge *Jupiter and Thetis,* but this was a work that nobody wanted and that the monarch finally purchased because Granet urged him to lend it to Aix. Just the same, this dry and stiff product of arduous labor without the tiniest spark of imagination could hardly have inspired admiration in the young aspiring artists of the town.

In those days the government policy of encouraging the arts consisted in buying at every Salon a given number of dreadful daubs which were so bad that the Parisian institutions laid no claim to them, whereupon they were graciously distributed among provincial museums, these having no way of escaping such gifts. (However, if there was a lascivious nude or a tear-jerking subject among the purchases, the Emperor acquired it for his private collection.) It goes without saying that all these insults to art were hung by their unlucky recipients with labels specifying that they were generously on deposit from the state. The museum of Aix did not escape its share of such horrors. In 1851 it received a dramatic, vacuous, and inept *Prisoner of Chillon* by Dubufe, and in 1857 an unspeakably trivial *Kiss of the Muse* by Frillie. Yet this time even the art commission of the Aix school and museum could not refrain from declaring that "the committee has, upon this occasion, expressed the vivid regret of not having received for some time anything but mediocre works from the government."

Just the same, it was precisely of Dubufe's *Prisoner of Chillon* and of Frillie's *Kiss of the Muse* that Cézanne painted excruciatingly faithful copies. His painting after Frillie's was actually his mother's favorite picture and it hung in her room; she always took it with her when the family moved between town and country.

Finding Cézanne thus at work, Zola doubtless encouraged him during his visits to Aix; in any case, Cézanne continued trying to persuade his father to let him take up painting as a career. Little by little he succeeded, and he was able to inform Zola in February 1860 that the banker was no longer opposed to his departure but wished first to consult Monsieur Gibert. Zola, delighted, immediately outlined a budget, telling Cézanne that 125 francs a month would be just adequate for his expenses in Paris and adding that it would be a good way for his friend to learn resourcefulness and the value of money. He also sent Cézanne a schedule to be followed during his stay in Paris: "From six to eleven you will go to a studio to paint from the living model; then you will lunch; then, from noon to four you will copy, either at the Louvre or the Luxembourg . . . which will make nine hours of work."

But Cézanne's trip kept being postponed. First his little sister took sick; then his teacher advised him to remain in Aix to study from models or plaster casts.

As Zola had predicted, "Master Gibert regretfully sees a pupil escape him." Cézanne's father was only too glad to follow the advice of the teacher and for the moment there was no longer any question of the trip to Paris. Zola wrote to his disappointed friend: "You must satisfy your father by studying the law as diligently as possible. But you must also work tenaciously at your drawing."

Cézanne seemed to yield to this reasoning, and Zola answered one of his letters in these words: "You are right not to complain about your luck: because, after all, as you say, with two loves, the love of woman and the love of the beautiful, it would be a mistake to despair. . . ." But Zola added: "One sentence in your letter made a bad impression on me. It was this: 'Painting, which I love, even though I am not successful, etc., etc.' You, not to be successful, I think you deceive yourself! I have already told you: in the artist there are two men, the poet and the workman. One is born a poet, one becomes a workman. And you who have the spark, who possess what cannot be acquired, you complain when all you need to succeed is to exercise your fingers, to become a workman!"

A few days later, Cézanne referred to the subject again: "When I have finished my law, perhaps I shall be free to do what I think best; perhaps then I can join you." To this Zola replied: "Be firm without being disrespectful. Realize that it is your future which is being decided and that all your happiness depends on it."

However, Cézanne's mood of discouragement and sadness grew to such an extent that he even considered remaining in Aix to study law and giving up all his dreams. He no longer dared ask his father to let him go to Paris, for he had doubts about his own talent and did not feel himself possessed anymore by the desire to paint. Once again Zola tried to encourage him:

In your last letter you seem to be depressed; you even speak of throwing your brushes away. You bewail your solitude. You are bored. Isn't this the sickness of all of us, this terrible boredom? Is this not the evil of our century? And isn't discouragement a result of this despondency which chokes us? As you say, if I were with you, I would try to console you, to encourage you. . . . Regain your courage; take up your brushes again, and let your imagination wander freely. I have faith in you, and if I push you toward misfortune, may this misfortune fall back on my own head. Courage, above all, and before you embark on this, consider carefully the thorns you may find in your path.

In the face of the inertia with which Cézanne met his advice, Zola, so gentle and patient with his friend until now, finally got angry. An end must be made to all these evasions; Cézanne must get the permission to go to Paris and there become an artist. And Zola demands:

Is painting only a whim that took possession of you when you were bored one fine day? Is it only a pastime, a subject of conversation, a pretext for not working at law? If this is the case, then I understand your conduct; you are right not to force the issue and make more trouble with your family. But if painting is your vocation—and that is how I have always envisaged it—if you feel capable of achieving something after having worked well at it, then you are an enigma to me, a sphinx, someone indescribably self-contradictory and obscure. One of two things is true: either you do not want to, and you are realizing your purpose admirably; or you do want to, and in that case I don't understand it at all. Sometimes your letters give me a lot of hope, sometimes they take even more away, like the last one in which you almost seem to say farewell to your dreams, which you could so well convert into reality. In this letter occurs this sentence which I have tried in vain to understand: "I am going to talk without saying anything, for my behavior contradicts my words." I have constructed many hypotheses on the meaning of these words, but none satisfies me. What, then, is your behavior? That of a lazy person, no doubt; but what is surprising about that? You are forced to do work that is distasteful to you and you want to ask your father to let you come to Paris to become an artist; I see no

TOP:
Achille Emperaire. *Male Nude.* 1846

ABOVE:
Achille Emperaire. *Figure Study* (after a plaster cast from the Antique). 1847. Both studies were drawn at the municipal drawing school in Aix-en-Provence

contradiction between this request and your actions. You neglect the law, you go to the museum, painting is the only work you find acceptable; there I find an excellent agreement between your wishes and your actions. Do you want me to tell you?—but be sure not to get angry—you are lacking in character; you dread fatigue of any kind, in thought as well as in action; your main principle is to let things take their course and to leave yourself at the mercy of time and chance. . . . I have thought it my duty to repeat here for the last time what I have often told you: my capacity as your friend excuses my frankness. In many respects, our characters are similar; but by Jesus, if I were in your place, I would want to have the answer, to risk all to gain all, and not to float vaguely between two such different futures, the studio and the bar. I am sorry for you, because you must suffer from this uncertainty, and this would be for me another incentive to tear the veil. One thing or the other, really be a lawyer, or else really be an artist, but do not remain a creature without a name, wearing a toga dirtied by paint.

Yet nothing could rouse Cézanne from his apathy, and Zola renewed the attack: "If you keep silent, how do you expect to progress and reach a conclusion? It is substantially impossible. And note that it is not the one who makes the most noise who is right; speak softly and wisely, but by the horns, the feet, the tail, and the navel of the Devil, speak, go ahead and speak! . . ."

Zola's letters to Cézanne in 1860 were prompted not only by his interest in his friend but also by his eagerness to be with him again, for Zola did not like Paris and he missed his comrades. The trip to Paris was a rather long one in those days. According to the timetables of 1863, the express train from Marseilles via Avignon took nineteen and a half to twenty and a half hours, whereas the local train covered the distance in twenty-nine to thirty-two and a half hours; in either case the journey meant sitting up an entire night. First-class tickets from Aix to Avignon and Paris cost 96.25 francs each way; second-class tickets were 72.20 francs, and the wooden benches of third class sold for 52.95 francs.

Unfortunately, Zola was unable to visit Aix during either the summer or the fall, though there were so many things he wanted to see: "Paul's panels and Baille's mustache." Zola's life in Paris was hard. After working on the docks as a clerk for several weeks and earning only sixty francs a month, he had had enough of it. Thus he remained without money or hope. Nevertheless he thought of nothing but literature, and even in his dreams he saw Cézanne's name joined with his. "I had a dream the other day," he wrote Paul. "I had written a beautiful book, a wonderful book, which you had illustrated with beautiful, wonderful pictures. Both our names shone in letters of gold on the first page and, inseparable in this fraternity of genius, passed on to posterity."

Zola was desperate at his increasing isolation in Paris, the more so as Cézanne's letters were fewer than before. Their content often worried Zola, who was also upset by what Baille wrote him. A certain coolness seemed to have developed between Cézanne and Baille. The latter, who was studying in Marseilles, complained to Zola of an inhospitable reception at the Jas de Bouffan, and when Zola reproached Cézanne for this, he received this reply: "You fear lest our friendship for Baille weaken. Oh, no, for he is a nice fellow, by Jove; but you well know that with my character I am not too aware of what I do, and so if I did him wrong, well then, he should forgive it."

Cézanne suggested a truth; because he and Zola were both artists, they were bound by an affinity that did not tie them to Baille. Memories of their boyhood spent together and a real friendship united all three, but Baille was not of the same breed and this became increasingly apparent. As Zola wrote Cézanne: "He is not like us, his skull is not cast in the same mold; he has many qualities we lack, and many faults also. . . . What difference does it make to us, his friends?

Does it not suffice that we have judged him to be a good fellow, superior to the crowd, or at least more able to understand our hearts and minds?"

Nevertheless, from 1860 on, a lack of understanding is apparent in their correspondence. The tact Zola employed in writing Cézanne is missing in his relations with Baille, and when Baille reproached him for "not facing reality courageously, of not making a position for himself," Zola replied: "The word 'position' smacks of the rich grocer in a way that gets on my nerves." Baille's answer expressed his contempt for "crazy" poets and their "false glory," and concluded by saying that he would "not be as stupid as they and, for the sake of applause, die in an attic."

Zola and Baille ended by tacitly avoiding any personal references in their letters and discussing only abstract subjects such as the Ideal or Reality, Shakespeare, George Sand, etc. Zola expounds his ideas in letters that are essentially literary, and it is with nostalgia that he remembers their last vacation in Aix: "Only a year has passed and yet how many changes have taken place in our characters, in our thoughts! Our minds are perhaps on a higher level now and our horizons wider, but we have lost our joyous carefree spirit, we want to solve the problems of life and with this seeking begin our doubts and tears."

Little by little Cézanne had given up his law studies to devote himself to painting. He still sketched at the municipal drawing school and described the model there as either taking a pose in the shape of an X or holding her belly. Zola reassured him on the subject of Parisian models: "The description of your model amused me very much—Chaillan claims that here the models are adequate without, however, being in their first youth. One sketches them in the daytime and caresses them at night (the word caress is a little weak). As to the fig leaf, it is unknown in the studios."

Cézanne not only worked in Professor Gibert's classes but also outdoors, even in winter, when he would sit on the frozen ground without heeding the cold. Zola approved with all his heart: "This news delighted me because such steadfastness denotes your love for the arts and the tenacity with which you apply yourself to your work."

Work, indeed, had given Cézanne courage and confidence and he again tried to get his father's consent to go away. Madame Cézanne took her son's part, saying: "He is named Paul, like Rubens and Veronese, and is no doubt predestined to paint." But her husband preferred to give their son only the sage advice he enjoyed dispensing: "Don't get too excited, take your time and act with caution!" or "Whenever you go out, know where you are going," etc.

Louis-Auguste Cézanne was sure that Zola was responsible for his son's "unhealthy" ideas and held this against him. When Baille informed Zola of this, Zola replied:

I felt that I had an opponent, almost an enemy, in Paul's family; our different ways of looking at things, of understanding life, made me sense how little sympathy M. Cézanne must have for me. . . . This seems to me to be the question: M. Cézanne has seen his son disrupt the plans he made for him. The future banker finds himself to be a painter and, feeling an eagle's wings on his back, wants to leave the nest. Surprised at this metamorphosis and this desire for liberty, M. Cézanne cannot understand that it is possible to prefer painting to the bank and the air of the sky to his dusty office, so M. Cézanne has decided to solve the riddle. He is not able to see that it was thus because God intended it to be, because God, having created him a banker, created his son a painter. But having examined the question thoroughly, he finally understands that I am responsible for it, that it is I who made Paul what he is today, that it is I who has robbed the bank of its dearest hope. The words "bad company" were no doubt used, and

The Cathedral of Saint-Sauveur, Aix-en-Provence. Photograph c. 1900

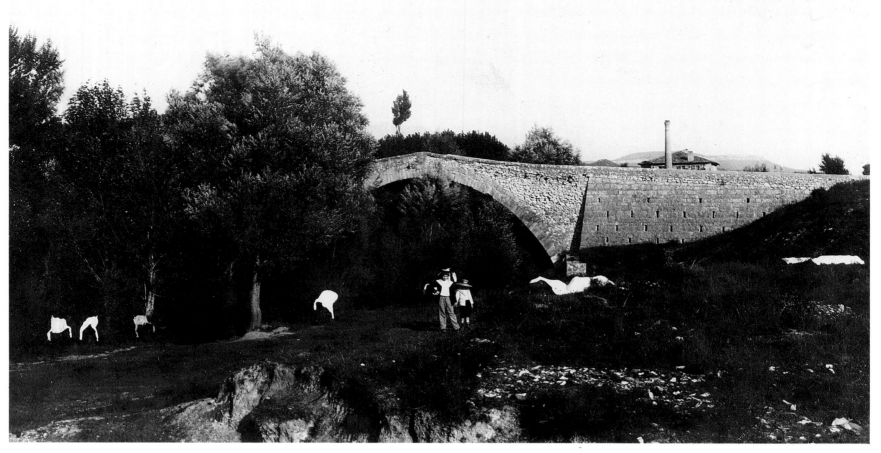

The Bridge of Les Trois Sautets near Aix-en-Provence.
Photograph c. 1900

that is how Emile Zola, man of letters, became an intriguer, a false friend, and I don't know what else. It is all the more sad because it is ridiculous. Fortunately Paul has doubtless kept my letters; it is evident from them what my advice was and whether I ever sent him on the wrong path. On the contrary, I repeatedly pointed out to him all the disadvantages of his trip to Paris and especially urged him to handle his father with care.

I cannot be blamed for the influence of these words on Paul's career. Without wishing to, I excited his love for the arts; no doubt I only developed the latent germs, a result that any other external cause could have produced.

At last Cézanne's father ended by giving in, for family life had become unbearable. Paul stayed away from home as much as possible and did not talk at all when he was there. The elder Cézanne finally put an end to this unpleasant state of affairs and gave his son permission to leave for Paris, but he felt sure that Paul would be bored in Paris once he had had his way and would hurry back to Aix to resume his studies or to go into the bank.

This time Paul Cézanne actually left Aix, and so suddenly that he did not even have time to notify Zola. Toward the end of April 1861, he took the train for Paris with his father and his sister Marie, who both returned to Aix after helping Paul find suitable lodgings. Cézanne was at last in Paris, free to realize his dreams.

CEZANNE'S first stay in Paris was one of the most unhappy periods of his life. Barely twenty-two, he had come there full of hope and with a great desire to work. Shortly after Cézanne's arrival, Zola informed Baille that Cézanne was working very hard and added rather regretfully that they seldom saw each other. Yet the meeting of the two friends had been extremely cordial. It was even apparent from the way in which Cézanne's father greeted Zola that he no longer felt any animosity towards him. After Louis-Auguste Cézanne's departure, Zola showed Paul the city and took him to admire the paintings of Ary Scheffer, of which he was especially fond, as well as the fountain of Jean Goujon, another of his enthusiasms. Together they visited art exhibitions and made plans for Sunday excursions to the outskirts of Paris—plans they were unable to realize for financial reasons. Paul received from his father a monthly allowance of one hundred twenty-five francs and presumably his expenses conformed to those outlined in a budget made by Zola. Cézanne's room, which cost twenty francs, and his meals (twenty-seven francs for lunch and thirty-three for dinner) consumed more than half his monthly allowance. In addition he needed ten francs for the studio where he sketched from life and the same amount for all his supplies. The remaining twenty-five francs had to pay for laundry, tobacco, and miscellaneous expenses.

As for Zola, he had not obtained a job since leaving the docks and he spent the whole year of 1861 without work, without money, with no foreseeable future, doing nothing. Cézanne had found him quite depressed.

In Cézanne's case, his father's predictions were coming true, one after the other. He had hardly been in Paris a month when he wrote to his friend Joseph Huot:

I do not wish to write elegies in these few lines, but must admit I am none too cheerful. I fritter away my life on all sides. The Atelier Suisse keeps me busy from six in the morning until eleven. I have some sort of a meal for fifteen sous; it is not very grand, but what can you expect? And I am not dying of hunger.

I thought that by leaving Aix I should leave behind the boredom that pursued me. Actually I have done nothing but change my abode, and the boredom has followed me. I have left my parents behind and my friends and some of my habits, that is all. And yet to think that I roam about almost the whole day. I have seen—it is naive to say this—the Louvre and the Luxembourg and Versailles. You know them, the boring things housed in these admirable monuments; it is astounding, startling, overwhelming.... Don't think that I am becoming Parisian....

I have also seen the Salon. For a young heart, for a child being born to art who says what he thinks, I believe that this is what is really best, because there all tastes, all styles, meet and clash. I could give you some beautiful descriptions and put you to sleep. Be grateful to me for sparing you.

Despite his admiration for the masters of official art, in spite of his walks, his frequent visits to the Louvre, and the hours spent with Emile Zola, the boredom that "pursued" Cézanne increased and he was becoming disgusted with Paris, with his friends, and, what was more serious, with his own work. He spoke of returning to Aix and of becoming a clerk in a business. Exasperated by this unhappy result of so many years of effort and so many letters, Zola wrote to Baille on June 10:

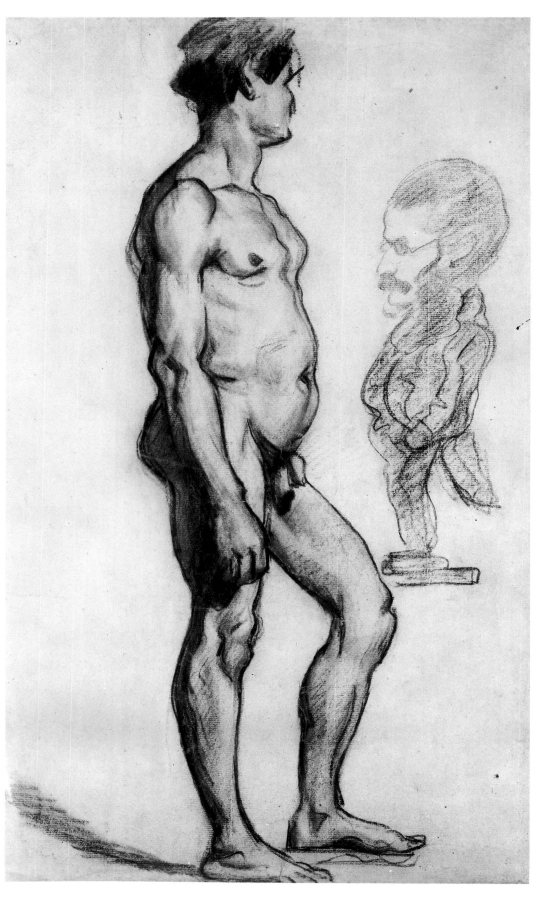

Male Nude. 1863–66. This study, as well as those on pages 31 and 32, were probably drawn at the Atelier Suisse in Paris.

I rarely see Cézanne. . . . In the mornings he goes to the Atelier Suisse while I stay in my room and write. . . . He then spends the rest of the day sketching at Villevieille's. Then he eats supper, goes to bed early, and I don't see him. Is that what I had hoped for? . . . Paul is still the same fine and strange fellow I knew at school. As evidence that he loses none of his originality, I need only tell you that no sooner had he arrived here than he spoke of returning to Aix. To have fought for his trip for three years and now not to give a straw for it! Confronted with such a character and such impulsive and unreasonable changes of behavior, I admit that I keep silent and suppress my logic. Proving something to Cézanne would be like trying to persuade the towers of Notre Dame to dance a quadrille. He might say yes, but he would not budge an inch. And note that age has developed his obstinacy without giving him rational grounds for it. He is all of a

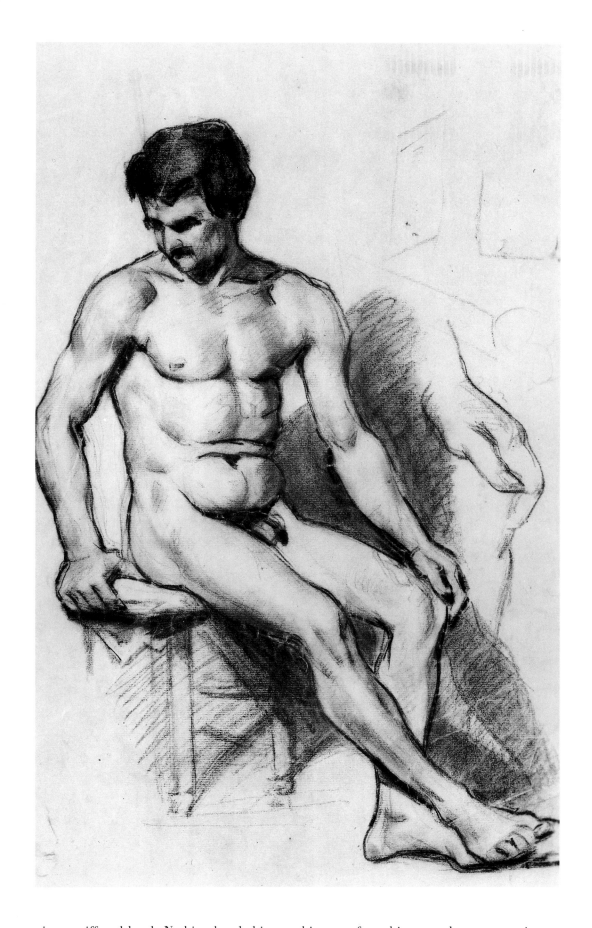

Seated Male Model. 1865–67

piece, stiff and hard. Nothing bends him, nothing can force him to make a concession. He does not even want to discuss what he thinks; he abhors discussion, because to talk is tiring, and also because it would be necessary to change his opinion if his adversary were right. There he is, thrown into the middle of life, bringing with him certain ideas, unwilling to change them except on his own judgment, nevertheless the nicest fellow in the world, always agreeing with you, result of his aversion to argument. . . . If, by chance, he advances a contrary opinion and you dispute it, he flies into a rage without wishing to examine, screams that you know nothing about the subject, and jumps to something else. Go ahead and argue—what am I saying?—simply converse with a fellow of this sort and you will not gain an inch of ground but you will have observed a most unusual character. I had hoped that age would make some changes in him. But I find

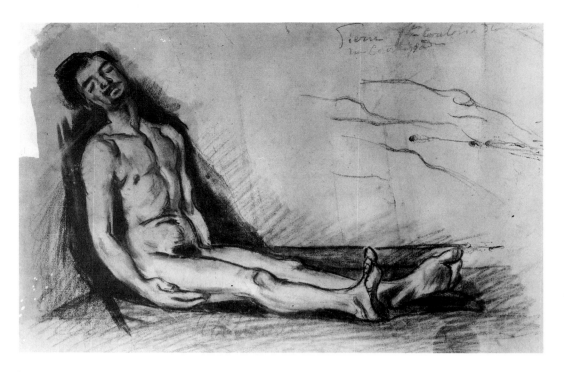

Study for The Autopsy. c. 1865

him the same as I left him. My plan of conduct is therefore very simple: never to check his whims; to give him at most very indirect advice; to put myself at the mercy of his good nature as regards the continuation of our friendship, and never to force his hand to shake mine; in a word, to efface myself completely, always receiving him gaily, seeking him out without importunity, and permitting him to determine the degree of intimacy he desires to have between us. Perhaps my way of speaking surprises you, but it is logical. To me Paul is always a good-hearted friend who knows how to understand and appreciate me. Only, since everyone has his own particular nature, out of wisdom I must conform to his moods if I do not wish to put his friendship to flight. In order to keep your friendship, I must use reason; with him, it would cause everything to be lost. Do not believe that there is any cloud between us; we are very close and everything I have just said is due rather unfortunately to chance circumstances that separate us more than I might wish.

Cézanne's queer moods reacted on his friend, and the tone of Zola's letters followed Cézanne's mental state. Thus, only a few days after his letter of June 10, Zola again wrote to Baille, who was then planning to join them:

I attempted to judge him and despite my good faith, I regret having drawn a conclusion that is not, after all, the right one. No sooner had he arrived from Marcoussis than Paul came to see me and was more affectionate than ever. Since then we spend six hours a day together. His little room is our meeting place, and there he paints my portrait while I read or we chat together and then, when we have had enough of work, we usually go to smoke a pipe in the Luxembourg gardens. Our conversations touch on all subjects, especially painting, and on our memories of the past. As for the future, we skim over it with a word in passing either to express a desire for our complete reunion or to pose ourselves the terrible question of success. . . .

I should like to give you still more details. Cézanne has many fits of discouragement; despite the somewhat affected scorn with which he speaks of fame, I see that he would like to gain it. When he does badly he speaks of nothing less than returning to Aix and becoming a clerk in a business firm. Then I have to give him long lectures to convince him of the folly of returning there; he readily agrees and goes back to work. Nevertheless, this idea consumes him; twice he has been on the verge of departure; I fear that he may escape me any moment. If you write him, try to speak to him in the most glowing terms of our forthcoming reunion; it is the only means of holding him.

To sum up all this, I must say that, notwithstanding its monotony, the life we are leading is not dull; work prevents us from yawning; and the exchange of our memories gilds everything with a ray of sunshine.

Come, and we shall be still less bored.

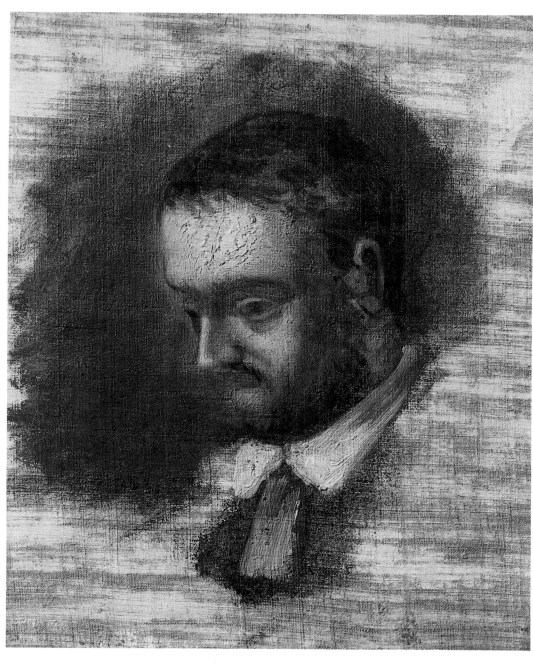

Portrait of Emile Zola. 1862–64

Zola had to exert his ingenuity to find ways of keeping his friend in Paris. One day he caught Cézanne preparing to leave, his trunks already packed, and suggested sitting for a portrait as a means of delaying him. "He accepted this idea joyfully," Zola wrote to Baille, "and this time there was no longer any question of returning." But the letter continues thus, speaking of this "damn portrait that was to detain him in Paris":

Having begun it twice, still dissatisfied with himself, Paul wanted to finish it and asked me for a final sitting for yesterday morning. Yesterday, then, I go to his place; when I enter I see the trunk open and the drawers half empty; Paul, with a gloomy face, is piling objects into the trunk in disorder. Then he tells me quietly:

"I am leaving tomorrow."

"And my portrait?" I ask him.

"Your portrait," he replies, "I have just smashed. I wanted to retouch it this morning and as it was getting worse and worse, I destroyed it; and I am leaving."

I still refrain from comment. We went to lunch together and parted only that evening. In the course of the day he became more reasonable and at last, when he left me, he promised to remain. But that is only a stopgap; if he does not leave this week he will go away next week; you may expect to see him leave any day. I even think he would do well to do so. Paul may have the genius of a great painter, but he will never have the genius to become one. The least obstacle makes him despair. I repeat that he should go if he wishes to avoid a lot of worry.

Photograph of Marie Cézanne. c. 1861

As one can see from Zola's letter, Cézanne did not work during the sittings exclusively but even more after the model had left. While the model was there he studied color and expression; only from time to time did he touch the canvas. Once the model had left, however, Cézanne really began to work, and painted until another sitting became necessary. Apparently the presence of a living person disturbed him and hindered him, up to a point, from working during the sittings. Indeed, in his still lifes and landscapes he adopted an entirely different approach, never painting without observing his subject.

Of the various portraits that Cézanne painted of Zola at this period, only one has been preserved. It is a sketch showing Zola in profile, a study in chiaroscuro. The forehead, which is strongly lighted, detaches itself from the dark background, while the black beard stands out against the whiteness of the collar. The effect is somewhat harsh.

A self-portrait that dates from this period is more interesting than the sketch of Zola, for it reveals Cézanne's mental state. It is fairly certain that Cézanne painted the portrait from a photograph, but he managed to change the general effect while preserving the details. By lengthening his chin and making his cheeks more prominent, by accentuating his eyebrows and completely changing the expression of his eyes, Cézanne gave to the gentle and quiet young man of the photograph a menacing face with a sharp and piercing expression. This look animates strangely the lifeless image he used as a model. The rather commonplace subject of the photograph seemed a stranger to Cézanne, who was a prey to perpetual doubts, disillusioned by everything and everybody, sad and in a state of revolt against others as well as himself. In this portrait he appears as he visualized himself. It is the portrait of a man who paid for each hour of hope with days of despair.

Cézanne was less dissatisfied with Paris than with himself and possibly also with Zola. The complete harmony, which they so much hoped for and needed in order not to feel lonely, had not been established between them. Zola was involved in his own projects, in the books he was planning to write, and felt bitterly disappointed in Cézanne. "Does our friendship need the sun of Provence in order to exist joyously?" he later was to ask Cézanne. He made a great effort and even succeeded in obtaining Cézanne's promise to stay until the autumn. "But is that his final decision?" he wrote to Baille. "I am in hopes that he will not change his mind."

Indeed Cézanne remained in Paris until September and only then left for Aix. The separation seems to have been cold; the two friends did not correspond for some time. Though Zola had known all along that after all his efforts Cézanne's victory could not be completed without some new battles, he never had doubted that his friend would eventually be able to overcome his difficulties. When he had urged Cézanne to join him, he had certainly not expected that some day Paul would leave Paris with the decision to renounce painting to enter his father's bank.

But no sooner had Cézanne taken a job in his father's office than the demon of painting took possession of him again. Aversion to business was enough to make him forget his doubts; his need to paint once more became imperative. It was then that he wrote on the ledger of the Banque Cézanne & Cabassol this verse:

The banker Cézanne does not see without fear
Behind his desk a painter appear.

Cézanne's father was beginning to realize that he would never be able to make his son either his successor at the bank or a prominent lawyer. He again

permitted Paul to follow his inclinations and Cézanne enrolled as usual with Coste, Huot, and Solari at the art school for the year 1861–1862, thus rededicating himself to painting.

The correspondence of the two friends was renewed after a lapse of several weeks by a letter from Cézanne written at the beginning of 1862, to which Zola replied assuring Cézanne of his continued friendship despite the temporary coolness in their relationship during Cézanne's stay in Paris. By that time Zola was no longer alone in Paris. Baille had just arrived and had been admitted to the Ecole Polytechnique. They saw each other regularly every Sunday and Wednesday.

It seems that Zola spent the summer of 1862 with Baille and Cézanne in Aix and there worked on his first novel, *La Confession de Claude*. This strange and violent book is a typical work of a beginner and full of unassimilated romanticism. Zola wrote it in the form of a "confession" for his two friends, to whom he dedicated the book. It was finished three years later and was published in October 1865.

Zola's productivity made Cézanne eager to join him again in Paris. Apprehensive because of his first failure there, he now submitted to Zola a program to which he wished to conform in the future. Zola replied: "I approve entirely of your idea of coming to Paris to work and of subsequently returning to Provence; I think it is a way to free oneself from the influence of the schools and to develop whatever originality one has."

Cézanne expected to remain in Aix until the end of the year and then leave for Paris. He was engaged in painting a *View of the Dam*, the dam that bears today the name of the engineer François Zola. Cézanne had often gone there with Emile Zola to watch the work progress and to swim in the big rock-bordered lake. This was one of their favorite outings. They followed the Tholonet road, which crosses the tiny river of the Torse and skirts the property of Château Noir, where Cézanne was to return to paint toward the end of his life. Then they crossed the Domaine St. Joseph on the so-called Colline des Pauvres, occupied at that time by the Jesuits, who offered them agreeable hospitality.

Zola having left, Cézanne became more intimate with Coste, several years younger than he. Together they attended the evening classes at the municipal drawing school, where Cézanne had painted a nude of the guardian of the dam, or they went to paint in the countryside.

Before leaving again for Paris, in November 1862, Cézanne probably had to promise his father to present himself to the Ecole des Beaux-Arts. His father believed that since his son was going to become a painter, it was best for him to study seriously in the official school.

Despite the constant struggle between father and son and despite the fact that the banker was obviously inordinately headstrong, he was far from primitive. He knew his son well and, to a certain degree, "understood" him without, however, being ready to capitulate before Paul's complicated personality. While he may have felt that his son's lack of stability called for particularly strict discipline, he must also have been impressed with the young man's tenacity, a characteristic he probably owed to paternal genes. The only thing that completely escaped him was the question of his son's talent; but this, it would seem, was of minor importance to the banker, since even the most promising artist would have made an unlikely successor for his business. What was of more immediate concern to him was that he was simply unable to comprehend anyone except those "who worked in order to get rich." In the end there was much more at stake for him than the mere exercise of his authority; he must have felt that, by protecting him against his youthful fancies, he acted in his son's own interest.

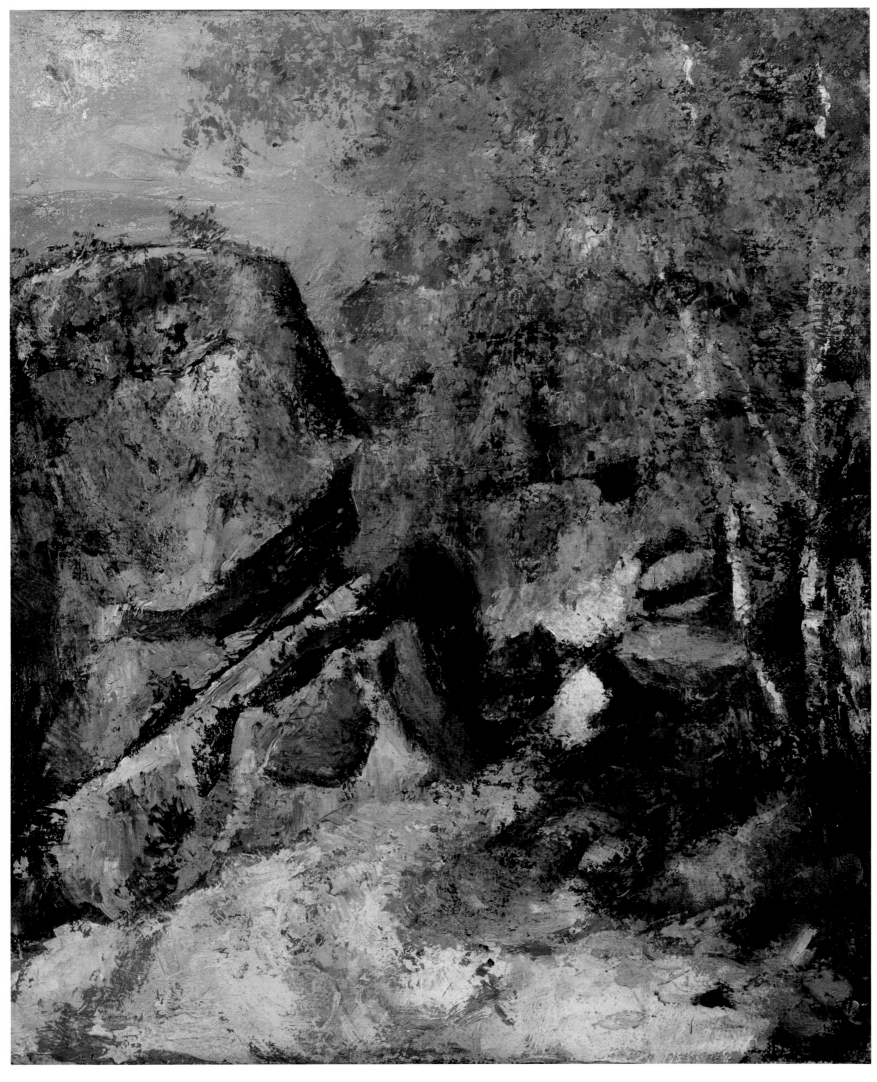

As SOON as Cézanne returned to Paris he began to work again at the Atelier Suisse on the Quai des Orfèvres. He went there "as formerly . . . in the morning from eight to one and evenings from seven to ten." This institute offered artists male and female models for a moderate monthly fee. Their work was not supervised, but Cézanne had a friend, Monsieur Chautard, who corrected his sketches. "I work calmly and eat and sleep likewise," he wrote Numa Coste.

Sundays were devoted to long excursions with Zola. "We used to leave on the first Sunday train," Zola wrote later, "in order to be outside the fortifications by early morning. Paul carried an entire artist's equipment while I had only a book in my pocket." On these excursions they would get out at Fontenay-aux-Roses and cut crosscountry to the left of Robinson. Here they would walk through great fields of strawberries before reaching Aulnay, where the famous Loups valley begins. Once they got lost in the forest; Cézanne climbed a tree to try to find the way, but he only scratched his legs and saw nothing but treetops. Zola later recalled:

One morning, while wandering through the forest we came across a pond, far from any path. It was a pond filled with rushes and slimy water, which we called "the green pond," not knowing its real name; I have since heard that it is called "the Chalot Pond." "The green pond" finally became the destination of all our walks—we felt for it the affection of a poet and a painter. We loved it dearly and spent our Sundays on the thin grass surrounding it. Paul had begun a sketch of it, the water in the foreground with big floating reeds, with the trees receding like the wings of a theater, draping the curtains of their branches as in a chapel, with blue holes that disappeared in an eddy when the wind blew. The thin rays of the sun crossed the shadows like balls of gold and threw on

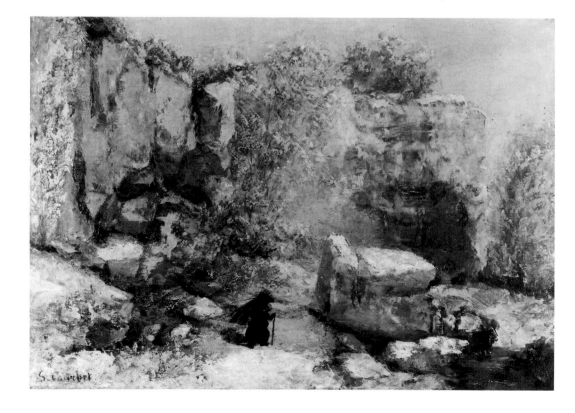

Gustave Courbet. *Snow Effect in a Quarry.* c. 1870

OPPOSITE:
Rocks in the Forest (Fontainebleau?). 1865–68

the lawns shining quoits whose round disks traveled slowly. I remained there for hours without boredom, exchanging an occasional word with my companion, sometimes closing my eyelids and dreaming in the vague and rose-colored light that bathed me. We camped there, we lunched, we dined, and only the twilight chased us away.

In January 1863, Cézanne's father came to Paris, making the trip, which then took about thirty hours, more for business reasons than to see his son. He probably availed himself of this opportunity to remind Paul of his wish to see him admitted to the Ecole des Beaux-Arts, but Cézanne was already contemptuous of official art and artists. He wrote in a letter to Numa Coste:

About a month has gone by since Lombard [a fellow student from the Aix drawing school] returned to Paris. I heard not without regret that he attends the studio of Signol. This worthy gentleman instructs after a conventional pattern destined to lead to an exact copy of his own; it is very beautiful, but not admirable. To think that an intelligent young man had to come to Paris to lose himself. . . .

I also like Félicien, who boards with Truphemus. The dear boy sees everything in relation to his illustrious friend and shades his opinions to match the latter's colors. According to him, Truphème surpasses Delacroix; he alone can produce color; also, thanks to a certain letter, he goes to the Beaux-Arts. *Don't think that I envy him.*

If Cézanne entered the competition for admission to the Ecole des Beaux-Arts, it must have been to satisfy his father. He was rejected.

At the Atelier Suisse, Cézanne had become acquainted with several young painters, including Antoine Guillemet, with whom he later worked in the outskirts of Paris and who was to visit him in Aix. He also met Armand Guillaumin and a Cuban painter, Francisco Oller. They introduced him to Camille Pissarro, who was not then working at the Atelier but who occasionally came to visit his friends there. As early as 1861, during Cézanne's first stay in Paris, Pissarro had noticed at the Atelier Suisse the "strange Provençal" whose drawings from life were ridiculed by everyone. It was either then or at some later time that Pissarro explained to a horrified acquaintance that "the drawing of Cézanne reminded him of that of Paul Veronese." In any case, Pissarro was the first to recognize the personality of the young artist, and a firm friendship soon united them.

Camille Pissarro, ten years older than Cézanne, had already exhibited once at the Salon without arousing the slightest public interest. In 1863 his entry was rejected along with the works of many other painters, among them Claude Monet and Edouard Manet, whose *Guitar Player* had obtained a certain success at the previous Salon. In fact, the jury was so severe this time that even the critics took the part of the painters and protested the numerous exclusions. But it was to be Zola's mission, three years later, to attack the prejudices of the jury and for the first time reveal to the public the abuses involved in having artists as judges of other artists. He was to expose the bickering and jealousy between different groups who tried to hide their opportunism behind moral convictions. Zola was to explain how, from the time they entered the Ecole des Beaux-Arts, where they received general instruction, and the Ecole de Rome, where their training was perfected, the young artists were led to take success for granted. They became convinced that "the State owes them everything, the lessons to teach them, the Salons to display their work, the medals and money to reward them." According to Zola, this system was responsible for their pretensions and intolerance of anything that did not conform to their despotic concepts of art. But when the jury of 1863 showed itself to be even more severe than its predecessors, the indignation of the rejected artists produced a furor of protest. The Emperor thereupon issued on April 24 a proclamation stating that the rejected works

would be exhibited in another section of the Palais de l'Industrie, so as to "let the public judge the validity of these protests."

Unfortunately, the public was by no means prepared to play the role of judge. It saw nothing but a practical joke in this exhibition of rejected works. Its inability to appreciate the efforts of unconventional artists may be explained in part by the fact that the bourgeoisie had only recently supplanted the aristocracy and the Church as patrons of the arts. Concerned with stabilizing its general position and extending its influence, it cared little for this new burden which it inherited along with all the others from those who preceded it in power. More interested in the development of science, the bourgeoisie assigned a completely new place to the artist. Instead of working for one patron he had to work for an unknown public, with the result that besides the sincere art, much was produced simply for the sake of achieving mass popularity. Unable to distinguish one type of art from the other, the public taste remained keyed to the pompous and artificial standards of the immediate past. Thus Delacroix, Daumier, Courbet, and other innovators encountered strong opposition, for the irrational admiration of the past precluded an understanding of the present.

In his treatise *Vom Nutzen und Nachteil der Historie für das Leben*, written about ten years later, Nietzsche describes the danger inherent in this "commemorative contemplation of the past." It applies to the situation prevailing at the time Edouard Manet exhibited his work in the Salon des Refusés. Nietzsche writes:

Let us take the simplest and most common example and imagine natures that are anti-artistic or endowed with a weak artistic temperament, armed and equipped with ideas borrowed from the commemorative history of art. Against whom will these natures direct their arms? Against their hereditary enemies: artistic temperaments that are strongly gifted, consequently against those who alone are capable of learning something from the historical events thus presented, capable of drawing from them what is applicable to life and of transforming what they have learned into improved justice. It is to them that the road is barred, the atmosphere darkened, whilst others dance slavishly and with zeal around a glorious monument of the past no matter what it is and without even understanding it, as though to say: "See, here is true and genuine art. What do you care about those who are still prisoners of development and will!" This dancing crowd even possesses, in appearance, the advantage of "good taste," for the creator has always been at a disadvantage with respect to the person who only observes without himself creating. If one thinks of transferring to the realm of art general suffrage and the rule of the majority in order somehow to force the artist to defend himself before a forum of idle esthetics, one can swear beforehand that he will be condemned. Not, as one might think, in spite of the canon of commemorative art, but because the judges have solemnly affirmed this canon (that of the art which, in accordance with the explanations given, has always "made an impression"). On the other hand, as concerns art which is not yet commemorative, that is to say which is contemporary, they lack, in the first place the need, in the second place the vocation, in the third place precisely the authority of history. On the contrary, their instinct tells them that art can be killed by art. For them the commemorative must at no cost be produced again and their argument stems from those who derive authority and commemorative character from the past. In this way, they appear to be connoisseurs of art, because they would like to suppress art; they mask themselves as doctors; whereas actually they behave like poisoners. Thus they develop their senses and taste in order to explain, by their behavior of spoiled children, why they so insistently reject everything that is offered them in art as real nourishment. For they do not want anything great to be produced; their method is to state: "See, that which is great exists already!" To tell the truth, this great thing which already exists concerns them just as little as that which is in the process of formation. Their life bears witness to this. Commemorative history is the garb worn by their hatred of the great and powerful of their own time, the garb that they try to palm off as admiration for the great and

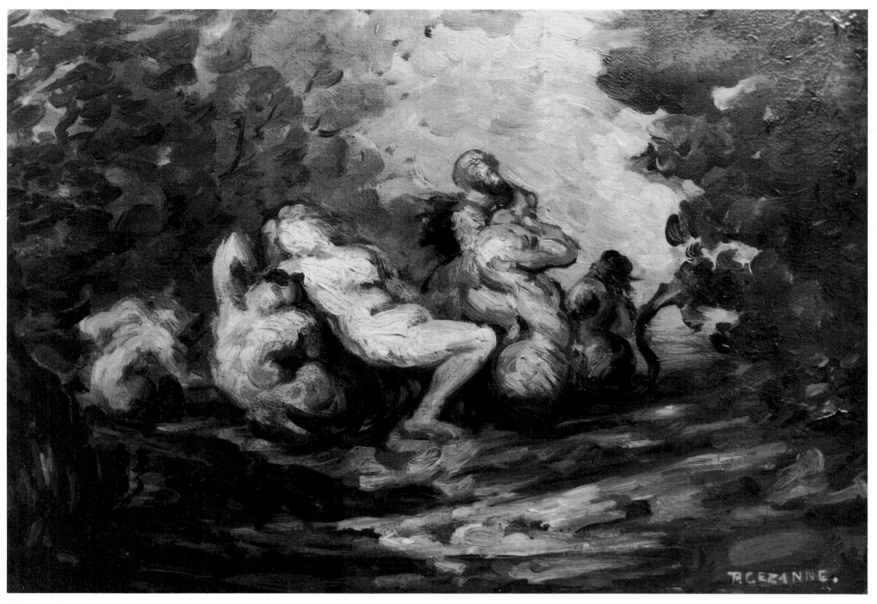

Nymph and Tritons. c. 1867

powerful of yore. This mask permits them to change the true meaning of this conception of history into a meaning diametrically opposed to it. Whether or not they realize it, they always act as though their motto were "Let the dead bury the living."

The public endorsed this gravedigger attitude with the collaboration of those artists who had already gained its favor and who stopped at nothing to prevent others from gaining the same honors. These artists succeeded in hiding their pettiness and poverty of spirit behind an academic correctness devoid of life. With untiring effort they supplied the public with historical paintings, or, like Cabanel and Bouguereau, with female nudes—maidens or Hebes, Springs or Truths—without a wrinkle of the skin, without any quivering of the flesh, too pink, with no inner movement of the forms, but always with curves. Their art had become the negation of nature. The tendency to prettify forms and colors, the choice of so-called noble subjects and picturesque scenery, had killed any feeling for things actually seen.

The catalogues of the Salons of this period bear witness to the mediocre trend of officially approved art. They contain titles such as *The Little Bird's Nester, First Caresses, The Sugar-Plums of the Baptism, A Good Mouthful, Grandmother's Friends, First Shave,* etc. Some paintings have a long caption such as the following:

Woman Tied to the Tree from Which Her Husband Had Been Hanged by Order of the Bastard of Vanves, Governor of Meaux in the XVth Century, Devoured by Wolves.

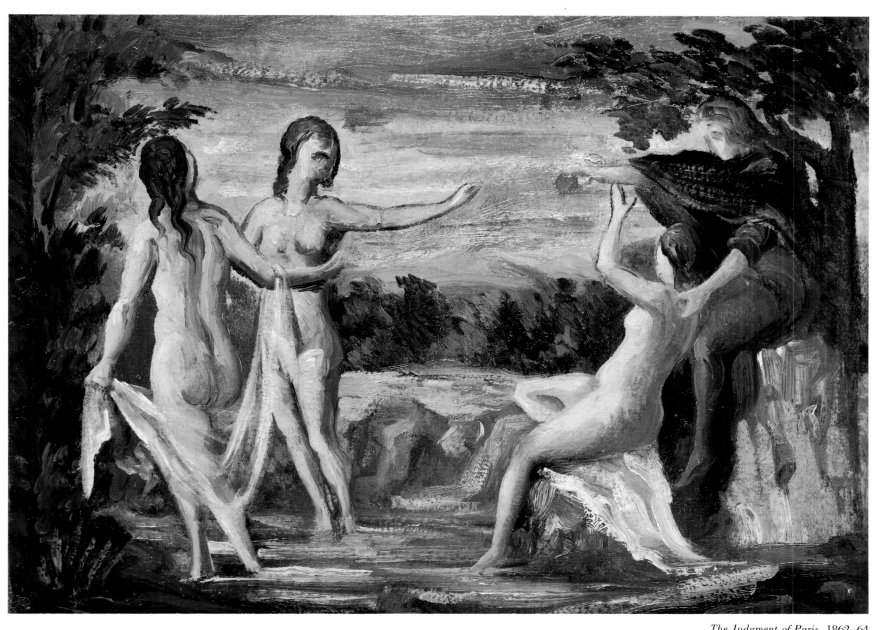

The Judgment of Paris. 1862–64

or:

Meeting of Francis I and His Fiancée, Eleanor of Austria, at Illescas (Spain).
"She Knelt and Asked to Kiss His Hand, and the King Replied: 'I Will Only
Give You My Mouth,' Raised Her Up, and Kissed Her."

It was thought that the subject matter of a painting was more important than
its esthetic value, that striking color effects were more to be sought after than
harmony, and that drawing was independent of color.

Those who disagreed with these ideas had to fight three enemies: the public,
the critics, and the official artists. These latter headed all committees and juries
and were thus in a position to exclude any nonconformers from public
exhibitions. Even if the work of an independent artist was not "judged unworthy
of being condemned by the public" and was consequently admitted, it was hung
in a distant corner where it attracted no interest and received no mention in the
interminable articles of the critics. The Salon des Refusés did not alter this
situation much. Although the arbitrary decisions of the jury had been
circumvented, the public and critics remained hostile to new trends. They
flocked to the exhibition, however, and its success was sufficient, because of the
novelty of the event, to inspire caricaturists with jokes of this kind: "The
accepted artists being little noticed, and jealous of the exhibition of those
rejected, plan to be rejected themselves next year."

The catalogue of the Salon des Refusés, which could not be sold on the
premises, is very incomplete. Among those listed are Manet with three paintings,
Jongkind with three canvases, and Pissarro with three landscapes. Fantin-Latour
had works both in the Salon and in the counter-exhibition. Not listed, though
exhibiting, were Cézanne and his friend Guillaumin. Neither the titles nor the
number of the paintings shown by Cézanne are known. Not one of the numerous
reviews seems to have mentioned his work.

The focal point of the Salon des Refusés was Manet's *Luncheon on the Grass.*
It became the target of indignant visitors and critics. Its artistic value being
ignored, the indignation centered on the subject: a nude woman in the company
of men wearing clothes. No one seemed to remember that Giorgione's painting
Pastoral Symphony, in the Louvre, contained a similar group.[4] (Zola was to
mention this later in his pamphlet on Manet.) If Manet had surrounded the
woman with nude men, calling it *A Scene of Fauns with a Nymph,* the public
would doubtless have been less shocked, but would still have refused to accept
his style, which it found most disturbing. Indeed, the difference between the
prize-winning pictures and the *Luncheon on the Grass* was enormous. Manet had
not based his painting on any anecdote or given it an "atmosphere," either sad or
gay, to transpose it from reality into the world of pleasant illusions.

"The first impression produced by a canvas of Edouard Manet is a little
harsh," Zola later wrote. "One is not accustomed to seeing such simple and
sincere renditions of reality." The violence with which the *Luncheon on the Grass*
contrasted with the historical and allegorical paintings in the careful technique
and pretentious triviality of the followers of Ingres, led the public to believe that
Manet was not master of his brush, that its effects were accidental, that his
colors were dirty and his draftsmanship nonexistent. He was reproached for not
having given his subjects contours, which are "the natural limits of color."
Censured for the "banality" of his composition, Manet was discovered only fifty
years later to have based his composition on an engraving after Raphael. Nobody
saw the qualities of his canvas because everybody sees through glasses of
convention, believing that only convention is true and natural.

This bourgeoisie, so receptive to innovation in the field of science and technology, disliked Manet, who, himself bourgeois and inspired by the same fever of conquest that shook his century, was trying, in his sphere, to make creative discoveries worthy of the era. But, as one of the few critics to appreciate him observed: "Every artist, every author of a new work done outside the realm of routine and convention is almost always rejected. He wounds the majority too much not to have his own individuality repudiated. Stupid people want others to resemble and imitate them."

Though rejected by the public, Manet had nevertheless awakened the enthusiasm of those young painters who were striving to escape from academic insipidity. Cézanne and Zola were deeply moved by Manet's painting, but for different reasons. Cézanne admired Manet's canvas because it revealed a new conception that was both sober and ardent and a new technique that seemed accidental but was actually extremely refined and full of virtuosity. He also admired the new use of color, its subtle oppositions and frank contrasts. Although none of this conformed to Cézanne's passionate temperament, or to his own work up to now, these new elements were to make an impression on him because he was seeking new means of expression. However, no direct influence of Manet may be found upon Cézanne's palette, which did not become brighter as a result of that impression.

Zola looked at the *Luncheon on the Grass* from quite another point of view. It conveyed to him "a feeling of unity and strength." He found it human and above all original. What Zola primarily sought in a canvas was "a man and not a painting."

"What I ask of an artist," he wrote a little later, "is not to give me tender visions or dreadful nightmares; it is to render himself, heart and flesh; it is boldly to express a powerful and individual mind that broadly takes nature in its grasp and plants it before us, just as he sees it. In a word, I have the most profound contempt for petty cleverness, for opportunistic flatteries . . . for all the historical dramas of this gentleman and all the perfumed dreams of that one. But I have the deepest admiration for individual works, for those which burst forth in one spurt, from a vigorous and unique hand."

These qualities, which Zola had sought everywhere in vain, he found in Manet's picture, and the public ridicule directed against it prompted him to study more carefully this proud protest against academic prejudice. It was doubtless Cézanne who initiated Zola into the hidden beauties of this painting and who pointed out to him "the delicate exactitude of the interrelationships of tones." Twenty years later, when Zola was collecting memories of his youth in order to put them in his novel *L'Oeuvre*, he still remembered Cézanne's enthusiasm and noted: "The Salon des Refusés. Great discussions with me."

It was due to these discussions and to his predilection for sincerity that Zola became a fervent admirer of Manet, whom he "loved instinctively." As it was not in keeping with Zola's character to conceal his admiration, he soon began a violent campaign in Manet's favor. Though Zola lacked sensitivity of observation and taste, and doubtless was unable to find complete satisfaction in a painting, he had the fine vehemence of an avant-garde fighter and a loud voice capable of drowning out detractors. The new school, which was born of the Salon des Refusés, and which assembled around Manet a group of young painters, could not have found a better champion than this young journalist who, renouncing any delicacy of language or esthetic terminology, spoke his mind crudely and sincerely. "I had the passion of my opinions," he later explained, "and would have forced my convictions down the throats of others."

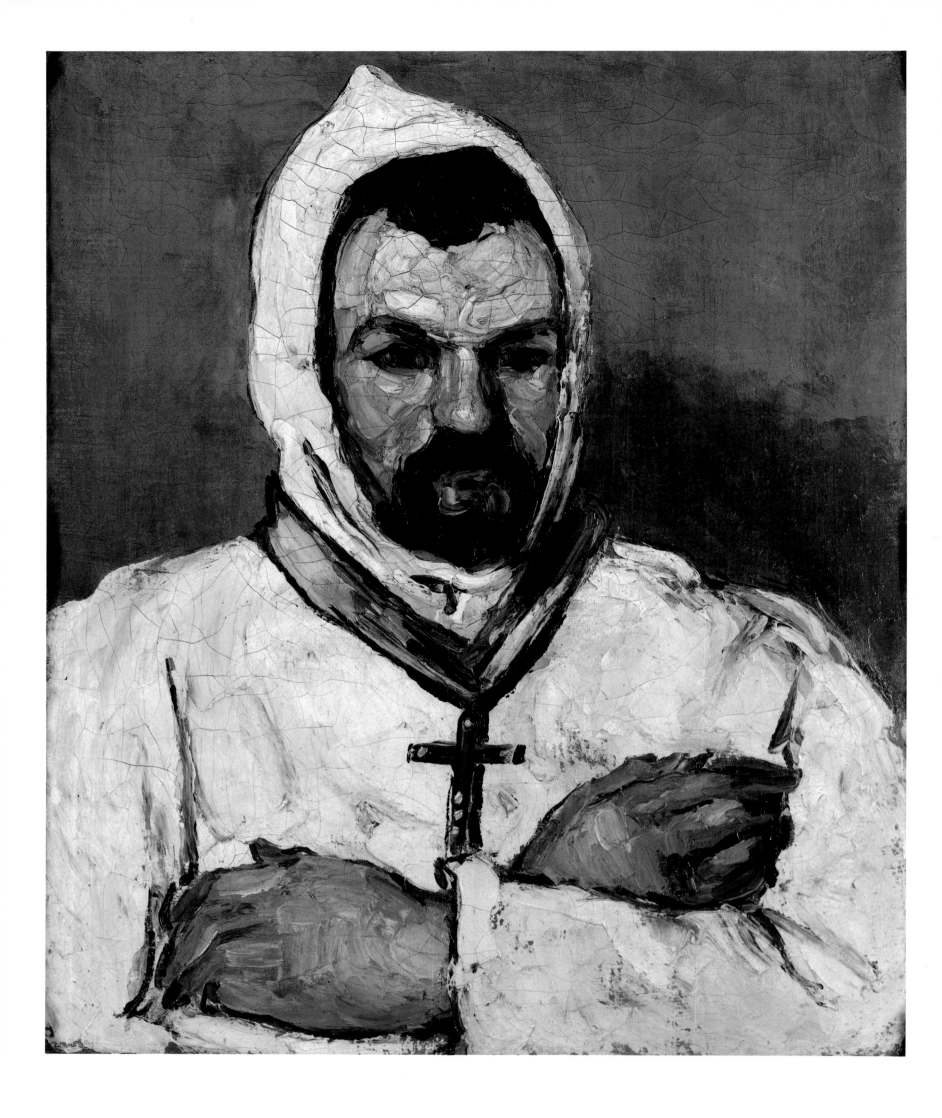

A FTER the Salon des Refusés, Cézanne took Zola around the studios; there they met the painters Béliard, Pissarro, Monet, Degas, Renoir, Fantin-Latour, and others. Later on Antoine Guillemet and the critic Duranty introduced Zola to Manet. Around that same time Zola also met Gabrielle Meley, whom he married in Paris several years later. It is believed that Cézanne introduced them to each other, but nothing definite is known about it.

Cézanne had become particularly friendly with Pissarro, Bazille, Guillemet, Renoir, Monet, and Armand Guillaumin. They did not see each other constantly, however, because from 1863 to 1870 Cézanne spent part of each year with his family in Aix.

At the beginning of 1864, Cézanne was in Paris and frequently met Baille. Their friend Coste, then still in Aix, wrote to inform Cézanne that he had drawn an unlucky conscription number (which meant seven years of military service). Cézanne, who had not had to serve, his father having bought him a substitute, consoled his friend in a long letter in which he advised him to volunteer immediately and try to be stationed in Paris:

One can make some progress, while being a soldier. I see some soldiers here who attend courses in anatomy at the Beaux-Arts. Lombard draws, paints, and whirls about more than ever; I have not yet been able to go to see his drawings, with which he tells me he is satisfied. For two months I have not touched my [illegible word] after Delacroix. I shall retouch it, however, before leaving for Aix, where I will only go in July unless my father sends for me. In two months, in May, there will be an exhibition like the one last year. If you were here we would go to see it together.

Cézanne was mistaken in believing that the Salon des Refusés, to which he refers, would be held again, for the hostile attitude of the public had endorsed the jury's verdict. Thus there was no reason for exhibiting the rejected canvases of that year.

Numa Coste followed Cézanne's advice and soon appeared in Paris where, in uniform, he joined the circle of Zola's friends. This group was composed mostly of comrades from Aix. Besides Cézanne and Baille, there were the sculptor Philippe Solari; Chaillan, a painter whose work Zola did not admire; and later the writers Antony Valabrègue and Paul Alexis. With those who could not yet come to Paris, Zola kept up a regular correspondence, as with Antoine-Fortuné Marion, who was studying in Marseilles to become a naturalist; Marguery, who published insipid novels in the local press; and Marius Roux, who was trying his hand at literary criticism.

Among Cézanne's Parisian friends who remained close to Zola as well were Camille Pissarro and Antoine Guillemet. Both Cézanne and Zola seem to have felt a real affection for Pissarro; as to Guillemet, particularly lively and gay, full of amusing ideas and ever good-natured, his company was always appreciated. Cézanne liked him so much that he even accepted his occasional gibes without ill feeling. Guillemet is credited with having supplied many a canvas by Cézanne with more or less fancy titles. Thus he christened one of his paintings: *The Wine Grog* or *Afternoon in Naples*, and another: *The Woman with the Flea*.

At that time Zola was putting the finishing touch to his novel *La Confession de*

ABOVE, TOP TO BOTTOM:
Antoine-Fortuné Marion. *Two Dogs.* 1869. *The Church of Saint-Jean-de-Malte, Aix-en-Provence.* c. 1866. *Rocky Landscape near Aix.* c. 1866

OPPOSITE:
Portrait of Uncle Dominique as a Monk.
c. 1866

The salon of the Jas de Bouffan with Cézanne's murals still in place. Photograph c. 1900

Claude, the background of which is Paris during the unhappy period of the author's first years there. In this book Zola carries out an idea that had been forming in his mind and that he had already mentioned in a letter to Baille in 1860—the "mad idea of bringing back to decent life an unfortunate woman, by loving her, by raising her up from the gutter." This love story, set in a frame of personal recollections, reveals how painful Zola's early years in Paris must have been, those years during which the will to work and confidence in his vocation were his only refuge. Now, in contrast, Zola had a great deal to do and was beginning to make money. When the book appeared at the end of 1865, the critics condemned its "ugly realism." But Zola doubtless had not exaggerated the misery of Claude, a character patterned after the author. He himself, however, judged his book severely.

"It is weak in certain parts," he wrote Valabrègue, "and still contains much childishness. Sometimes it lacks vitality; the observer disappears and the poet returns, a poet who has drunk too much milk and eaten too much sugar. The work is not virile, it is the writing of a child who cries and revolts."

Marius Roux reviewed *La Confession de Claude* for an Aix paper in an article that Zola called "the best that has been published." At Zola's special request "to give publicity to Baille and particularly to Cézanne, in order to please their families," Roux spoke at length about the two native sons to whom the book was dedicated. It is the first article that mentions Cézanne. Roux wrote:

We are a group of citizens of Aix, all of us old schoolmates, all of us joined in good and genuine friendship. We do not know what the future has in store for us, but meanwhile we are working and struggling. . . . If we are all joined in the bonds of friendship, we are not always united in our conception of the beautiful, the true, and the good. In such an instance, some of us vote for Plato and others for Aristotle; some admire Raphael and others Courbet. M. Zola, who prefers the *Spinner* [by Millet] to the *Virgin of the Chair* [by Raphael], dedicates his book to two devotees of his school.

M. Cézanne is one of the good students that our Aix school has contributed to Paris. He has left us with the memory of an undaunted worker and a conscientious pupil. There he will establish himself, thanks to his perseverance, as an excellent artist. Although a great admirer of Ribera and Zurbarán, our painter is original and gives his work a style of his own. I have seen him at work in his studio and if I cannot yet predict for him the brilliant success of those he admires, I am sure of one thing, that his work will never be mediocre. Mediocrity is the worst thing in the arts. Better be a mason if

that is your profession; but if you are a painter, be a complete one or die in the attempt.

M. Cézanne will not die in it; he has brought from the school of Aix principles that are too good, he has found here examples that are too excellent, he has too much courage, too much perseverance in his work to fail in reaching his objective. If I were not afraid of being indiscreet, I would give you my opinion of some of his canvases. But his modesty does not permit him to believe that what he produces is adequate, and I do not want to hurt his fine feelings as an artist. I am waiting until he displays his work in broad daylight. That day, I shall not be the only one to speak. He belongs to a school that has the privilege of provoking criticism.

La Confession de Claude soon attracted the attention of the courts because of its daring language. In a letter to the keeper of the seals, however, the attorney general concluded that the purpose of the book was not immoral. "What the author intended," he said, "was to cause young people to become disgusted with these impure relationships into which they allow themselves to be drawn at the word of poets who have idealized these bohemian love affairs."

Nevertheless an investigation ensued at the Librairie Hachette, where Zola held the position of chief of propaganda service at an annual salary of 2400 francs. As a result of this incident, Zola resigned and resolved to devote himself entirely to literature.

Photograph of Antoine-Fortuné Marion. c. 1866

Cézanne was more fortunate than his friend in not having to earn his own living, although he often was short of funds despite the allowance his father gave him. He made shy attempts to sell pictures but with little success. His life at Aix was calmer than in Paris. He retired to the Jas de Bouffan where he saw no one and worked in complete solitude, painting chiefly portraits. One of his favorite models was his uncle Dominique Aubert, a bailiff by profession, who was his mother's brother. Cézanne's father also posed for him several times, as well as his two young sisters and some friends, including Achille Emperaire, Antony Valabrègue, and Fortuné Marion. He hardly ever did portraits of his mother.

In later years, Rose Cézanne's husband was to reveal that there had been a room (or two) at the Jas de Bouffan where the artist used to store his paintings when he went away and where these were slashed by the banker during Paul's absence. This story, if at all true, would have to be placed in the early years of the antagonism between father and son, long before Rose got married. Moreover, it seems implausible that under these circumstances Cézanne would have left paintings behind where his father could get at them; after all, a single experience of this kind should have been enough to prevent him from exposing his canvases to his father's vengeance. Neither in his letters nor in conversations did Cézanne ever mention such occurrences and there is, after all, a considerable body of early works indicating that the banker's destructive moods did not extend to all of his son's output. On the other hand, some of the damaged pictures referred to by Rose's husband may have been torn up by the artist himself in his periodic fits of rage or depression and may have been "saved" by his devoted mother.

That his father was not completely hostile to his son's early endeavors is indicated by the fact that he gave Paul permission to decorate the big salon of the Jas, and he copied Lancret's *Dance in the Country* directly onto the wall. This painting reveals a feeling for tones of green, while the shadows still are often painted black. Opposite to this, Cézanne copied Sebastiano del Piombo's *Christ Descending to Limbo*, of which he had found a print in one of his books. In the center of an alcove at the end of the room, in the place of honor, so to speak, Cézanne painted the portrait of his father in profile, and on the two side panels he represented the four seasons in a style that strangely combines a primitive awkwardness with sophisticated elegance. He signed these panels very

conspicuously with the name of Ingres, for no apparent reason. This seems all the more amusing since Cézanne had admired Manet's work precisely for "the kick it gave the Institute."

Besides portraits and murals, Cézanne worked between 1863 and 1870 at various group compositions of an unusual character. In these the artist was guided solely by his inspiration, haunted by the grandiose and passionate scenes

The Negro Scipion. c. 1867.
Painted at the Atelier Suisse in Paris

that his mind and restless imagination constantly conjured up. Possessed by a veritable rage for work, Cézanne now felt no patience to study nature and obstinately pursued the realization of his dreams.

The execution of these paintings, sometimes slow, sometimes impetuous, and their heavy texture bear witness to long and arduous work. Their composition often lacks verisimilitude, and the figures frequently appear out of proportion. The foreground, the middle ground, and the background are not sufficiently distinct from one another to allow any orientation, and instead of being spread out in depth, the composition is often built up as if seen from above. Cézanne finally realized that he was attacking problems too difficult for him and was subsequently satisfied with simpler arrangements, dominated by groups in the foreground. If he learned anything from Manet, it was doubtless how to organize space in definite planes. His paintings of this period represent the phases of his

Paul Alexis Reading to Zola. 1869–70

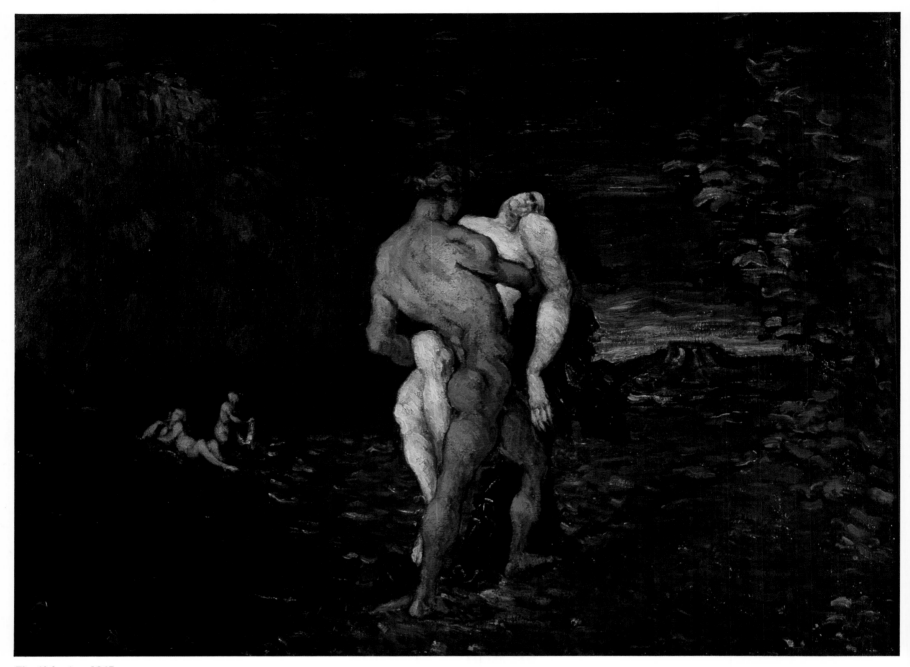

The Abduction. 1867

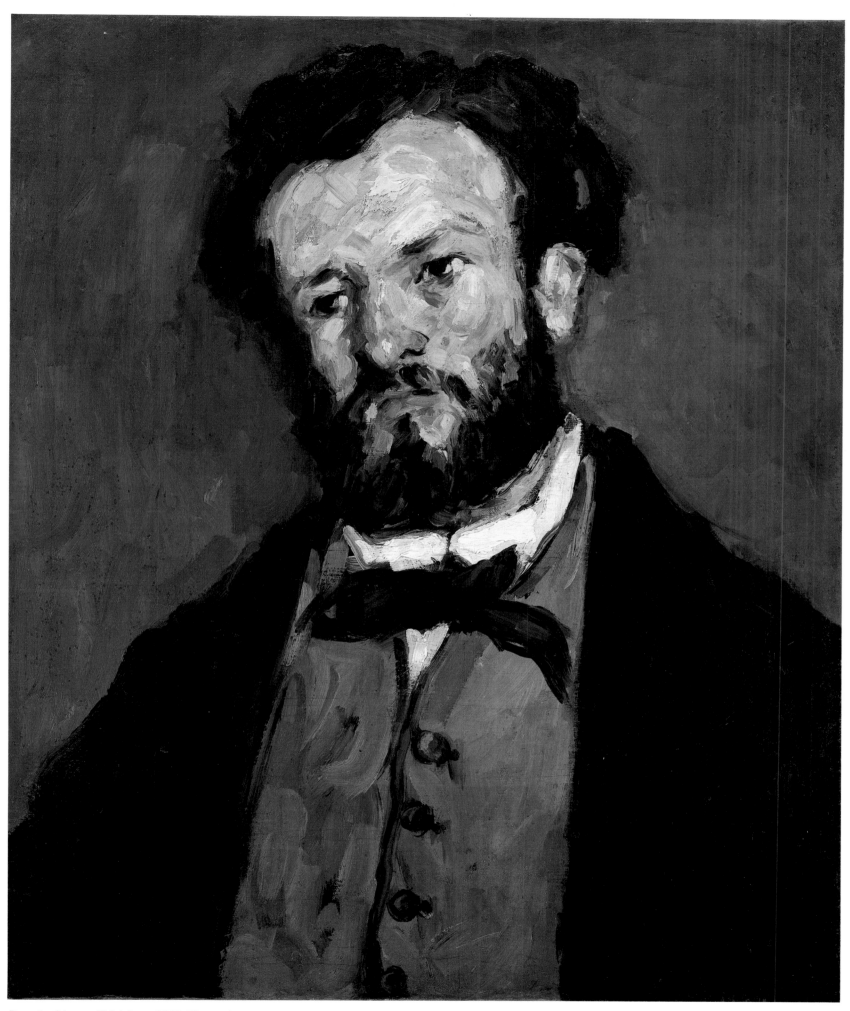

Portrait of Antony Valabrègue. 1869–70

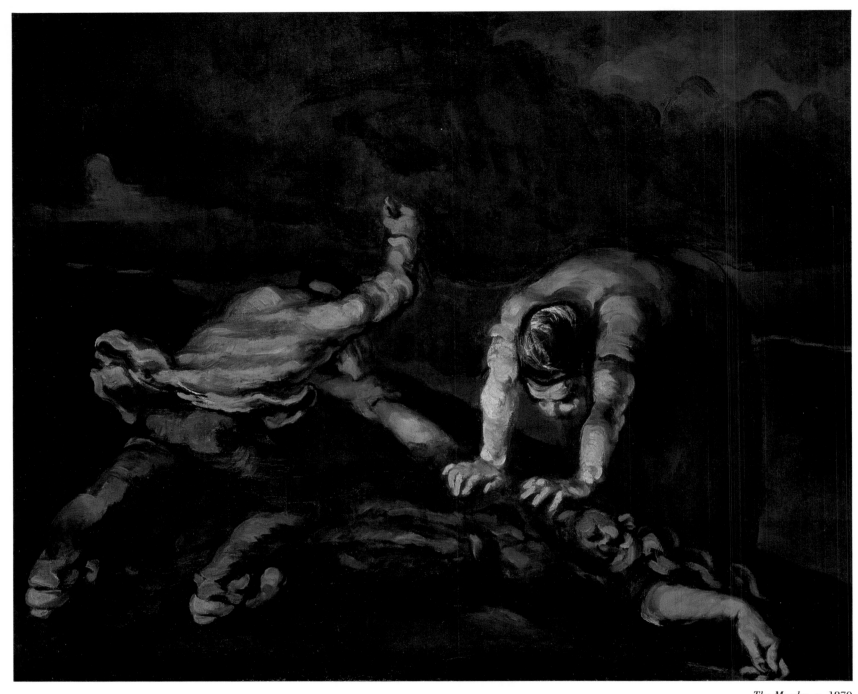

The Murder. c. 1870

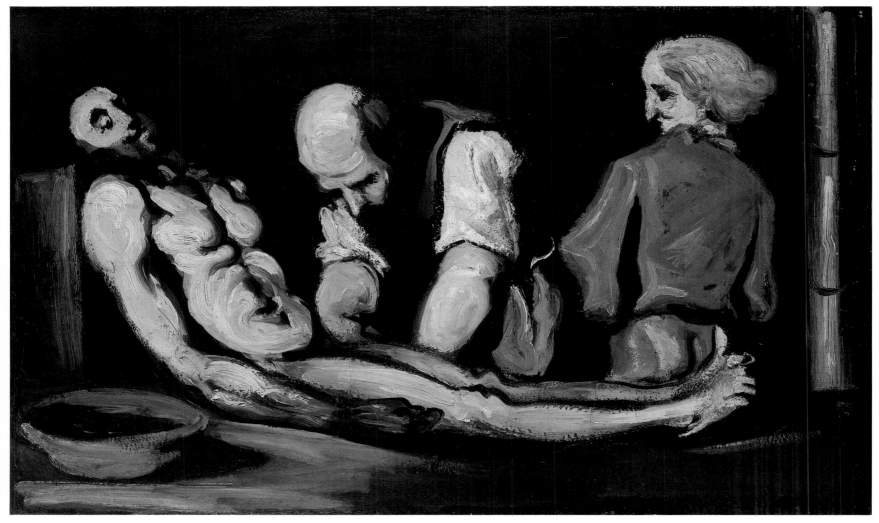

Preparation for the Funeral, also known as *The Autopsy*. 1869

struggle to balance the baroque inclination of his fancy and the slowly growing tendency to interpret what he saw.

Sometimes, seeking a kind of prop, Cézanne more or less freely copied reproductions in books and magazines, such as the *Magasin Pittoresque* and the *Musée des Familles*, to which his sisters subscribed, as well as the art history volumes of Charles Blanc.

Cézanne's palette shows the influence of Delacroix with his Veronese green, his purple, and his Prussian blue. Already at this early date one can see in Cézanne (in the words of Roger Fry) the gift that never failed him, his sensitivity to color. It was never possible for him to put a touch of color on the canvas that was discordant or failed to add to an original chromatic creation.

In his youthful work, in which imaginary scenes predominate, a few portraits afford a contrast, for while his compositions are passionate and full of movement, his likenesses have a certain gravity. In these Cézanne sought the greatest possible simplicity and liked to represent his models either full face or in profile with a strong tendency toward symmetry. These portraits are sometimes more than life size. They are striking by virtue of the contrasts of vivid color—Achille Emperaire is shown wearing an intense blue dressing gown with a very bright red foulard—and they also have a plasticity that is not apparent in Cézanne's purely imaginative work. It is above all in a portrait of his father seen full face, seated slightly sideways, that a great mastery of the problems of volume and space manifests itself. These large canvases seem to be the fruit of much less painful toil and of a greater self-confidence than most of Cézanne's other work of this period. The influence of Courbet appears not only in the size and the execution, but also in the approach to the model; yet these portraits are sufficiently individual to show that by now Cézanne only needed experience to develop his amazing gifts.

Yet there are also small works that reveal Cézanne's search for expression; among them is a landscape with delicate tonalities remindful once more of Courbet, both in its attitude toward nature—the mingling of rocks and foliage—and in its execution of subtle modulations, as if the artist had actually striven to equal the master. On the other hand there are occasional paintings, such as a tiny still life, that show an incredible daring which goes far beyond Courbet or Manet. Here the painterly qualities are not so much the result of skill or refinement as they are the product of a truly turbulent execution that adds to the attraction of the vivid colors a lively surface texture such as has never before been attempted. In other words, the technique of Cézanne's paintings of this period is not always the same. Like Courbet, Cézanne often used the palette knife, building up in pigment such portraits as those of *Uncle Dominique*, his father reading *L'Evénement*, and a *Self-Portrait* that is completely modeled in paint, and in which the high domed forehead, magnificently wild beard, and energetic expression portray him as an inspired creator.

Still experimenting with methods, Cézanne overcame his hesitations by will power and enthusiasm for work. But his isolation at Aix often weighed upon him so that from time to time he felt the need to plunge himself into the stimulating atmosphere of Paris.

EZANNE spent the winter of 1865 at Aix. "I often see Paul in the
afternoon," Valabrègue informed Zola. "He is always the best of
comrades. He, too, has changed, for he speaks, he who seemed your
silent shadow. He expounds theories, builds up doctrines; crime of crimes, he
even suffers that one talk politics with him (theoretically, of course) and replies
by saying terrible things about the tyrant [Napoléon III]."

Once more, Cézanne attended the art school. He also met frequently with
Fortuné Marion who introduced him to the German musician, Heinrich Morstatt.
The latter used to play for them, and Cézanne was delighted to let his "nerves
vibrate to the noble tones of Richard Wagner," as he wrote in a letter. This
admiration for Wagner was soon to find expression in a painting entitled *Overture
to Tannhäuser*.

In February 1866, Cézanne returned to Paris where he joined the group of
friends that gathered every Thursday evening at Zola's. In cordial though heated
debates, Baille, Coste, Pissarro, Solari, Cézanne, and Zola discussed painting,
poetry, and criticism. Each spoke of his projects, his dreams, and all were
animated by the desire to help each other. When Solari, for instance, had spent

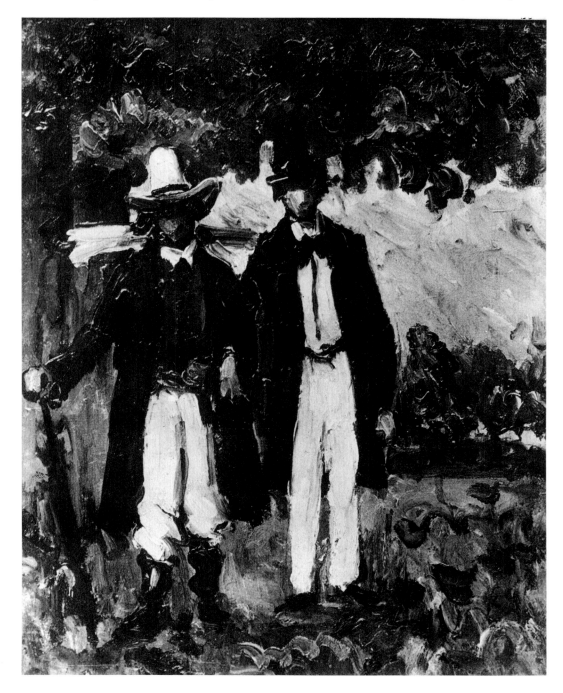

Marion and Valabrègue Leaving for the Motif.
Autumn 1866

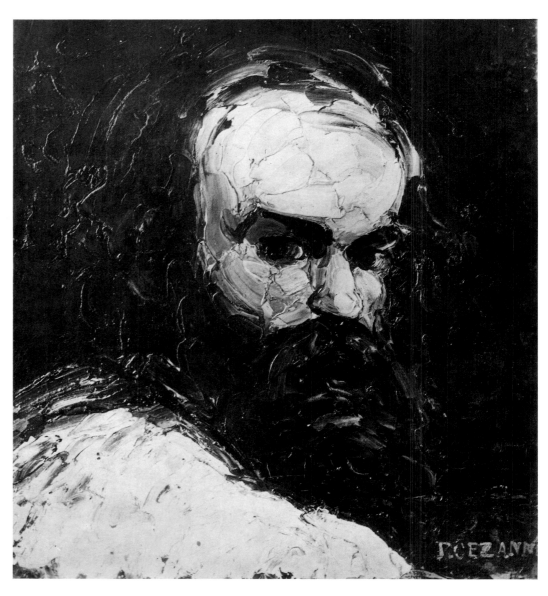

Self-Portrait. c. 1866

all the money from a fellowship in sculpture given by the academy of Aix, Cézanne helped him out. Cézanne was very fond of this friend with his exalted visions who, however, lacked a sense of the demands of life. Remarkably indifferent, serious, absent-minded, always calm, he was a disinterested and timid bohemian.

The atmosphere of the meetings at Zola's is revealed in a letter written by the novelist to Antony Valabrègue, who was still in Aix: "I do not conceal the fact that I would have preferred to see you among us, fighting like ourselves, daily renewing your attempts, striking to the right, striking to the left, always marching ahead."

Many of Zola's friends complained to him of hard times. Zola alone was successful. On February first he had become book reviewer for the influential newspaper *L'Evénement*. Meanwhile Cézanne was preparing paintings for the Salon that, as he had told Pissarro the preceding year, "would make the Institute [Academy of Fine Arts] blush with rage and despair." He was quite sure that his entries would not be accepted but felt a certain pleasure at the prospect of shocking the jury. According to Zola, Cézanne "now maintained that one should always present something to the jury, if only to put it in the wrong; moreover, he recognized the usefulness of the Salon, the only battlefield on which an artist could reveal himself at one stroke."

Cézanne's entry had been rejected the year before, though an exceptionally broad-minded jury had accepted even Manet's *Olympia*. But the public reaction to that painting had been so violent that the jury decided to make no future concessions. Its anger was turned particularly against Manet, whom Cézanne met for the first time in April 1866. A record of their meeting is preserved in a letter from Valabrègue to Marion: "Cézanne has already written to you about his visit to

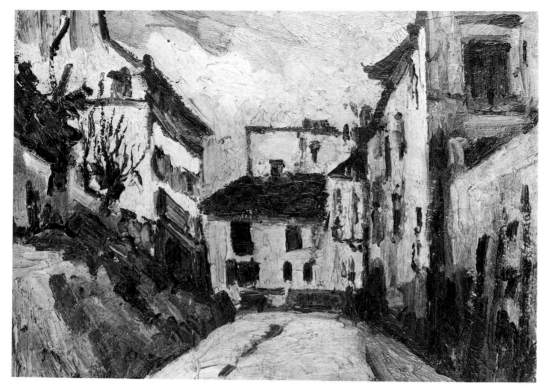

Motif for *The Rue des Saules in Montmartre*.
Photograph c. 1935

The Rue des Saules in Montmartre. 1867–68

Manet. But he has not written you that Manet saw his still lifes at Guillemet's. He found them powerfully treated. Cézanne is very happy about this, though he does not expatiate about his happiness and does not insist on it as is his wont. Manet is going to call on him. Parallel temperaments, they will surely understand one another." What Cézanne did not know was that Manet actually considered him "not much more than an interesting colorist."

Manet's appreciation bolstered Cézanne's morale in the events that followed his two submissions to the Salon in 1866, one of which was a portrait of Valabrègue. He delivered his entries to the Palais de l'Industrie, where the Salon was held, on the last possible day and at the last minute. They were brought in a wheelbarrow, pushed and pulled by his friends. At their arrival in front of the Palais, Cézanne slowly removed his canvases from the wheelbarrow and showed them to the crowd of idlers at the door.

Cézanne had no illusions; he knew perfectly well that his pictures would be turned down—he even wished it. Thus Marion wrote to his friend Morstatt in March 1866: "I have just had a letter from my Paris friends: Cézanne hopes to be rejected at the exhibition and the painters of his acquaintance are preparing an ovation in his honor."

A little later Valabrègue, who in the meantime had arrived in Paris, informed Marion: "Paul will without doubt be rejected at the exhibition. A philistine in the jury exclaimed on seeing my portrait that it was not only painted with a knife but with a pistol as well. Many discussions have arisen. Daubigny [a member of the jury] said some words in defense of my portrait. He declared that he preferred pictures brimming over with daring to the nullities that appear at every Salon. He didn't succeed in convincing them."

Marion forwarded Valabrègue's letter to Morstatt, adding:

Since then I had more news: the whole realist school has been refused, Cézanne, Guillemet, and the others. The only pictures accepted are Courbet's things—it appears that he is growing weak—and a *Fife Player* by Manet, one of the youthful glories who decidedly occupies the first rank. . . . [Marion erred here, Manet's canvas was actually rejected.] In reality we triumph and this mass refusal, this vast exile, is in itself a victory. All we have to do is to plan an exhibition of our own and put up a deadly competition against those blear-eyed idiots.

We are in a fighting period: youth against old age . . . the present, laden with promise of the future, against the past, *that black pirate*. Talk of posterity. Well, we are

posterity. And we are told that it is posterity that judges. We trust in the future. Our adversaries can *trust at best in death*. We are confident. All we want is to *produce*. If we work, our success is certain. . . .

Cézanne shared this point of view and upon learning that his paintings had been rejected along with those of Manet, Renoir, and others, he wrote a strong letter to Count de Nieuwerkerke, Director of Fine Arts, demanding the reestablishment of the Salon des Refusés. As he did not receive an answer, Cézanne wrote again on April 19:

Sir,
Recently I had the honor of writing to you concerning the two pictures that the jury has just turned down. Since I have had no reply, I feel compelled to insist on the motives that caused me to apply to you. As you have no doubt received my letter, I need not repeat here the arguments that I thought necesssary to submit to you. I shall content myself with saying once more that I cannot accept the unfair judgment of colleagues whom I myself have not commissioned to apprise me. I am therefore writing to you to emphasize my demand. I wish to appeal to the public and show my pictures in spite of their being rejected. My desire does not seem to me extravagant, and if you were to ask all the painters in my position, they would reply without exception that they disown the jury and that they wish to take part in one way or another in an exhibition that should be open as a matter of course to every serious worker.

Therefore, let the Salon des Refusés be reestablished. Even were I to be there alone, I ardently desire the public to know at least that I do not wish to be confused with the gentlemen of the jury any more than they seem to wish to be confused with me.

I hope, Monsieur, that you will not choose to remain silent. It seems to me that any decent letter deserves a reply.
Paul Cézanne
22, Rue Beautreillis

Cézanne's letter is more than an expression of personal feelings. It no doubt represents the opinion of all those whose entries had received the same treatment and who belonged to the camp of insurgents led by Manet. Probably Zola had a part in this manifesto, for it contains the same impassioned and ironical phrases that reappear in the series of articles on the Salon that Zola was shortly to publish. If Zola helped Cézanne with his letter, the painter also collaborated indirectly in this series, which again demanded the reopening of a Salon des Refusés. But nothing could induce the Beaux-Arts to change its decision. On the margin of Cézanne's letter was written the draft for the official reply: "What he asks is impossible; it has been recognized how little suitable the exhibition of the rejected was for the dignity of art, and it will not be reestablished."

Emile Zola availed himself of the opportunity to use his pen on behalf of his painter friends. He obtained permission to review the Salon for *L'Evénement* and immediately announced that he intended to attack the jury and to reveal "great and terrible truths" about it. His friends, especially Guillemet, gave him the inside story on the way the jury got itself elected and how it fulfilled its functions, "amputating art and only presenting the crowd with the mutilated corpse." He explained first of all that a "Salon in our day is not the work of artists, it is the work of a jury." Indeed the rules of the Salon specify that the jury on awards and commissions shall be elected by artists having previously won awards. But they do not mention the fact that the prizewinning artists, those who elect the judges of their colleagues, were admitted to the Salon without being passed upon by the jury.

On this jury, according to Zola, "there are the nice fellows who reject and accept with indifference, there are the successful ones who are above the battle, there are the artists of the past who cling to their beliefs, who deny all novel

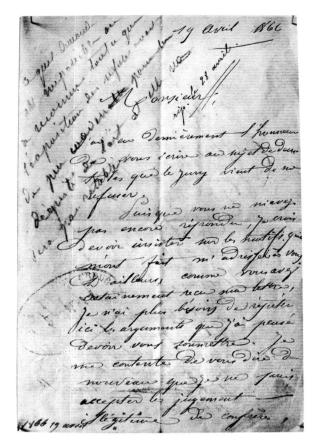

ABOVE AND OPPOSITE:
Cézanne's letter of protest to Count de Nieuwerkerke of April 19, 1866, with the latter's negative reply written across the upper left corner

attempts, and finally there are the artists of the present whose little style has its little success and who hold onto this success with their teeth while scolding and threatening any approaching colleague."[5]

It was obvious that any artist who blazed his own trail, refusing to follow official esthetic paths, was doomed to rejection. Zola states that "the exhibitions were created to give ample publicity to serious workers. All taxpayers contribute, and the question of schools and systems should not open the door to some and close it to others. . . . Yet there are men placed between the artists and the public. With their omnipotent authority, they only reveal a third, only a quarter, of the truth." In order to show better how they judged, Zola gave the example of a painter known as a pupil of Courbet, who had entered paintings under two different names. Those signed with his real name were rejected, whereas those bearing a pseudonym were accepted.

Zola's articles, signed Claude, did not fail to attract public attention. Though he was not the first to attack the Salon jury, he did it with unusual eloquence shot through with irony, and above all he did it in a widely read paper. Up to now, Zola had only criticized the judges and demanded a new Salon des Refusés. Pressed to give a positive opinion on contemporary art, he did so in the second article of his series.

"We live in times of struggle and fever," he wrote. "We have our talents and our geniuses." Referring to the Salon as a "mass of mediocrity," he said that although it contained two thousand pictures, not even ten men were represented there. Zola then proceeded to develop his conception of art, explaining: "A work of art is a corner of nature seen through a temperament." This definition was doubtless the fruit of long discussions about art between Zola and Cézanne, though, curiously enough, the painter had not yet found the balance between nature and temperament.

Zola's third article was devoted to Edouard Manet. In it he declared that before guiding the readers of *L'Evénement* through the vast halls of the Palais de l'Industrie, full of nonsense, he wished to visit with them the studio of Manet and speak to them of the only painter he admired. The fact that in a long article he praised a painter whom everyone ridiculed was enough to provoke lively protest. The critic affirmed that "Manet's place in the Louvre is reserved, like that of Courbet," and the public took offense at such remarks. It was scandalized that he should start his comments on the Salon by speaking of a rejected painter as though he were a master. Monsieur de Villemessant, editor of *L'Evénement*, received innumerable letters of protest:

Sir,
When I read your paper this morning, I asked myself whether you were still running it, for I have always noticed that you had consideration for your subscribers. This is not the case today, and I have rarely seen an article in which the author ridicules his readers with such impudence as he who signs himself Claude in your paper.

I do not know what ties of kinship or amity link this writer with M. Manet, but in truth, it is abusing his public strangely and making a fool of it to declare this bungler to be the foremost painter of the epoch. Moreover, it is a bad thing to insult the painters most beloved by the public in order to make of these insults a pedestal for the miserable dauber he would like to consider an artist.

It seemed to me that you had made it your mission, in creating your various papers, to enlighten your readers while amusing them, and that that is what has made them successful; but a few more articles in the taste of the one to which I refer, and I do not doubt that a good number of your intelligent readers (and, in spite of what M. Claude may think, there are still a few) will dispense with a newspaper that treats them thus as imbeciles and fools. . . .

It is good to have, as you often say, a rostrum from which all ideas and opinions may be expressed; however, there must be a brake on shamelessness and bad faith.

I hope, sir, that you do not see in this letter anything but an expression of the sympathy that attaches me to your publications and my desire that they should not degenerate in giving asylum to such senseless works.

Another reader, signing himself "bourgeois, though artist," wrote to Monsieur de Villemessant in the same vein:

Your M. Claude is exasperating; no theories, no esthetic knowledge, no reasoned criticism; an enthusiasm in the void and insults, it is too much and too little. . . .

M. Claude politely calls idiots all those who laugh at M. Manet's paintings. But why is not M. Manet satisfied with being mediocre? Why is he vulgar and grotesque? Why do his dirty figures seem to have emerged from a sack of coal? One looks with pity upon involuntary ugliness; how then is one not to laugh at affected ugliness? . . .

For mercy's sake, Monsieur le directeur, spare your readers any further mental torture by your M. Claude or the cancellation of subscriptions, which is a reality, will soon follow.

And a painter, over the signature of A.P., bade the editor of *L'Evénement* "raise a little the standard of criticism by entrusting it to clean hands."

Monsieur de Villemessant was obliged to yield to his indignant readers. He and Zola agreed that "Claude" was to share his task with a more conformist art critic and that each of them would be allowed three articles. Thus Zola, who had expected to write a series of sixteen or eighteen essays, could only add three more to the five already published.

In order to show that he was not the standard-bearer of a school, as he had been reproached for being, Zola had attacked the "realists" of the Salon on the grounds that nothing except their subject matter aspired to realism. It was not the subject, Zola said, but rather its technique and individual character that determined whether or not a work of art was realistic. He considered Claude Monet's *Camille* the only "realist" work in the Salon. Further he declared: "Any school is displeasing to me, for a school is the very negation of human liberty to create." To emphasize his independence, Zola, in his sixth article, did not hesitate to reproach Courbet, Millet, and Théodore Rousseau for not living up to their own standards. But he began to ask himself whether it were really any use to be disagreeable and to speak his mind frankly when the next day, in the same place, his opposite number was handing around compliments. Zola now no longer had the courage necessary to write the articles he had planned in favor of Daubigny, Corot, and Pissarro, knowing that they would be received with scorn. Moreover, was he doing them any good by praising them in his discredited series? Consequently, instead of writing the two articles to which he was still entitled, Zola sent only one more to *L'Evénement*, "Farewell of an Art Critic," and handed in his resignation.

"Actually, I am delighted," he concluded. "Imagine a doctor who does not know where the wound is and who, in palpating the body of the patient hears him cry out in terror and anguish. I admit to myself that I found the right place, since it causes pain. It does not matter to me that you do not want to get well. I now know where the wound is."

Zola had indeed achieved his purpose; he had discovered the sad truth that the more commonplace one is, the more one is admired and understood: "Ah! if art had not become a pomposity and a joke, if there were fewer daubers painting for amusement and vanity, if our painters lived like fighters, like powerful and vigorous men, if they learned their business, if they forgot the Ideal and

remembered Nature, if the public were willing to be intelligent and not to hoot at new personalities, we would perhaps see other works hung on the walls of the galleries, works alive and human, full of deep truth and interest."

Zola immediately reprinted his articles in a pamphlet bearing on the cover and the title page the words: "That which I seek above all in a picture is a man and not a picture." This booklet was published in the spring of 1866 and entitled *Mon Salon.* Its long dedication to Cézanne is a symbol of Zola's gratitude for his friend's more or less direct collaboration, for it was in their discussions that most of the ideas that Zola later developed were born. But it is to his childhood friend rather than to the younger painter that this dedication is addressed:

I experience deep joy, my friend, in having a tête-à-tête with you. You cannot imagine how much I have suffered from this quarrel which I have just had with the herd, with the unknown crowd; I felt so misunderstood, I felt such hatred around me, that discouragement often made me drop my pen. Today I can avail myself of the intimate pleasure of one of the good talks we have had together for the past ten years. It is for you alone that I write these few pages, I know you will read them with your heart, and that tomorrow you will love me more affectionately.

Imagine that we are alone together in some remote place, far from any struggle, and that we are talking like old friends who know each other's very soul and understand each other at a mere glance.

For ten years we have been speaking of art and literature. We have lived together—do you remember?—and often daybreak caught us still conversing, searching the past, questioning the present, trying to find the truth and to create for ourselves an infallible and complete religion. We shuffled stacks of terrible ideas, we examined and rejected all systems, and after such arduous labor we told ourselves that outside of powerful and individual life there only exist lies and stupidity.

Happy are they who have memories! I envisage your role in my life as that of the pale young man of whom Musset speaks. You are my whole youth; I find you mixed up with all my joys, with all my sufferings. Our minds, in brotherhood, have developed side by side. Today, at the beginning, we have faith in ourselves because we have penetrated our hearts and flesh.

We used to live in our shadows, isolated, unsociable, enjoying our thoughts. We felt lost in the midst of the complacent and superficial crowd. In all things we sought men, in every dawn, in every painting or poem we wanted to find an individual emphasis. We asserted that the masters, the geniuses, are creators, each of whom had made a world of his own, and we rejected the disciples, the impotent, those whose trade it is to steal here and there a few scraps of originality.

Did you know that we were revolutionaries without being aware of it? I have just been able to say aloud what we told each other for ten years. The noise of the quarrel reached you, did it not? And you have witnessed the fine welcome accorded our dear thoughts. Ah! the poor lads who lived healthily in the middle of Provence, in the sun, and who clung to such folly and such bad faith!

For—you probably did not know this—I am a man of bad faith. The public has already ordered several dozen straitjackets to take me to Charenton [an insane asylum]. I only praise my relatives and my friends, I am a fool and an evil man, I am a scandalmonger.

This inspires pity, my friend, and it is very sad. Will it always be the same story? Will we always have to talk like the others or remain silent? Do you remember our long conversations? We said that the least new truth could not be revealed without provoking anger and protests. And now I, in turn, am being jeered at and insulted.

It is a good experience, my friend. For nothing in the world would I wish to destroy these pages; they are not much in themselves but they have been, so to speak, my touchstone of public opinion. We now know how unpopular our dear thoughts are.

Yet, I am pleased to present my ideas a second time. I believe in them, I know that in a few years everyone will agree with me. I am not afraid that they will be thrown in my face later on.

Emile Zola

Paris, May 20, 1866

Portrait of Cézanne

CEZANNE, approaching thirty, was tall and thin, "bearded, with knotty joints and a strong head. A very delicate nose hidden in the moustache, eyes narrow and clear... deep in his eyes, great tenderness. His voice was loud." At this period he wore "a battered black felt hat and an enormous overcoat, once a delicate maroon, which the rain had streaked green. He was a little stoop-shouldered and had a nervous shudder that was to become habitual. He planted himself in laced boots and his short trousers revealed blue stockings." Thus Zola depicted him several years later when creating the character of the painter Claude Lantier for *Le Ventre de Paris*, published in 1873. The notes for this novel mention Cézanne by name. Subsequently, when preparing *L'Oeuvre*, a novel of which Claude Lantier was the protagonist, Zola dwelt in greater detail upon his recollections of the youthful Cézanne: "He was wary of women.... He never brought girls to his studio; he treated them all like a boy who ignored them, hiding his painful timidity under a rude bluster.... 'I do not need any women,' he said, '—that would disturb me too much. I don't even know what they are good for—I have always been afraid to try.'"

Zola wrote and underlined the words "very important" in the margin of this last note. He also underlined another remark apropos of the grossness of Cézanne's language: "He swore, used filthy words, wallowed in mud, with the cold rage of a tender and exquisite soul who doubts himself and dreams of being dirty." Cézanne's mood was very uneven; gay in the morning, unhappy in the evening. Sometimes he called painting "a dog's profession"; sometimes he said, "When I paint, it's as though I tickled myself"; sometimes he exclaimed in despair, "I have never finished, never, never."

"Paul is wonderful this year," wrote Marion to Morstatt in the summer of 1866, "with his scarce and extremely long hair and his revolutionary beard."

The son of Henri Gasquet, who knew Cézanne toward the end of his life, later wrote: "Those who saw him at that time described him to me as frightening, full of hallucinations, almost bestial in a kind of suffering divinity. He changed models each week. He was in despair because he could not satisfy himself. He suffered from those combinations of violence and timidity, of humility and pride, of doubts and dogmatic assertions, which shook him all his life. He shut himself up for weeks, not wanting to let a living soul enter his studio, shunning any new acquaintance."

At such times Zola witnessed "the outburst of the artist, impotent in the face of substantial and living works of which he dreamed." "Every day, a long despairing effort," he noted, adding: "He destroys about fifteen canvases... reproaches himself for the failure of his painting.... Never again will he touch a brush."

In Cézanne's studio there was complete disorder. It was only swept once a month "for fear that the dust might cover his fresh canvases." A thousand things were strewn on the floor, and ashes piled up there. The sole big table was always littered with brushes, paints, dirty plates, a spirit lamp, etc. Unframed sketches hung on the wall all the way down to the floor, where they were piled up on a heap of canvases.

Cézanne had very little money, for either his father did not give him a large

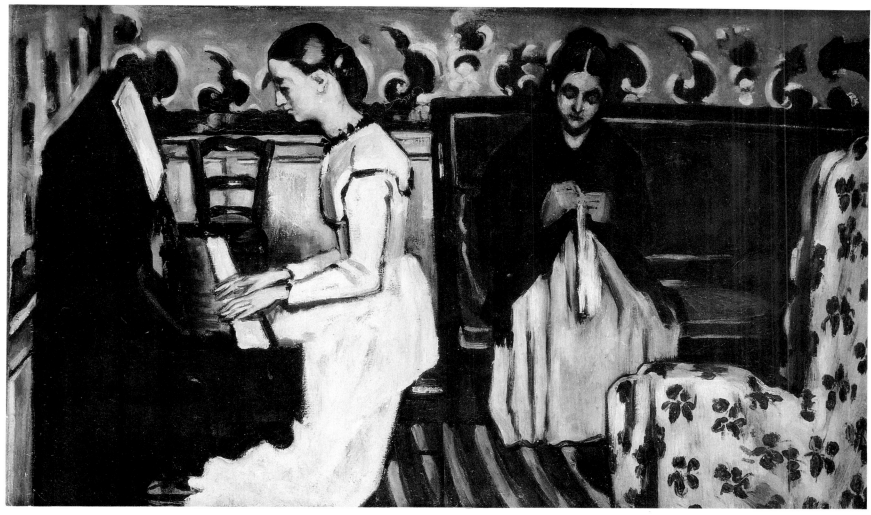

enough allowance, or else Cézanne did not know how to control his expenses. His mother managed to send him funds from time to time by economizing on household expenses, but in any case he was delighted to accept occasional loans from Zola and Baille, for, as he said in a letter: "I am still sadder when I have no money." Cézanne was working very hard. His discouragements no longer made him think of going back into his father's bank, but rather stimulated him to new efforts. Relentlessly he touched up earlier paintings, a method that often obliged him to do the pictures all over again.

Cézanne spent the summer of 1866 with Zola and his mother in Bennecourt near Paris, where they were joined by Baille, Solari, Valabrègue, Chaillan, and Gabrielle. Their carefree life in the country, on the banks of the Seine, at the inn of Mère Gigoux, brought the friends closer together and animated their exchange of views.

"After dinner," Zola reports, "the group stretched out on two bales of straw that Mère Gigoux had the generosity to provide in a corner of the courtyard. It was the hour of theories, of furious discussions that lasted till midnight and kept the trembling peasants awake. We smoked pipes while contemplating the moon. We called each other 'idiot' or 'half-wit' for the least difference of opinion."

What made their debates particularly heated was the fact that the poets defended romanticism while the painters were rabid realists. "We executed men in the limelight, we were drunk with the hope of overthrowing everything in the future so as to reveal a new art of which we would be the prophets." Zola formed a plan of writing an essay on the work of art before criticism, but he never carried it out.

Cézanne had brought his canvases and paints along, and Zola informed Numa Coste: "Cézanne works; he becomes increasingly firm on the original road to which his nature has led him. I have much hope in him. We expect him to be

rejected for another ten years. Right now he is trying to do big works, canvases four to five meters in size."

A refusal by the jury of the Salon had come to have the same meaning as an award in the eyes of the young friends. Among Zola's comrades only Solari succeeded in being accepted. He had just exhibited a more than life-size bust of Zola in the casting of which Zola and Cézanne had helped him. Cézanne himself was all the less discouraged by the rejections of his pictures, for he believed, as he wrote Pissarro, that "in following the path of virtue one is always rewarded by men, but not by painting." Nevertheless he preferred to find satisfaction in his work.

From Bennecourt Cézanne returned to Aix where, as Marion wrote Morstatt, "we are beginning to attract attention. They bow to us. Some idiot dedicated a poem to Paul Cézanne in the local newspaper. What a bunch of morons!"

This notoriety, added to the sincere admiration of his friends, helped to bolster Cézanne's morale. He kept those left behind in Paris informed of what he was doing. In September Guillemet wrote to Oller (who had suddenly returned to Puerto Rico): "Cézanne is in Aix where he has painted a good picture. He himself says so even though he is very critical of his own work. He has done some superb studies full of audacity; by comparison Manet resembles Ingres. . . . Cézanne has come a long way and is unrecognizable."

Guillemet urged Oller to return to Paris where the climate, according to him, was becoming increasingly revolutionary. In his customary exaggerated and half-mocking style vibrant with the sanguinary vocabulary of the sansculottes, Guillemet announced:

Courbet is becoming classical. He has painted splendid things, but next to Manet he is traditional, and Manet next to Cézanne will become so in turn. Try to come back. . . . There is only Paris. What the devil are you going to do in Puerto Rico; what would Pissarro do in Saint-Thomas [in the Virgin Islands where he was born], what would I do in China! We are working on top of a volcano; the year '93 of painting will soon ring in its demise, the Louvre will go up in flames, the museums of antiquities will disappear, and as Proudhon [the libertarian socialist and friend of Courbet] has said, a new art can only arise from the ashes of ancient civilizations. We are burning with fever; an entire century separates today from tomorrow. . . . Let's rush to take up arms, let's grasp with an eager hand the dagger of insurrection, let's demolish and reconstruct *(et monumentum exegi aere perennius)*. Courage, brother! Let's close ranks; we are too few not to make common cause—they'll kick us out of the door, we'll slam the door in their faces! The classics stumble. Nieuwerkerke is tottering on his foundations. Let's begin the assault and crush the infamous . . . let's only trust ourselves, build, paint with loaded brushes, and dance on the belly of the terrified bourgeois. Our turn will come, too. . . . Work, my dear fellow, be brave, heavy pigment, the right tonalities, and we'll bring about the triumph of our way of seeing!

Cézanne doubtless did not disagree with this diatribe. He was then expecting the author of these provocative lines, who arrived in Aix by mid-October 1866. After spending a few days at the Jas de Bouffan, Guillemet rented a small house near the Route d'Italie, not far from where Zola had lived. In a letter to Zola he reported:

For a month now I have been in Aix, this Athens of the Midi, and I assure you that the time has not passed slowly. Fine weather, beautiful country, people with whom to talk painting and develop theories that are demolished on the morrow have all helped to make my stay in Aix agreeable. In his two letters Paul told you more about me than about himself and I shall do the same thing, that is to say the opposite, and shall tell

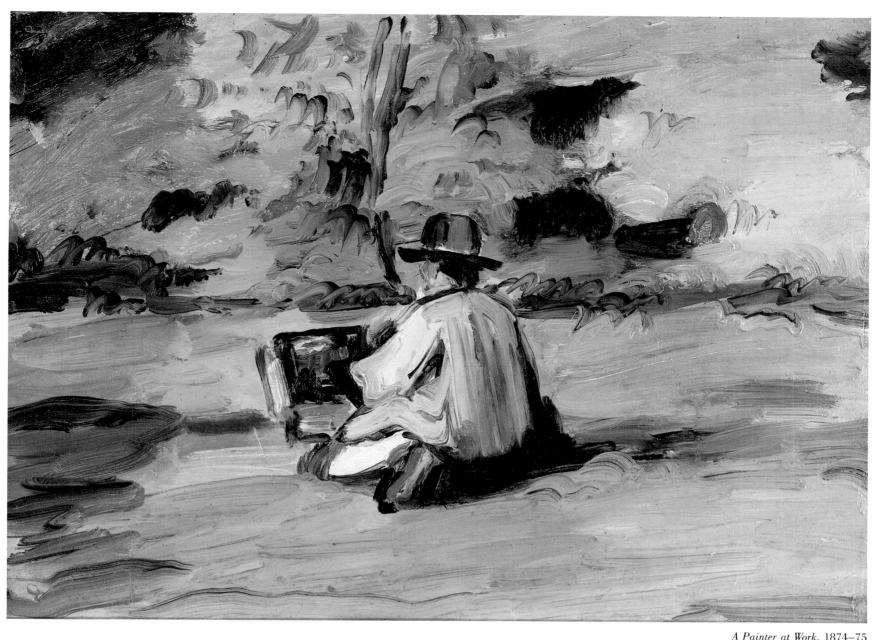

A Painter at Work. 1874–75

Factories in Front of the Mont du Cengle. 1867–69

you a lot about the master. His physique has rather improved, his hair is long, his face reflects health, and his costume makes a sensation on the main street. You may therefore feel reassured on this score. His mind, although always in effervescence, leaves him moments of clarity, and his painting, encouraged by some real commissions, promises to reward his efforts. In a word, "the sky of the future seems at times to be less black." On his return to Paris you will see some pictures that you will like very much, among others an *Overture to Tannhäuser*... and a portrait of his father in an armchair, which looks very good. The painting is light in color and the effect very fine; the father looks like a pope on his throne were it not for *Le Siècle* that he is reading [the elder Cézanne actually is reading *L'Evénement*]. In a word, it goes well, and be sure that we shall soon see very beautiful things.

The people of Aix continue to get on his nerves; they ask to see his painting only to malign it afterwards. He has found a good way of dealing with them: *Je vous emmerde*, he tells them, and the people who have no temperament flee in horror. In spite or perhaps because of that there is obviously a movement towards him, and the time is near, I believe, when he will be offered the directorship of the museum. I greatly hope for this because either I know him little or else we shall be able to see there some pretty successful landscapes done with the palette knife that have no other chance of getting into a museum.

The cholera, as you know, has left the Midi, but we still have Valabrègue who, with surprising fecundity, daily brings to light one or more corpses (in verse, that goes without saying). He will show you quite a lovely collection on his return to Paris. The verses that you are familiar with as "The Two Corpses" are now called "The Eleven Corpses." ... A very nice fellow, giving the impression of having swallowed a lightning conductor, making it difficult for him to walk.

As for young Marion, whom you know by reputation, he is cherishing the hope of being called to a chair of geology. He excavates hard and tries to demonstrate to us that God never existed, and that it is a put-up affair to believe in him. About which we bother little, for it is not painting. . . .

In Guillemet's letter it is difficult to distinguish between seriousness and irony, but it is not impossible that Cézanne's friends really thought for a time that he had a chance of becoming curator of the museum. They seem to have been intoxicated by the sensation their group made in Aix, the poem dedicated to Cézanne, and the writings of Zola. It was at this period that Marion wrote to Zola: "Paul has been an epidemic germ in Aix. Now all painters, even glassmakers, have begun to impaste!" Cézanne himself was doubtless inspired to paint enormous canvases by the belief that glory was near. But it goes without saying that all these dreams were far from realization and meanwhile discouragement, as usual, followed upon enthusiasm. Thus Cézanne wrote Pissarro: "I see Guillemet every day. He is going to paint a large picture as soon as possible. . . . I always am working a little, but paints are scarce here and very expensive; and apathy, apathy. Let us hope that the sale will come off. In that event we shall sacrifice a golden calf. I do not want to submit any more [to the Salon in Marseilles], especially as I have no frames and it involves expenses that would be better saved for painting. I say this as regards myself, and *merde* for the jury."

And Antoine Guillemet added to Cézanne's letter: "Cézanne has done some beautiful paintings. He is making them light again and I am sure you will be pleased with the three or four canvases he will bring back."

Guillemet took advantage of his stay in Aix to induce Cézanne's father to increase Paul's allowance. Cézanne's stay with his parents evidently lasted longer than expected, for Zola wrote Valabrègue in December 1866: "Tell Paul to come back as soon as possible. He will bring some courage into my life. I await him as a savior. If he is not coming in a few days, ask him to write. Let him be sure to bring me all his sketches to prove to me that I must work."

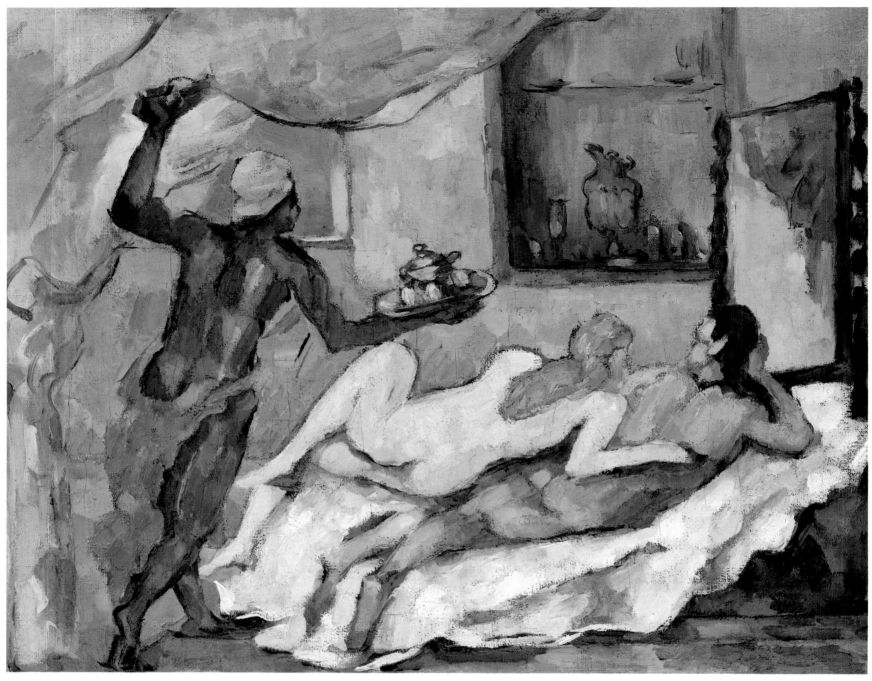

Afternoon in Naples, also known as *The Wine Grog*. 1876–77

AT THE beginning of 1867 Cézanne was again in Paris. "Paul works hard," Zola wrote to Valabrègue, "he dreams of immense paintings." Preparations for the Salon this time took on especial importance as it was hoped that Zola's violent articles had produced a change of attitude. Moreover, the World's Fair, which was taking place in the same year, attracted a large crowd to Paris. But Zola and his friends were to be disappointed once more. The jury replied to Zola's attacks by new rejections.

In April 1867, *Le Figaro* reprinted an article by Arnold Mortier that had appeared in another paper:

I have heard of two rejected paintings done by M. Sésame (nothing to do with the *Arabian Nights*), the same man who, in 1863, caused general mirth in the Salon des Refusés—always!—by a canvas depicting two pig's feet in the form of a cross. This time M. Sésame has sent to the exhibition two compositions that, though less queer, are nevertheless just as worthy of exclusion from the Salon. These compositions are entitled: *The Wine Grog.* One of them depicts a nude man to whom a very dressed-up woman has just brought a wine grog; the other portrays a nude woman and a man dressed as a *lazzarone:* in this one the grog is spilt.

Zola quickly protested to *Le Figaro* in a letter that was printed on April 12:

My dear colleague:
Be good enough, I beg you, to insert these few lines of correction. They concern one of my childhood friends, a young painter whose strong and individual talent I respect extremely.

You reprinted a clipping from *L'Europe* dealing with a M. Sésame who was supposed to have exhibited at the Salon des Refusés in 1863 "two pig's feet in the form of a cross" and who, this year, had another canvas rejected, entitled *The Wine Grog.*

I must say that I had some difficulty recognizing under the mask stuck on his face one of my former schoolmates, M. Paul Césanne [*sic*], who has not the slightest pig's foot in his artistic equipment, at least so far. I make this reservation because I do not see why one should not paint pigs' feet just as one paints melons and carrots.[6]

M. Paul Césanne, in excellent and numerous company, has indeed had two canvases rejected this year: *The Wine Grog,* and *Intoxication.* M. Arnold Mortier has seen fit to be amused by these pictures and to describe them with flights of imagination that do him great credit. I know all that is just a pleasant joke, which one must not worry about. But I have never been able to understand this particular kind of criticism, which consists of ridiculing and condemning what one has not even seen. I insist at least on saying that M. Arnold Mortier's descriptions are inaccurate.

Even you, my dear colleague, add your opinion: you are "convinced that the artist may have put a philosophical idea into his paintings." That is an inappropriate conviction. If you want to find philosophical artists, look for them among the Germans, or even among our pretty French dreamers; but know that the analytical painters, the young school whose cause I have the honor to defend, are satisfied with the great realities of nature.

Moreover, it is up to M. de Nieuwerkerke that *The Wine Grog* and *Intoxication* be exhibited. As you know, a number of painters have just signed a petition demanding the reopening of the Salon des Refusés. Perhaps some day M. Arnold Mortier will see the canvases he has so glibly judged and described. Such strange things do happen.

It is true that M. Paul Césanne will never call himself M. Césame and that, whatever happens, he will never be the creator of "two pig's feet in the form of a cross."
Your devoted colleague,
Emile Zola

This time, like the preceding year, there was no Salon des Refusés; the newspapers carried an announcement saying that Count de Nieuwerkerke had once more refused the appeal addressed to him by the rejected artists. "Paul has been rejected," Zola informed Valabrègue, "Guillemet has been rejected, all have been rejected; the jury, annoyed by my Salon review, has thrown out all those who follow the new path. . . ." And he added: "I have been obliged to give up the idea of writing a Salon review. It is possible, however, that I may publish a pamphlet on my painter friends."

Indeed, Zola did publish a series of articles on Manet. But according to Paul Alexis, who had it from Zola himself, Zola also wrote a Salon review for a newspaper called *La Situation*, which belonged to the King of Hanover. This paper can no longer be found and, furthermore, this series was almost immediately stopped because of the reviewer's violence.

His numerous publications on art gave Zola an important place in the group of young painters. His pamphlet with its long and affectionate dedication to Cézanne and his intervention in the latter's behalf in *Le Figaro* were to have a curious result. Until then, to the artists to whom Cézanne had introduced Zola, the writer had been "the friend of the painter." Now that Zola had become the champion of the group, it was the painter who was known as "the friend of the writer."

A letter from Valabrègue to Zola at the end of April 1867 confirms this state of affairs by alluding to the correction Zola had sent to *Le Figaro:*

Paul wrote to me recently. Your letter had informed me of his rejection by the jury, which I expected, as did you and he. When will Paul not be rejected? On the other hand, I have learned with pleasure of the vigorous way you answered for him. . . . You are destined to torture his enemies. It is impossible to congratulate you too heartily on this fine role. Paul is the child, innocent of life, of whom you are the guardian and guide. You watch over him, he walks by your side, always sure of being defended. An alliance between you to defend him has been signed, an alliance that will even be an offensive one if necessary. You are his thinking soul; his destiny is to make paintings, just as yours is to make his life!

Without Zola's devoted friendship, Cézanne would surely have felt still more isolated and discouraged, especially as the repeated rejections by the jury affected him much more than he cared to admit and deprived him of the only means of exhibiting. "Cézanne will go back to Aix in about ten days," Zola wrote Valabrègue in May 1867. "He will spend three months in the solitude of the province and will return to Paris in September. He has great need of work and of courage."

After Cézanne's departure, Marius Roux also went to Aix, and Zola asked him to see Cézanne and speak to him. Zola thereupon received the following report from Roux, which reflects the strange impression that Cézanne made on his friends:

I promised to write to you immediately upon my arrival in Aix. This would have been too soon for I would not have been able to answer your questions. Even now is too soon. Paul to me is a real sphinx. I went to see him during the first few days of my stay here. I saw him at his house and we talked quite a long time. A few days ago we went to the country together and slept there one night; we had a lot of time to chat.

Well! All I can tell you about him is that he is in good health. Nevertheless, I have not forgotten our conversations. I will report them to you verbally and you will translate them. As for me, I am not capable of translating them. You understand what I mean: I have not a deep enough intimacy with Paul to know the exact meaning of his words.

However (for I can hazard a guess), I believe that he has retained a holy enthusiasm for painting. He is not yet beaten; but without having for Aix the same enthusiasm as for painting, I believe that henceforth he will prefer the life he leads here to that which he

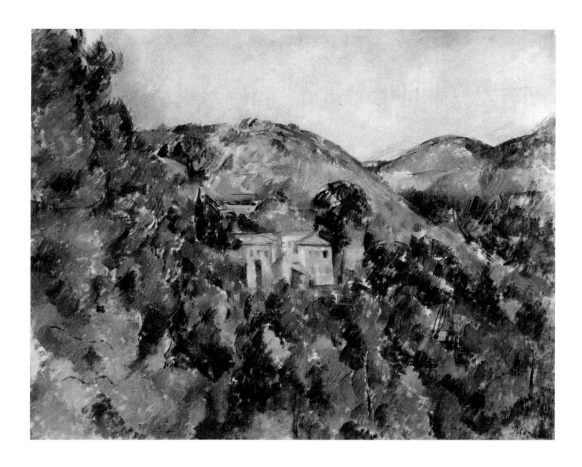

leads in Paris. He is vanquished by this Gomard-like [?] existence and he has a devoted respect for the paternal vermicelli.

Does he deceive himself? And does he believe himself to be beaten by Gomard [?] instead of by Nieuwerkerke? That is what I cannot tell you and what you will decide for yourself when I describe our conversations at greater length.

It seems, however, that Cézanne was able once again to overcome his deep discouragement and return to work, for at about the same time Marion wrote to their friend Morstatt: "Paul is here, painting, more Paul than ever, but imbued this year with a firm determination to succeed as quickly as possible. Lately he has painted some really beautiful portraits, no longer with the knife, but just as vigorous and much more skillful and pleasing in technique. . . . His watercolors are particularly remarkable, their coloration amazing, and they produce a strange effect of which I did not think watercolors were capable."

"I wish you could see the canvas he is doing now," Marion wrote a little later. "He has taken up again the subject you already know, *The Overture to Tannhäuser*, but in entirely different tones, in very clear colors, and all the figures are very finished. There is a head of a blonde girl, which is both pretty and amazingly powerful, and my profile is a very good likeness; it is carefully done without harshness of color and that somewhat repellent ferocity. The piano is wonderful, as in the other painting, and the draperies, as always, astonishingly real. Probably it will be refused at the exhibition, but it will certainly be exhibited somewhere; a canvas like this is enough to make a reputation."

But Cézanne was far from gaining the reputation that Marion hoped for him. An attempt to show a picture at the beginning of that year had proved this, as Valabrègue described to Zola: "I want to tell you that Marius exhibited a painting of Cézanne's in Marseilles, in a shop window. The result has been a lot of noise. People gathered in the street; the crowd was stupefied. Paul's name was asked, there was some activity on that side and a slight *succès de curiosité*. For the rest, I think that if the painting had been displayed much longer, they would have ended by breaking the window and smashing the canvas."

Meanwhile Marion, too, achieved some notoriety of sorts. In the spring of

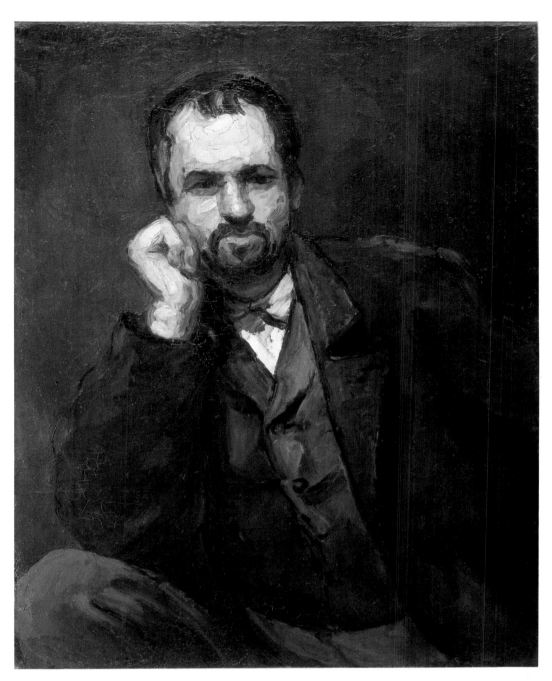

Portrait of a Man. c. 1866.
The sitter is probably Uncle Dominique.

1867, a Paris newspaper reprinted a news item from the *Mémorial d'Aix*, according to which "a certain Marion, attached to the Faculty of Science at Marseilles, has discovered on the Colline des Pauvres near Aix, in a kind of cave, a statue by men from the stone age and has found there a quite important bed of flint cut for axes, knives, and spearheads."[7]

It is not impossible that Cézanne accompanied his friend on his excursions to such sites as the one on the Colline des Pauvres, with which he was quite familiar, just as Marion occasionally painted at Cézanne's side in the country around Aix. On the other hand, Marion's geological interests eventually prompted him to give up painting altogether.

Zola, in Paris, was associated more or less exclusively with painters. He wrote Valabrègue that there was not a single writer in his circle with whom he could talk. He was often seen with Manet at the Café Guerbois, in the Batignolles quarter. They met almost daily in this café and spent many evening hours there discussing art with Duranty, Fantin-Latour, Degas, Monet, Burty, and others. The acknowledged leader of what was commonly called *Le groupe des Batignolles* was Manet, who always showed up dressed as a gentleman, with gloves and cane, wearing a top hat.

Cézanne rarely came to the Café Guerbois. He did not like the atmosphere of

discussions and theories at these reunions. In spite of his admiration for Manet as an artist, he despised his mannerisms. He himself was not satisfied with expressing in his painting alone his disdain for conventions, but wished to express revolt with his whole being. He was negligent of his clothing and language and took a certain pleasure in shocking those around him.

On arriving at the café, Monet later remembered, Cézanne would give the group a mistrustful look. Then, opening his vest, he would pull up his pants and ostentatiously readjust his red sash, after which he would shake hands all round. But in Manet's presence, he would take off his hat and in a nasal voice say with his smile: "I do not shake your hand, Monsieur Manet; I have not washed for a week."

He would sit in a corner, seeming little interested in the remarks being exchanged around him. Sometimes, when he heard an opinion that was too much opposed to his own, he would rise abruptly and instead of answering, take himself off without a word to anyone.

In the spring of 1868 Zola, and with him the Batignolles group, once more impatiently awaited the jury's decision. Solari, who had obtained a great success at the Salon the year before, went to the Palais de l'Industrie to get the latest news on the deliberations. He reported to Zola: "I met there Pissarro, Guillemet, in short all the Batignolles. They consider Cézanne's painting very good. Since then, I have seen Cézanne who told me that the last is even better."

Cézanne's entry was rejected again, although the jury showed itself less severe toward his friends. The paintings of Manet, including his *Portrait of Emile Zola*, as well as works by Pissarro, Claude Monet, Bazille, and Renoir were accepted. This success doubtless led the management of *L'Evénement Illustré* (which had replaced *L'Evénement* and of which Monsieur de Villemessant was no longer director) to entrust Zola with reviewing the Salon, at the same time reserving for the paper the right to follow up with a series of articles by a more conciliatory author. Zola began his work with the proviso that he could speak of the official school only in generalities, and Zola actually did, in his own words, avoid "mentioning by name a single one of the painters whose pictures irritate me."

As a result, this new series of critical articles did not reveal the same belligerent spirit as the first. It was now simply a question of drawing attention to painters like Jongkind, Monet, Renoir, and Pissarro, whose works had otherwise little chance of being noticed. Zola wrote:

The classical landscape is dead, killed by life and by truth. No one nowadays would dare to say that nature needs to be idealized, that the sky and water are vulgar, and that it is necessary to make horizons harmonious and correct in order to create beautiful works. . . .

Certain landscape artists of our day have created a nature after the taste of the public, which has a certain appearance of truth and possesses at the same time the sparkling grace of the lie. . . .What I accuse them of is of lacking personality. They have created a conventional nature, cut after the pattern of real nature, and one finds that nature indistinctly in all their paintings. Naturalists of talent, on the other hand, are individual interpreters; they translate truths in original language, they remain profoundly truthful and at the same time keep their individuality. They are above all human and mix their humanity with every leaf they paint. That is what will make their work live.

Our landscape artists leave at dawn, box on back, happy as hunters who love fresh air. They sit down anywhere, at the edge of the wood, or near the water, hardly choosing their themes, finding everywhere a living horizon of human interest so to speak. . . .

Zola thus gives the impression that all his friends worked outdoors, whereas actually they had hardly begun to do so. Until then, artists had painted

landscapes in their studios with the aid of sketches done in the open. Most of the landscapes of Millet, Daubigny, Rousseau, Courbet, and Corot were done in that way. But Corot's sketches from nature, for instance, were obviously, as Zola put it, "more sincere and striking" than his large studio canvases in dull and dreamy harmonies. Only a last step toward nature remained to be taken—that of painting entirely outdoors. Jongkind was among the first to do watercolors in this fashion; Eugène Boudin and Claude Monet followed his example, and that very year Pissarro, working at Pontoise, near Paris, sent to the Salon a painting of the Ermitage done completely from nature. It was this canvas which prompted Zola to remark: "A beautiful picture by this artist is the deed of an honest man."

Zola probably owed his knowledge of outdoor painting to Pissarro, Monet, Boudin, and possibly Renoir, rather than to Cézanne, who did figure compositions, nudes, portraits, and still lifes, but rarely landscapes. Theoretically, however, Cézanne was enthusiastic about open-air painting. In 1866 he had told Zola: "You know, all pictures painted inside, in the studio, will never be as good as the things done in the open air. When outdoor scenes are represented, the contrast between the figures and the ground is astounding and the landscape is magnificent. I see some superb things and I shall have to make up my mind only to do things out-of-doors. . . . I feel sure that all the paintings by the old masters representing outdoor scenes have been done from imagination, for they do not seem to me to have the true and above all original aspect lent by nature." Obviously again Cézanne's opinions on art were reflected in Zola's writings.

Zola closed his series of articles, in which he had dealt at length with painters he admired, with high praise for an enormous piece of sculpture by Solari, entitled *Sleeping Negro*, and with these general comments on the exhibition: "Melodrama abounds. Deceived husbands who shoot pistols are much appreciated. There is also a taste for dying persons who marry to the accompaniment of the sobs of the bystanders. Young artists of tomorrow, take these as models. Success lies in lugubrious or terrible subjects. It is useless to know how to paint, to have individuality, and eagerly to seek after truth. . . . That is the highest skill: to tickle the senses and make a show of idealism."

The publishers of *L'Evénement Illustré* followed up Zola's review with two articles by one Paul Delmas, explaining: "As our colleague Emile Zola has only dealt with a restricted number of exhibiting artists in a very personal way, *L'Evénement*, while allowing him complete freedom of expression, has reserved for itself the right to supplement his deliberate omissions."

There follows "a list of remarkable canvases exhibited this year," chosen from what must have been a "nonpersonal" point of view. It begins with Cabanel and Bouguereau, the chiefs of the official school, and goes right on down the line. Thus in his second battle Zola won no further ground for his friends. This may be due to the fact that he had not completely lived up to his own motto: "It is not enough to speak well of those whom one admires; one must speak ill of those one hates."

It is surprising that Zola, in reviewing the works of his friends, did not discuss Cézanne's canvases. The explanation could of course be that in a report on a Salon there is no place for painters who have not been admitted. But if Cézanne had no place among the exhibitors, he had one—prominent at that—among the rejected. Had Zola so desired, he could have found more than one way to proclaim his admiration for the painter of *The Wine Grog*, whom he had defended against ridicule without, however, any word of real appreciation. Had not Zola written about Manet, though he was not represented at the Salon? Possibly this curious neglect was occasioned by the fact that while Cézanne remained for Zola

his most precious childhood friend, the artistic friendship that linked him to Manet was stronger.

It is questionable, of course, whether Zola's preference for Manet was based on purely esthetic considerations. Zola wanted to be the chronicler of modern life and was interested in an artist whom he presumed to have the same goal. Besides, Manet's work and fame could contribute to the future prestige of his own theories. Deficient in esthetic appreciation, Zola was unable to understand fully the efforts of either Manet or Cézanne. But, while Cézanne was still caught in his peculiar romanticism, Manet offered a counterpart of Zola's naturalistic theories. It was doubtless because Manet's approach was clearer to him that Zola became the ardent champion of his art.

Some of their common friends, however, already considered Cézanne a very great artist. For instance, when Marion discussed with Morstatt the respective merits of Courbet and Manet in 1867, he wound up by stating: "Paul is really much stronger than they. He is convinced of being able, by a more skillful execution and perception, to admit details while retaining breadth. Thus he would achieve his aims, and his works would become more complete. I think that the moment of his success is not far off. It is merely a question of producing."

But a little later Marion complained to his friend:

Realist painting, my dear fellow, is farther off than ever from official success and it is quite certain that Cézanne has no chance of showing his work in officially sanctioned exhibitions for a long time to come. His name is already too well known; too many revolutionary ideas in art are connected with it; the painters on the jury will not weaken for an instant. And I admire the persistence and nerve with which Paul writes me: "Well! They will be blasted in eternity with even greater persistence." All that considered, he ought to think about finding another and greater means of getting publicity. He has now reached an astonishing perfection of technique. All his exaggerated fierceness has been modulated, and I think it is time that circumstances offer him the means and opportunity to produce a great deal.

Why did Zola not help Cézanne by giving him the publicity of which Marion speaks? Perhaps a more important reason for this silence is to be found in Zola's mental evolution. The years had blunted his youthful enthusiasm for Cézanne as a painter. His faith in Cézanne's genius remained intact, but he doubted increasingly Cézanne's ability to express this genius. Although he was shocked by the repeated rejections of Cézanne's work, he nevertheless believed that Cézanne had not yet given his best. A letter from Zola to the critic Théodore Duret is significant here. The continuous rejections of Cézanne's work had resulted in exciting Duret's curiosity, and he wrote to his colleague on the *Tribune:*

My dear Zola,
I hear of a painter called Cézanne, or something like that, who comes from Aix and whose paintings have been rejected by the jury. I seem to recall that you once spoke to me of a very eccentric painter from Aix. Could that be the one rejected this year?
If it is, will you please give me his address and a note of introduction so that I may make the acquaintance of the painter and his work.
Yours,
Théodore Duret

Zola replied: "I cannot give you the address of the painter of whom you speak. He shuts himself in a great deal; he is going through a period of groping. And, to my mind, he is right not to allow anyone in his studio. Wait until he has found himself."

The Temptation of Saint Anthony. c. 1877

Cézanne and Zola at Work

CEZANNE spent the summer of 1868 at the Jas de Bouffan, where he led such a retired life absorbed in his work that he was even unable to date his letters, and it was "around the beginning of July" that he wrote to Numa Coste:

Alexis was good enough to come to see me, having heard from the great Valabrègue of my return from Paris. He even lent me a little review of 1840 by Balzac; he asked me whether you were still painting, etc.—you know, all the things people say when chatting. He promised to come back to see me; I have not seen him for a month. For my part, and especially since receiving your letter, I directed my steps in the evening toward the Cours Mirabeau, which is somewhat contrary to my solitary habits. Impossible to meet him. However, a great desire to fulfill my duty urging me, I shall attempt to descend on his home. But on that day I shall change my shoes and shirt beforehand.

I have seen Aufan a little, but the others seem to hide themselves and a great vacuum seems to surround one when one has been away for some time. I shall not tell you about him. I don't know whether I am living or simply recollecting, but everything makes me think. I wandered alone over to the dam and to Saint-Antonin. There I slept on a heap of straw at the mill; good wine, good hospitality. I remembered our attempts at climbing [Sainte-Victoire]. Shall we never begin them again? How strange life is, what a diversion, and how difficult it would be at the present time to be once more, the three of us and the dog, where we were only a few years ago.

I have no amusement, except the family and a few issues of *Le Siècle* where I find unimportant news. Being alone, I hardly ever venture to the café. But deep down I am always hopeful.

Alexis was kind enough to read me a poem, which I found really very good; then he recited by heart a few verses from another one, entitled "Symphony in A Minor." I found these few verses more individual, more original, and complimented him on this.

A second letter to Coste, written "towards the end of November," reveals the same ennui. In it Cézanne speaks of his forthcoming return to Paris and of several painters in Aix, especially of his former teacher at the drawing school, "Gibert Pater, bad painter."

"I was glad to hear from you for it drew me out of the lethargy into which I had fallen. The beautiful expedition to Sainte-Victoire that we were to have made fell through this summer, owing to the heat, and in October, owing to the rain. From that you can judge the softening that is beginning to make itself manifest in the willpower of our little comrades. But that is how it is, it seems one is not always full of vitality; one would say in Latin *semper virens*, 'always vigorous,' or better, 'full of good intentions.'"

Besides Alexis, whom Cézanne considered very talented, he again saw a great deal of Fortuné Marion. Cézanne accompanied him on his search for fossils and Marion in turn went with Cézanne to the "motifs."

"Cézanne is planning a picture," Marion wrote to Morstatt, "for which he will use some portraits. One of us, in the middle of a landscape, will be speaking while the others listen. I have your photograph and you will be in it. . . . Paul intends to make a gift of the canvas, nicely framed, if it is welcome, to the Marseilles museum, which will thus be forced to display realist painting and our glory."

What became of this work is not known; perhaps it was never finished. The wild boldness of Cézanne's plans was as usual followed by complete discouragement. As Marion lamented in a letter to Morstatt: "What a generation of sufferers, my poor old friend. Zola, the two of us, and so many others. There are sufferers among us who are just as unhappy with fewer troubles—Cézanne with his living secure and his black despairs of morale and temperament. One must still resign oneself to all that." And Marion again expressed this resignation in another letter: "Here it is almost always the same. In the morning I work on geology, evenings I spend at Paul's in the country. . . . We dine. We take a little walk. We don't get drunk. All that is very sad."

Cézanne returned to Paris at the beginning of 1869. It is about this time that he met a young model, Hortense Fiquet, who was then nineteen. She was born in Saligny in the Jura and had lived in Paris with her mother until the latter's death. Nothing is known of her father except that he was a landowner in the department of Doubs around 1886. Hortense Fiquet was a tall and handsome brunette with large black eyes and a sallow complexion. Cézanne, eleven years older than she, fell in love with her and persuaded her to live with him. Thus he was no longer alone, but he kept his affair secret from his parents, or rather from his father. This change in Cézanne's emotional life does not appear to have influenced either his art or his relationship to his friends.

At this period Cézanne had a predilection for violent and erotic subjects. His imagination, savage and impulsive, is reflected in his use of color and movement, whereas Zola's imagination, imbued with romanticism, expressed itself in sobs and lamentations. Zola was disturbed by Cézanne's lack of moderation as revealed in canvases such as one showing a nude negro, lying on a couch, embraced by a fair-skinned girl while in the background appears a maid with a tray (reminiscent of the black servant with a bouquet in Manet's *Olympia*), or another in which a naked woman, on a magnificent bed with its curtains wide open, allows herself to be gazed upon by a motley crowd that includes a man with Cézanne's own features.

Later on, in *L'Oeuvre*, Zola attempted to explain his friend's eroticism: "It was a chaste man's passion for the flesh of women, a mad love of nudity desired and never possessed, an impossibility of satisfying himself, of creating as much of this flesh as he dreamed to hold in his frantic arms. Those girls whom he chased out of his studio he adored in his paintings; he caressed or attacked them, in tears of despair at not being able to make them sufficiently beautiful, sufficiently alive."

An indication of what Zola thought of Cézanne's work at this period may be found in an episode of *Thérèse Raquin*, one of his early novels. The impression produced by the paintings of Laurent, one of the characters of the book, is thus described: "There were five studies, painted with real energy, thick and solid in appearance, each part standing out in magnificent strokes. . . . Of course these studies were clumsy, but they had a strangeness and character so powerful that they proclaimed a highly developed artistic sense. It might be called painting that had been lived. Laurent's friend had never before seen sketches so full of promise."

Zola was still awaiting the realization of this promise after so much groping. He was waiting for a work that would reveal strength, will, the man. Meanwhile Zola looked upon Cézanne's works as sketches, especially as the artist himself always expressed dissatisfaction with them as soon as the slightest occasion for self-doubt arose.

With the exception of Pissarro and Marion, most of Cézanne's friends, while

optimistic about his future, seem to have been reticent on the subject of his painting. Guillemet, for instance, wrote Zola in July 1869: "Give me news of Paul. Has he successfully finished his picture? It is time for him to create according to his own conception and I am anxious to see him occupy the position he ought to have. What a strange thing painting is; it is not enough to be intelligent to do it well. Still, in time he will arrive, I am sure. . . ."

Zola's reply must have been discouraging, reflecting his lack of confidence in his friend's art, for Guillemet wrote to him the following month: "What you tell me about Paul makes me very sad; the good fellow must suffer like a damned soul because of all the attempts at painting into which he throws himself headlong and which only rarely succeed, alas! Where there is good material one cannot despair; as for me, I always expect him to produce beautiful things that will give pleasure to us, his friends who love him, and that will confound the sceptics and detractors."

Cézanne's work done between 1866 and the war of 1870 bears witness to his many efforts to achieve an individual technique and palette. It includes still lifes, portraits, group compositions, sketches made in museums, landscapes. Cézanne still kept his preference for picturesque subjects, which distinguished him from the Batignolles group. Thus, while Monet and Pissarro became landscapists, Cézanne appeared as the heir of Delacroix, at least insofar as subject matter was concerned. Under the influence of Courbet, the others simplified their subjects; Monet painted his *Camille* and Renoir his *Lise*, but Cézanne painted violent scenes, often of an erotic kind such as *The Temptation of Saint Anthony, The Orgy*, and *The Judgment of Paris*. Whereas the imagination of Manet and his friends was limited by visual experience, Cézanne, at that time, considered himself a visionary. His imagination was aimed at more than a purely plastic rendition of his impressions. Above all he wished to externalize the agitations of his inner life.

One of his most remarkable paintings of this period was done at Zola's house in the Rue de la Condamine, and Cézanne made his friend a present of it. This painting, *The Abduction*, dated 1867, even though not reaching the 12 or 15 feet of which the artist had dreamed, measures 35 by 46 inches. It represents a large green plain done in vivid, comma-like strokes that make it look like troubled water. Against this a nude giant strangely bronzed stands out. In his arms he carries a pale woman with blue-black hair; from her hips falls a dark blue drape. The harmony between her white skin and the bronze of the man, surrounded by the blue material and the green plain, is harsh. In the background, in front of a white cloud, arises a mountain vaguely reminiscent of Sainte-Victoire. At the left two little pink bodies of young girls enliven the composition. Zola was to think of them later on when describing in *L'Oeuvre* a canvas of Claude Lantier. He no doubt admired this painting for its bright colors, its dramatic composition, the impression of force that it gives, as well as the stubborn individualism that was so typical of the companion of his walks and of his dreams.

It is not surprising to note that during those years Cézanne's paintings are very diverse and often have little in common either in technique or composition. Besides large canvases, there are very small ones; besides scenes done completely from imagination, there are others for which Cézanne made use of studies sketched at the Atelier Suisse; besides paintings executed with verve and virtuosity in large strokes with a brush full of paint that sometimes leaves lumps of color on the canvas, there are those like *The Abduction* where he employs small and carefully placed brushstrokes. Several still lifes were done with the palette knife, while in others Cézanne applied color in a way that often conceals the individual strokes, though it provides a rich texture and great plasticity.

Still Life with Bread and Eggs. 1865

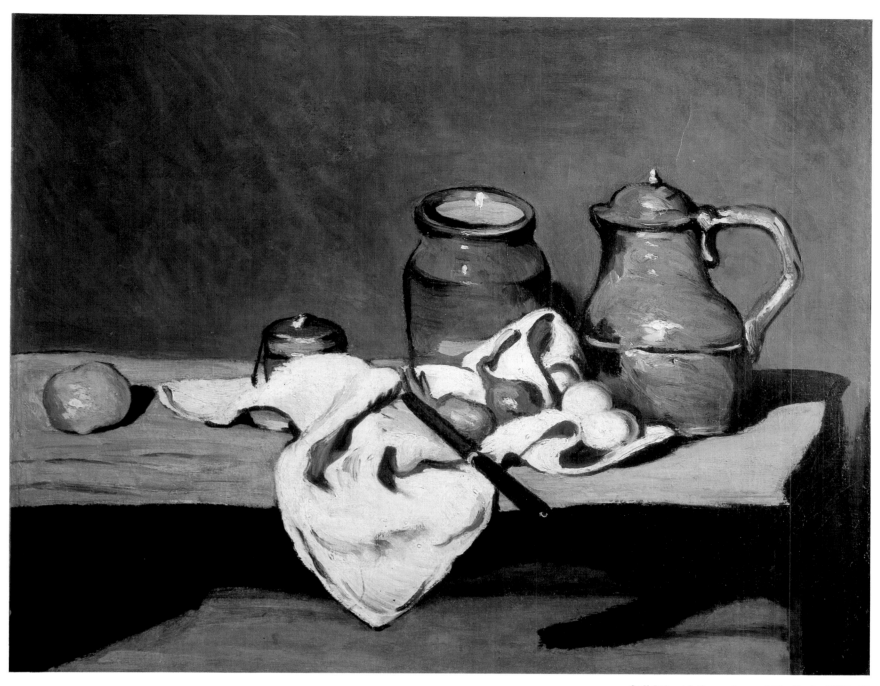

Still Life with Green Jug and Tin Kettle. 1867–69

Among the portraits of this period is one of Cézanne's fifteen-year-old sister, which is known only through the description Cézanne gave Zola: "I have just finished a small painting that I believe to be the best I have done. It portrays my sister Rose reading to her doll. It is only a little over three feet; if you like, I will give it to you. . . . My sister is seated in the middle, holding a small book, which she is reading. Her doll is on a chair, she is in an armchair. Black background, light head, blue hairnet, blue pinafore, a dark yellow dress, a bit of still life to the left: a bowl and toys. . . . I shall send it to the Salon."

At the same time, Cézanne was working outdoors and planned to do a painting of Marion and Valabrègue setting out to paint a landscape. Guillemet admired the sketch for this canvas which, in Cézanne's own words, "was done from nature and makes everything else fall flat and seem bad." Valabrègue, however, thought less highly of this sketch and wrote to Zola in October 1866: "Paul has written you recently. He has just finished two excellent paintings: one a scene in which music is being played, and the other of his sister looking at her doll. At the present time Marion and I are posing for him. We are arm in arm, and have hideous shapes. Paul is a horrible painter as regards the poses he gives people in the midst of his riots of color. Every time he paints one of his friends it seems as though he were revenging himself on him for some hidden injury."

A little later Valabrègue again tells Zola about Cézanne's paintings: "Paul made me sit yesterday for the study of a head. Flesh: fire red with scrapings of white; the painting of a mason. I am colored so strongly that I am reminded of the statue of the curé of Champfleury when it was coated with crushed blackberries. Fortunately I only posed for it one day. The uncle is more often the model. Every afternoon there appears a portrait of him, while Guillemet belabors it with terrible jokes."

Cézanne's "blond style" upon which Guillemet had commented is found chiefly in his outdoor paintings. But even there he does not yet temper the force of his impression; his brush exaggerates the better to emphasize the wonder of the Midi landscape. "You are perfectly right," he wrote Pissarro, "to talk about gray; it alone reigns in nature, but it is frightfully hard to capture."

Most of the landscapes dating from this period portray the garden of the Jas de Bouffan or the banks of the Arc. Cézanne worked outdoors with a palette that comprised white, blue, green, and black and liked to juxtapose these colors; he would, for example, set off greenish-black foliage against a blue-white sky. As for the gray that reigns in nature, Cézanne still does not appear to have succeeded in "capturing" it, although he understood that he could only achieve it by the use of color. He needed several more years and above all the example of Pissarro to uncover the mystery of this gray, which is composed of a number of tones and which he was to render in all its richness by means of a technique of small strokes.

In truth, Cézanne was more vigorous at this time than he was subtle, and the clumsiness of certain of his youthful works was due to an excess of passion that art did not control.

Although from 1866 on, Cézanne became increasingly interested in nature, he was no less interested in still lifes, in which he attained a remarkable density of expression and mastery of technique. His *Still Life with Black Clock*, which belonged to Zola, his *Tin Jug*, and others are extremely well composed, having great stability and a monumental calm. They are painted in strong tones and his use of black is very plastic. Of all the varied works of his youth, imaginative scenes, portraits, landscapes, murals, copies, etc., it is in his still lifes that

Cézanne reveals most clearly the accuracy of his perception and the richness of his genius as a colorist.

In Paris, where he had little opportunity to work in the open, Cézanne often came to Zola and worked on several portraits of his friend and Alexis reading together. Zola also sat for Fantin-Latour's group composition, which was exhibited at the Salon of 1870 under the title *The Studio of the Batignolles*. Thus the novelist saw his portrait at the Salon for the third time: the first, that of an "unknown young man," was the bust by Solari; the second, of the "avant-garde critic," was by Manet; and the third shows Zola as an important member of the Batignolles group standing with Monet, Renoir, Bazille, and others around Manet's easel.

At the end of 1869 Zola began working every day at the Bibliothèque Impériale in order to study psychology and history in preparation for a projected work that was to be the history of a whole family—*Les Rougon-Macquart*—in about ten volumes. In his general notes on the progress of this series Zola wrote:

A central family upon which at least two other families exert an influence. Expansion of this family in the modern world, in all classes. Progress of this family towards refinement in sensation and intelligence. Drama within the family due to hereditary causes. . . . Exhaustion of intelligence on account of the rapidity of the leap to the heights of sensation and of thought. Return to a state of degradation. Influence of the feverish modern environment on the impatient ambitions of the characters. The actual environments—locale and place in society—determine the class of the character (worker, artist, bourgeois—myself and my uncles, Paul and his father).

The last sentence of these notes reveals that from the inception of the stupendous construction of his Rougon-Macquart novels, Zola had Cézanne in mind. At that time Zola may not as yet have had any precise ideas about how to utilize him as a character, but among his friends Cézanne apparently seemed the most obvious for his purposes. Besides, Zola intended to devote one volume of his series to artistic problems, planning to depict the "intense psychological processes of an artist's temperament and the terrible tragedy of an intelligence that consumes itself."

Cézanne's father provided several traits for the character of François Mouret in *La Conquête de Plassans*, as revealed by Zola's notes: "Take the type of person that Cézanne's father is, mocking, republican, bourgeois, cold, meticulous, stingy; picture of his home: he refused to give his wife luxury, etc. Moreover, he talks a lot, depends on his fortune, and doesn't care what others do or think. . . ."

Zola's notes for his novels constitute a kind of written soliloquy. In them he indicates what must be done and what must be avoided, and so it is possible to follow the development of his thoughts in detail. "It is absolutely necessary to note this," Zola wrote before beginning *Les Rougon-Macquart*. "I do not deny the greatness of the modern trend, I do not deny that we may progress more or less toward liberty and justice. Only my belief is that men will always be men, good or bad animals, according to circumstances."

In his series of novels Zola made use of his memories of Aix, which he calls "Plassans." In these memories Paul Cézanne was the inseparable companion; thinking of Aix, thinking of his youth, meant for Zola also to think of Cézanne.

The first volume of *Les Rougon-Macquart*, entitled *La Fortune des Rougon*, began to appear in serial form in the newspaper *Le Siècle* in the summer of 1870. Its publication was interrupted by the Franco-Prussian War.

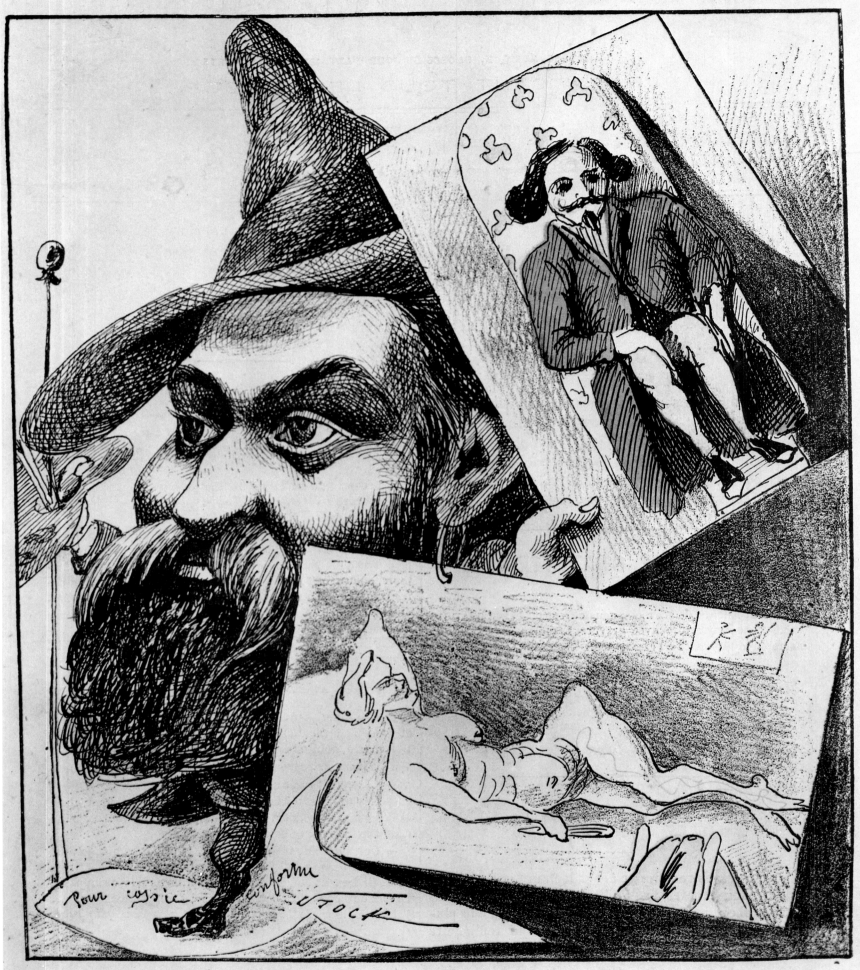

Incident du 20 mars au Palais de l'Industrie ou un succès d'antichambre avant l'ouverture du Salon

EZANNE, always more blustering than any other member of the Batignolles group, remained faithful to his project of offending the jury rather than trying to be accepted by it. In 1870 he therefore waited until the very last day before delivering his paintings and selected two canvases most likely to displease "those gentlemen." These were a *Reclining Nude* (probably the one baptized *The Wife of the Sewage Collector* by the facetious Guillemet and now lost) and a large portrait (more than six feet high) of Cézanne's friend Achille Emperaire. The latter depicts a dwarf whose musketeer's head dominates a fragile body with spindly limbs. This strange and almost grotesque figure, dressed in a blue flannel robe that opens above the knees to show long, purple drawers and red slippers, is seated in a huge, upholstered armchair of a flower design that, according to some, is actually a *chaise percée*. It was a work of tremendous power and audacity compared to which Manet's efforts to be modern without leaving the path of tradition appeared almost conventional. No other member of the Batignolles group had yet dared to search for an expression so completely new, had used contrasts of color with such brutal force, had initiated a statement of such utter individuality. This statement—in spite of its romantic exaggerations—was saved from being gaudy through the miraculous cohesion of an unbridled instinct.

As to Cézanne's second picture, it apparently represented a nude of rather angular forms, lacking in all the elements of "charm," "grace," and "finish" so much appreciated by the jury. The arrival of these two canvases caused a sensation. A journalist immediately reported the event in the press (illustrating his text with a caricature of the painter and his works):

The artists and critics who happened to be at the Palais de L'Industrie on March 20th, the last day for the submission of paintings, will remember the ovation given to two works of a new kind. . . . Courbet, Manet, Monet, and all of you who paint with a knife, a brush, a broom, or any other instrument, you are outdistanced! I have the honor to introduce you to your master: M. Cézannes [*sic*]. . . . Cézannes hails from Aix-en-Provence. He is a realist painter and, what is more, a convinced one. Listen to him rather, telling me with a pronounced *provençal* accent: "Yes, my dear Sir, I paint as I see, as I feel—and I have very strong sensations. The others, too, feel and see as I do, but they don't dare . . . they produce Salon pictures. . . . I dare, Sir, I dare. . . . I have the courage of my opinions—and he laughs best who laughs last!"

In spite of the rejections, which he had obviously expected, Cézanne remained in Paris for the Salon. When Zola married in Paris on May 31, 1870, Cézanne was one of his witnesses. At that time he was living at 53, Rue Notre-Dame-des-Champs. Nothing in his life had changed. "I have been rejected as in the past," he wrote to a friend in Aix, "but I am none the worse for it." And he added: "It is unnecessary to tell you that I am still painting." Cézanne did not mean to give up his painting during the war and remained in the Midi for its duration.

The war scattered the little group of the Café Guerbois. Zola, who was nearsighted, was not accepted in the National Guard and went with his wife and mother to Marseilles where, with Marius Roux, he attempted unsuccessfully to

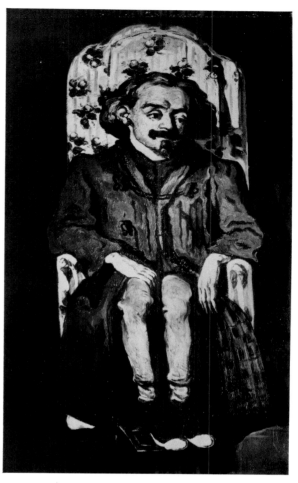

Portrait of Achille Emperaire. c. 1868

OPPOSITE:
Stock. Caricature of Paul Cézanne
with the two paintings
rejected by the Salon jury of 1870

TOP TO BOTTOM:
Achille Emperaire. *Nude. Self-Portrait.*
Still Life with Pitcher and Fruits.
No dates available

publish a newspaper. Monet went to England where he met Pissarro, whom the invasion had forced to flee. Manet was an officer in Paris, Bazille had enlisted, and Renoir was called up and stationed part of the time in Bordeaux, part of the time in the Pyrénées.

Cézanne does not seem to have been included, at the beginning at least, in any class of mobilization. He left the Jas de Bouffan to meet Hortense Fiquet in L'Estaque and to live with her there without his parents' knowledge. Zola went to stay with him for a while before leaving for Bordeaux, where he arrived in December. Meanwhile, at Sédan the Prussians had inflicted a crushing defeat on Emperor Napoléon III, who capitulated on September 1, 1870, and fled. But the enemy troops continued their advance and eventually besieged Paris while the young Republic, born from disaster, tried to offer what resistance it could. In January 1871, Zola received a letter from Marius Roux:

Concerning the mobilization of the Guard, I have two pieces of news for you, one unpleasant, and the other astonishing.

The unpleasant news is that Paul C. . . . is being looked for and I am very much afraid he will not escape being found if, as his mother says, he is still in L'Estaque. Paul, who at first did not foresee what was going to happen, was seen in Aix a good deal. He even went there quite often and remained one, two, or three days and sometimes more. It is also said that he got drunk in the company of gentlemen of his acquaintance. He must have—it is even certain—given his address, since the gentlemen in question (who must be jealous of him for not earning his livelihood) hastened to denounce him and to give all information necessary for finding him.

These same gentlemen (here is the astonishing news) to whom Paul said that he was living in L'Estaque with you—not knowing that since then you were able to leave that hole and not knowing whether you were married or a bachelor—also gave your name as a defaulter. On the evening of January 2 my father took me aside and told me:

"I have just heard a conscript who said this: 'There are four of us, including Corporal So-and-so, who have been ordered to Marseilles to bring back defaulters.' " He gave the names.

"Among them"—my father told me—"I remember those of Paul Cézanne and Zola!"

" 'Those two'—added the conscript—'are in hiding in Saint-Henri [a village near L'Estaque].' "

I told my father to lend a deaf ear and to take no part in any conversation of this kind. I got busy and the next morning hurried to the town hall. There I have complete freedom and was shown the list of evaders. Your name was not on it. I told Ferand, who is a reliable man and devoted to me, what was being said. He replied: "They must have mentioned Zola only because of Cézanne, who is being diligently sought; but if your friend's name was given, it must have been before information was acquired, since Zola does not come from Aix and is married! . . ."

At the town hall, nothing official, and among the crowd that bandies Cézanne's name about, I have never heard yours.

Evidently the police went to the Jas de Bouffan, where Madame Cézanne told them to search the place freely, that her son had left two or three days before, and that she would notify them when she knew where he was.

It is doubtful that Cézanne was hunted in L'Estaque itself, for then it would have been almost impossible not to find him. He did not conceal his presence in the little village by the Mediterranean, thirty kilometers from Aix, where he worked in the open air, painting the rocks, the hills, the village, and the sea. Roux's information notwithstanding, Cézanne does not seem to have been worried. It is certain that he took no part whatsoever in the war and later on, when asked about the life he had led during that period, he replied that he had been in L'Estaque, dividing his time between landscape painting and work in his studio.

Bathers. c. 1870

Thus Cézanne remained far from the fever that shook his country, far from the battlefield, and far from his friends, most of whom did not even know where he was, though supposing him to be somewhere in the Midi. He also stayed away from Aix, where, since the proclamation of the Third Republic, things had happened that could not have left him indifferent. When, on Sunday, September 4, 1870, toward ten o'clock in the evening, a telegram had arrived from Paris announcing the Republic, the anti-imperialists of Aix went en masse to the town hall where they proclaimed the fall of the local government and of the municipal council established by the last elections. The mayor and an assistant, who had rushed to the scene, were obliged to withdraw in the midst of uproar and confusion. Then the republicans met in the council hall and a provisional municipal body was chosen by popular acclaim.

The democratic list, defeated at the previous election, furnished the necessary names for the new council. But among the new members of the municipal council thus elected were also some who had not figured on that list, among them Baille, who was with the Paris observatory; Victor Leydet, merchant (another schoolmate); Valabrègue, writer; and Louis-Auguste Cézanne, banker. One Alexis, pharmacist, became provisional mayor.

After the election, the bust of Napoléon III and his portrait were destroyed. The painting was torn to shreds; the cast-iron bust was knocked off its pedestal, kicked out of the room, and finally thrown in the fountain.

The Republic was officially proclaimed at ten o'clock the following morning on the steps of the Palais de Justice, and on September 11 was posted an appeal to the population of Aix, signed by the entire municipal council: "Let us arise, citizens, and march as one man! The Municipal Council of Aix calls you to the defense of your country; it assumes the responsibility of providing for the needs of the families of all those who will volunteer to bear arms to save France and gain respect for our glorious and pure Republic."

In spite of the seriousness of the situation, Marius Roux couldn't help writing to Zola: "I am bored stiff here. I watch the revolution pass. In the gang are our admirable friends, Baille and Valabrègue. They amuse me tremendously. Can you see those quitters from Paris who come here to stick their noses into the local government and vote resistance. Let us march like one man say their proclamations. March! They are a fine pair."

The new municipal council took its duties seriously and, in one of its first sessions, formed committees. Louis-Auguste Cézanne, then seventy-two years old, was chosen member of the committee on finance; Baille was put on the committee of public works; and Valabrègue and Leydet were put on the one dealing with miscellaneous issues. Baille and Valabrègue also took part in the census for the organization of the National Guard, and they may well have prevented too thorough a search for Cézanne.

The painter's father was usually absent from the meetings of the municipal council, possibly because of a reluctance to commit himself on current issues. Elected without having been a candidate, he probably owed this honor to his financial ability, which also put him on the committee on finance. It does not seem as though his political convictions had caused his nominations since his shunning of the meetings "without known reason" (as recorded in the minutes) would be even more incomprehensible. While he kept away from the council, the latter honored his son by nominating him member of the committee on the art school and the museum. But Cézanne took as little interest in civic affairs as his father, who was not even candidate for the municipal council that replaced the provisional one in the spring of 1871. When the arts committee was dissolved at

The Village of the Fishermen, L'Estaque. c. 1870

about the same time, Cézanne lost the opportunity to influence the policy of the museum, an opportunity of which he had failed to avail himself.

"As soon as the municipal elections are over," the local press announced, "the elections for the Constituent Assembly will take place. Among the republican candidates from the Bouches-du-Rhône will probably be one of our local citizens, M. Emile Zola."

Nothing came of this, although Zola had aspired at one time to become sous-préfet of Aix. Indeed, he had abandoned his literary activity for the duration of the war and had devoted himself to politics. In Bordeaux he became parliamentary correspondent for *La Cloche*, and his writings there during the period were the only products of his pen with the exception of numerous letters to his friends. He received a reply to one of these from Manet under the dateline Paris, February 9, 1871:

I am very glad to have good news from you. You have not wasted your time. Recently we have suffered a great deal in Paris. Only yesterday I heard of the death of poor Bazille. I am overcome—alas, we have seen many people die here in many ways. At one time your house was lived in by a family of refugees. Only the ground floor; all the furniture was moved upstairs. I think no damage was done to your things. I am leaving soon to join my wife and my mother in Oloron in the Basses-Pyrénées. I am anxious to see them again. I shall pass through Bordeaux and will perhaps come to see you. I shall tell you then what cannot be put on paper.

Melting Snow, L'Estaque,
also known as
The Red Roofs. c. 1870

Landscape (near L'Estaque?).
c. 1870

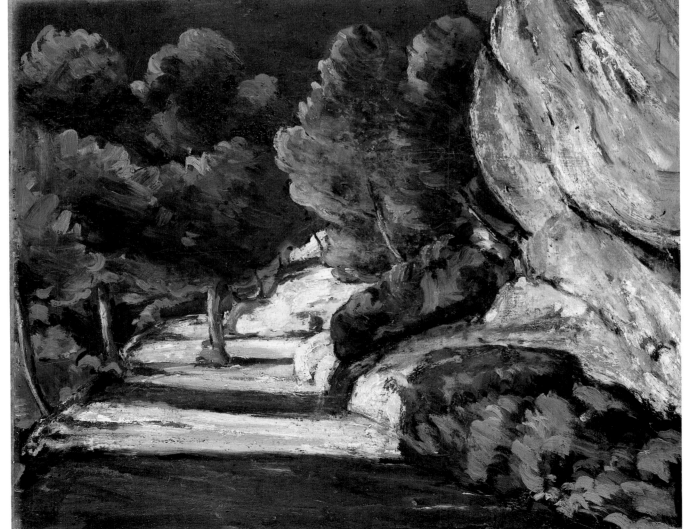

At the beginning of March, Zola wrote to Paul Alexis from Bordeaux that he had not heard from Cézanne, whom he imagined to be somewhere in the country near Aix. A few weeks later Alexis, who had seen Zola in Paris in the meantime, wrote to him from L'Estaque: "No Cézanne. I had a long talk with M. Giraud, called Longus [owner of the house Cézanne rented in L'Estaque]. The two birds flew away—a month ago! The nest is empty and locked. 'They went to Lyons,' M. Longus told me, 'to wait until Paris stops smoking.' I am surprised that for a month we have not seen him in Paris. I hope that when you receive this letter you will know more about him than I do."

To this Zola replied:

What you tell me about Cézanne's flight to Lyons is an old wives' tale. Our friend merely wanted to throw M. Giraud off the scent. He went into hiding in Marseilles or in some valley. And I hope to know his whereabouts as soon as possible, for I am worried.

Just imagine—I wrote to him the day after you left. My letter, which was sent to L'Estaque, must have miscarried, which is not a great loss; but I am afraid lest by an unforeseen chain of circumstances it may have fallen into Cézanne's father's hands. It contains some particulars compromising to the son. You follow the reasoning, do you not?

I would like to find Paul to have him claim this letter. Therefore I count on you for the following errand: one of these mornings you will go to the Jas de Bouffan where you will give the impression of seeking news of Cézanne. You will manage to talk to the mother for a moment privately and will ask her for her son's exact address. . . .

Alexis apparently had no difficulty in tracing Cézanne through his mother. The painter thereupon wrote to Zola, who replied immediately, on July 4, 1871:

My dear Paul,

I was very glad to get your letter, as I was beginning to be worried about you. Four months have elapsed since we have heard from one another. I wrote to you at L'Estaque around the middle of last month. Then I found out that you had left there and that my letter might be lost. I was having great difficulty finding you when you helped me out.

You ask for my news. Here is my story in a few words. I wrote to you shortly before leaving Bordeaux and promised to write you another letter as soon as I returned to Paris. I arrived in Paris March 14. Four days later the Commune was established, the postal services were suspended, and I no longer thought of getting in touch with you. For two months I lived in the furnace, night and day, with cannon and, towards the end, shells whistling over my head, in my garden. Finally, on May 10, I was threatened with seizure as a hostage. I fled, with the help of a Prussian passport, and went to Bonnières to spend the worst days. Today I am staying quietly at the Batignolles, as though I were waking up from a bad dream.[8] My pavilion is the same, my garden has not budged; not a single piece of furniture or plant has suffered and I could even believe that the two sieges were bad jokes invented to frighten children.

What makes these bad memories more fleeting for me is that I have not stopped work for a moment. Since leaving Marseilles I have been earning my living very well. . . . I am telling you this so that you may not pity my lot. I have never been more hopeful or desirous of working. Paris is being reborn. As I have often told you, our reign has begun!

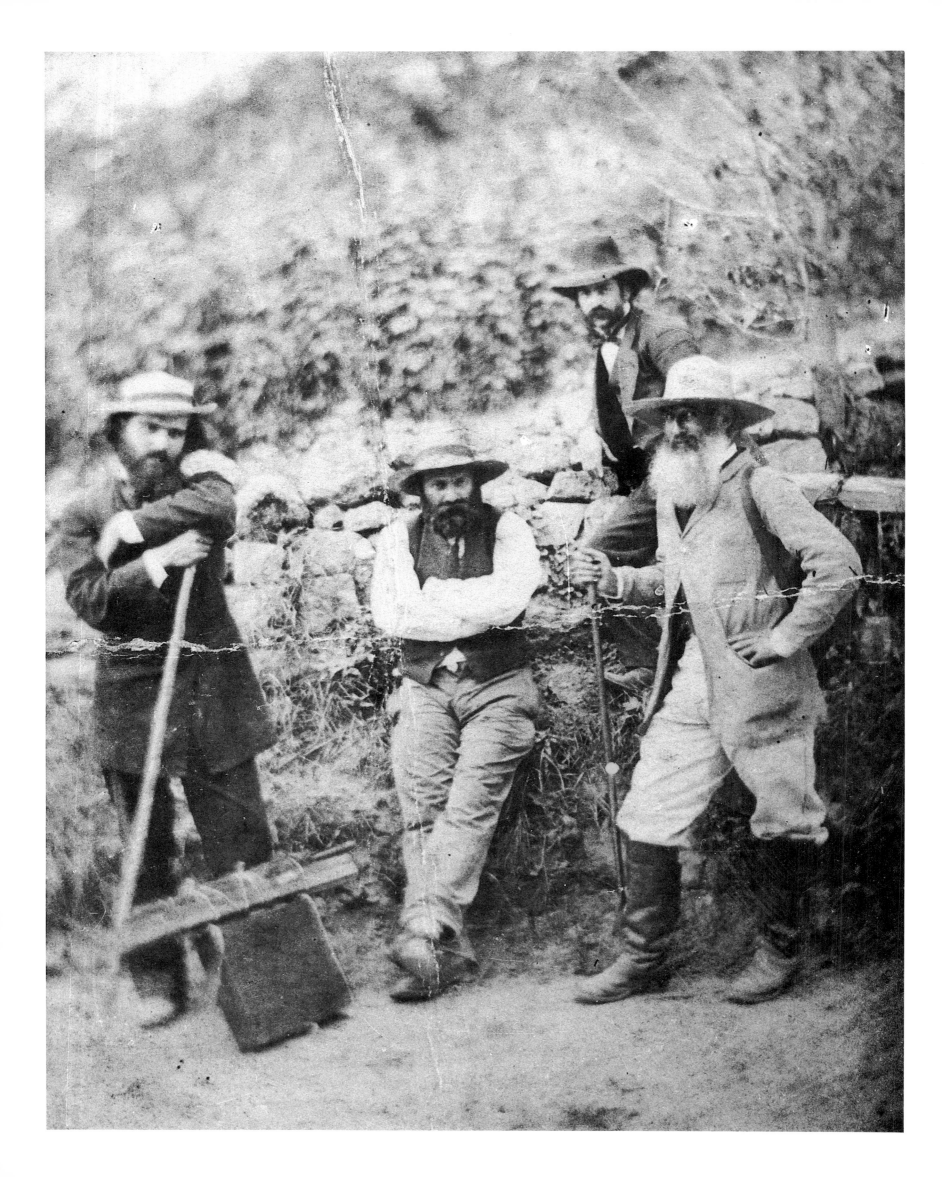

CEZANNE'S first paintings done in L'Estaque have much in common with his previous work. They show the same dramatic emphasis and exuberance, the same violent color contrasts. Though black predominates, there are strong reds and warm ochers that enhance the power of his style.

Still imbued with the ardor that produced *The Abduction* and *The Temptation of Saint Anthony*, Cézanne dramatized what he saw. Trees, rocks, and houses became manifestations of his passionate temperament. Abandoning imaginary scenes more and more, Cézanne felt inspired by the magnificent bay of Marseilles, surrounded by mountains, by the roofs of villages and the belfries and tall chimneys that rose toward the cloudless sky, by the pines on the green hills, and by the distant reflection of little rocky islands in the water.

The scenery around L'Estaque is extremely beautiful. Zola described it in one of his novels:

A village just outside of Marseilles, in the center of an alley of rocks that close the bay. . . . The country is superb. The arms of rock stretch out on either side of the gulf, while the islands, extending in width, seem to bar the horizon, and the sea is but a vast basin, a lake of brilliant blue when the weather is fine. At the foot of the mountains the houses of Marseilles are seen on different levels of the low hills; when the air is clear one can see, from L'Estaque, the gray Joliette breakwater and the thin masts of the vessels in the port. Behind this may be seen, high on a hill, surrounded by trees, the white chapel of Notre-Dame de la Garde. The coastline becomes rounded near Marseilles and is scooped out in wide indentations before reaching L'Estaque; it is bordered with factories that sometimes let out high plumes of smoke. When the sun falls perpendicularly to the horizon, the sea, almost black, seems to sleep between the two promontories of rocks whose whiteness is relieved by yellow and brown. The pines dot the red earth with green. It is a vast panorama, a corner of the Orient rising up in the blinding vibration of the day.

But L'Estaque does not only offer an outlet to the sea. The village, its back against the mountains, is traversed by roads that disappear in the midst of a chaos of jagged rocks. . . . Nothing equals the wild majesty of these gorges hollowed out between the hills, narrow paths twisting at the bottom of an abyss, arid slopes covered with pines and with walls the color of rust and blood. Sometimes the defiles widen, a thin field of olive trees occupies the hollow of a valley, a hidden house shows its painted facade with closed shutters. Then, again, paths full of brambles, impenetrable thickets, piles of stones, dried-up streams, all the surprises of a walk in the desert. High up, above the black border of the pines, is placed the endless band of the blue silk of the sky.

And there is also the narrow coast between the rocks and the sea, the red earth where the tileworks, the big industry of the district, have excavated large holes to extract clay. . . . One would think one were walking on roads made of plaster, for one sinks in ankle-deep; and, at the slightest gust of wind, great clouds of dust powder the hedges. . . .

When this dried-out country gets thoroughly wet, it takes on colors . . . of great violence: the red earth bleeds, the pines have an emerald reflection, the rocks are bright with the whiteness of fresh laundry.

Only a small number of the pictures that Cézanne painted in L'Estaque are known, but these suffice to show his artistic development, which drew him from the expression of his visions to the study of nature. Continuing in this vein, Cézanne was later to say that art can develop only from contact with nature, a

OPPOSITE:
Paul Cézanne (center) with Camille Pissarro (at right) in the region of Auvers. Photograph c. 1874

Quai de Bercy—La Halle aux Vins, Paris. 1872

contact he began to seek only at the age of thirty. The ardor that produced his first landscapes was succeeded by an increased sensitivity that made him perceive differences of tone. In order to develop his individuality more freely, Cézanne needed technical advice, which he was able to get from his friends who had returned to France as soon as the war was over.

The gatherings at the Café Guerbois were resumed, though less frequently than formerly, and soon the meeting place was changed to the Café de la Nouvelle-Athènes. The calm that followed the change of government filled the group with new hope. In Paris Cézanne found not only Zola and Pissarro, but also Valabrègue, Roux, and Solari. The latter had married before the war and supported his wife and child in any way he could, sometimes "by turning out saints at sixty centimes an hour while waiting for something better." Cézanne lived for six months in the same house as Solari, 5, Rue de Chevreuse, but in December 1871 he moved to 45, Rue de Jussieu, opposite the Halle aux Vins. There, on January 4, 1872, Hortense Fiquet gave birth to a boy who was registered by his father under the name Paul Cézanne. The artist sent a short note to Emperaire, enclosing a letter that he asked him to deliver to his mother. This letter doubtless contained the announcement of the arrival of the child, a fact that had to be kept hidden from the banker who as yet knew nothing of his son's liaison.

A few weeks later Emperaire arrived in Paris, having been invited to stay with Cézanne, who had specified, however, that Emperaire would have to bring his own sheets since his host was unable to lend him any. In February Emperaire informed friends in Aix: "Paul was at the station. I went to his house in order to get some rest and then spent the night with . . . a sculptor." Shortly afterwards he specified: "Paul is not very well set up; also there is a noise that would awaken the dead. As I couldn't help myself, I accepted [his hospitality], but even if he offered me a kingdom, I would not stay with him." Toward the end of March 1872 Emperaire announced: "I have left Cézanne—it was unavoidable, otherwise I would not have escaped the fate of the others. I found him here deserted by everybody. He hasn't got a single intelligent or close friend left. . . . He is the strangest chap one can imagine. . . ."

It is of course conceivable that the irascible Cézanne had quarreled with his friends during his hard times at the Rue de Jussieu, and it is also possible that—at least in the beginning—Hortense had not fitted well into the circle of young artists from Aix. But these difficulties were eventually patched up; the softening of hostilities may actually have been helped by the fact that in the spring of 1872 Cézanne and his little family left Paris.

Ever since he himself had settled outside of Paris, a few years before the war, Pissarro had tried untiringly to persuade his friends to abandon the city and join him in the country. Convinced of the advantages of outdoor painting, Cézanne now went with Hortense and their child to join Pissarro in Pontoise. There he would be able to benefit from the advice of his friend, almost ten years older than he. Pissarro was always anxious to help others profit from his experience. This generous attitude explains the role he played among his friends; no one would advise, help, encourage as he could, and though his criticism was just, it was tempered by leniency. It is not surprising, then, that a small group of painters gathered in Pontoise around Pissarro, a group of which Cézanne now became a member.

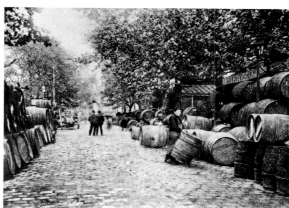

La Halle aux Vins, Paris. Photographs c. 1900

In September 1872 Pissarro proudly informed Guillemet: "Béliard is still with us. He is doing very serious work at Pontoise. . . . Guillaumin has just spent several days at our house; he paints in the daytime and in the evening works at his ditchdigging.[9] What courage! Our friend, Cézanne, raises our expectations, and I have seen and have at home a painting of remarkable vigor and power. If, as I hope, he stays some time in Auvers, where he is going to live, he will astonish a lot of artists who were too hasty in condemning him."

Not far from Pontoise, at Auvers-sur-Oise, where Daubigny lived, Dr. Gachet, an habitué of the meetings of the Batignolles group, had just bought for his ailing wife a large and isolated house on a hillside overlooking the entire valley. He usually spent three days a week there with her and their two children. Pissarro and Cézanne, as well as Guillaumin, who joined them, saw a lot of the doctor. He particularly urged them to do etchings—being an enthusiastic engraver himself—and put at their disposal his plates and the press that he had installed in his attic.

Toward the end of 1872 or at the beginning of 1873, Cézanne left Pontoise for Auvers where he took up residence near Dr. Gachet. Auvers was little more than a village of thatched cottages on unpaved country lanes, in contrast to Pontoise, which was more a town, though with a certain rural character. In Auvers Cézanne could work at ease without being watched by curious spectators (whom he loathed), whether he painted on the road that led to Gachet's house or out in the fields. And he did so with untiring zeal. It is said that Daubigny, who once had recommended Cézanne's *Portrait of Valabrègue* for admission by the jury, one day watched the painter at work and could not restrain his enthusiasm. "I've just seen on the banks of the Oise an extraordinary piece of work," he told a friend. "It is by a young and unknown man, a certain Cézanne."

Cézanne's two years in Pontoise and Auvers were crucial ones in his artistic development. He benefited greatly from his more or less direct collaboration with Pissarro, for the latter clarified his palette and produced a change in his technique. Although he no longer made use only of dark colors, Cézanne at first continued to paint with dramatic strokes, but soon, following his friend's example, he employed special palette knives about two fingers wide, very long, flat, and supple, to paint large masses of color. With these spatulas he built up the color, sketching in the features of his motif rather summarily; by means of accentuated shadows and a few sharp tones of red and yellow-green, he tried to

Camille Pissarro. *Les Mathurins, Pontoise.* 1875

Les Mathurins, Pontoise. 1875–77

give his landscapes a certain plasticity. The better to assimilate Pissarro's palette
and technique, Cézanne faithfully copied a large *View of Louveciennes* painted by
his mentor.

In 1874 Pissarro painted a likeness of his friend that Lucien, his eldest son,
then eleven years old, later described:

Cézanne's portrait, painted by father, resembles him. He wore a cap, his long, black
hair was beginning to recede from a high forehead, he had large, black eyes that rolled
in their orbits when he was excited. He walked with a stick, steel-pointed at the ferrule,
which frightened the peasants. . . . Cézanne lived in Auvers and he used to walk three
kilometers [about two miles] to come and work with father. They discussed theories
endlessly; I remember some words that I overheard: "The form is of no importance. It is
the harmony." One day, they bought palette knives to paint with. Several pictures
remain of the work they did at this time. They are very similar in treatment, and the
motifs are often the same.

When one day some collectors came to dinner, Pissarro hoped they would buy
pictures. His wife prepared an excellent meal and put on her best silk dress. The
meal had just begun when Cézanne appeared, as shabby as ever. He was, of
course, asked to sit at the table. Madame Pissarro was endeavoring to act the
perfect hostess, very ladylike and polite, and this acted as a spark to Cézanne's
malicious humor. He began to scratch himself vigorously. "Don't take any notice,
Madame Pissarro," he said. "It's only a flea."[10]

Camille Pissarro does not seem to have resented his friend's pranks; instead he
rejoiced in his progress, watching how Cézanne gradually abandoned dark colors,
with the exception of black, and did away with heavy and earthy tones. "We are
perhaps all derived from Pissarro," Cézanne later said. "Already in '65 he had
eliminated black, bitumen, sienna, and ochers. This is a fact. 'Only paint with
the three primary colors and their immediate derivatives,' he told me. . . ."

Cézanne took this advice. The winter, with its snow, which he had seldom
observed in the Midi, introduced to him tones of light gray, and he continued to
brighten his palette by painting winter scenes. Twenty years later, Pissarro
explained to his son that while they had often set up their easels side by side, it

Camille Pissarro. *The Rue de la Citadelle, Pontoise in Winter.* 1873

Snow Effect, Rue de la Citadelle, Pontoise. 1873.

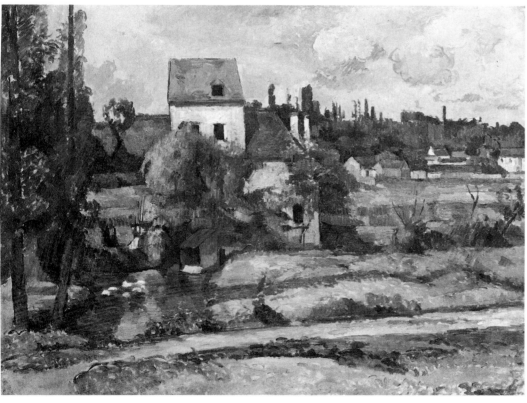

The mill on the banks of La Couleuvre near Pontoise. From a turn-of-the-century postcard

The Mill on the Banks of La Couleuvre near Pontoise. 1881

was certain that each kept the one thing that counts, his "sensation."

Pissarro was happy to see Cézanne gain control of his ebullient temperament in intimate contact with nature, but he was too modest to insist on the part he himself played in this decisive period of Cézanne's evolution. When Zola and Béliard were surprised by the similarity of some of their works, Pissarro pointed out that it was wrong to think "that artists are the sole inventors of their styles and that to resemble someone else is to be unoriginal." Conscious of the give-and-take between artists who work together, Pissarro later acknowledged having been influenced by Cézanne, even while influencing him.

Thus the advice Pissarro gave to his friend was by no means intended to prevent him from realizing his own sensations. On the contrary, Pissarro

98

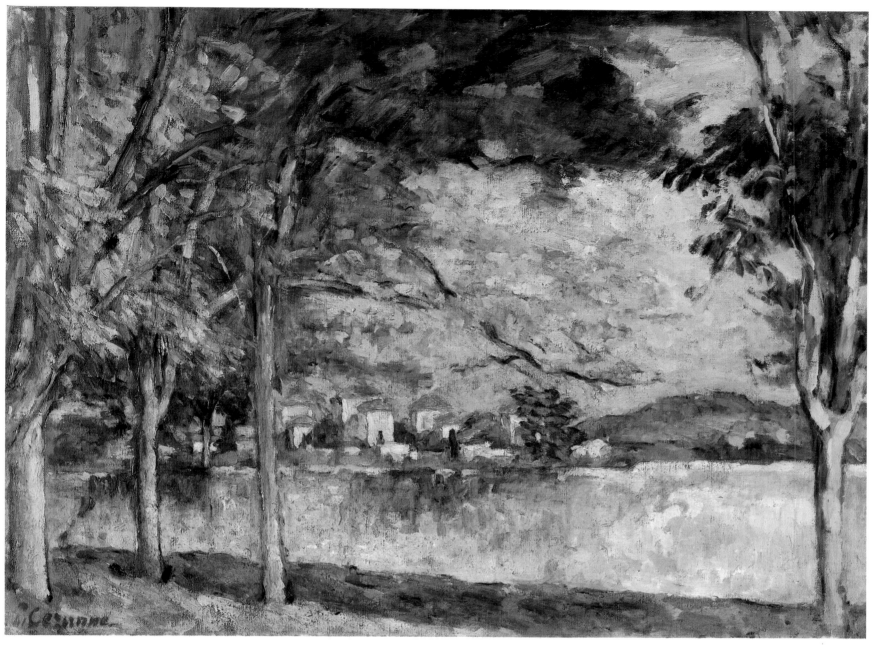

The Road, also known as *The Wall*. 1875–76

OPPOSITE:
View of Auvers-sur-Oise—The Fence. c. 1873

The group of houses that appears in the center of the
painting reproduced on the opposite page. Photograph
c. 1935

Camille Pissarro. *Portrait of Paul Cézanne.* c. 1874

incessantly repeated that one should have no master but nature, who was always to be consulted. He was satisfied with giving Cézanne certain practical advice, the fruit of his experience, telling him, for example, that it was not necessary to insist on linear form, since form could be achieved by other means, namely color.

But now that Cézanne had replaced his dark palette with a bright one, he needed to develop this new palette so that it might attain the richness of color he admired so much in Delacroix. And he depended on nature for that richness which he sought for the expression of his sensations. He remembered Pissarro's remarks that museums ought to be burned, that "we must portray what we see and forget what appeared before our time."

Consequently, Cézanne studied effects of light and air and tried to convey them through color; he learned that objects have no specific color of their own, but reflect each other, and that air intervenes between eye and object. Cézanne not only made these observations on nature but also expressed them in his still lifes. The first of these, painted in Auvers, still reveal some of Manet's influence and are in somber tones: dull yellows and reds against absolutely black backgrounds. Cézanne painted them in Dr. Gachet's studio and chose as subjects glasses, bottles, knives, and other not very colorful objects. He also painted a plaster medallion by Solari, a portrait in profile of the sculptor, and some tapestries that he had brought with him. But Cézanne soon tired of the limited range of whitish browns and the grays that predominate in these compositions and began to paint the flowers that Madame Gachet picked for him in her garden. These little canvases have remarkably clear and vibrant colors: blues, reds, and yellows of extraordinary intensity that bear witness to the pleasure he felt in rendering such richness of tone. However, the realization was still difficult and painful. Cézanne now went even farther in his scruples to be truthful than he had once gone in his independence of nature. He no longer dared to work with sweeping brush strokes, but instead covered his canvases with heavy layers of color through the use of small patches and spots of paint. His extreme effort to render every nuance observed led him to proceed patiently and as if he were building up a mosaic. Thus he worked slowly, and one day when he was painting some distance away from Pissarro in the outskirts of Auvers, a peasant told Pissarro, "Well, boss, you have an assistant over there who isn't doing a stroke of work!"

When he was questioned later concerning his reasons for abandoning the impetuosity that characterized his first period in favor of the technique of separate touches in his work at Auvers, Cézanne replied: "I cannot convey my sensation immediately; so I put color on again, and I keep putting it on as best I can. But when I begin, I always try to paint sweepingly, like Manet, by giving form with the brush."

As a result, Cézanne's paintings have amazing color relief, for on the first layer of paint are placed innumerable small daubs that give tremendous richness of tone: the skies are not only blue, but also pale green, blue-gray, bright violet, brown, and pink. The straw roofs have a comparable range of color, the tree trunks and foliage are touched with violet, the contours of objects are done in yellow, maroon, and blue. Cézanne observed that there are no lines in nature, no shadows without color. He was later to remark: "Pure drawing is an abstraction. Line and modeling do not count; drawing and outline are not distinct, since everything in nature has color. . . . By the very fact of painting, one draws. The accuracy of tone gives simultaneously the light and shape of the object, and the more harmonious the color, the more the drawing becomes precise. . . ."

In his attempt to achieve this accuracy of tone, Cézanne had difficulty in finishing a picture, for he was always anxious to add more touches of paint.

Camille Pissarro. *Portrait of Cézanne*. 1874

When his friend Dr. Gachet decided that a painting had nothing more to gain, but, on the contrary, a lot to lose, he would say: "Come on, Cézanne, leave that picture alone, it's finished. Don't touch it." And Cézanne obeyed, grumbling. The doctor bought a number of paintings from him, as well as from Pissarro and Guillaumin, thus acquiring a truly remarkable collection. It was also on the advice of Dr. Gachet and Pissarro that the grocer in Pontoise accepted some paintings from Cézanne in payment of his bills.

To please their friend, both Pissarro and Cézanne made a few etchings, the only ones Cézanne ever did, among them a portrait sketch of Guillaumin. He also drew a portrait of Dr. Gachet etching and a profile of Pissarro as well. The latter, in turn, did several portraits of Cézanne: on copper, in pencil, and in oils.

In spite of his intense work from nature during this period, Cézanne was still haunted by the idea of composing agitated scenes. He painted yet another *Temptation of Saint Anthony* and an astonishing *Modern Olympia* that is perhaps the strangest work produced by him in Auvers. In this painting he himself appears, seen from behind, gazing upon a woman who is half crouching, half lying on an enormous divan while a negress removes her last veil. This is a less refined and more female *Olympia* than Manet's, presented in an atmosphere less cold and reserved, and surrounded by fireworks of color. A huge bouquet picked in a dream meadow illuminates the scene.

Pissarro must have praised this painting since Théodore Duret—who had once tried in vain to approach Cézanne through Zola—wrote to him: "If it were

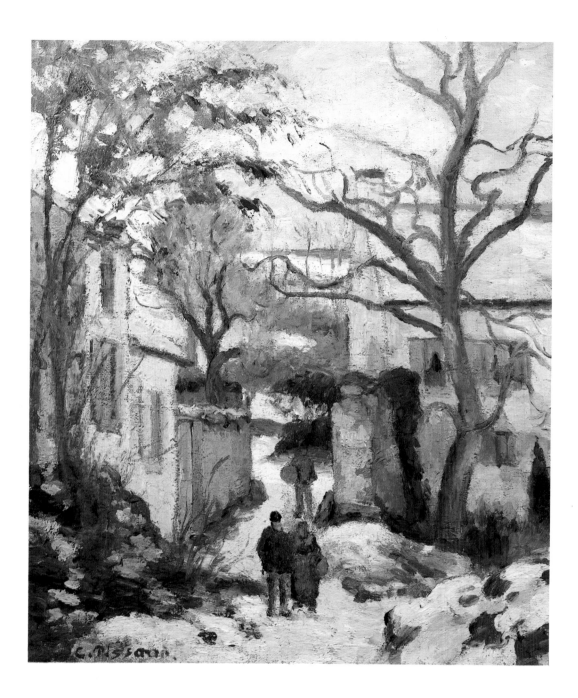

Camille Pissarro. *Road of the Hermitage, Pontoise, under the Snow.* c. 1874

possible, I would be glad to see some of Cézanne's work in your home, for in painting I look more than ever for sheep with five legs." Pissarro immediately replied: "If it is five-legged sheep that you are seeking, Cézanne can satisfy you, for he has made some studies that are very strange and seen in a unique manner."

Cézanne was working feverishly. Oil paintings, watercolors, drawings, etchings, and even pastels, the latter probably at the behest of Guillaumin, served him as means of expression. He had no wish to leave the friends who had been so helpful to him, nor did he care to be separated for any length of time from Hortense and their small son, the more so as his father, still kept in ignorance, might decide to cut off his allowance while his son lived at the Jas de Bouffan. Cézanne therefore tried to explain to his parents, as best he could, why he dreaded going back to Aix:

You ask me in your last letter why I have not yet returned to Aix. Apropos of this I have told you that it gives me more pleasure than I can express to be with you, but once in Aix, I am no longer free. When I want to return to Paris it is always a struggle for me, and although opposition to my return is not adamant, I am very much shaken emotionally by your resistance. I fervently wish that my freedom of action were not hampered, and, if that were the case, I would be all the happier to hasten my return.

I ask Papa to give me 200 francs a month; that will permit me to make a long stay at Aix and I shall be very glad to work in the Midi, which offers my painting so many

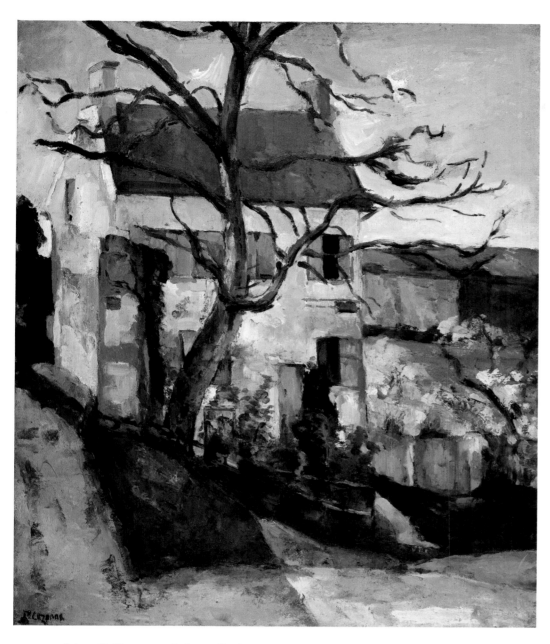

Camille Pissarro. *The Road of the Hermitage, Pontoise.*
1874

House and Tree near the Road of the Hermitage, Pontoise.
1873–74

opportunities. Believe me, I do really beg Papa to grant this request, and then I shall, I
think, be able to continue the studies I wish to undertake.

A feeling of confidence and optimism ran high among the Batignolles friends,
most of whom by now worked in the outskirts of Paris but saw each other from
time to time. They realized the necessity of sticking together and holding on, the
more so as it became obvious that in progressing in their work they gradually
abandoned the standards of the Salon. Among the dealers, only Paul Durand-
Ruel, whom Monet and Pissarro had met in London, supported their efforts. He
regularly purchased works from them as well as from Manet, Renoir, and Sisley,
to the extent that his fate became linked to theirs, especially when he had
difficulties disposing of their paintings. Since the public was not exactly rushing
to acquire their canvases and since their prices remained rather low, Durand-
Ruel probably feared that Cézanne's pictures would prove even less salable and
did not add any of them to his steadily expanding stock of unsold paintings.

But even though progress was very slow, Pissarro was hopeful. "We are
beginning to make ourselves a niche," he wrote to Duret. "We are contested by
some masters, but mustn't we expect these differences of view, when we have
succeeded as intruders in setting up our little banner in the midst of the fray?
Durand-Ruel is steadfast; we hope to advance without worrying about opinions."

As they were anxious to show the public the results of their studies, and as
they felt increasing confidence, the friends presently decided to hold a joint
exhibition of their work.

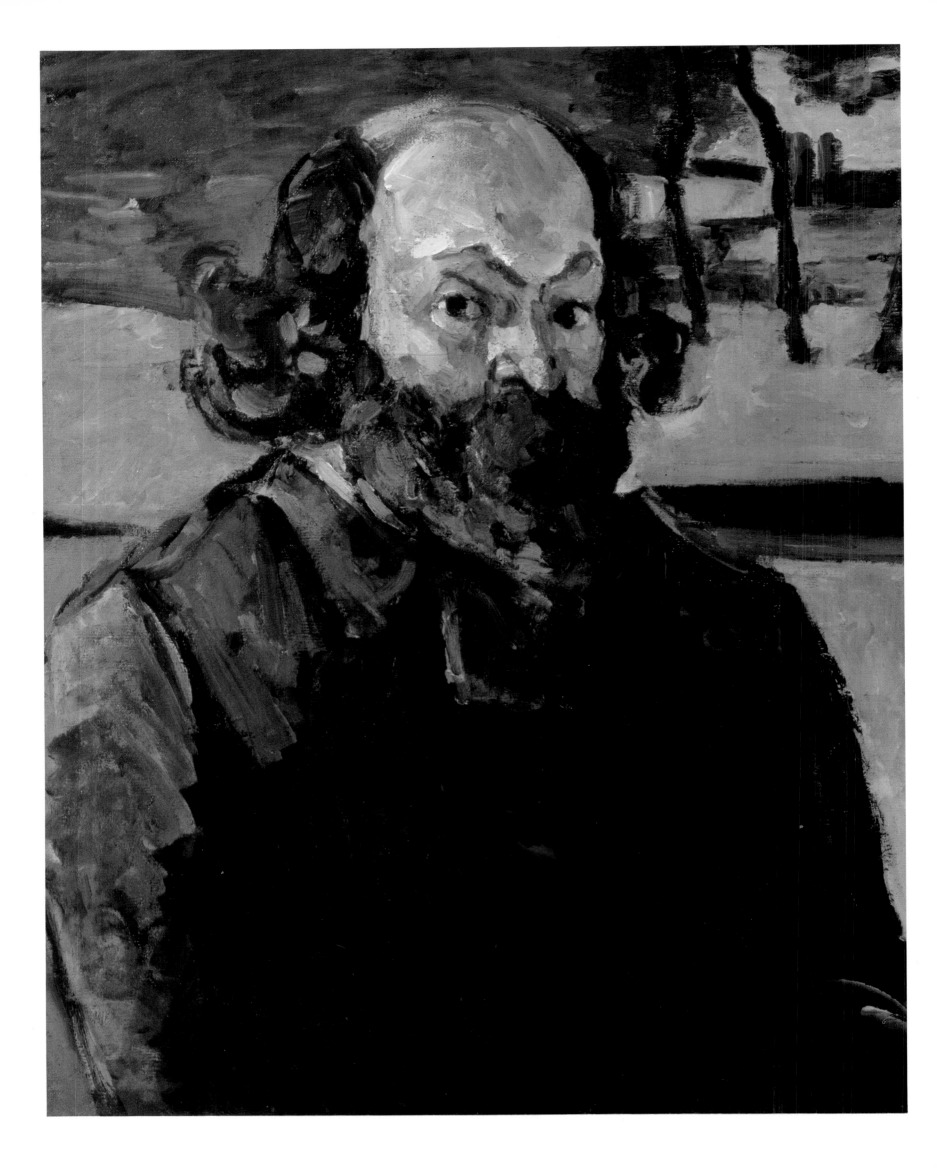

THE Société Anonyme des Artistes, Peintres, Sculpteurs, Graveurs opened its first exhibition on April 15, 1874. It lasted for one month and was located in the photographer Nadar's studios, Boulevard des Capucines. No longer willing to submit their works to a jury they considered incapable of appreciating them, the Batignolles group decided to ignore the Salon with its medals and official encouragements. At their own expense, risk, and peril, they now addressed themselves to the public, who was to judge them, criticize them, or support them. "This procedure is not without daring," the press admitted. "It bears witness to much good faith." Thirty artists are listed in the catalogue of the exhibition, among them Boudin, Cézanne, Degas, Guillaumin, Monet, Berthe Morisot, Pissarro, Renoir, and Sisley. Several artists objected to including Cézanne, fearing public opposition, but Pissarro (and possibly also Monet) insisted that he participate in their common showing.

Two of the most important members of the Batignolles group did not join their friends. One was Manet, who was now being accepted more or less regularly at the official Salon and who did not want to risk his chances of achieving success there. On the other hand, Zola failed to review the show, to draw the attention of the public to his friends' work, or to foster understanding of it. Certainly, understanding on the part of the public was conspicuously lacking, and the exhibition provoked the same reaction as Manet's painting at the Salon des Refusés. The public came to laugh. In *L'Oeuvre* Zola later transcribed the atmosphere of an art gallery resounding with the laughter of curiosity seekers:

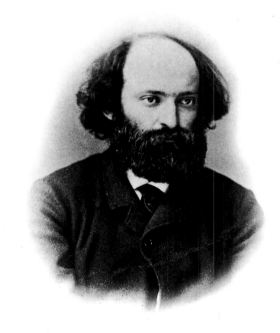

Photograph of Paul Cézanne. c. 1875

These laughs were no longer smothered by the handkerchiefs of the ladies, and the men distended their bellies the better to give vent to them. It was the contagious mirth of a crowd that had come for entertainment, was becoming excited by degrees, exploded apropos of nothing, and was enlivened as much by beautiful things as by execrable ones. . . . They nudged each other, they doubled up . . . every canvas had its appreciation, people called each other over to point out a good one, witty remarks were constantly being passed from mouth to mouth . . . the round and stupid mouth of the ignorant who criticize painting, expressing the sum total of asininity, of absurd commentary, of bad and stupid ridicule, that an original work can evoke from bourgeois imbecility.

"The conscience of the public was indignant," one critic stated. "This was awful, stupid, dirty; this painting had no common sense." Consequently the so-called serious critics refused to pay any attention to the show. If they mentioned it at all, it was by making fun of an honest effort. "Shall we speak of M. Cézanne?" the reviewer for *Le Rappel* asked. "Of all known juries, none ever imagined, even in a dream, the possibility of accepting any work by this painter, who used to present himself at the Salon carrying his canvases on his back like Jesus his cross. A too exclusive love for yellow has up to now compromised the future of M. Cézanne."

One of the paintings exhibited that aroused particularly the hilarity of the public and reviewers was Cézanne's *Modern Olympia*. A lady who signed her articles *Marc de Montifaud* commented: "On Sunday the public saw fit to sneer at a fantastic figure that is revealed under an opium sky to a drug addict. This apparition of a little pink and nude flesh, which is being pushed, in the

empyrean cloud, by a kind of demon or incubus, like a voluptuous vision, this corner of artificial paradise, has suffocated the most courageous, and M. Cézanne merely gives the impression of being a sort of madman who paints in delirium tremens."

If the critics did not express themselves as violently on the other exhibitors, it can hardly be said that they were flattering. A current joke was to repeat the remark a member of the jury had already made upon seeing Cèzanne's portrait of Valabrègue, to the effect that these painters proceeded by loading a pistol with several tubes of color and firing it at a canvas. All they had to do was sign the work.

Taking issue with a painting by Monet, entitled *Impression*, the critic for the widely read *Charivari* mockingly called the group of painters "Impressionists," a name that immediately caught on and was finally—almost in defiance—accepted by the artists themselves. However, the understanding and sympathy the painters had hoped for did not materialize. Though people thronged to their exhibition, they came only to poke fun. From Pontoise, in early May, Pissarro wrote Duret: "Our exhibition is going well. It is a success. The critics are devouring us and accuse us of not studying; I am returning to my studies—that is more worthwhile than reading. One learns nothing from them."

Once the exhibition closed, Cézanne suddenly left for Aix without even taking leave of his friend Pissarro. No sooner was he back in Aix and had started to paint again, than his former teacher, the painter Gibert, curator of the Aix museum, "impelled by a curiosity aroused by the Paris newspapers," asked to see his canvases. This is the report Cézanne gave Pissarro of the interview:

... To my assertion that on seeing my productions he would not have a very accurate idea of the progress of evil and that he ought to see the works of the great Parisian criminals, he replied: "I am well able to conceive of the dangers run by painting when I see your assaults." Whereupon he came over and when I told him, for instance, that you replaced modeling by the study of tones and was trying to explain this to him by reference to nature, he closed his eyes and turned his back. But he said he understood, and we parted well satisfied with each other. Yet he is a decent fellow who urged me to persevere, because patience is the mother of genius, etc.

When, in December 1874, Renoir assembled the "Parisian criminals" in his studio to settle the accounts of the exhibition, it turned out that each participant owed the group the amount of 184.50 francs and it was decided to dissolve the association. Cézanne, although by then back in Paris, did not attend the meeting. It is likely that he now had to turn to his father in order to raise the money he owed. The banker was obviously less than pleased with the whole venture, which had earned his son only ridicule and debts.

Yet, in spite of the resounding failure of the exhibition, Cézanne does not seem to have lost courage. He felt himself on the right track and had few illusions about the value of such attempts. In the autumn, back in Paris, he wrote a letter to his mother that reveals for the first time optimism and self-confidence:

Pissarro has not been in Paris for about a month and a half; he is in Brittany, but I know that he thinks well of me, who think well of myself. I begin to find myself superior to those around me, and you know that the good opinion I have of myself has only been reached after mature consideration. I must always work, but not to achieve a final polish, which is for the admiration of imbeciles. And this thing which is commonly so appreciated is only the accomplishment of artisan's skill and makes every work resulting from it inartistic and vulgar. I must strive after completion only for the pleasure of giving

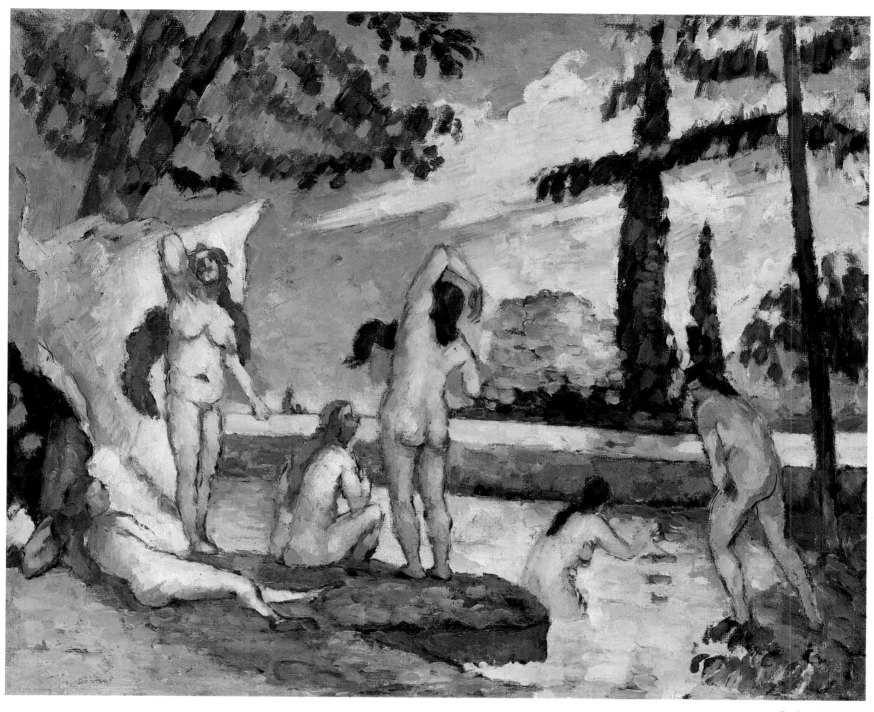

Bathers. 1874–75

Women Picking Fruit. 1876–77

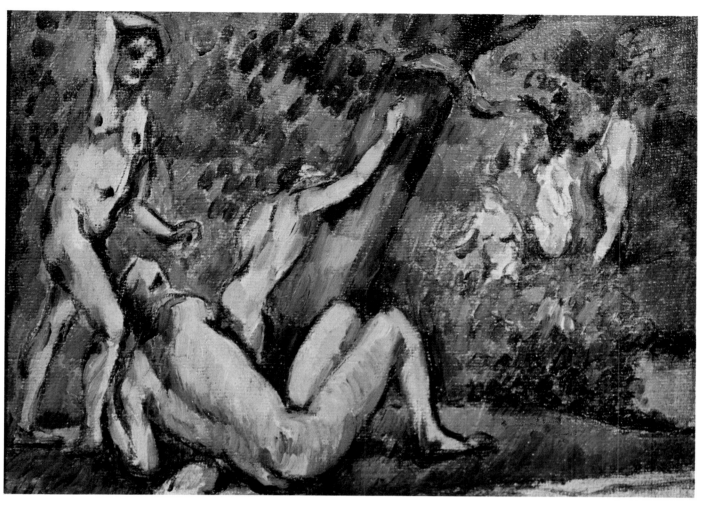

Bathers. 1875–77

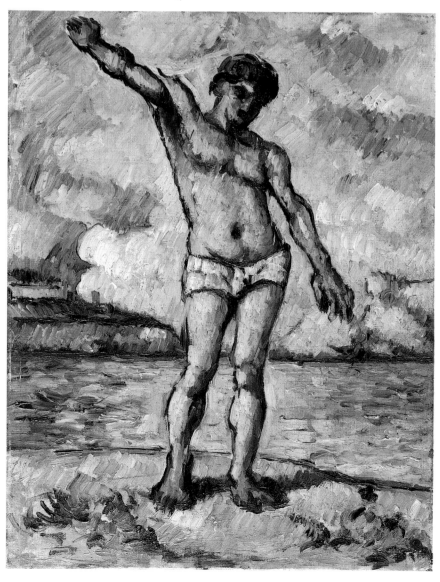

Bather with Arms Spread. 1877–78

added truth and learning. And believe me, there always comes a time when one arrives, and one has much more fervent and devoted admirers than those who are flattered by vain appearances.

This time is very bad for sales; all the bourgeois look sulky at parting with their sous. But that will end. . . .

Since it did not look as though Monet—for financial reasons—would be able to arrange a second Impressionist group exhibition for 1875 (as indeed he wasn't), Cézanne and Guillaumin, upon Pissarro's advice, joined a newly founded Union Artistique, a cooperative organized by a certain Alfred Meyer, who had been among the participants of the 1874 show.

Ten months after that show, Monet, Renoir, and Sisley, in desperate need of money, arranged for a sale to be held at the Hôtel Drouot. This auction brought them very little money and, despite a few favorable comments in the press, the jeers of the crowd predominated. The sale, however, resulted in acquainting the artists with an understanding collector, Victor Chocquet, who became especially interested in the work of Renoir. Chocquet commissioned Renoir to paint a portrait of Madame Chocquet, and Renoir soon took the collector to a modest paint dealer, *père* Tanguy, whom Pissarro had recommended to Cézanne and who had agreed to provide Cézanne with paints and canvases, taking some paintings in exchange. Tanguy was thus the first to handle Cézanne's work. Chocquet was immediately taken by the pictures Tanguy showed him and though he feared his wife's opposition, could not resist purchasing one. A little later, the collector met Cézanne through Renoir and a fast friendship soon united them.

A simple chief supervisor in the customs administration, Chocquet had the spirit of the true collector, preferring to make his discoveries for himself, taking as his guide only his own taste and pleasure, never thinking of speculation, and wholly uninterested in what others did or thought. Although his resources were limited, he had lovingly brought together through the years an extremely rich collection of works by Delacroix. Cézanne, who shared Chocquet's admiration for the master, liked to say: "Delacroix acted as intermediary between you and me," and it is reported that both men had tears in their eyes when, together, they looked at the Delacroix watercolors owned by Chocquet.

To his collection of Delacroix, Chocquet soon added works by the Impressionists. In the catalogue of the second exhibition of the group, held in 1876, he is listed as a lender of canvases by Renoir, Monet, and Pissarro. This second show was organized, like the first, one month before the opening of the Salon. It took place at the Durand-Ruel Galleries and presented more or less the same artists, with the exception of Cézanne, who was in Aix and who had again submitted to the Salon. The show once more received considerable commentary. Besides the numerous derogatory reviews, this time there were also a few that took sides with the painters. Duret defended them, and Degas's friend, the novelist Duranty, affirmed that the little group's contribution to art "consists in having recognized that bright light discolors tones, that the sun, reflected by objects, tends, through brightness, to give them this luminous unity, which welds its seven prismatic rays into a single colorless brightness, which is light."

There was also a strange though not hostile comment that appeared in a Salon review, in which one Mario Proth stated:

Something unusual is happening in the art world. It is moderately disturbed, it moves with some heaviness, but it does move. We only need refer to the eccentrics and the warped minds. . . . The exhibition of the Impressionists (or Impressionalists?) has risen one notch, it is true, in the public's appreciation. One has sincerely and deservedly

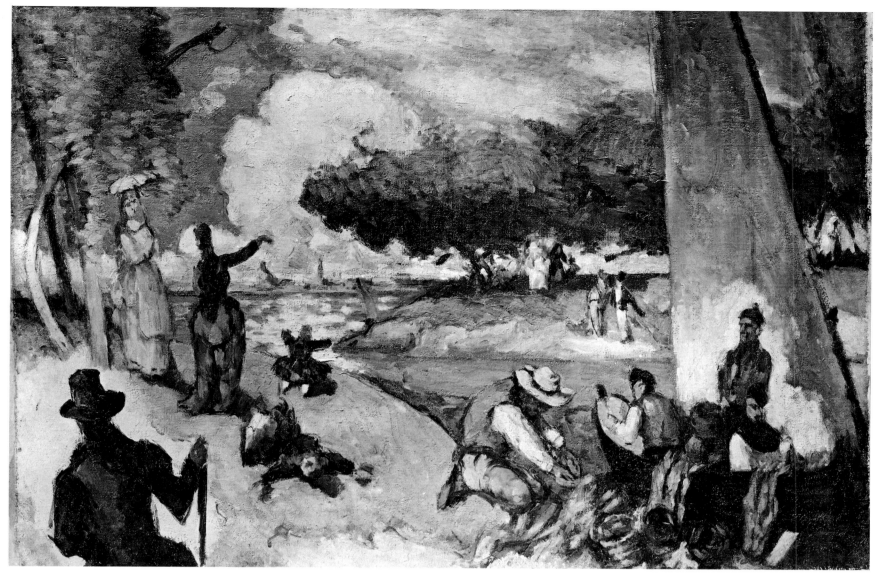

The Fishermen. c. 1875

applauded their courage; those interested in art went to visit them, the press examined their works. Among them were discovered, if not real talents, at least potentialities, promises of talent, something like green apples, very green ones, and which may possibly ripen if they don't carry the original worm and if the sun offers them life. Some of them have stopped us for an instant and have even astonished us. Might one already apply to them, with a slight variation, the charming word of Nodier concerning women: "When one astonishes the public, the public becomes interested, and once it becomes interested one isn't far from pleasing it". . . ?

Chocquet provided Cézanne in the South with press clippings concerning the second group exhibition, among which there was a particularly nasty one by Albert Wolff from *Le Figaro*, who called the painters madmen. Cézanne, who had once again been rejected by the Salon jury—a fact that did not surprise him, as he wrote to Pissarro—spent the summer of 1876 at L'Estaque where he painted a view of the bay for Chocquet. When he returned to Paris in the fall, he went to see Guillaumin who filled him in on all the news concerning their friends' second show, from which he had been absent. Cézanne then informed his parents:

I learned from Guillaumin that the exhibition organized by the painters of our group last April went very well. The rent of the premises where the show took place, Rue Le Peletier and Rue Laffitte (one enters through a door on the Rue Le Peletier and leaves by another, Rue Laffitte) amounted to 3,000 francs. Fifteen hundred francs only were paid in advance and the landlord [Paul Durand-Ruel] was to retain the other 1,500 francs from the entrance fees. Not only have the 3,000 francs been raised, but the 1,500 paid in advance by the artists in equal shares have been reimbursed to them, plus a dividend of three francs, which doesn't mean much, it is true. Still, it is a nice

beginning. And already the artists of the official exhibition, learning about this little success, have come to retain the hall, which, however, has already been reserved for next year by the participants of this year's exhibition. According to what Guillaumin told me, I am one of three new members who will take part [in the next show] and I was most warmly defended by Monet when, on the occasion of a dinner reunion that took place after the exhibition, a certain Lepic spoke out against my inclusion.

It is possible that Cézanne provided his parents—or rather his father—with all these financial details concerning an exhibition in which he had not even participated, in order to reassure the banker as to the solvency of the next enterprise, for which he obviously would have to request paternal help when it came to participate in the expenses. (Maybe Cézanne had even been *obliged* to abstain from the second group show because his father would not lend him the money for his shares?)

Meanwhile Monet—who had just sold a painting for the "sensational" price of 2,000 francs—was busy preparing a third group show, managing to do so with the support not only of Paul Durand-Ruel but also of a new friend, a painter and wealthy Argenteuil neighbor, Gustave Caillebotte. This completely changed Cézanne's interest in Alfred Meyer's Union Artistique. He wrote to Pissarro in a somewhat confused but extremely frank style:

If we were to exhibit with Monet, I should hope that the exhibition of our cooperative will be a flop. You will think me a blackguard, perhaps, but one's own affairs first. Meyer, who does not have the elements of success in his hands with the cooperative, seems to me to become a bloody stick who, by planning to open his show ahead of the Impressionists, tries to harm the latter. He may tire public opinion and create confusion. First of all, too many successive exhibitions seem bad to me; on the other hand, people who may think they will see Impressionists will see nothing but cooperatives.—Cooling off.—But Meyer must be very eager to damage Monet. . . . Since Monet is making money, why, as this exhibition is a success, should he fall into the trap of the other one? Once he is successful he is right. I say Monet—meaning the Impressionists.

Eventually Cézanne, Pissarro, and Guillaumin resigned from Meyer's cooperative to exhibit exclusively with Monet and his group. This time Duret and Duranty, who had spoken favorably of the second Impressionist show, were joined by a new critic and friend, Georges Rivière, introduced by Renoir. Through his zeal in the defense of the new painting, Rivière took the place left vacant since Zola had abandoned art criticism.

The exhibition of 1877 was held in April in an apartment rented by the artists in the Rue Le Peletier. According to Rivière, the hanging was in the charge of Renoir, Monet, Pissarro, and their friend Caillebotte, who gave Cézanne the most prominent position in the main room. Monet showed no fewer than thirty paintings, Cézanne seventeen, among them a *Portrait of Chocquet*. Georges Rivière, who issued a little paper for the duration of the exhibition, *L'Impressioniste*, stated in it that what distinguished the Impressionists from other painters was the treatment of a subject in terms of colors and not of the subject itself. He published several articles in strong praise of his friends and began with Cézanne:

The artist who has been the most attacked, the most mistreated by the press and the public for the past fifteen years, is M. Cézanne. There is no outrageous epithet that has not been attached to his name; his works have had a success in ridicule and continue to have it. A newspaper called the portrait of a man exhibited this year *Billoir en chocolat*. [This was Chocquet's portrait. Billoir was a famous murderer.] These laughs and outcries stem from a bad faith that they do not even attempt to dissimulate. They come to M. Cézanne's works in order to laugh their heads off. For my part, I do not know of any painting less laughable than this. . . .

M. Cézanne is, in his works, a Greek of the great period; his canvases have the calm and heroic serenity of the paintings and terra-cottas of antiquity, and the ignorant who laugh at the *Bathers*, for example, impress me like barbarians criticizing the Parthenon.

M. Cézanne is a painter, and a great painter. Those who have never held a brush or pencil claim that he does not know how to draw, and they have criticized him for imperfections that are actually a refinement obtained through tremendous knowledge. . . .

His beautiful still lifes, so exact in the relationship of tones, have a solemn quality of truth. In all his paintings the artist produces emotion because he himself experiences in the face of nature a violent emotion that his craftsmanship transmits to the canvas.

But Georges Rivière was still one of the few to recognize Cézanne's "knowledge and greatness." The public continued to be amused by his work, the chief object of ridicule being his portrait of Victor Chocquet. The collector, who spent all his time at the exhibition, was untiring in his efforts to convince the visitors of Cézanne's mastery. Duret later wrote:

He was worth seeing. He became a sort of apostle. One after another he took the visitors whom he knew or approached others to try and make them share his admirations and his pleasure. It was an ungrateful role. . . . He got nothing but smiles or mockery. M. Chocquet was not discouraged. I remember having seen him try thus to persuade well-known critics and hostile artists who had come simply to run the show down. This gave Chocquet a reputation, and whenever he appeared people liked to attack him on his favorite subject. He was always ready. He always had the right word when it was a question of his painter friends. He was particularly indefatigable on the subject of Cézanne, whom he placed on the very highest level. . . . Many were amused at Chocquet's enthusiasm, which they considered something like a gentle insanity. . . .

Cézanne painted several portraits of this friend and benefactor; the one he exhibited in 1877 attracted the crowd because of its strange and striking colors. It is a very clear and calm painting; the blue-green reflections in the hair, some blue touches in the beard, red and yellow tones of the skin, greenish parts around the beard and mouth—all this was disconcerting to the public. Despite Chocquet's patience in explaining to the laughing visitors that these were reflections cast by light upon objects, and that the everlasting pink of the skin shown in official portraits was done only to a blind convention, he did not succeed in convincing them. The portrait of Chocquet caused the critic of *Le Charivari* to advise his readers not to linger before Cézanne's painting if they were visiting the exhibition with a pregnant woman, as this might give the infant yellow fever before its birth. The critic for *Le Petit Parisien* summed up the reaction of the majority of the public with less cynicism when he stated that Cézanne's impression of nature was not the same as that of other people. On the whole, the reviewers were less severe, and this time even Zola published a short article on the show. He called Monet the outstanding personality among the exhibitors and, quite unexpectedly, went on: "Next I wish to name M. Paul Cézanne, who is certainly the greatest colorist of the group. There are, in the exhibition, some Provençal landscapes of his that have a splendid character. The canvases of this painter, so strong and so deeply felt, may cause the bourgeois to smile, but they nevertheless contain the makings of a great artist. . . ." Having thus at last found a few kind words for his old friend, Zola praised the works of Renoir, Berthe Morisot, Degas, Pissarro, Sisley, and Caillebotte, concluding: "The proof that the Impressionists constitute a movement is that the public, though laughing, throngs to their exhibition. One counts more than 500 visitors a day. That is success. . . . Not only will the expenses be covered, but there might even be a profit. . . ."

Simultaneously, the critic O'Squarre noted in *Le Courrier de France:* "The lion

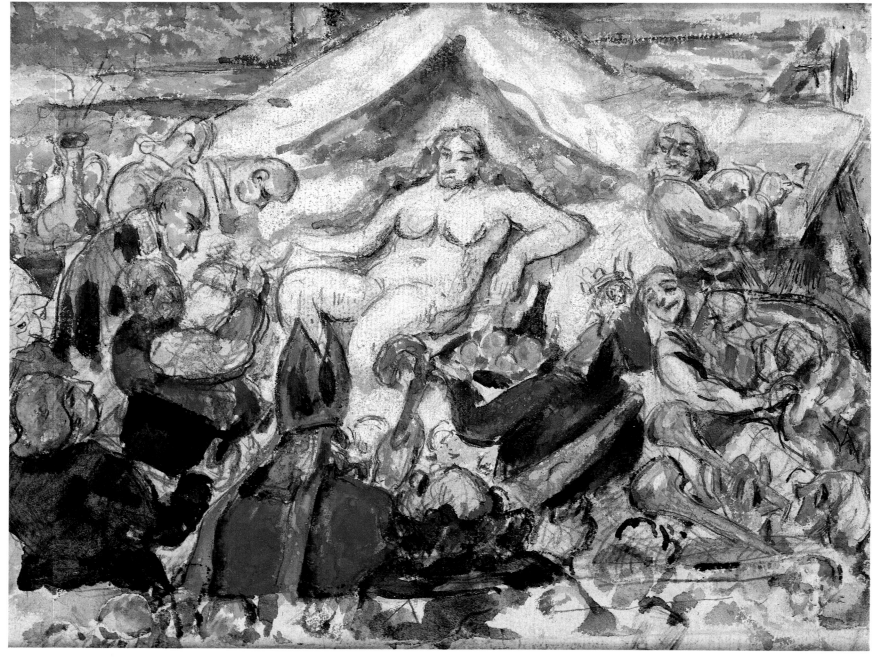

The Eternal Feminine, also known as *The Triumph of Women*. c. 1877

Cézanne seldom made detailed preparatory watercolors for
his oil paintings. The intricate composition of *The Eternal
Feminine*, a subject to which he must have devoted a great
deal of thought and which represents one of the many
facets of his attitude toward women, is an exception. In
this case his painting even followed very closely the
multiple elements and the vivid colors previously
established in this watercolor.

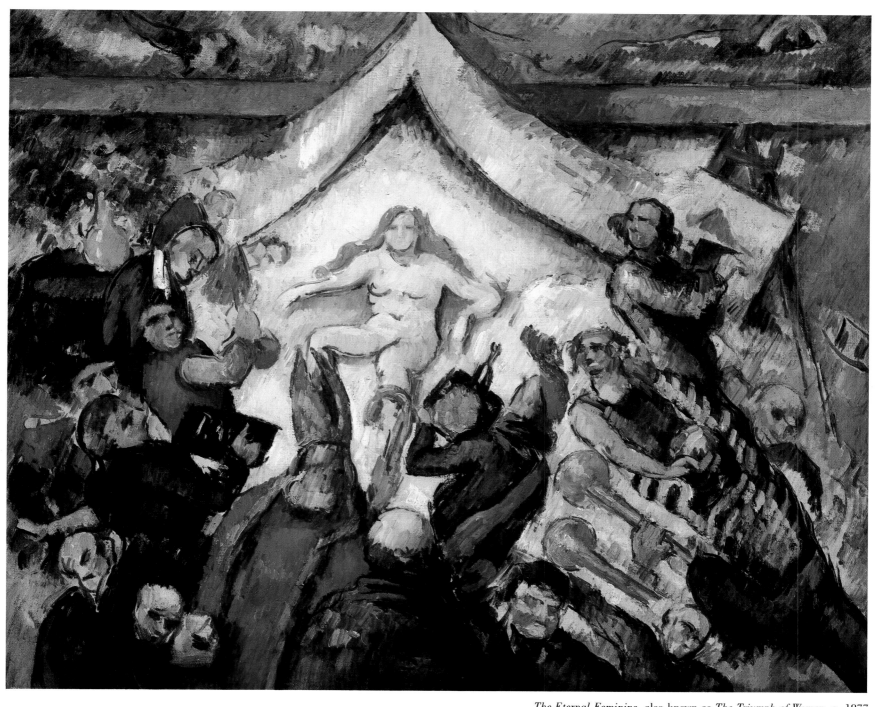

The Eternal Feminine, also known as *The Triumph of Women.* c. 1877

House of the Hanged Man, Auvers-sur-Oise.
c. 1873

of criticism has become gentler. The wild beast has drawn in its claws and one might think that the hostility which the Impressionists met at their debut was only the clumsy and somewhat savage expression of a profound stupefaction." However, the beast had by no means lost its claws, and Rivière remarked that "in France the fear of ridicule is so great that one mistrusts and laughs at everything original." Indeed, Paul Mantz, influential art critic of *Le Temps*, published the following thoughts on the Impressionists: "They have closed eyes, a heavy hand, and superb contempt for technique. There is no need to concern oneself with these chimerical minds who imagine that their casualness will be taken for grace and their impotence for candor. . . . No matter what they do, the prognosis for the future remains reassuring. One need not fear that ignorance will ever again become a virtue."

Even those who were beginning to be indulgent toward Renoir, Monet, or Berthe Morisot had no respect for Cézanne's work, and when Arsène Houssaye, editor of *L'Artiste*, asked Rivière for an article on Impressionism, he requested him not to mention either Pissarro or Cézanne, in order not to shock the readers of his magazine.

Apparently Cézanne was deeply disappointed by this new setback, for he decided to "work in silence" and not to exhibit with his friends again. This decision was partly due to his doubts, to his tendency never to be satisfied with results and always to attempt improvements, but it may also have been induced by his conviction that critics and public could not be entirely mistaken in their judgment. He accepted certain objections concerning his "lack of draftsmanship" and his "immoderate use of color," since he felt himself still far from the goal to be attained. He also feared that the noisy ridicule which greeted his paintings might damage the reputation as a serious artist that he coveted. For, if Cézanne thenceforth no longer exhibited with his friends, he continued each year to send a submission to the official Salon, although he always received a letter of rejection, which, as he wrote Pissarro, he found "neither new nor surprising." The opportunity to show his work to the public, offered to him by his friends in their exhibitions held annually from 1879 to 1882 and again in 1886, was thus repudiated by Cézanne; he still hoped to be accepted by the jury.

OPPOSITE:
Portrait of Victor Chocquet. 1876–77

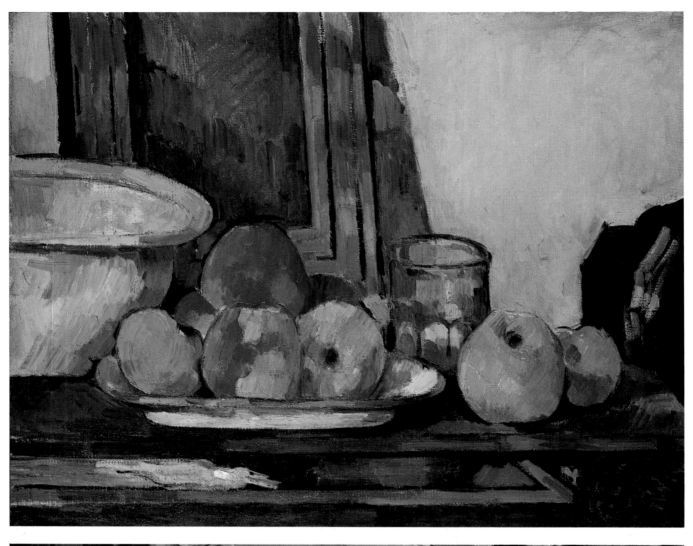

Still Life with Open Drawer. 1877–79

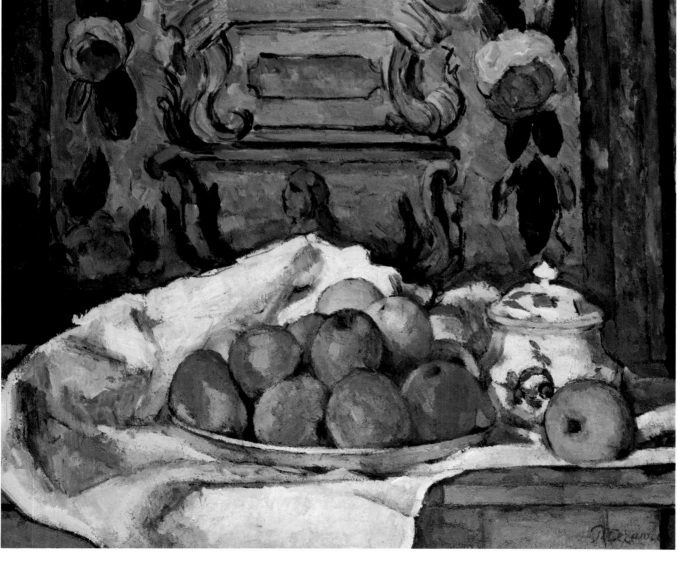

The Plate of Apples. 1878–79
(possibly earlier)

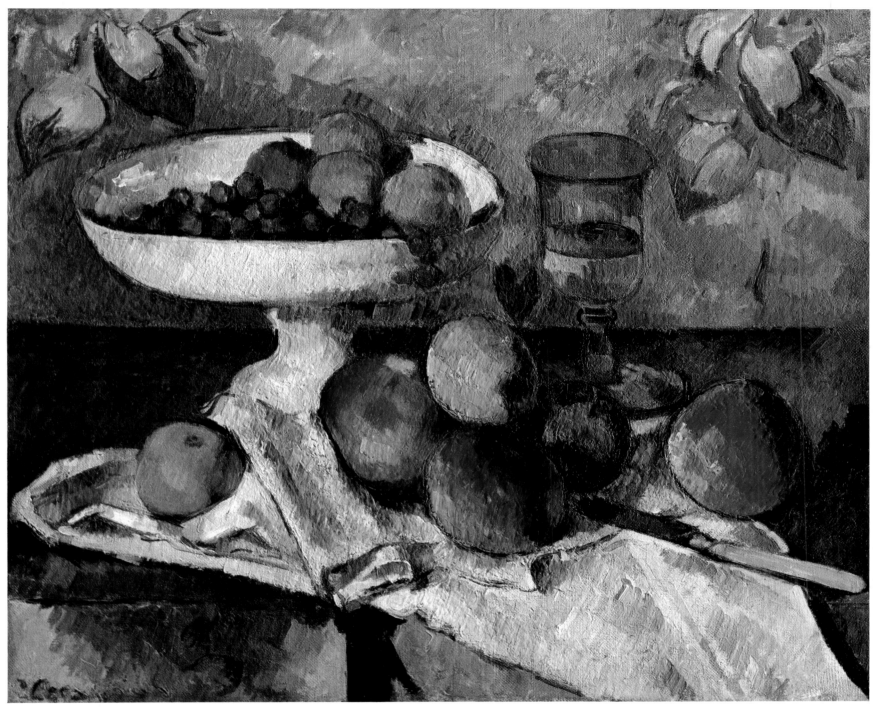

Still Life with Compotier. 1879–80

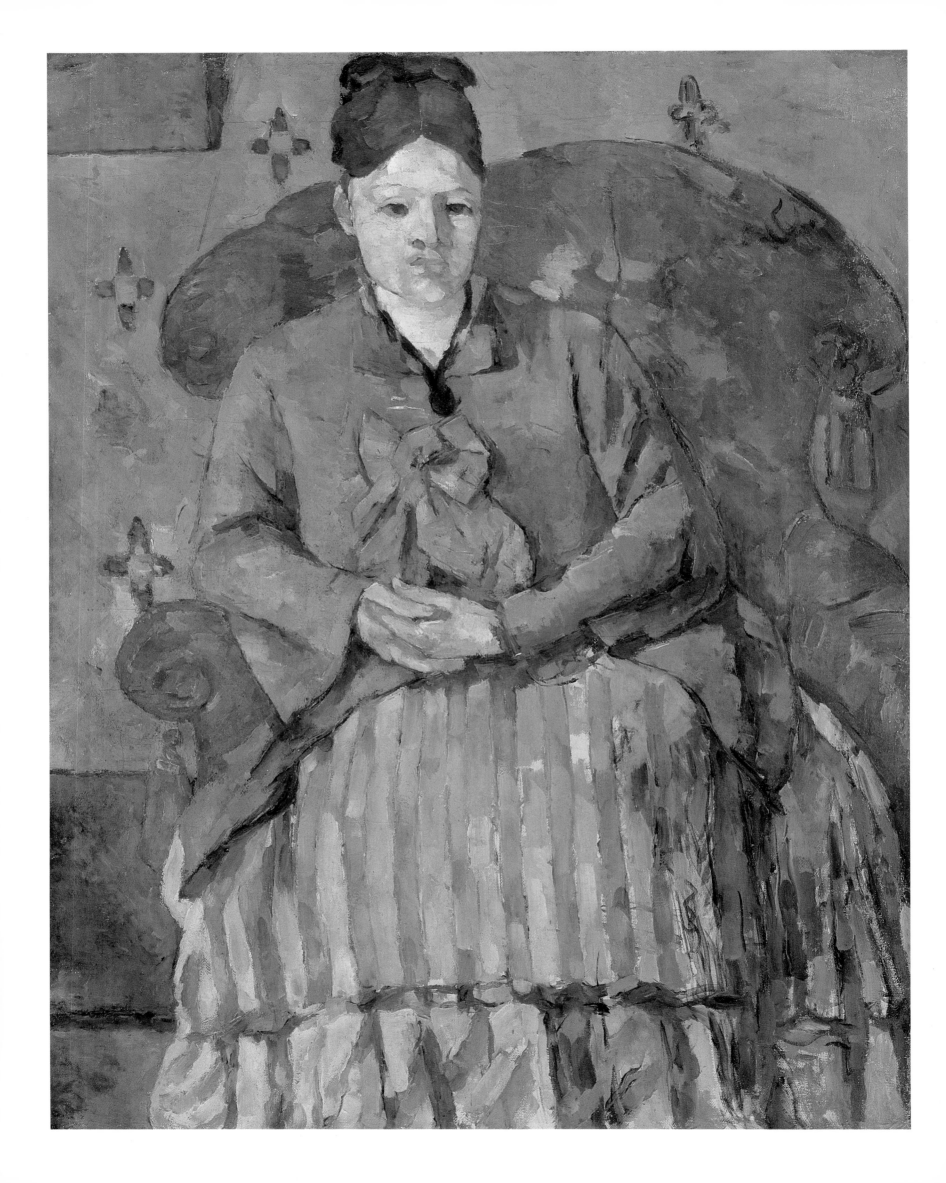

Cézanne and His Family

AFTER the closing of the Impressionist exhibition of 1877, Cézanne continued to paint in the outskirts of Paris. He worked with Pissarro in a vegetable garden at Pontoise; he stayed briefly in Auvers; he went to Chantilly, to Fontainebleau; he set up his easel on the banks of the Seine and the Marne. "If this is of interest to you," Duranty wrote Zola, "Cézanne appeared a short while ago at the little café on the Place Pigalle in one of his costumes of olden times: blue jacket, vest of white linen covered with the strokes of brushes and other instruments, battered old hat. He made quite an impression!"

Zola was spending the summer with his wife and eldery mother in L'Estaque, to relive a phase of his past and write his novel *Une Page d'Amour*. "The country is superb," he said in a letter to a friend. "You would perhaps find it arid and desolate, but I was brought up among these rocks and bare wastelands, which is why I am moved to tears when I see it. The mere odor of the pines evokes my whole youth."

Cézanne took advantage of Zola's stay in L'Estaque to ask him to give messages to his mother who, as usual, had rented a small house in the village. The painter did not want to write to his mother directly, knowing that his father opened all her letters, so he wrote to Zola:

I would like you to let my mother know that I do not want anything, as I expect to spend the winter in Marseilles. If in December she wishes to find me a very small two-room apartment in Marseilles, inexpensive, but in a district where not too many murders take place, I would be very pleased. She could have a bed put up in it and whatever else is needed for sleeping, and two chairs from her house in L'Estaque, in order to avoid unnecessary expense.

I go to the park of Issy here every day to make some studies. And I am not too dissatisfied, but it appears that profound desolation reigns in the Impressionist camp. Gold is not exactly flowing into their pockets and the pictures are rotting on the spot. We are living in very troubled times and I do not know when unhappy painting will regain a little of its luster. . . . With the exception of two or three painters, I see absolutely no one.

A few days later Cézanne wrote to Zola countermanding his message to his mother and saying that he expected to visit Aix in December or early January.

Cézanne went to live in L'Estaque at the beginning of 1878 in order to "savor the most perfect tranquility," but no sooner had he taken up residence there than the misunderstanding between his father and him became painfully manifest.

The banker had all the qualities and faults of the self-made man. Strong-willed and direct in pursuit of his aims, he was exasperated by the everlasting hesitations and the apathy of his son. As he was intelligent and observant, he knew Paul's faults, but on the other hand, his uncultivated and unimaginative mind was incapable of grasping his son's intellectual needs and artistic aspirations. Although he was very rich, Monsieur Cézanne gave Paul little money, rather from resentment than avarice, for he was appalled that a man of forty should be unable to earn his living. He continued to treat his son as a child and even opened his mail. Thus, one day he read a letter from Chocquet addressed to the painter, in which Chocquet mentioned "Madame Cézanne" and "little Paul." Embarrassed and against all evidence, the son denied his liaison

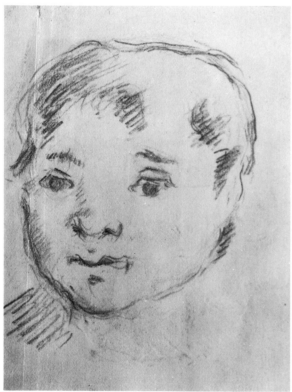

The Artist's Son. Both drawings c. 1878

and the existence of his child. This made his father so furious that he decided to reduce his allowance from two hundred francs to one hundred a month, on the ground that this was sufficient for a bachelor. Consequently, Cézanne's financial straits were such that he was obliged to write to Zola begging him to find him any sort of job so that he might support his family. Zola, who had just obtained his first great success with the novel *L'Assommoir*, persuaded his friend not to provoke a complete rupture with his father and generously offered financial help for as long as would be necessary. Cézanne accepted gladly, especially as his boy was ill and living with his mother in Marseilles, while Cézanne himself was with his parents in Aix. He asked that the money be sent directly to Hortense; he took every precaution against giving his father definite proof of his liaison, whereas the latter tried by any means to catch him.

"I stole away on Tuesday, a week ago," Cézanne wrote Zola on April 4, 1878, "to go to see the boy; he is better, and I had to return to Aix on foot as there was a mistake in the timetable, and I had to be back for dinner." Cézanne was an hour late to dinner, although Aix is about eighteen miles from Marseilles.

The situation was very difficult for Cézanne; it was aggravated by the fact that the owner of his Paris apartment forwarded mail to the Jas de Bouffan, where the banker promptly opened it. In this way Cézanne's father learned that his son had left the key to his apartment with a shoemaker who had let a few relatives stay there during the World's Fair of 1878. The banker concluded that his son was "hiding women in Paris." "It's beginning to resemble a vaudeville," wrote the painter bitterly to Zola.

Cézanne's father, who knew already from others that Paul had a child and who had every intention of "ridding" him of his dependents, now went so far as to have him followed. Thus one day, meeting the painter Villevieille, a friend of his son's, the banker said to him out of a clear sky:

"You know, I'm a grandfather!"

"What do you mean? Paul isn't married!"

"He was seen coming out of a shop with a rocking horse and other toys. You are not going to tell me that they were for himself."

"So much the better," was Villevieille's only reply. "It's about time you found out."

And according to a letter Numa Coste sent Zola, the father knew that "Paul has a brat. He said to somebody who questioned him: 'It seems that I have some grandchildren in Paris; I'll have to go and see them some day.'"

But the silent struggle between father and son went on.

In November 1878 Hortense had to go to Paris for several weeks and Cézanne stayed in L'Estaque with his child, fearing momentarily a visit from his father. He was so tired of all the quarrels that he was ready to renounce his rights to any future inheritance on condition that his father settle on him two or three thousand francs more per year. "My good family," he wrote to Zola, "which is very worthy, to be sure, is perhaps a bit tightfisted for an unfortunate painter, who has never been able to do anything; it is a light failing and doubtless easily excusable in the provinces." Toward the year's end, however, everything must have been straightened out. Cézanne was no longer obliged to accept money from Zola, having succeeded in obtaining an adequate allowance from his father, doubtless at his mother's behest.

Little is known of Madame Cézanne, and there are no letters of hers extant. Her son painted her seldom. She was probably just as shy as Paul, and this may have prevented her from posing. Yet, Cézanne did make one drawing of her at about this time, while she was asleep in her armchair. If he inherited certain morbid character traits from his mother, it was perhaps to her that he also owed

his genius. She was very intelligent, with a subtle and impulsive mind and a lively imagination. Dark and tall, with a big frame and a thin face, she resembled her son. Paul was her favorite child and, far from trying to dissuade him, she even encouraged his painting, full of confidence in her son's talent. Her husband showed a preference for their daughter Marie because of her calmness, which was in such contrast with Paul's turbulence.

Cézanne found in his mother a confidante and ally; they seemed always to have been in complete agreement of ideas and feelings. Not only had she secretly helped him out when he was short of money, but she apparently also knew about his liaison from the beginning. She visited her grandchild on the sly and loved him dearly, the more so because she was a grandmother for the first time. It was quite natural that she should have attempted to win over her husband, yet it is more likely that it was Marie who eventually obtained the banker's consent to his son's marriage.

The aging banker probably grew slowly weaker during his last years. He distributed at least part of his wealth among his children, although in those days inheritance taxes, as well as fiscal control, were practically nonexistent. It is not impossible that he merely wished to be relieved of some burdens. Be this as it may, it would scarcely seem that his children brought the old man much comfort and satisfaction. In 1881 his youngest daughter, Rose, had married Maxime Conil, a lawyer; her husband, while astute and alert, did not show any particular business acumen and proved a better spender than earner. His older daughter, Marie, turned into an increasingly devout spinster. It was with resignation and possibly bitterness that Louis-Auguste Cézanne began complaining: "Paul will be devoured by painting and Marie by the Jesuits."

Under these circumstances Marie may have brought about the final "reconciliation" of father and son. She obviously knew about the painter's liaison; disturbed by Paul's "irregular situation" as well as the illegitimacy of his child, and conceivably feeling that marriage—even with Hortense Fiquet, of whom she had a rather low opinion—would redeem her brother, she ceaselessly admonished him, "Marry her—why don't you marry her?"

To straighten out the uneasy relations between her probably agnostic father and sinning brother must have become a sacred errand for Marie, anxious to secure the salvation of their souls. Her pious zeal was to reap its reward when she obtained the father's—weary?—consent to Paul's marriage. How otherwise explain that the banker, aged eighty-seven, should have accepted the legalization of ties he had fought so strenuously for so many years, or that the son, certainly no longer in love with Hortense Fiquet, with whom, as the future was to reveal, he had no intention of living permanently, should have agreed to marry the mother of his by then fourteen-year-old boy? It is possible, however, that the painter was anxious to legitimize his son, whom he adored, and to put an end to the equivocal situation.

In any case, on April 28, 1886, Paul Cézanne and Hortense Fiquet were married at Aix in the presence of the painter's parents, who both signed the marriage register at the town hall. The witnesses to the religious ceremony that took place the following morning at the church of Saint-Jean-Baptiste were his sister Marie and Maxime Conil. A few months after this marriage, Cézanne's father died on October 23, 1886, at the age of eighty-eight. After his death the painter constantly expressed his admiration for him and said: "My father was a man of genius; he left me an income of 25,000 francs."

Four years before his marriage, Paul Cézanne had thought of making his will because, being of an anxious disposition, he thought himself destined to die young. But he made fun of his own fears, and wrote to Zola: "I am thin and can

ABOVE:
Certificate of the religious wedding of Paul Cézanne and Marie Hortense Fiquet in the Church of Saint-Jean-Baptiste of the parish of the Jas de Bouffan, on April 29, 1886. The witnesses were the artist's brother-in-law, Maxime Conil, and one Jean-Baptiste Galby; Cézanne's sister Marie also signed this document but his parents did not attend. The bride's domicile is given as Gardanne.

TOP:
Certificate of Cézanne's civil marriage at the town hall of Aix-en-Provence, signed April 28, 1886, by Paul Cézanne, Hortense Fiquet, and the artist's parents

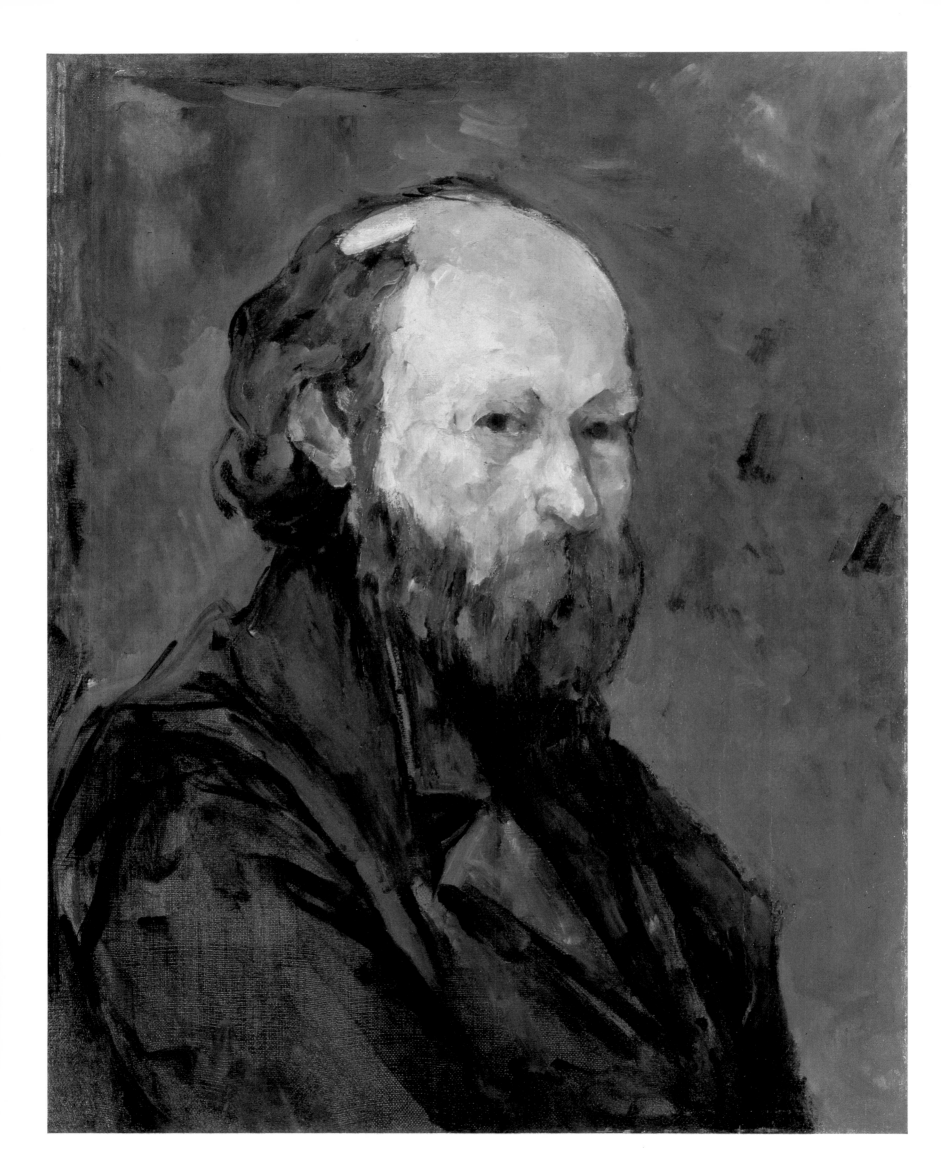

do nothing for you. As I shall be the first to go, I shall arrange with the All-Highest to reserve a good place for you."

In November 1882 Cézanne wrote to Zola asking his advice concerning his will. His father, who had retired from the bank after the war of 1870, had placed his fortune in the name of his children; feared by them for his authoritarian temper, Louis-Auguste Cézanne knew that he could trust them not to touch the fortune that, though legally theirs, he continued to administer. While not using this money, Paul Cézanne was entitled to bequeath it to whomever he wished, and he decided to leave half of it to his mother, and half to his son. He asked Zola to keep a copy of his will and sent it to him from L'Estaque in May 1883 after having consulted a lawyer in Marseilles. This will must have been revised after Cézanne's marriage.

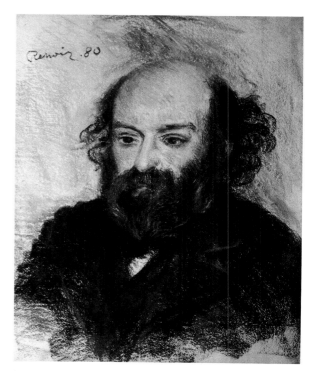

Auguste Renoir. *Portrait of Paul Cézanne*. 1880

Cézanne's marriage produced no change in his existence for, after his father's death, he continued to live with his mother and his sister Marie. His wife—using her delicate health as an excuse—spent most of her time in Paris with their son. She did not like the Midi although she loved to travel. Cézanne said of her: "My wife likes only Switzerland and lemonade." From time to time she visited Aix, but she and her husband did not get along very well. Cézanne's old mother tried to mediate in their quarrels, and though not extremely fond of her daughter-in-law, did her best to be agreeable. Hortense's only contribution to her husband's life as an artist was in posing for him repeatedly without moving or talking. Cézanne rarely painted any other woman, and it must have entailed considerable sacrifice on the part of his lively and talkative wife to lend herself to the endless sittings he inflicted on her. When she occasionally attempted to participate in the discussions on art that Cézanne had with his friends, her husband would say to her in a quiet, reproachful voice: "Hortense, be still, my dear, you are only talking nonsense."

A long letter from Alexis to Zola, written in Aix on February 13, 1891, gives a good picture of Cézanne's marital life. Alexis tells that by cutting her allowance in half, the painter succeeded in bringing his wife and son to Aix:

Yesterday evening, Thursday, at seven o'clock, Paul left us to meet them at the station . . . and the furniture, brought back from Paris for four hundred francs, is arriving too. Paul expects to settle the whole business in a place he rented on the Rue de la Monnaie, where he is going to pay them an allowance. . . .

Nevertheless, he himself does not intend to leave his mother and his older sister with whom he is living in the outskirts [doubtless the Jas de Bouffan] and where he feels very well, definitely preferring this life to that woman. Now, if—as he hopes—the Ball [the nickname of Hortense Fiquet] and the little one take root here, nothing will prevent him from spending six months in Paris every now and then. "Long live the bright sun and freedom!" he cries.

Besides, he has no financial troubles. Thanks to the author of his days whom he now venerates . . . he has enough to live. He has divided his income into twelve monthly shares, and each of them is subdivided into three: for the Ball, for the bullet, and for himself. Only the Ball, not very delicate as it seems, shows a constant tendency to infringe on his personal fraction. Today, braced by his mother and sister, who can't stand the lady in question, he feels strong enough to resist.[11]

Since the share of Hortense Cézanne and her son was about 16,000 francs a year, the painter had thus provided generously for his wife and could believe that he owed her nothing more. Although indifferent as a husband, he was a tender and indulgent father. Cézanne not only loved his son, but forgave him in advance for any pranks. "Whatever mischief you may get into," he told him, "I shall never forget that I am your father."

OPPOSITE:
Self-Portrait. 1878–80

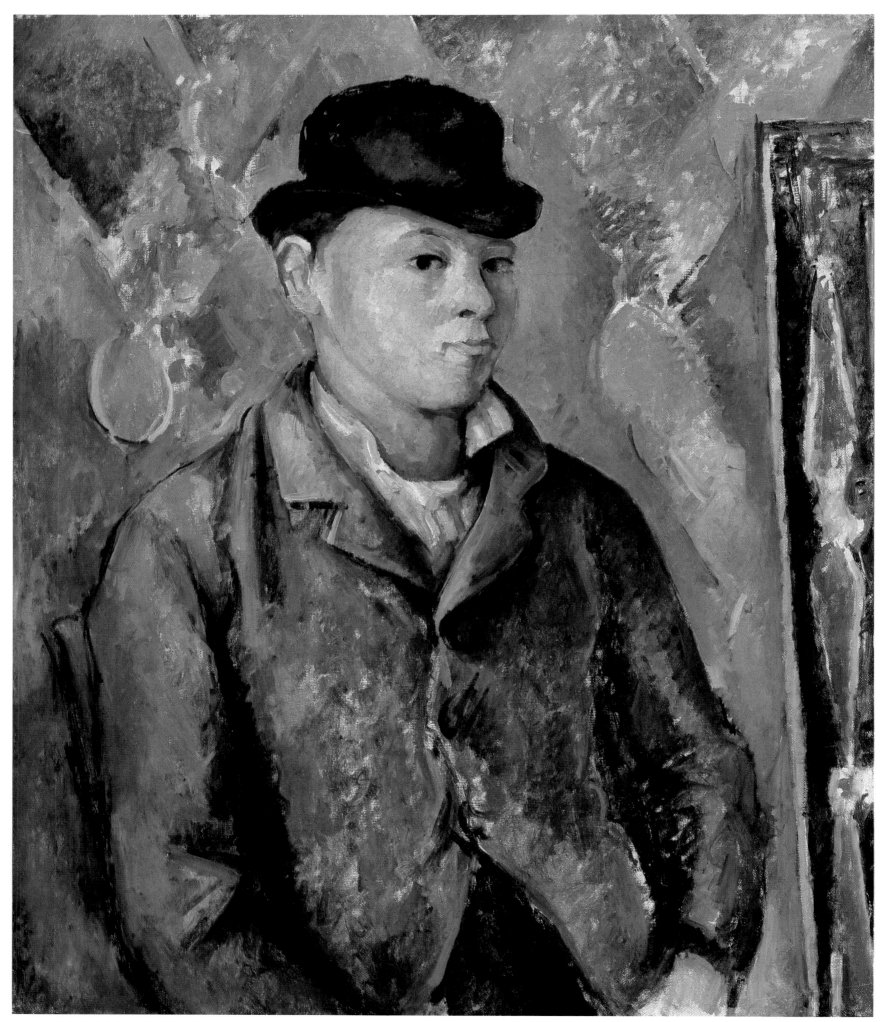

Portrait of the Artist's Son, Paul. 1888–90

The very qualities Cézanne had been unable to appreciate in his father, common sense, balance, and self-assurance, he now admired in his own son. "Life is fearful," was one of Cézanne's habitual remarks. Finding himself "weak," as he put it, in the face of the realities of life, he instinctively sought a prop. His mother and Zola fulfilled this function for many years. After the former's death in 1897, he leaned upon his son, who remained his adviser and confidant throughout his life, taking care of money matters and the sale of pictures. That Cézanne was well aware of his incapacity to direct his own life is revealed by a letter he wrote to Chocquet in 1886, the year of his marriage: "I should have wished to possess the intellectual equilibrium that characterizes you and permits you to achieve without fail the desired end. . . . Chance has not favored me with an equal self-assurance; it is the only regret I have about things of this earth."

Little by little, this lack of "intellectual equilibrium," his dread of life and doubtless also of death, as well as the influence of his mother and sister, made of Cézanne, who had been inveterately anticlerical, a churchgoing Catholic. "It is fear!" he explained to Paul Alexis in 1891. "I feel that I have only a few days left on earth—and then what? I believe I shall survive and do not want to risk roasting *in eternum*."

Cézanne went to Mass, which, however, he mockingly referred to as taking his "slice of the Middle Ages." He hated priests and was afraid of getting into their "clutches," and this aversion even extended to religion, which he called "moral hygiene." Sometimes he fell asleep during services, and one day, irritated by an organist who played off-key, he wrote to his son: "I think that to be a Catholic one must be devoid of all sense of justice, but have a good eye for one's interests." Nor did Cézanne's faith prevent him from speaking ill of priests, whom he often called filthy; it also failed to eliminate his swearing. Curses were for him a way of relieving his rages, and when he had trouble with his painting he would sometimes sing to a tune of the vespers: "Nom de Dieu de nom de Dieu de nom de Dieu. . . ."

But in spite of all his sallies and jeers, it seems certain that Cézanne did find in religion the support he sought. "Once we have attained a certain age," he was to write his young niece, "we find no other support and consolation than in religion."

Cézanne's assiduity at Mass has been attributed to the influence of his sister Marie, as well as to his desire not to offend his neighbors in Aix. Yet it is a fact that the painter attended religious services regularly, even when away from his hometown. Provincial environment and family beliefs thus eventually shaped a part of Cézanne's individuality, confining it within the limits of its rigid customs and prejudices, while his artistic individuality continued to develop and broaden his whole life long.

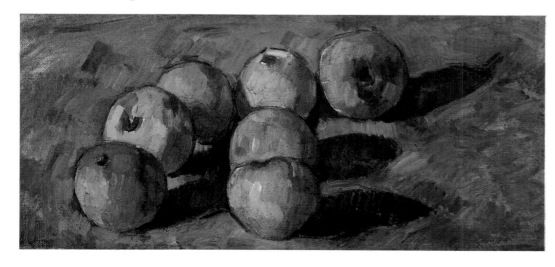

Seven Apples. 1877–78

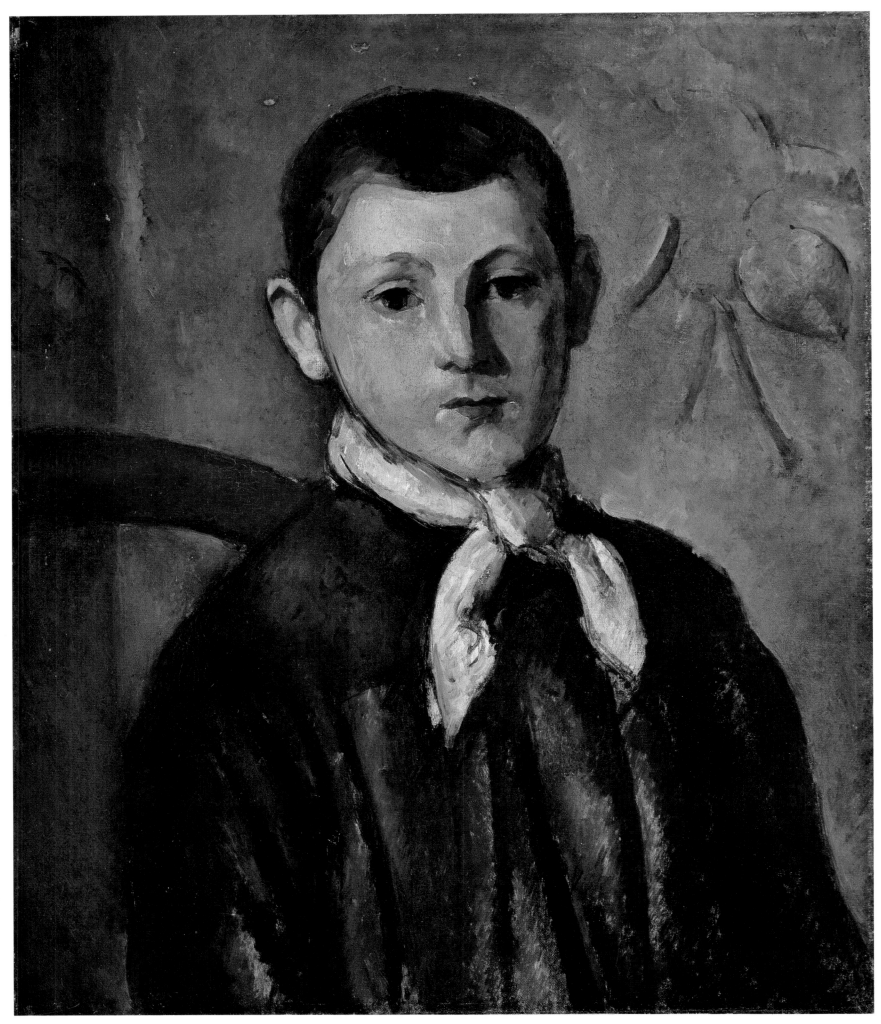

Portrait of Louis Guillaume. 1879–80

Cézanne at Zola's in Médan

THE SUCCESS of *L'Assommoir* in 1878 made it possible for Zola to buy a summer house, surrounded by a garden on the Seine, at Médan, near Paris. There he worked, saw his friends, and lived in the open air. Cézanne was delighted to hear the news. "I congratulate you on your purchase," he immediately wrote Zola, "and with your consent I shall take advantage of it to get to know the country better. If life is not impossible for me either at La Roche-Guyon or at Bennecourt, or a little here and a little there, I shall try and spend a year or two there, as I did at Auvers."

Cézanne did not carry out this plan, but he often spent weeks in the outskirts of Paris and paid numerous visits to Zola at Médan. Zola soon enlarged his property and added new buildings, which made it possible for him to entertain his guests more comfortably. He enjoyed gathering his friends around him, and there was always room for a new arrival. Cézanne, Numa Coste, Antoine Guillemet, and all the other comrades were always welcome for a night, a couple of days, or as long as they chose.

At the end of September 1879 Cézanne was expected at Médan. He accepted the invitation with all the more joy since, as he put it, at that season "the country is really astonishing. There seems to be greater silence. These are feelings I cannot express; it is better to experience them."

The following year, before going to Médan for a week, Cézanne wrote Zola from Paris: "The moment I will not be in your way, please write to me and I shall be very happy to go to Médan. And if you are not alarmed at the length of time that I risk taking, I shall make so bold as to bring a small canvas with me and paint a motif, always providing that you see no objection."

While at Médan, Cézanne worked on the banks of the Seine or on a little green island belonging to Zola, only a stone's throw from his house. Cézanne made use of Zola's boat, called *Nana*, and from this island painted a view of Médan dominated by the château with its dormer windows.

Paul Gauguin, who owned this painting, possibly acquired at *père* Tanguy's, had a story to tell about it, a story he may have heard from Pissarro or from Cézanne himself:

Cézanne paints a glittering landscape with an ultramarine background, and heavy greens and ochers of silken luster; the trees are in a straight line, and through the entwining branches may be seen the house of his friend Zola [it is actually the château of Médan; Zola's house was off to the right] with its vermilion shutters made orange by the chromes that sparkle on the limewash of the walls. Crackling Veronese greens indicate the superb foliage of the garden, and the grave contrasting note of the violaceous nettles in the foreground orchestrates the simple poem.

The pretentious and shocked passerby looks at what he thinks is a lamentable daub by an amateur and, a smiling teacher, says to Cézanne: "You are painting."

"Certainly, but so little. . . ."

"Oh! I can see that. Here, I am a former pupil of Corot, and if you will allow me, with a few deft touches I will straighten all this out for you. Values, values—that is all that counts."

And the vandal impudently puts some stupid strokes on the glittering canvas. Dirty grays cover the Oriental silks.

The Oise Valley. c. 1880

Cézanne exclaims: "Monsieur, you are fortunate and when you paint a portrait you probably put highlights on the tip of the nose, as on the rung of a chair."

Cézanne takes up his palette and scratches out with his knife all the mess made by the gentleman.

After a silence he lets out a terrific fart and turning to the gentleman he says: "What a relief."

Gauguin has, of course, to take responsibility for this episode, yet all those who knew Cézanne were agreed that he could upon occasion be extremely vulgar. There are even reports that he behaved thus with Zola's guests, but the repeated invitations Zola extended to him seem to negate this. Cézanne's vulgarity, as Zola remarked, was a mask for his lack of ease and his timidity. More often, however, when he was troubled, the painter reacted with outbursts of rage and sudden flights. For example, one day when he was painting a portrait of Madame Zola, whom he had asked to pose in the garden, standing beside a table and serving tea, Antoine Guillemet interrupted him; whereupon Cézanne broke his brushes, tore holes in the canvas, and left in one of his usual rages.

"No news of Paul," Zola subsequently wrote to Guillemet. "He must have run like a hare." But this kind of incident never prevented Cézanne from starting another canvas, nor did this one stop him from returning to Médan to shake Zola's hand, to chat with him, and to inquire whether he shared his opinion about "painting as a medium for the expression of sensations."

Cézanne spent the spring of 1881 in Pontoise where he often saw Pissarro, as well as the landscape painter Vignon and Paul Gauguin, who, accompanied by his wife, had come to spend his vacation with Pissarro. The latter was then advising Gauguin in his first attempts at painting. They had long discussions together about theoretical and practical questions, and after Gauguin had returned to his banking business in Paris, he asked of Pissarro: "Has Monsieur Cézanne found the exact *formula* for a work acceptable to everyone? If he discovers the prescription for compressing the intense expression of all his sensations into a single and unique procedure, try to make him talk in his sleep by giving him one of those mysterious homeopathic drugs and come immediately to Paris to share it with us."

The Seine at Bercy, Copy after Guillaumin. 1876–78

Armand Guillaumin. *The Seine at Bercy.* 1873–75

Village behind Trees, Ile de France. c. 1879

It must have been this innocent remark, doubtless quoted by Pissarro, which made Cézanne suspicious of Gauguin. He later went so far as to accuse Gauguin of wanting to steal his "little sensation."—"Never mention Gauguin to Cézanne!" Monet used to warn. "I can still hear him shout with his southern accent: 'That Gauguin, I'll wring his neck!' "

It was during his stay at Pontoise that Cézanne received an invitation from Zola, which he again accepted eagerly. Yet it is difficult to imagine Cézanne in Zola's house, always full of visitors and cluttered with tasteless bric-à-brac that surprised even the novelist's most fervent admirers. Indeed, Zola lived in pretentious and sumptuous surroundings. The enormous rooms were hung with antique tapestries and received a checkered light through stained-glass windows. In this setting Zola entertained Cézanne, who was accustomed to studios without luxury and to a life of extreme simplicity. If Cézanne was able to stand at Zola's an environment that certainly could not have pleased him, this proves that he was much less eccentric than generally supposed and that his simplicity was not naiveté.

Nowhere was Cézanne welcomed with so much affection than in Médan, and this hospitable atmosphere put him at ease. In Zola's house he was not the painter ridiculed by the critics, but a friend of the master, and his canvases, of which the novelist owned about a dozen, were hung in the hall. Others decorated Zola's Paris home, along with works by Manet, Monet, and Pissarro. Zola was

Armand Guillaumin. *Village behind Trees, Ile de France.* c. 1879

indifferent to the opinion of those among his guests who could barely conceal their astonishment at finding in his house such paintings "without great originality, without real value," as one of them remarked.

It is true that Cézanne fled from the company of anyone who disturbed his work, evaded those who wanted to get him "in their clutches," was irritated and troubled by people who talked too much, but in this he reacted like any creative person who needs solitude to find himself, and who fears society because he feels misunderstood. Yet it took very little to put Cézanne at his ease. What made him difficult to get along with was a special attitude produced by a mixture of mistrust and confidence; with his old friends, however, who knew how to handle him, the painter even enjoyed being sociable.

What Cézanne found at Médan was a "moral support" he deeply appreciated. It was not only the novelist who made his visits agreeable; in Zola's house Cézanne met his "compatriot," as he called Paul Alexis, as well as Numa Coste and such writers and critics as Théodore Duret and J.-K. Huysmans. He was grateful to Zola for introducing him to "these very remarkable people."

When Zola had guests for whom Cézanne did not care, Cézanne was always free to go off and paint the many admirable motifs in the surroundings. On one occasion, in the fall of 1882, Cézanne spent no less than five weeks at Zola's.

Thus Cézanne was unquestionably happy in Médan. He found there, if not the esteem to which he was entitled as painter, at least a sincere affection from the bottom of Zola's heart for the oldest and best friend of his youth.

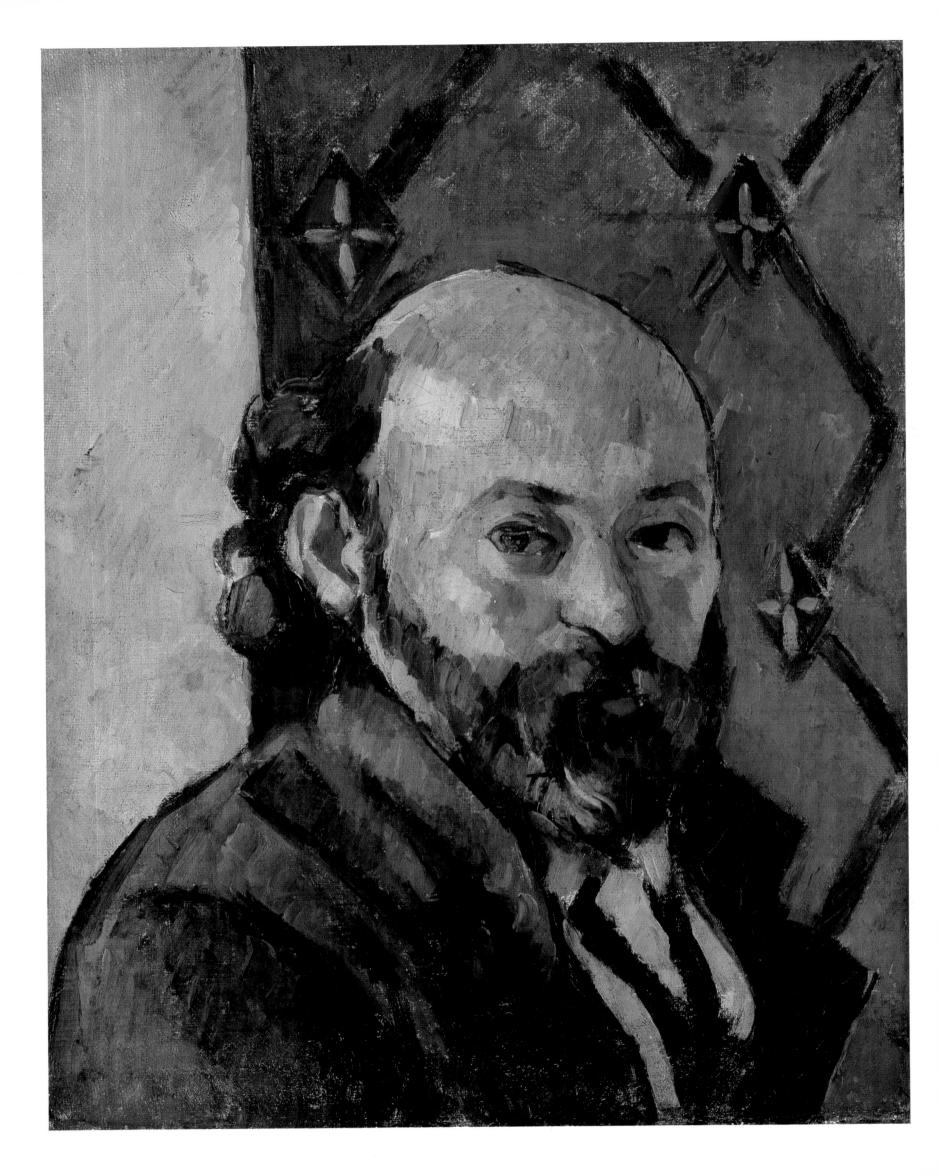

AT THE Salon of 1880 the paintings were arranged in a new way. They were no longer hung in alphabetical order but were divided into separate categories: the artists *hors concours*, that is, exempt from being passed by the jury, those not exempt, and, lastly, foreign exhibitors. The drawbacks of this system were soon apparent. For one thing, the large space reserved for artists *hors concours* emphasized the banality of their works; for another, the visitors could not find the canvases they were looking for. "Where the devil have they hidden your paintings?" asked Zola of Numa Coste, who continued to paint as an amateur and send to the Salon. "I spent two hours in the Palais de l'Industrie without being able to find them."

Discouraged by the failure of their successive group exhibitions, Monet and Renoir had decided that year to submit again to the Salon jury. Their works were hung so badly that they addressed a letter of protest to the Minister. They begged Cézanne to forward their letter to Zola. "This is what I am requested to ask you to do," Cézanne commented. "It is to publish this letter in *Le Voltaire*, preceded or followed by a few words on the previous activity of the group. These few words should aim at showing up the importance of the Impressionists and the real interest they aroused."

Ready to oblige, Zola wrote a series of four long articles on *Le Naturalisme au Salon* in which he referred to the demand of his friends and dwelled at length on Impressionism. In these articles he mentioned Cézanne's name for the first time in years.

Although the tone of his articles is friendly, they reveal some of the ideas that were beginning to separate Zola from his painter friends. Zola wondered whether they had acted wisely in ceasing to exhibit their work at the official Salon only to return there as Monet and Renoir were now doing. Manet, who had continued to exhibit at the Salon, had finally been accepted by the public, whereas the others had lost ground through their private exhibitions.

"Of course," Zola wrote, "there was a great uproar. The Impressionist exhibitions were the talk of the town; they were lampooned, they were laughed at and insulted, but visitors came in droves. Unfortunately that was only noise, the noise of Paris, which is gone with the wind." Yet, as Zola stated, while the Impressionists were being ridiculed, the new art that they proclaimed crept in at the Salon. Their efforts had not been in vain, for there was a slow evolution toward modern subjects and bright painting. "They shoot us," Degas remarked bitterly, "but they pick our pockets."

"It is," wrote Zola, "a rising tide of irresistible modernism that is gradually carrying away the Ecole des Beaux-Arts, the Institute, all the precepts and conventions.... It is Impressionism corrected, tempered, put within range of the masses...."

In view of this unexpected result, Zola asked himself whether his friends' abstention from the official exhibitions had not left the road to success open to unscrupulous imitators. Zola thought their group shows too easy and too dangerous a means of trying to gain recognition and that the greatest courage lay in "staying in the breach, no matter what the circumstances." He was convinced

Young Girl with Unbound Hair. 1873–74

Though very few oil studies of details for Cézanne's
numerous compositions of bathers exist, this charming
small sketch, for which Hortense Fiquet may well have
posed, appears somewhat related to the seated nude figures
that appear at the right of the two groups of bathers
reproduced on pages 137 and 138.

that "it is enough to paint great pictures; even if they are rejected for ten years, badly hung for another ten years, they always end by gaining the recognition they deserve. So much the worse for the weak who fall to the ground, crushed by the strong!..."

But in spite of his objections to their private exhibitions, Zola wanted to help the Impressionists and to put an end to the gossip circulating about them: "They are called practical jokers, charlatans who mock the public and make a lot of noise about their work, whereas on the contrary, they are serious and sincere observers. People seem to ignore that most of these fighters are poor, working themselves to death, struggling with misery and fatigue. Strange practical jokers, these martyrs to their beliefs!"

However, Zola could not hide from himself the fact that these martyrs had not yet produced the great works for which he had so long been waiting. Convinced that Impressionism or, as he preferred to call it, Naturalism, was the art of the future, he asked himself why his friends had not obtained the success they deserved. Since his own work, since Naturalism in literature, was beginning to be accepted, it could not be either Naturalism itself or the public that prevented the victory of their common cause. Therefore Zola ended by blaming his friends for not having lived up to their promise, for not having created what they owed to their era. And he concluded:

The real misfortune is that no artist of this group has achieved powerfully and definitely the new formula that, scattered through their works, they all offer. The formula is there, endlessly diffused; but in no place, among any of them, is it to be found applied by a master. They are all forerunners. The man of genius has not arisen. We can see what they intend and find them right, but we seek in vain the masterpiece that is to lay down the formula and make heads bow before it. This is why the battle of the Impressionists has not yet ended; they remain inferior to what they undertake; they stammer without being able to find the word.

Thus Zola was disappointed in his hope, which he had expressed so proudly fourteen years earlier, in the preface of *Mes Haines:* "The hour is palpitating, full of anxiety: One awaits those who will strike hardest and most accurately, whose fists will be powerful enough to close the others' mouths, and at the bottom of each new fighter's heart may be found a vague hope of being this dictator, this tyrant of tomorrow.... Let the blind repudiate our efforts, let them see in our struggles the convulsions of agony, though these struggles are the first stammerings of birth...."

These stammerings still had not become words, it seemed to Zola, and he resigned himself to the fact. Since the Impressionists "showed themselves incomplete, illogical, exaggerated, impotent," they would have to remain merely the avant-garde of a cause that, sooner or later, was destined to conquer, instead of being themselves the leaders of an irresistible movement.

The impression made by these articles upon Zola's friends is summed up in a letter from Manet to Théodore Duret. Although Manet was not immediately concerned, he severely criticized Zola's articles; but in a second letter, he asked Duret to destroy the first one, explaining: "...It seems that I am in the wrong, but I had not judged Zola's article from a personal standpoint and I thought it contained too much eclecticism. We have so much need of being defended that a little radicalism would have done no harm, it seems to me...."

Cézanne, however, did not look at the matter in the same way. On two occasions he thanked Zola on behalf of himself and his colleagues. His attitude may be explained by the fact that he did not believe he had much in common

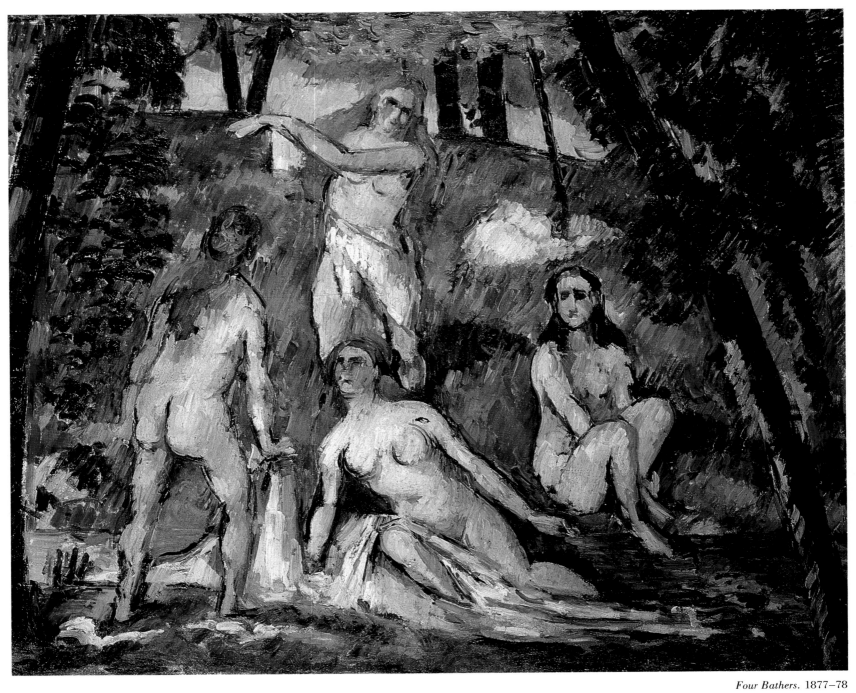

Four Bathers. 1877–78

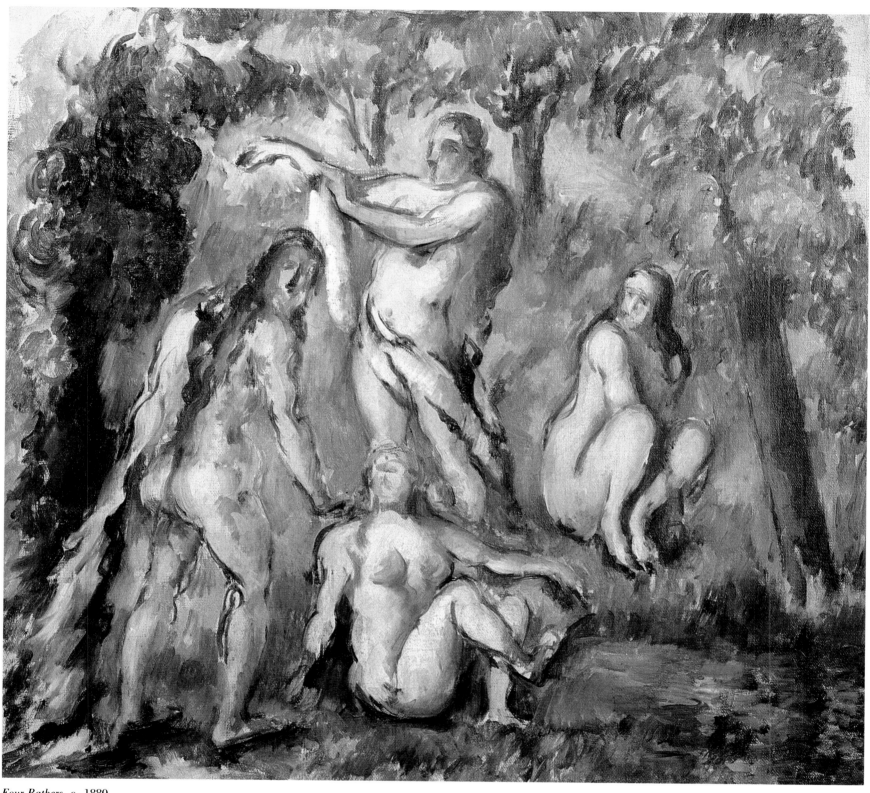

Four Bathers. c. 1880

with the Impressionists, and he shared Zola's opinion of them. This opinion he echoed later in speaking of "the Impressionist gang, which lacks a leader and ideas." As for Zola's remark concerning himself, here again he agreed with his friend. "M. Paul Cézanne," Zola had written, "has the temperament of a great painter who still struggles with problems of technique, and remains closest to Courbet and Delacroix." Actually Cézanne always did maintain that he was still seeking, that nature presented the greatest difficulties, and that he was far from being satisfied with his results.

But Cézanne was the only one of Zola's painter friends to approve of his ideas. Though they were surprised and worried by Zola's defection, the Impressionists nevertheless continued to approach him when they needed a spokesman. In forwarding to Zola the requests of his comrades, Cézanne felt he ought to explain his situation and wrote in one instance: ". . . I shall not add that whatever answer you consider proper to give to this request must have no influence on your friendly feelings for me, nor on the good relations that you have been kind enough to preserve between us. For I am liable more than once to have to make requests that could annoy you. I merely act as an intermediary and nothing more."

Cézanne no longer was very close to the Impressionists at this period. His decision not to show with them anymore, his frequent absences from Paris, and his lack of interest in the meetings at the Café de la Nouvelle-Athènes separated him from his comrades. "Fearful of seeing new faces," as Monet described him, Cézanne avoided those gatherings, where, to talk with a few friends, he had to put up with other people who were indifferent to him. He accompanied Zola only once to the salon of Madame Charpentier, who entertained the élite of the literary and political worlds. He rarely went to the house of Nina de Villard where he had met Léon Dierx, Frank Lamy, de Marrast, Ernest d'Hervilly, Villiers de l'Isle-Adam, and others. He visited the Café de la Nouvelle-Athènes, where he could see Zola, Alexis, and Manet, so seldom that most of the younger habitués knew of him only by hearsay. When he appeared there, he did so in his picturesque working clothes, which created quite a sensation and which led Duranty to comment: "Those are dangerous demonstrations."

This flouting of conventions was indeed "dangerous" in the sense that it encouraged all sorts of rumors which began to circulate concerning the painter. For instance, George Moore, who frequented the café in 1879, wrote in his *Reminiscences:*

I do not remember ever to have seen Cézanne at the Nouvelle-Athènes; he was too rough, too savage a creature, and appeared in Paris only rarely. We used to hear about him—he used to be met on the outskirts of Paris wandering about the hillsides in jack-boots. As no one took the least interest in his pictures, he left them in the fields. . . . It would be untrue to say that he had no talent, but whereas the intention of Manet and of Monet and of Degas was always to paint, the intention of Cézanne was, I am afraid, never very clear to himself. His work may be described as the anarchy of painting, as art in delirium.

It is easy to see how Cézanne became a legendary figure. Those who neither knew the painter nor his work were of course incapable of understanding the conscientious efforts and painful vehemence with which he pursued his aims. It was difficult, indeed, for anyone to form an accurate opinion of Cézanne when all that was popularly known about him, besides the rumors that circulated, was that he was Zola's friend, that he had exhibited queer work, and that he was violent,

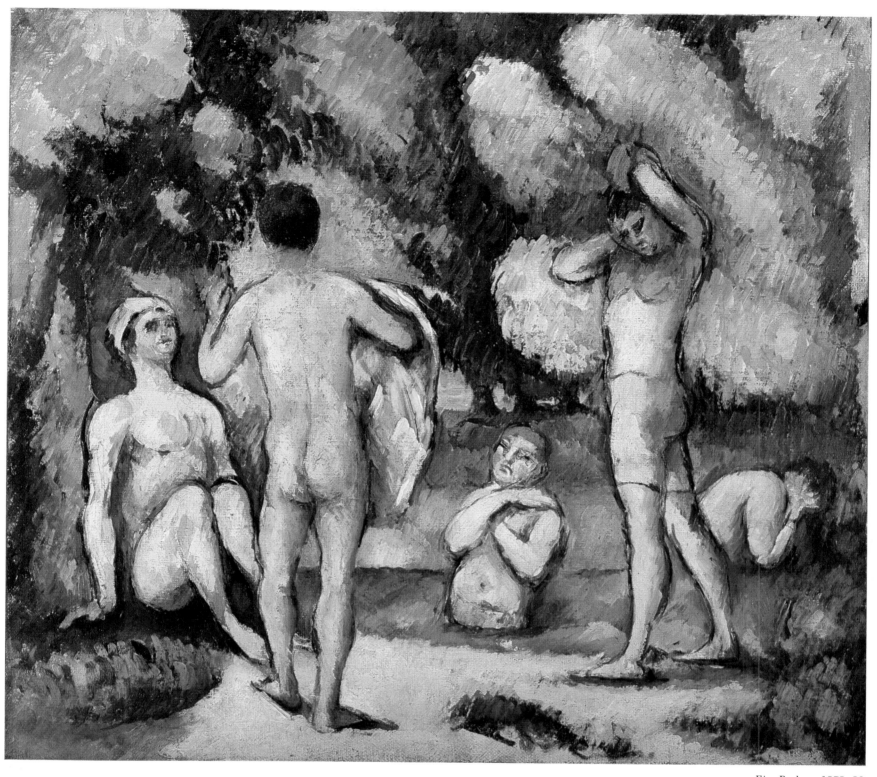

Five Bathers. 1879–80

timid, and proud. To the incredible words and deeds that were reported was added, in 1881, a rather heavy-handed caricature of Cézanne by Duranty, published after the author's death. The principal character of a story, the painter Maillobert, was partly based on Cézanne. Reporting a visit to Maillobert's studio, Duranty had written:

When I was about to knock, I heard a parrot's voice within. I knocked. "Come in," someone shouted in an extraordinary accent.

No sooner had I entered than I exclaimed to myself, "I am visiting a madman!"

I was completely confused by the environment and the individual. . . . The painter, bald, with a huge beard . . . looking at once both young and old, was himself like the symbolic divinity of his studio—indescribable and sordid. He made me a deep bow, accompanied by a smile I could not define, sly and idiotic.

At the same time my eyes were assailed by so many enormous canvases hung everywhere, and of such terrible colors, that I was petrified.

"Ah! Ah!" said Maillobert in a nasal, drawling, and exaggerated accent of Marseilles, "Monsieur is a connoisseur of painting? Here are the little scraps from my palette!" he added, pointing to his most enormous canvases.

At this moment the parrot cried out: "Maillobert is a great painter. . . ."

"That is my art critic," the painter said to me with a disturbing smile. . . .

Then, when he saw me looking curiously at a number of large pharmacist's pots bearing the abbreviated Latin inscriptions Jusqui., Aqu., Still., Ferrug., Rib., Sufl., Cup., Maillobert said:

"This is my paintbox. I show the others that with drugs I can do real painting whereas they, with their beautiful colors, only make drugs!"

. . . My eyes fastened on the very tall picture representing a coal man and a baker clinking glasses in front of a nude woman over whose head was written "Cooperation." When I say a coal man and a baker, it is because Maillobert explained to me that such were these naked people, the one slashed with white, the other with brown. The three figures were giants, twice normal size, done against an entirely black background by means of wide, jerky strokes in which vermilion, Prussian blue, and silver-white clashed furiously; huge eyes with a shining dot in each stood out on their heads. Nevertheless an arm here, a lip there, or a knee, were treated with a certain power.

"It is the expression of civilization," Maillobert told me, "we must satisfy the philosophers who are always barking at our heels."

A series of portraits then attracted me, portraits without faces, for the heads were a mass of spots in which no feature could be seen; but on each frame a name was inscribed, often as strange as the painting: Cabladours, Ispara, Valadéguy, Apollin, all disciples of this master.[12]

"Maillobert is a great painter," cried the parrot who seemed instinctively to know the right moment to intervene.

"He is right," the painter said with animation.

At this time two of his friends arrived, bearded, black, dirty.

"Might he be the head of the school of chimney sweeps?" I thought.

They contemplated the works of the master as though seeing them for the first time.

"How bold! What energy!" they exclaimed. "Compared to this, Courbet and Manet produce only chaff."

Maillobert smiled, expansive.

He dipped a spoon in one of the pharmacist's pots and drew out a regular trowelful of green, which he applied to a canvas on which a few lines indicated a landscape. He turned the spoon around and, with an effort, one could see a meadow in what he had just smeared on. I then observed that on his canvases the color was about half an inch thick and formed valleys and hills in relief. Apparently, Maillobert believed that a pound of green was greener than an ounce of the same color.

Thus the picture of Cézanne continued to be distorted. His few friends could not deny everything, and he himself did not make the slightest effort to correct this kind of criticism. Since he had ceased to exhibit, his paintings, hidden in his studio, could not bear public witness to his sincerity, to his hard and

Young Woman Sewing. 1881.
Cézanne obviously availed himself of Pissarro's model while the young woman posed for his friend.

painstaking work. Thus, when J.-K. Huysmans published his book on modern art in 1883, he did not give Cézanne the importance that, according to Pissarro, was due him. Indeed, Pissarro reproached the author in a letter, asking: "Why is it that you do not say a word about Cézanne, whom all of us recognize as one of the most astounding and curious temperaments of our time and who has had a very great influence on modern art?"

Huysmans immediately replied. His explanation to Pissarro once more reflects the current misconceptions about Cézanne:

Let's see; I find Cézanne's personality congenial, for I know through Zola of his efforts, his vexations, his defeats when he tries to create a work! Yes, he has temperament, he is an artist, but in sum, with the exception of some still lifes, the rest is, to my mind, not likely to live. It is interesting, curious, suggestive in ideas, but certainly he is an eye case, which I understand he himself realizes. . . . In my humble opinion, the Cézannes typify the Impressionists who didn't make the grade. You know that after so many years of struggle it is no longer a question of more or less manifest or visible intentions, but of works that are real contributions, that are not monsters, odd cases for a Dupuytren museum of painting [Dupuytren was the founder of a medical museum of anatomy].

Camille Pissarro. *Young Woman Sewing.* 1881

Huysmans's letter illustrates the opinions on Cézanne held by Zola's entourage in Médan. Yet the views of this group were rather diverse. Zola, for example, while agreeing with Huysmans's criticism of Monet to the effect that Monet worked too rapidly and was satisfied with rough drafts, did not agree with him concerning Courbet, whom Zola admired, and Degas, whom he did not like.

Zola wrote Huysmans: "As years go by, the more I detach myself from points of view that are simply odd, the more love I feel for the great and prolific creators who produce a world."

"And the more I turn away from the Impressionists," he might have added.

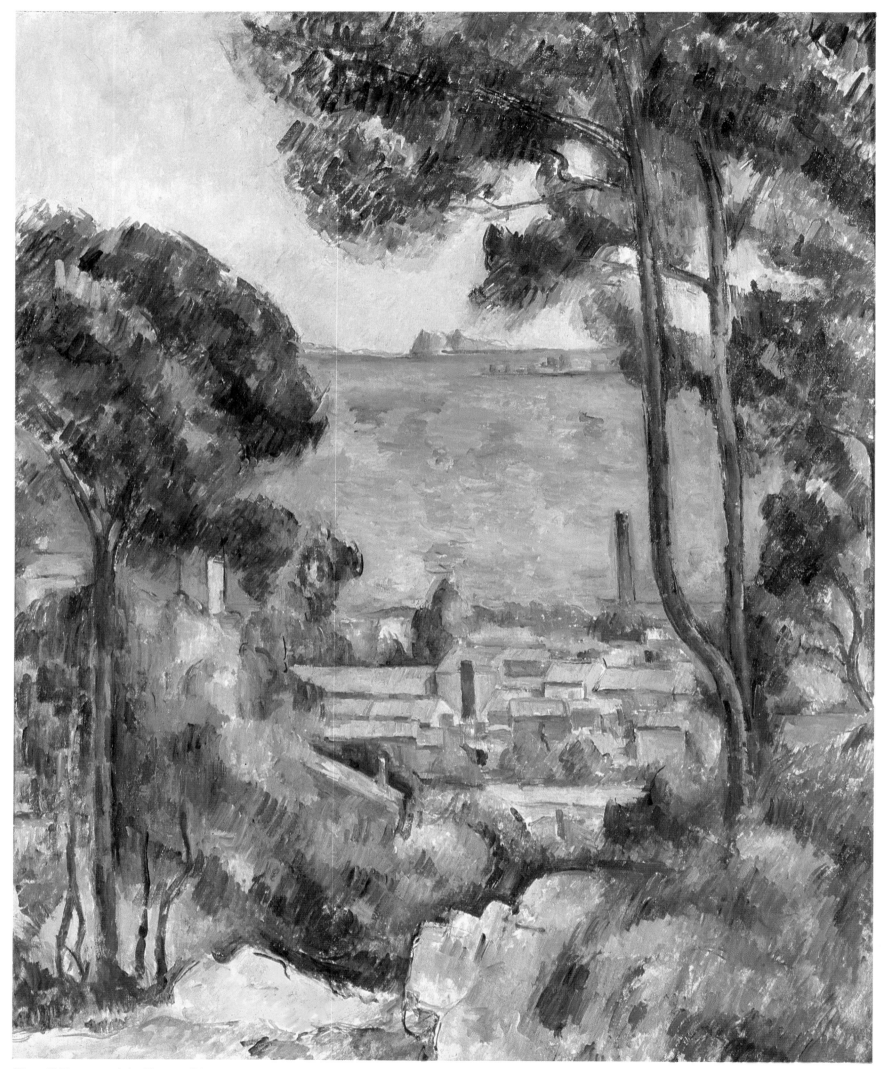

View of L'Estaque and the Château d'If. 1883–85

AFTER spending the summer of 1881 in the Ile-de-France, where he stayed with Pissarro in Pontoise, but worked, as he told Zola, "without much vigor," Cézanne paid a visit to Médan and then went south in the fall. He returned to Paris in February 1882 for a period of six months and spent five weeks in Médan. In October he was again in Aix, where he settled down for the next three years to the calm existence in Provence.

Life in Aix could hardly have been interesting, to judge from Alexis's letters to Zola, written when family matters forced him to go there. "It seems to me that I am at the bottom of a well!" Alexis complained. "Neither air nor sun, intellectually speaking. Ouf!... here no one talks about literature or, if they do talk about it, it is enough to make your hair stand on end. A year here will make me stupid or insane."

If Cézanne did not find the provincial atmosphere suffocating, it was because he seldom saw anyone and rarely left the Jas de Bouffan. Hortense Fiquet and their son had probably remained in Paris, for Cézanne does not mention them in his letters, and he had lost touch with his friends during his frequent absences from the Midi. The pupils of his former schoolmate Villevieille, who now taught drawing at the school in Aix, made fun in the street of Cézanne's tangled mane, which surrounded his bald dome, and this convinced him to have his hair cut. "It may be too long," he conceded. Fortuné Marion had become professor of science in Marseilles, but Cézanne could not make up his mind to visit him there as he suspected him of "not being sincere about art." Cézanne could not reach an understanding with the old "Sieur Gibert" either, for, as he wrote to Zola: "These people see correctly, but they have the eyes of professors," regretting that

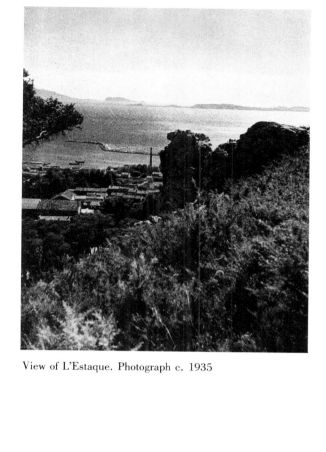

View of L'Estaque. Photograph c. 1935

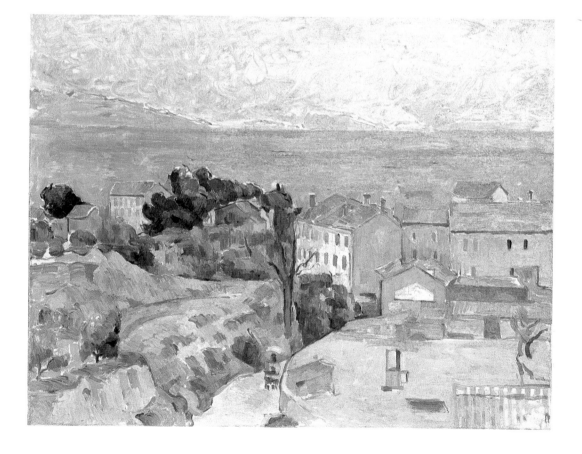

View of L'Estaque. 1882–83

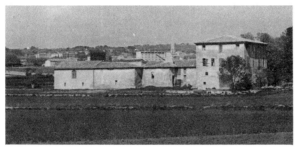

TOP:
Farmhouses near the Jas de Bouffan. 1877–80

ABOVE:
Farmhouses near the Jas de Bouffan.
Photograph c. 1935

it was only technical questions that interested them in art. However, Cézanne did not dislike his life of solitude in Aix, for it enabled him to work. Furthermore, he did not care for the pleasures of cities.

"Marseilles is France's oil capital," he wrote Zola, "just as Paris is the butter capital. You have no idea of the presumptuousness of this fierce population; they have but one instinct, that of money. It is said that they earn a lot, but they are very ugly. Communications efface the most salient features of the types from an external point of view. In a few centuries it will be quite senseless to be alive, everything will be so flattened out. But the bit that remains is still very dear to the heart and to the eye."

At this period Cézanne used to visit Marseilles quite often, nevertheless, to see the painter Monticelli, with whom he had become very friendly. He liked to arrive unannounced, to chat and to watch Monticelli work. On one occasion they took off together, their packs on their backs, to spend a month roaming about the country between Aix and Marseilles.

It may have been on Monticelli's behalf that Cézanne asked Victor Chocquet by letter "how to go about sending a painting to the administration of the Beaux-Arts in order to submit it to the approbation of the Salon jury." He explained carefully that he was asking this question "to help out one of my compatriots. . . . It is not for me."

Cézanne himself continued each year to submit works to the jury. When he did not deliver his canvases personally to the Palais de l'Industrie, he apparently asked *père* Tanguy to do it for him. Cézanne's paintings were regularly rejected, an experience he called "undergoing the dry guillotine." Suffering from public indifference, in Aix as well as in Paris, Cézanne ardently desired to be accepted by the Salon, if only to impress the people of his hometown. He wished to show them in his obstinacy that he could obtain admission to the official exhibitions. Although he chose canvases that seemed least likely to be rejected, he never made any concessions to official art. He thought that in following his own path and in succeeding to satisfy himself he would at the same time succeed in satisfying the demands of the jury. Thus, upon learning of a new rejection, he had once exclaimed: "I can quite understand that it could not be accepted because of my starting point, which is too far removed from the aim to be attained, that is to say, the rendering of nature."

In 1879 Antoine Guillemet had done his best to have a painting by Cézanne accepted, but "alas, without bringing any change in the attitude of those hard-hearted judges." Guillemet had left far behind the days in which his bloodthirsty enthusiasm had been eager to wield the dagger of insurrection and to dance on the belly of the terrified bourgeois. By now a comfortable bourgeois himself, he

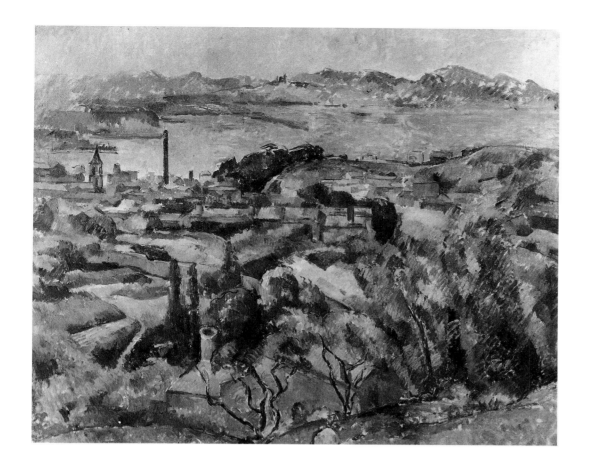

View of Saint-Henri and the Gulf of Marseilles.
Photograph c. 1935

Saint-Henri and the Gulf of Marseilles. c. 1883

had—through the consistent insignificance of his landscapes—even achieved a certain official status by becoming a member of the Salon jury. But at least he had not forgotten his comrade of earlier battles. It was finally in 1882 that he managed to have a canvas of Cézanne's "accepted" by using the prerogative of jury members to exhibit the work of one of their students. Cézanne, who sent in a *Portrait of Monsieur L. A.*, thus is listed in the catalogue as "pupil of Antoine Guillemet." It is not known which work Cézanne selected; some say it was a self-portrait (which seems unlikely). The initials L.A. could have stood for those of the artist's father, Louis-Auguste, although it appears doubtful that Cézanne would have picked such an early work, except that it was a painting Guillemet had once greatly admired. In any case, Cézanne's portrait did not attract public attention, though a critic, taking the "pupil of Antoine Guillemet" for a novice, wrote: "*Monsieur L. A.* is painted with wide brushstrokes. The shadow of the eye socket and that of the right cheek as well as the quality of the light tones presage a future colorist." The words could very well have been prompted by Cézanne's *Portrait of Louis-Auguste Cézanne Reading* L'Evénement.

However, the prerogative that had opened the back door of the Salon to Cézanne was remanded that same year, and Guillemet thus was no longer able to use his position on his friend's behalf.

Goaded by his endless difficulties with the jury, Cézanne continued his "research in painting." In the beginning of 1882 he worked again at L'Estaque. It was there that Auguste Renoir met him in February and was immediately taken with the charm of the landscape. "As it is very beautiful here," Renoir wrote from L'Estaque to his dealer Durand-Ruel, "I am staying another fortnight. It would really be a pity to leave this lovely country without bringing back something. And the weather! The spring with a gentle sun and no wind, which is rare in Marseilles. Moreover, I ran into Cézanne and we are going to work together."

But Renoir was stricken with pneumonia a few days later. On March 2, he wrote to Chocquet: "I have just been ill and am convalescing. I cannot tell you how nice Cézanne has been to me. He wanted to bring me his entire house. We

Tall trees at the Jas de Bouffan.
Photograph c. 1935

are going to have a farewell dinner with his mother at his home; he is going back to Paris and I am obliged to stay somewhere in the South. . . . At lunch Madame Cézanne made me eat a ragout of cod; this is, I think, the ambrosia of the gods. One should eat this and die. . . ."

Cézanne returned to Paris in the spring of 1882, and again the following spring when, on May 4, 1883, he attended Manet's funeral together with Renoir, Pissarro, Durand-Ruel, Clemenceau, Puvis de Chavannes, etc. Among the pallbearers were Zola, Degas, Monet, Fantin-Latour, and Duret. Manet's friend Antonin Proust spoke a few moving words at the grave.

A few days later, Cézanne returned to the Midi and settled in L'Estaque for the rest of the year. "I have rented a little house and garden at L'Estaque," he wrote Zola, "just above the station and at the foot of the hill where behind me rise the rocks and the pines. I am still busy painting, I have some beautiful viewpoints here, but they do not quite make motifs. Nevertheless, climbing the hills at sunset, one has a glorious view of Marseilles in the distance and the islands, the whole giving a most decorative effect when bathed in the evening light."

In December 1883, Monet and Renoir, coming from Genoa, went to see Cézanne in L'Estaque, but apart from these infrequent visits and his walks with Monticelli, Cézanne lived in complete solitude. Only the letters and reading matter sent him by Zola interrupted his isolation. He asked Zola to enliven "the long sequence of identical days" and wrote him: "When you can, if you want to tell me about the state of affairs in art and literature you will give me much pleasure. Thus I shall be still farther removed from the provinces and nearer to Paris."

The situation in the world of art was of particular concern to Cézanne, inasmuch as he was trying to leave Impressionism behind him. He felt that the moment of Impressionism was passing. The group of artists who had banded together to combat two enemies, the past (Classicism and Romanticism) and the present (Academicism) began to disperse. Cézanne was no longer the only one to abstain from the group shows; Monet, Renoir, and Sisley did not contribute regularly. Although their artistic convictions had united all the Impressionists, each one of them had kept his own personal temperament, vision, and style.

L'Estaque Seen through the Pines. 1882–83

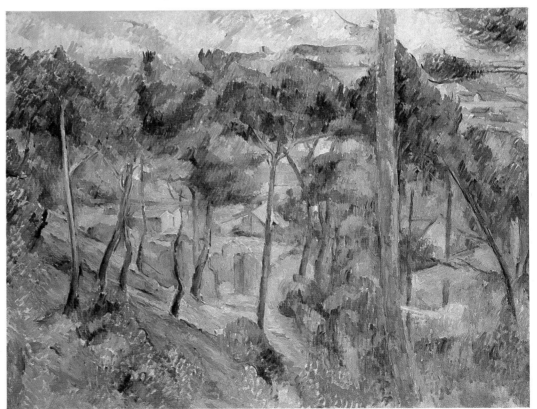

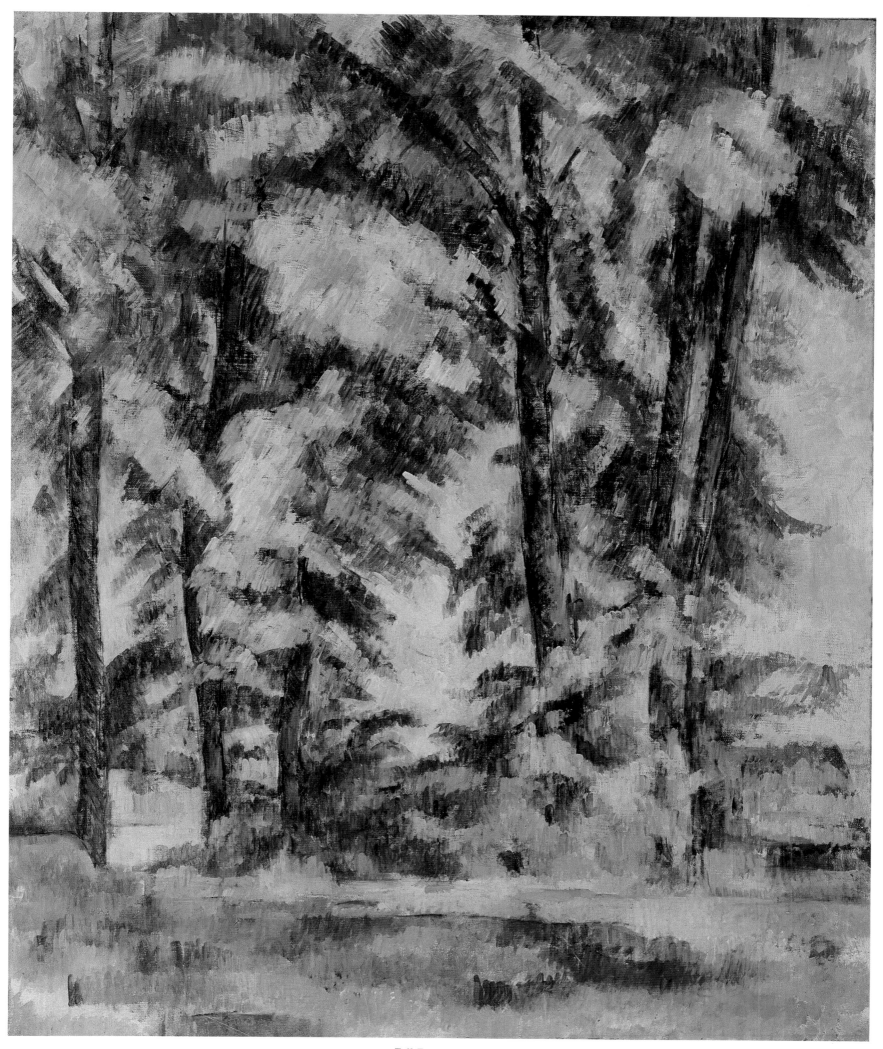

Tall Trees at the Jas de Bouffan. 1885–87. See the photograph of these trees on the opposite page.

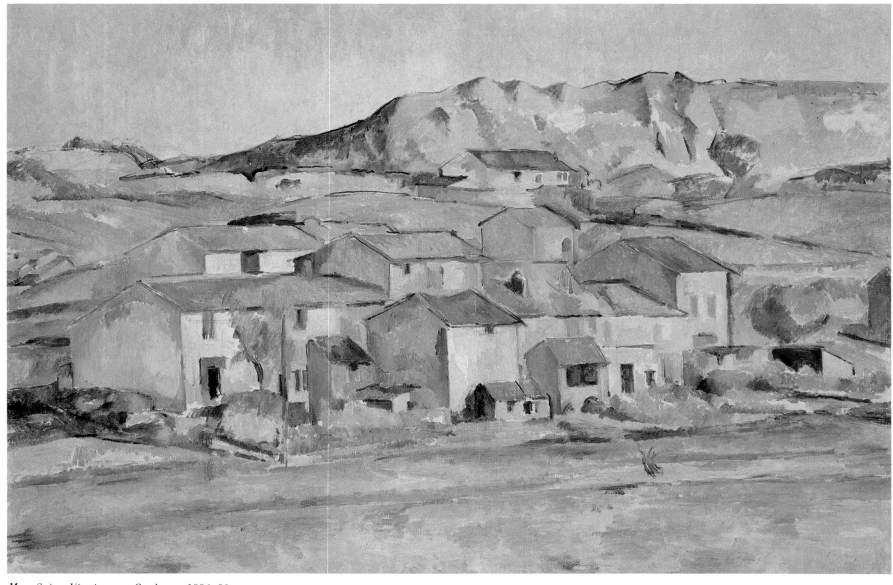

Mont Sainte-Victoire near Gardanne. 1886–90

*Chestnut Trees and Farmhouse
at the Jas de Bouffan.* c. 1885

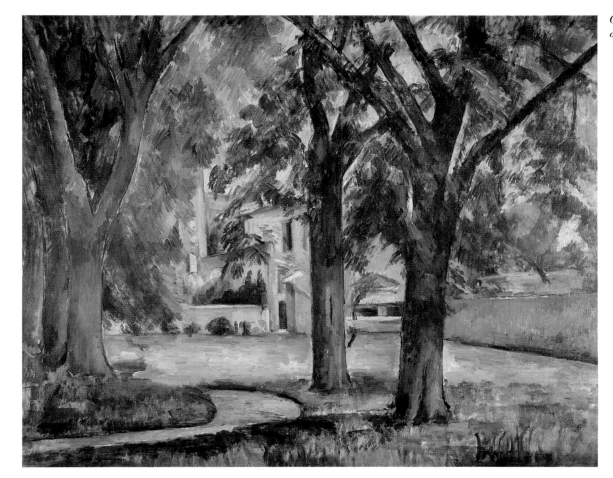

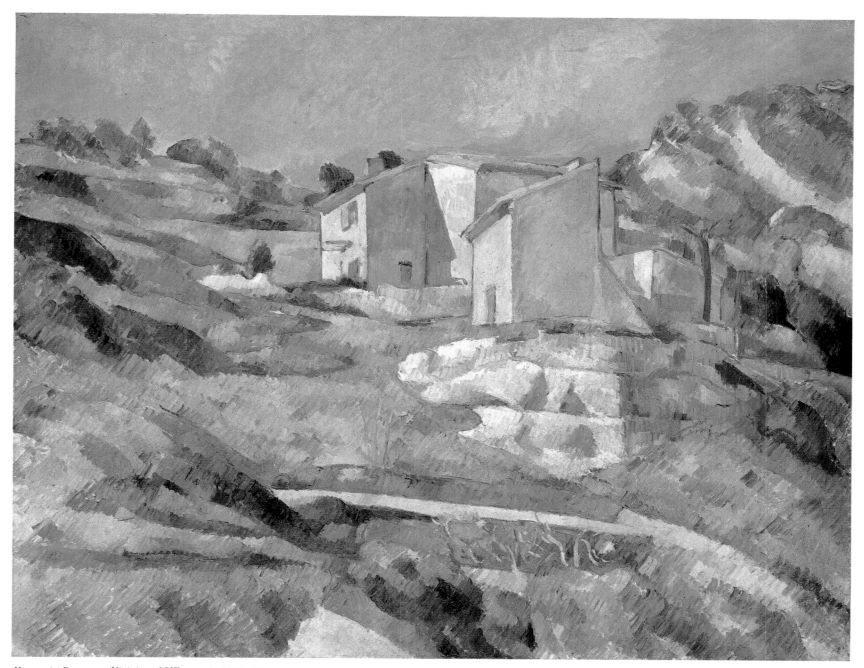

Houses in Provence (Vicinity of L'Estaque). 1879–82

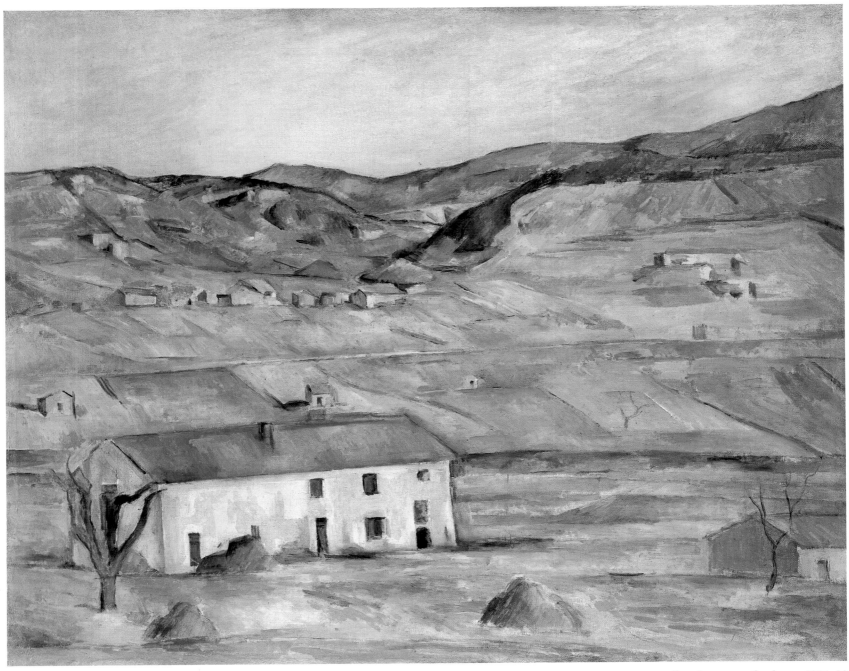

Farmhouse near Gardanne. 1886—90

Gardanne. c. 1886

View of Gardanne.
Photograph c. 1935.
This sector has since
been completely industrialized.

Farmhouse near Gardanne.
Photograph c. 1935

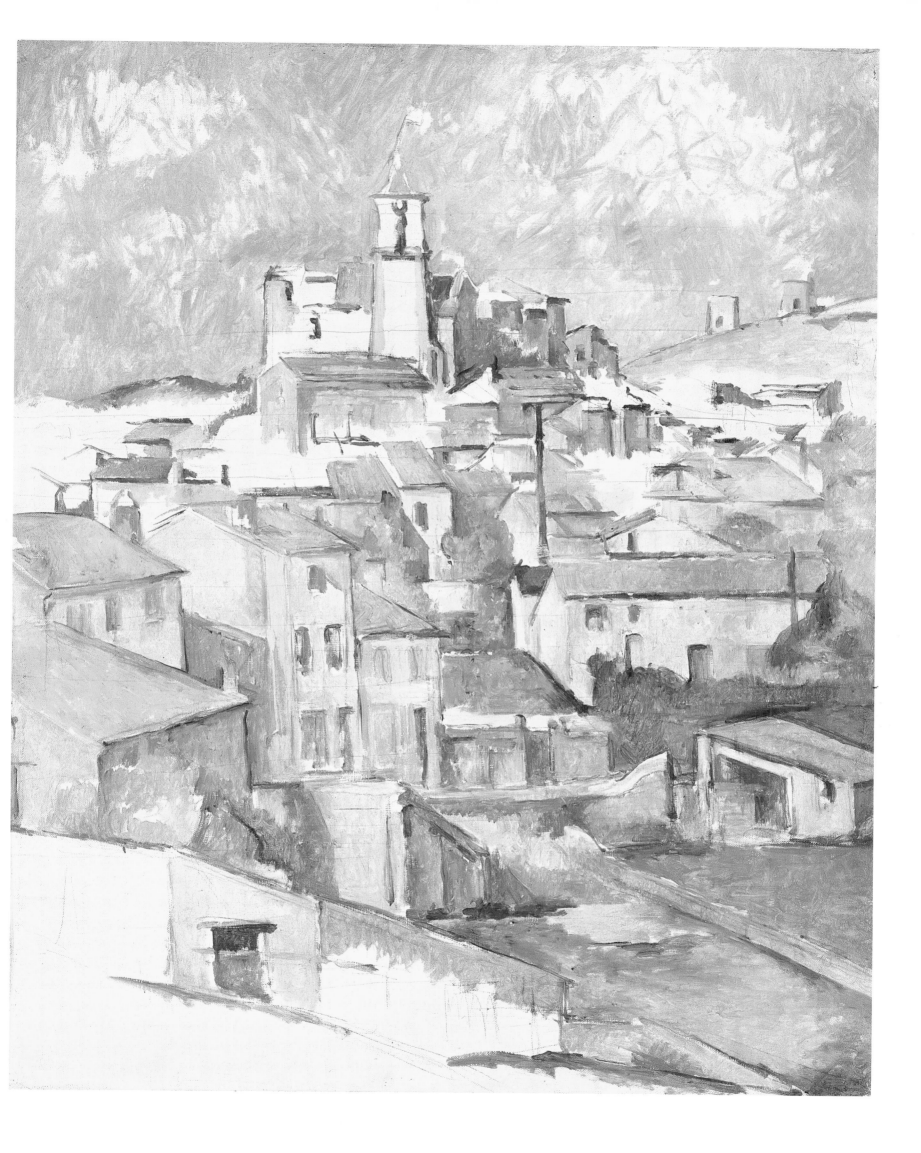

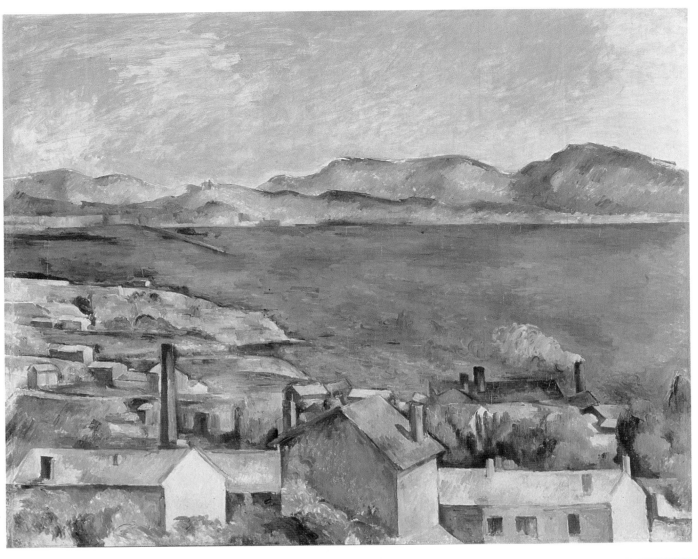

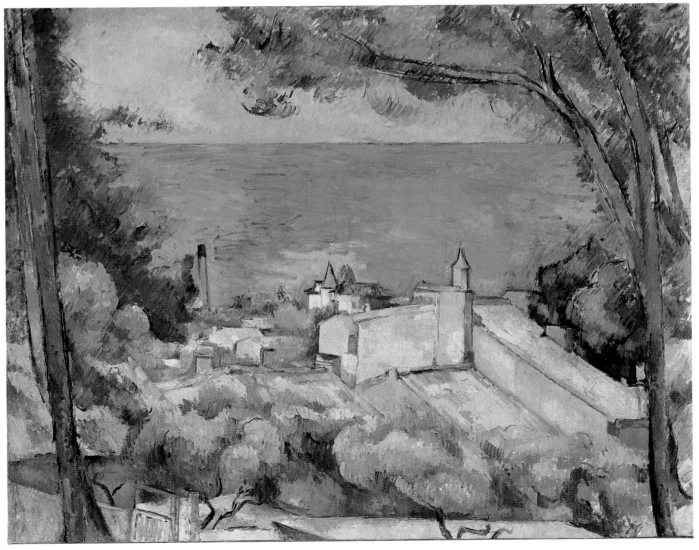

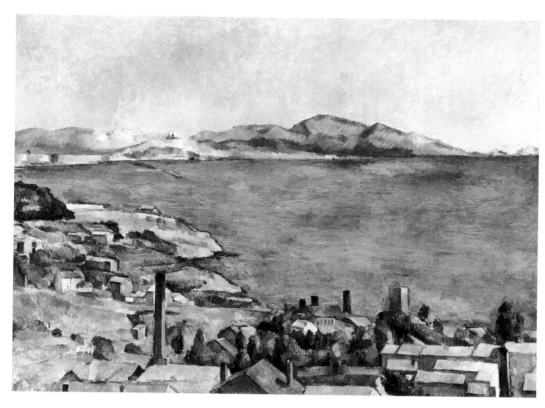

The Gulf of Marseilles, Seen from L'Estaque.
c. 1885

After their common exhibitions, each had confined himself in his work to develop his personality and his understanding of nature. With Henri de Maupassant, they felt: "What childishness to believe in reality since each one of us carries his own in his thought and organs. . . . The great artists are those who impose on humanity their own personal vision."

In seeking his own individuality, Cézanne endeavored to react against the danger he felt was inherent in Monet's complete dissolution of mass and elimination of local color. This did not prevent him from saying admiringly of Monet: "He is nothing but an eye, yet what an eye!" However, Cézanne felt that observation was not enough, that thought was essential. As he later remarked: "There are two things in the painter: the eye and the brain. The two must cooperate; one must work for the development of both, but as a painter: of the eye through the outlook on nature, of the brain through the logic of organized sensations that provide the means of expression."

The difference between the impressionistic sensation, which is rapid, ephemeral, and fleeting, and that of Cézanne is that his sensations result logically in the full knowledge of the subject in the classical sense. Cézanne often said that he wished "to become classical again through nature, that is to say, through sensation." And Classicism, as he understood it, meant to "revive Poussin in contact with nature." Nature was the essential element, the source of art, but "one must not reproduce it, one must interpret it. By means of what? By means of plastic equivalents and color."

"As you say," Cézanne wrote from L'Estaque to Zola, "there are some very beautiful views here. The difficulty is to reproduce them; it is not exactly what I am achieving. I began to perceive nature rather late, though this does not prevent it being full of interest to me."

A letter to Pissarro reveals the strong emotion aroused in Cézanne by the view of the beautiful bay of L'Estaque: "It is like a playing card. Red roofs on the blue sea. The sun is so terrifying that it seems as though the objects are silhouetted, not only in black and white, but in blue, red, brown, and violet. I may be mistaken, but it seems to me to be the very opposite of modeling."

In this light, which appears to emphasize the contours of objects, to flatten them while at the same time giving them a gentle and precise relief, Cézanne

OPPOSITE, ABOVE:
The Gulf of Marseilles, Seen from L'Estaque.
c. 1885

OPPOSITE, BELOW:
Red Roofs, L'Estaque. 1883–85

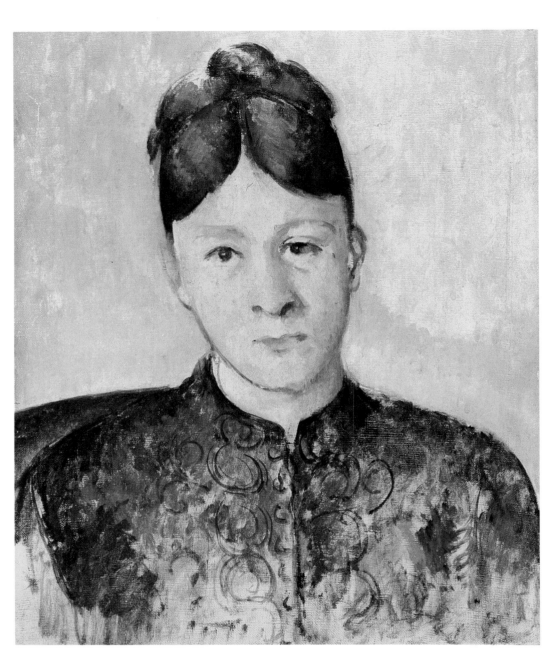

Portrait of Madame Cézanne. c. 1885

attempted to oppose to the transformation of masses into colored spots the precision of planes that he perceived. He used contrasting colors to create space and proceeded with a slow thoughtfulness that tried to capture the general character of a landscape beyond its momentary aspect. Cézanne painted many views of the village of L'Estaque, with its roofs, factories, and belfries, often as seen through the pines that grow tenaciously on the rocky slopes. In the background there is always the sea and a little bit or a wide expanse of sky. It is an extraordinary landscape, whose main forms combine the cubes of the houses and the irregular shapes of the trees with the huge plane of the multicolored water, the predominant blue of which is intensified by the rays of the sun.

"Art is changing terribly in its outer form," he wrote Zola in somewhat cryptic style, "and is assuming all too strongly a poor, miserable aspect while at the same time the ignorance of harmony is being revealed more and more in the discordance of the coloring and, what is even worse, in the deadness of the tone. After groaning, let us cry, 'Long live the sun, which gives us such beautiful light.'"

At the beginning of 1885 Cézanne's lonely contemplation of nature was interrupted by a violent love affair with a woman about whom little is known except that he met her in Aix. On the back of a drawing the painter wrote the draft of a love letter, which breaks off at the bottom of the page without entirely revealing the secret of this strange episode:

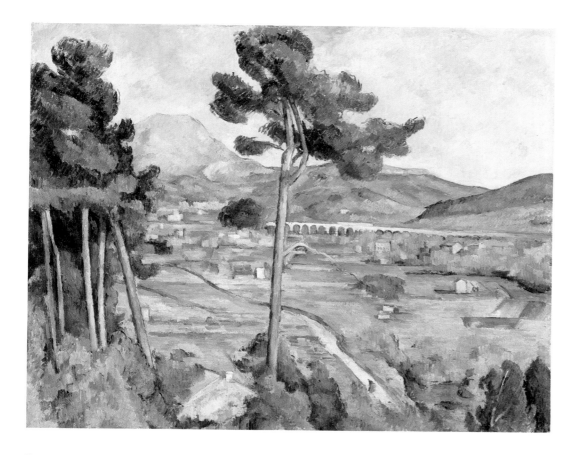

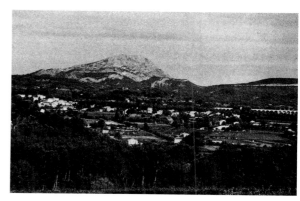

View of Mont Sainte-Victoire and the Arc valley with viaduct. Photograph c. 1935

Mont Sainte-Victoire, Seen from Bellevue, also known as *The Viaduct.* 1882–85

I saw you and you permitted me to embrace you; from that moment on a profound emotion has not ceased tormenting me. You must excuse the liberty that a friend, tortured by anxiety, takes in writing to you. I do not know how to excuse this liberty, which you may think a great one, but could I have borne the burden that oppresses me? Is it not better to give expression to a sentiment rather than to conceal it?

Why, I asked myself, should I suppress the cause of my agony? Is it not a relief to suffering to give it expression? And if physical pain can find some assuagement in the cries of the unfortunate, is it not natural, Madame, that spiritual sadness seek the consolation afforded by confessing it to a beloved being?

I realize that this daring and premature letter may seem indiscreet to you, and that it has to commend me to you only the goodness of. . . .

Stirred, confused, tormented, the prey of a sudden and irresistible passion, Cézanne asked Zola to act as intermediary for the correspondence that had to be hidden: "I would like you to do me a favor, which is, I think, tiny, but vast for me. It would be to receive some letters for me and to forward them by mail to the address I shall send you later. I am either mad or very sensible. *Trahit sua quemque voluptas.*[13] I am appealing to you and I implore your absolution. Happy are the sages."

The following month Cézanne, Hortense Fiquet, and their son were staying with Renoir at La Roche-Guyon not far from Paris. Cézanne immediately begged Zola: "If you should receive a letter from Aix, be good enough to address it to General Delivery and to send me a line and let me know by making a cross in a corner of your letter."

But in his agitation and confusion Cézanne forgot to collect his mail. Life at La Roche-Guyon became difficult for him, "due to fortuitous circumstances," as he wrote to Zola. The latter replied immediately: "Your note has upset me considerably. What's going on? Can't you wait a few days? In any event, keep me informed and let me know if you have to leave La Roche [-Guyon], since I want to know where to write to you when my house is finally available. Be philosophical, nothing goes as one would like. I too am very much upset at the moment. So until soon? As soon as I can, I'll write to you. Affectionately, Emile Zola."

But Cézanne was becoming restless, and after spending about a month at Renoir's where he began a landscape that he never finished, he suddenly left for Villennes near Médan but found no lodging and so proceeded to Vernon. Zola could not put him up at Médan for two weeks.

"I am at Vernon," he informed Zola. "I cannot find what I want in the conditions in which I now am. I have decided to leave for Aix as soon as possible. I shall go by Médan to shake your hand." And a few days later, on July 19, he wrote again: "I would have liked to go on with my painting, but I was in a state of very great perplexity. For, as I must go south, I concluded that the sooner the better. On the other hand, perhaps it would be better if I waited a little. I am in a state of indecision. Perhaps I will get out of it?"

Apparently Cézanne, not wanting to stay in Vernon, passed briefly through Médan where Zola may have read him a few chapters of the novel he was working on, *L'Oeuvre*. Cézanne finally returned to the Jas de Bouffan. He was to remain there for two or three years without revisiting the Ile-de-France.

What happened at Aix, after his return, is not known, but it is unlikely that Cézanne saw there the woman who had aroused him so deeply. In a letter to Zola of August 20, he speaks of the "pebbles under my feet, which are like mountains." And a few days later he specifies: "As for me, the most complete isolation, the brothel in town, or anything else, but nothing more. I pay, the word is ugly, but I need rest, and at this price I get it. . . . If my family were only indifferent, everything would have been for the best."

Perhaps it was in order to escape his family as well as the memories of his romance that Cézanne went off every morning to the neighboring town of Gardanne, only returning late in the evening to the Jas de Bouffan. Soon, to avoid these daily trips of about six miles each way, Cézanne rented a small apartment in Gardanne and moved there with Hortense Fiquet and young Paul, now thirteen years old, who was sent to the local school.

"I am beginning to paint," Cézanne informs Zola toward the end of August, "because I am almost without troubles," Everything seems forgotten. He had taken up his brushes again and in his canvases of Gardanne there is not the least reflection of mental turmoil. It was from Gardanne that Cézanne wrote to Victor Chocquet: "The country here, which has never found an interpreter worthy of the richness it harbors, contains many treasures to be gathered."

Gardanne was a picturesque little town nestling against a small hill crowned by a steepled church, which gave the landscape the shape of a pyramid. Cézanne frequently painted the still life of roofs and square houses, interspersed with a few trees. The slopes in the background were studded with the squat towers of three old mills. In the outskirts of Gardanne Cézanne found admirable motifs composed of slightly undulating planes stretching to the Mont du Cengle, a foothill of Mont Sainte-Victoire. The mountain is seen here as an elongated and jagged plateau; its heavy mass bars the horizon. Its colors vary from a dull gray to a limpid blue, passing through shades of pink and pale gray. Cézanne painted several views of this harmonious landscape that reveal the purity of its form and richness of its colors; the red of the earth, the yellow of the houses, the green of the trees, and the blue of the sky create an atmosphere of admirable serenity.

Since 1881, Cézanne's brother-in-law, Maxime Conil, owned a property called Bellevue southwest of Aix. Situated on a hill, it dominates the entire wide valley of the Arc to the distant wall of Sainte-Victoire. Cézanne often went there to paint and in several pictures represented the house, the farmyard, and the pigeon tower of Bellevue. One of his favorite motifs was the view from the edge of a

little wood on the summit of the hill, between Bellevue and the neighboring estate of Montbriant. Thence he overlooked the valley extending all the way to the truncated cone of Mont Sainte-Victoire. This landscape, composed of wide planes, large masses, and sharp lines, such as the railway in the foreground and the viaduct farther back with its light arches, this landscape in which the masses seem to absorb the details, might explain why Cézanne loved, as he said, "the conformation of my country." He preferred it to the landscapes of the North because there he did not find such closed panoramas and his eye could not take in such views without being brought up short or losing itself in the distance. Moreover, there was the difference of color and light; here on this hill of Bellevue a landscape spread itself at his feet, rich and firm, harmonious in its lines, soaked in the southern sun.

It was on these motifs that the painter endeavored to further develop his sensibility, to discover the laws of perspective as linked to color, which enabled him to reproduce his sensations, to remain faithful to nature, and to translate all its richness and space on a piece of canvas.

"I try to render perspective through color alone," Cézanne later explained. And he added with emphasis: "I proceed very slowly, for nature reveals herself to me in very complex form, and constant progress must be made. One must see one's model correctly and experience it in the right way, and furthermore, express oneself with distinction and strength."

"I believe," he said on another occasion, "that I am daily closer to achieving it, albeit painfully, for if the strong feeling for nature—which I assuredly have—is the necessary basis for all conception of art upon which depend the greatness and beauty of all future work, the knowledge of the means of expressing our emotion is no less essential and is only to be acquired through very long experience."

As Cézanne developed his art, he detached himself increasingly from the Impressionist conceptions. He did not seek to capture the impression and vibrant atmosphere of a landscape but rather to portray its forms and colors, its planes and light. He did not approve of Monet's attempts to render the same subject at different times of the day, to show the different shapes and tints produced by the varying intensity of the sun. Nor did he approve of the efforts of "the humble and colossal" Pissarro, as he called him admiringly, who was then being attracted by the Divisionism of Georges Seurat and painting his pictures in the pointillist technique. Regretfully Cézanne remarked: "If he had continued to paint as he did in 1870, he would have been the strongest of all." He now criticized Manet severely for having been "poor in feeling for color." As for Renoir, Cézanne did not like his landscape technique, which he called "cottony." Altogether he had the impression that his friends experimented too much, that they did not look behind the colorful exterior for the actual structure of things; it is doubtless for this reason that he assumed the task of "making out of Impressionism something solid and durable like the art of museums."

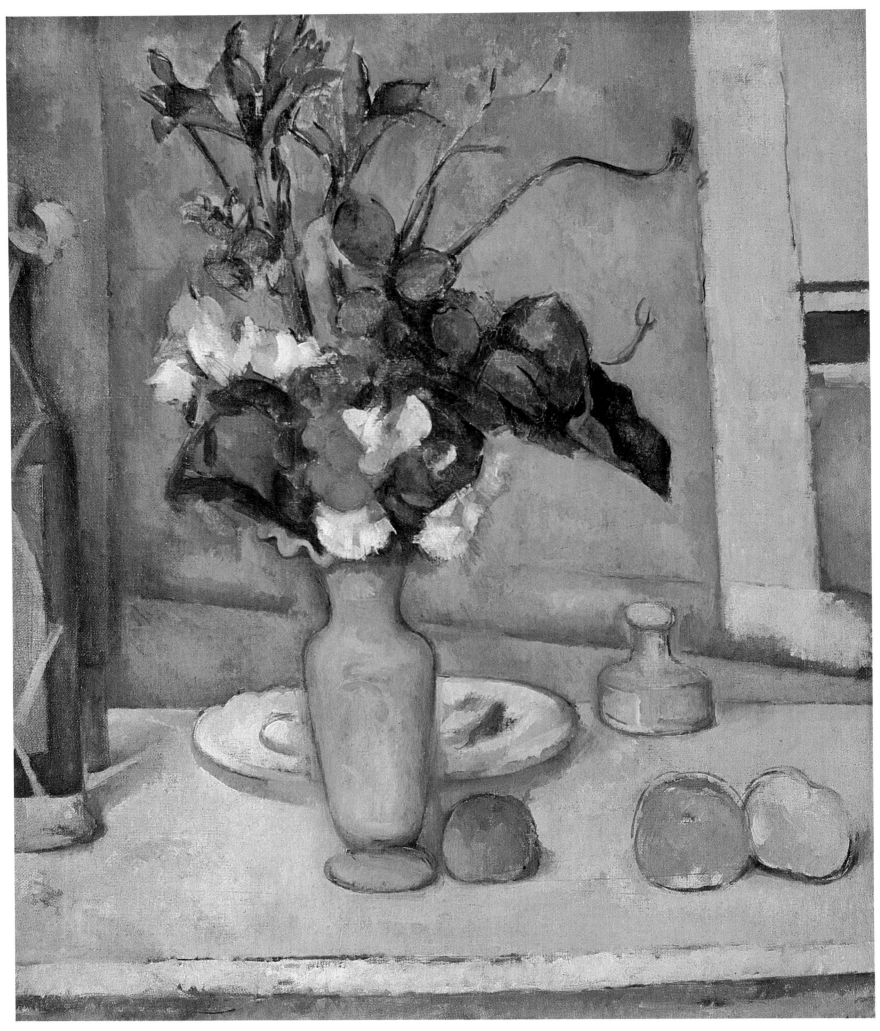

The Blue Vase. 1889–90

SINCE back in 1868, when Zola began his work on *Les Rougon-Macquart*, he
had decided to devote a novel of this series to the story of an artist
member of that family called Claude Lantier. When Paul Alexis published
in 1882 a book on Zola, who himself furnished all documents and details, he was
able to announce the literary plans of his friend. Giving specific information
about Zola's projects, Alexis mentioned:

. . . a work for which the documentation will be less difficult: the novel he plans to write
on art. Here he need only recall what he saw in our circle and experienced himself. His
chief character is all ready: this painter, captivated by the modern ideal of beauty, who
appears briefly in *Le Ventre de Paris* [1873] is that Claude Lantier of whom he says in
the family tree of the Rougon-Macquarts: "Claude Lantier, born in 1842—mixture,
blending; predominating mental and physical characteristics from his mother (Gervaise in
L'Assommoir); the inheritance of a neurosis turning into genius. Painter."

Zola's purpose is to describe in this novel his years in Provence. . . . I know that in
Claude Lantier he plans to study the terrible psychology of artistic impotence. Around
the central man of genius, the sublime dreamer whose production is paralyzed by an
infirmity, other artists will gravitate, painters, sculptors, musicians, men of letters, a
whole band of ambitious young men who have also come to conquer Paris: some of them
failures, others more or less successful; all of them cases of the sickness of art, varieties
of the great contemporary neurosis. Of course Zola, in this work, will be obliged to use
his friends, to assemble their most typical traits. If I find myself included in it and even
if I am not flattered, I promise not to bring suit against him.

These last lines indicate clearly that Zola by no means hid from his friends his
intention of giving this project more or less the character of a *roman à clef*. Zola's
notes for this novel, *L'Oeuvre*, are a further proof, since he constantly uses the
proper names of his friends, instead of the fictitious ones they were to bear in the
book.

In Zola's work this novel is unique, for no other contains such detailed use
of personal memories, nor lends itself better to a study of the people who
surrounded the author in his youth. A long time before beginning *L'Oeuvre*,
Zola had written in the *Nouveaux Contes à Ninon* that "memory is today the only
joy in which my heart finds rest." In going back to his youth, Zola sought a
moment of respite after so many novels that had required careful research into
surroundings unfamiliar to him. After *L'Assommoir*, *Nana*, and *Germinal*, he now
had merely to gather his recollections of Cézanne, Baille, Coste, Valabrègue,
Manet, and so many others. "Before making the outline," he wrote in his notes,
"I must make a list of memories." The outline itself comprises only a few
sentences:

Passion, good nature, gaiety.
Genesis of the work of art, nature embraced and never conquered.
Struggle of the woman against the work, the childbirth of the work against the childbirth
 of real flesh.
A whole group of artists.

Proceeding with his list of memories, Zola jotted down:

Provençal Landscape. c. 1886

L'Estaque and the Gulf of Marseilles. 1882–85

My youth at school and in the fields—Baille, Cézanne—All the memories of school, comrades, professor, quarantine, we three friends.—Out-of-doors, hunting, swimming, walking, reading, the families of my friends.

In Paris. New friends. School. Arrival of Baille and of Cézanne. Our Thursday reunions.—Paris to conquer, walks.

The museums.

The various lodgings—Chaillan—the cafés; Solari and his marriage.

Manet's duel [with Duranty]. The studios of Cézanne. The stays at Bennecourt.—The Thursday reunions continue.

Of himself, Cézanne, and Baille, Zola remarked: "No cafés, no women, an outdoor life that saved them from provincial stupidity." And several times in his notes occurs the phrase: "I would like gay characters."

However, if the author's youthful companions were used in *L'Oeuvre* and

furnished physical as well as character traits, not one of them is directly portrayed. Far from copying faithfully the personalities of his various friends, Zola mixed their characteristics in such a way that each figure in his book shows peculiarities of more than one of them. Thus, Claude Lantier is not only Paul Cézanne as he was in *Le Ventre de Paris*, but he also has some of Manet's traits, especially in his role as leader of the group, and in his paintings may be found details of works by Cézanne, Manet, Monet, and others. Furthermore, he bears the Christian name used by Zola himself when he published his *La Confession de Claude* and again when he signed his first Salon reviews in *L'Evénement*. Some of Zola's own blood flows in the veins of Claude Lantier.

As Zola had to adapt the characters of his novel to the social background of *Les Rougon-Macquart*, Claude Lantier is not, like Cézanne, the son of a rich provincial banker but comes from a working-class family, that of Gervaise and Auguste Lantier, in *L'Assommoir*. Zola intended studying in this artist "a curious effect of heredity, which transmits genius to the son of illiterate parents." (It is true that Cézanne's parents, though not workers, were also quite illiterate. Cézanne's father wrote phonetically, his mother not at all.)

Claude Lantier's artistic training is that of Cézanne, for Zola notes: "Musée de Plassans [Aix], Atelier Suisse, a master who tells Claude he will never accomplish anything, the Louvre. . . ." Claude, very uncompromising, accepts only Delacroix and Courbet.

Cézanne's first name constantly escapes Zola's pen when he is writing about Claude Lantier:

Not to forget Paul's despair; he always thought he was discovering painting. Complete discouragement, once ready to give up everything; then a masterpiece, nothing but a sketch, quickly done and which rescues him from his extreme discouragement.—The question is to know what makes him powerless to satisfy himself: he himself, primarily, his physiognomy, his breeding, his eye trouble; but I would like our modern art to play a role, our fever to want to do everything, our impatience in shaking traditions, in a word, our lack of equilibrium. What satisfies G. [Guillemet?] does not satisfy him; he goes further ahead and spoils everything. It is incomplete genius, without full realization: he lacks very little, he is a bit hither-and-yon due to his physical makeup; and I add that he has produced some absolutely marvelous things, a Manet, a dramatized Cézanne, nearer to Cézanne.

Another time Zola ascribes to this unbalanced artist some of his own traits:

In Claude Lantier I wish to paint the artist's struggle against nature, the creative effort in the work of art, effort of blood and tears to give one's flesh, to create life: always wrestling with the truth and always beaten, the battle with the angel. In short, I shall relate my intimate life as creative artist, this perpetual and painful childbirth; but I shall enlarge the subject and dramatize it through Claude who is never satisfied, who is tormented by his inability to give birth to his own genius and who, at the end, kills himself before his unfulfilled work.—He will not be an impotent artist, but a creator with too great an ambition who wants to put all nature on a single canvas and who dies in the attempt. I shall have him produce some superb things, fragmentary, unknown, and possibly ridiculed. Then I shall give him a dream of immense pages of modern decoration, of frescoes epitomizing the whole epoch, and it is there he will destroy himself.

Zola gives Claude Lantier a friend, Sandoz, a writer who "is only there," Zola says, "to give my ideas on art—my character, my ideas." Sandoz is above all the portrait of the author and appears "either to complement Claude or to be contrasted with him." And Zola specifies:

Lamenting Woman. c. 1873

It will be best to consider me only as a theorist, to leave me in the background, without giving any details concerning my production. Claude's schoolmate, doing work of my own, scoffed at, humiliated, successful toward the end; only less absolute; yielding to my nature, and producing, whereas Claude stumbles. . . . I shall only furnish ideas, with the fatigue, the pallor of work, without details; whereas the whole battle of production will be on Claude. Myself, always respectful of his efforts. . . . Myself, born in Paris, but a student at Plassans where I was a schoolmate of Claude and the architect (Baille), both born there. We met Valabrègue not at school but in a little pension; Alexis joins them from there, younger. . . .

Claude Lantier and Pierre Sandoz, the painter and the writer, are the two principal characters of the novel. They represent "two young creators, full of their future, plunging into the literary and artistic current." They stand out against the background of the Salon des Refusés, the first Impressionist exhibitions, and the battle fought by the painters around Manet.

"The question of the Impressionists" Zola underlined. "I shall take for Claude some theories of the Impressionists, the *plein-air*, the decomposition of light, all this new painting that requires a genius to be fulfilled. . . . Claude will rise up against their too hasty work, the painting done in two hours, the sketch that satisfies them, the hasty sales of Monet. . . ." Claude Lantier "is at bottom a romantic, a builder. Thence the struggle; he wants to embrace nature, which eludes him."

Zola records the whole period of the Salon des Refusés and his discussions with Cézanne after their first visit to the exhibition. His own Salon reviews Zola ascribes in the novel to Jory, a "poet fallen into contemporary journalism." These articles create a furor, although they do no more than repeat "the theories accepted by the group." But Jory is also "an Alexis dramatized and made evil, a great rake."

Valabrègue is transposed into a painter who "with great and naive ambitions, sinks to little insignificant paintings," and the sculptor Mahoudeau is based on Solari, whose natural strength had to be diminished "since strength belongs to Claude." He has "no primary education, only instincts."

Baille, under the name of Dubuche, is at first "architect at the Ecole des Beaux-Arts, very staid, cold, duty, good student," and later "an employee not caring about art, who makes a rich marriage."

Victor Chocquet appears as Monsier Hue, who had chosen Claude Lantier's "crudest works, which he hung next to his paintings by Delacroix, prophesying for them equal fame."

Christine Hallegrin, the friend, model, and wife of Claude Lantier, is the only woman who plays an important part in this story of artists. From all that is known about her, it appears that Zola had Hortense Fiquet in mind when he described this eighteen-year-old girl at the beginning of the novel, at the time she meets Claude: "A tall, supple, and slim girl, still a little thin in body, but exquisitely pure, young, and virginal. Already rather full-breasted, with a slim waist. . . . A brunette with black hair and black eyes. The upper part of the face very gentle, with great tenderness. Long eyelids, pure and tender forehead, small and delicate nose. When her eyes laugh, exquisite tenderness. But the lower part of the face is passionate, the jaw is a little prominent, too strong. . . ."

To the notes on the various characters Zola added an outline for the novel, dealing with the march of events, and containing memoranda by Zola himself or by his friends. Antoine Guillemet reported on the functioning of the Salon jury of which he was a member; Francis Jourdain furnished information about architecture, and Béliard about music and musicians. There are also notes on

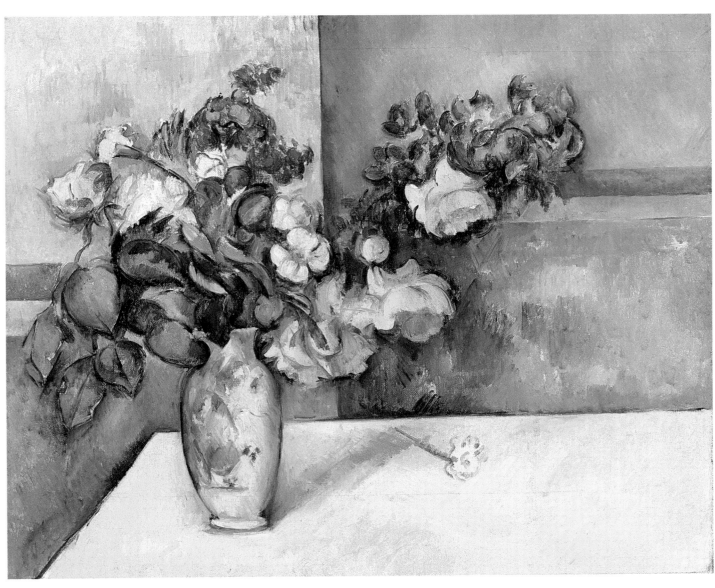

Still Life, Flowers in a Vase.
c. 1885–88

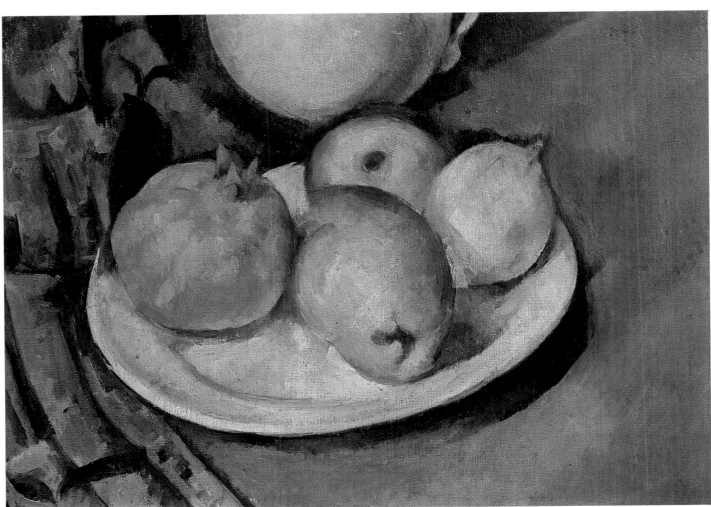

*Still Life with Pomegranate
and Pears on a Plate.*
1885–90

art dealers, including Durand-Ruel and Petit, and on collectors, supplied by Guillemet. Zola once more studied the public, the artists, and the paintings at the Salon and took detailed notes. He also dwelt at length upon the different aspects of Paris, the bridges and quais, views of the Cité, Montmartre, the Place de la Concorde, the cemetery, etc., to which he added some photographs to refresh his memory.

One document that does not appear among Zola's notes but deserves mention has to do with the suicide of Claude Lantier in front of his large canvas. In writing this final episode Zola must have recalled his visit in 1866 to the studio of a young artist who had just committed suicide after being rejected by the Salon jury. Indeed, Zola's famous articles in *L'Evénement* were preceded by a short notice entitled "Un Suicide," in which Zola described this visit to the sad and empty studio and announced his planned attack upon the jury. Thus even Claude Lantier's death, although the logical result of the sequence of events, belongs to the author's memories of his youth.

Sometimes Zola's memories were so little changed that his intimates could easily recognize them. Guillemet, for example, on reading serials of *L'Oeuvre* in the newspaper *Gil Blas*, wrote Zola on February 1, 1886: "... I came across a scene at Bennecourt so masterfully described, so moving, so true that I relived there a little of my—of our—youth; and the small stream of Jeufosse and the islands and all that returned to my memory—and I was deliciously moved. It is so good to become a little younger."

Yet in this dramatized story of artistic effort, the historian finds few authentic data on the epoch of which the author and his characters were both witnesses and actors. Whatever information Zola does provide is to be found in his notes, rather than in the finished work, precisely because there appear the names of those who served as models. In the novel itself Zola's personages present an agglomerate of traits, which prevents their being identified with any one of the author's friends.

Of course the line of demarcation between actual circumstances and those invented by Zola could never be clearly drawn, and this gave rise to misinterpretations. The public, having been prepared by Paul Alexis to find in *L'Oeuvre* portraits of Zola's friends, tried to guess the originals. As it was known that Zola had been closely associated with the group of the Café Guerbois and the Nouvelle-Athènes, his readers expected the novel to offer a romanticized history of Impressionism and the Impressionists. This certainly was not Zola's intention. The public, nevertheless, insisted on seeing in Claude Lantier an impotent Impressionist on the verge of madness. And this unsuccessful painter appeared to be the head of the new school in art. The only member of the group who was then well known to the public and who was considered the leader of the Impressionists was Zola's friend Edouard Manet, who had just died. Even those, like Vincent van Gogh, who were close to the Impressionists, did not hesitate to take the protagonist of the novel for a portrait of Manet.

Because Cézanne was unknown, no one thought that he could have been the model for Claude Lantier. A few years later only, through literary indiscretions, doubtless originating in Médan, it was hinted "that in his novel *L'Oeuvre*, Emile Zola imparted to one of his chief characters the moral traits and artistic ideas of Cézanne."

The surprising fact, however, and one that escaped most readers, is that Claude Lantier actually has few traits in common with Cézanne, Manet, or any other Impressionist. He belongs to no school, for he really is not even a painter; he is the son of a novelist and never quite escapes the influence of his father, Zola. The author doubtless did not intend Claude Lantier to be a true

Impressionist; he wanted to create an artist belonging to no specific group and carrying on all alone his struggle for innovation. But since he planned the *Rougon-Macquart* series as a vast picture of the Second Empire, Zola did not hesitate to make Claude Lantier the exponent of "some of the Impressionist theories," as he had written in his notes. However, he did not succeed in having Claude Lantier do a single Impressionist painting, "some absolutely marvelous things," as was his intention. The works of Claude Lantier are actually literary works because he lacks the Impressionist eye. That Claude Lantier was a "failure" was without a doubt a necessity imposed by the general story of *Les Rougon-Macquart*, but his being a painter imbued with literary spirit and even with academic tradition was an involuntary distortion on Zola's part.

George Moore, friend of Manet and Degas, offers in his *Reminiscences of the Impressionist Painters* some interesting information concerning Zola's own conception of Claude Lantier:

One evening, after a large dinner party given in honor of the publication of *L'Oeuvre*, when most of the guests had gone and the company consisted of *les intimes de la maison*, a discussion arose as to whether Claude Lantier was or was not a man of talent. Madame Charpentier, by dint of much provocative asseveration that he was undistinguished by even any shred of the talent that made Manet a painter for painters, forced Emile Zola to take up the cudgels and defend his hero: Seeing that all were siding with Madame Charpentier, Zola plunged like a bull into the thick of the fray, and did not hesitate to affirm that he had gifted Claude Lantier with infinitely larger qualities than those which nature had bestowed upon Edouard Manet. This statement was received in mute anger by those present, all of whom had been personal friends and warm admirers of Manet's genius, and cared little to hear any word of disparagement spoken of their dead friend. It must be observed that Emile Zola intended no disparagement of Manet, but he was concerned to defend the theory of his book—namely that no painter working in the modern movement had achieved a result equivalent to that which had been achieved by at least three or four writers working in the same movement, inspired by the same ideas, animated by the same estheticism. And, in reply to one who was anxiously urging Degas's claim to the highest consideration, he said: "I cannot accept a man who shuts himself up all his life to draw a ballet girl as ranking coequal in dignity and power with Flaubert, Daudet, or Goncourt."

The way in which Zola confused the subject with its interpretation (judging the subject by its "dignity" and forgetting even to mention the painter's creative effort) clearly reveals his literary approach to art. Zola's ideas were obviously in complete opposition to the very basis of the Impressionist movement. His painter friends were both aroused and pained by his conceptions; Zola's novel not only offended them because of its distortions but also because it reiterated Zola's pronouncements of 1880 in *Le Voltaire* concerning the Impressionists: "They all keep to rough drafts, hasty impressions, and not one of them seems to have the power to be the awaited master. Is it not irritating to see this new recording of light, this passion for truth carried to the point of scientific analysis, this evolution which began with such originality and is delayed and falls into the hands of the clever and is not completed because the essential man has not been born?..."

The disappointment with the novel was general among Zola's painter friends, and Renoir commented: "What a fine book he could have written, not only as an historical record of a very original movement in art, but also as a 'human document,'... if, in *L'Oeuvre* he had taken the trouble simply to relate what he had seen and heard in our reunions and our studios; for here he actually happened to have lived the life of his models. But, fundamentally, Zola did not

Self-Portrait in a White Turban. 1881–82

give a darn about portraying his friends as they really were, that is to say, to their advantage. . . ."

Pissarro did not think otherwise. "I dined with the Impressionists," he wrote his son Lucien in March 1886. "I had a long talk with Huysmans; he is very conversant with the new art and is anxious to break a lance for us. We talked about *L'Oeuvre.* . . . It seems that he had a quarrel with Zola, who is very worried." And Pissarro reports that Antoine Guillemet's enthusiasm had vanished once he had read the entire book.

Indeed, Antoine Guillemet, one of Zola's most fervent admirers, could not refrain from voicing some criticism, and tactfully called the novel "a work of creation rather than of observation," so as not to be obliged to call it badly observed. He wrote Zola:

A very gripping but a very depressing book, all in all. Everyone in it is discouraged, works badly, thinks badly. People endowed with genius or failures all end up by doing poor work; you yourself, at the end of the book, are completely frustrated and depressed; it is pessimism, since the word is fashionable.

Reality is not so sad, fortunately. When I began to paint I had the pleasure and the honor of knowing the wonderful pleiad of modern geniuses: Daumier, Millet, Courbet, Daubigny, and Corot, the most human and pure of them all. All of them died after producing their best work and all their lives they progressed. You yourself, whose friend I am proud to be, do you not always progress and is not *Germinal* one of your finest

works? In your latest book I find only sadness or impotence. . . .

As for the friends who occupy your Thursdays, do you think they end as badly—I mean to say as courageously? Alas, no. Our good Paul is putting on weight in the beautiful sunshine of the South, and Solari is scratching his gods; neither one considers hanging himself—very fortunately.

Let us hope, by God, that the little gang, as Madame Zola calls it, does not try to recognize themselves in your uninteresting heroes, for they are evil into the bargain.

Guillemet's fears concerning the "little gang" were only too justified. Degas alone refused to become upset; his hatred for writers merely made him remark scornfully, at Berthe Morisot's, that he thought Zola had only written *L'Oeuvre* to prove the superiority of the writer over the painter, an opinion consistent with the arguments used by Zola at Madame Charpentier's. Degas doubtless thought it beneath him to discuss such a point of view, but Monet took a different attitude, not only seeing the causes, but also fearing the results. As soon as he had finished the novel, Monet asked Pissarro: "Have you read Zola's book? I am very much afraid it will do us a great deal of harm." But Pissarro was more calm and did not see things in this light.

"I am half through Zola's book," he answered. "No! That is not it. It is a romantic book; I do not know the ending, it doesn't matter, that is not it!— Claude is not carefully studied; Sandoz is done better, one can see that he understood him.—As far as doing us harm is concerned, I don't think so. It is not a successful novel for the author of *L'Assommoir* and *Germinal*, that is all."

Yet, Monet not only considered *L'Oeuvre* an unsuccessful novel, he foresaw the confusion it would create in the public mind and felt he ought to speak to Zola directly of his fears. Realizing that Zola was chiefly guilty of clumsiness and lack of understanding, Monet wrote him from Giverny on April 5, 1886:

My dear Zola,
You were good enough to send me *L'Oeuvre*. I am very grateful to you for it. I have always enjoyed reading your books, and this one was doubly interesting to me because it raises questions about art for which we have been fighting so long. I have just read it and I am worried and upset, I admit.

You were purposely careful to have none of your characters resemble any one of us, but, in spite of that, I am afraid lest our enemies amongst the public and the press identify Manet or ourselves with failures, which is not what you have in mind, I cannot believe it.

Forgive me for telling you this. It is not a criticism; I have read *L'Oeuvre* with great pleasure, finding memories on every page. Moreover you are aware of my fanatical admiration for your talent. No; but I have been struggling for a long time and I am afraid that, just as we are about to meet with success, our enemies may make use of your book to overwhelm us.

Excuse this long letter. Remember me to Madame Zola, and thank you again.
Devotedly yours,
Claude Monet

Zola's reply is not known. We do know, however, his answer to a young student who, several years later, asked him for the real names of his characters in *L'Oeuvre*. "What good would it be to give you names?" Zola wrote. "They are those of failures whom you would hardly know, I think."

Orchard. c. 1890

The Break with Zola

CÉZANNE was closer to Zola than anyone else. He could not be taken in by any disguise or any trick. When, in *Le Ventre de Paris*, Zola had used him for the minor figure of Claude Lantier, Cézanne had doubtless been amused to recognize himself. Now he found his portrait enlarged and retouched in the first chapters of *L'Oeuvre* and, according to Joachim Gasquet, he was profoundly touched. Cézanne described these chapters as being of an authenticity hardly transposed and intimately moving to him, bringing back the most beautiful hours of his youth. Later, when the story branches off, with the character of Lantier threatened by madness, Cézanne understood, as he told Gasquet, that this was necessitated by the plot, that he himself had completely gone from Zola's mind, that—after all—Zola had not written his memoirs but a novel, and one that was part of an immense, carefully planned whole.

Cézanne fully realized the duality of Zola's hero: Paul Cézanne and Claude Lantier at the same time. He was too intelligent not to discern the characteristics that Claude Lantier inherited from the Rougon-Macquarts and realized that they must fatally and logically lead to madness and suicide. On the other hand, Cézanne understood Zola too well, and himself well enough not to experience a painful shock at the description of Sandoz's thoughts on looking at a painting by Lantier:

. . . He recalled their efforts, their certainty of glory, the splendid unlimited hunger, their talk of swallowing Paris in one gulp. At this period how often had he envisaged Claude as the great man whose unbridled genius would far outstrip the talents of others! Great canvases were dreamed of that would shatter the Louvre; a continuing struggle, ten hours of work a day, the entire gift of his being. And then, twenty years of this passion result in this, this poor thing! . . . So many hopes, tortures, a life made up in the hard labor of childbirth, and then that, and then that, my God!

Here Cézanne understood that he himself, rather than Claude Lantier, was the object of Sandoz/Zola's bitter regrets. It was he, his struggles, his dreams of immense paintings, all his efforts, his hopes and discouragements that his friend was evoking. And it was of him that Zola thought when he spoke of the fraternity of artists that united Sandoz with Claude Lantier and that increased when Sandoz, as the novelist said, "saw Claude lose his footing, drown in the heroic folly of art. At first he had been amazed for he had believed in his friend even more than in himself; he had always considered himself second since college, had placed Claude very high among the masters who revolutionize a school. Later he had been seized with a painful compassion for this failure of genius, with a bitter and heartrending pity for this frightful torment of impotence. Did one ever know in art where madness began? All failures moved him to tears. . . . He quivered with charity, with the need of burying piously, in the extravagance of their dreams, these victims of their work."

Rough in aspect and manners, Cézanne had a subtle mind. Step by step he had followed the decline in Zola's enthusiasm, once so overflowing, for the genius of the painter; first the silence about him in Zola's articles, then the

The Forest. 1890–92

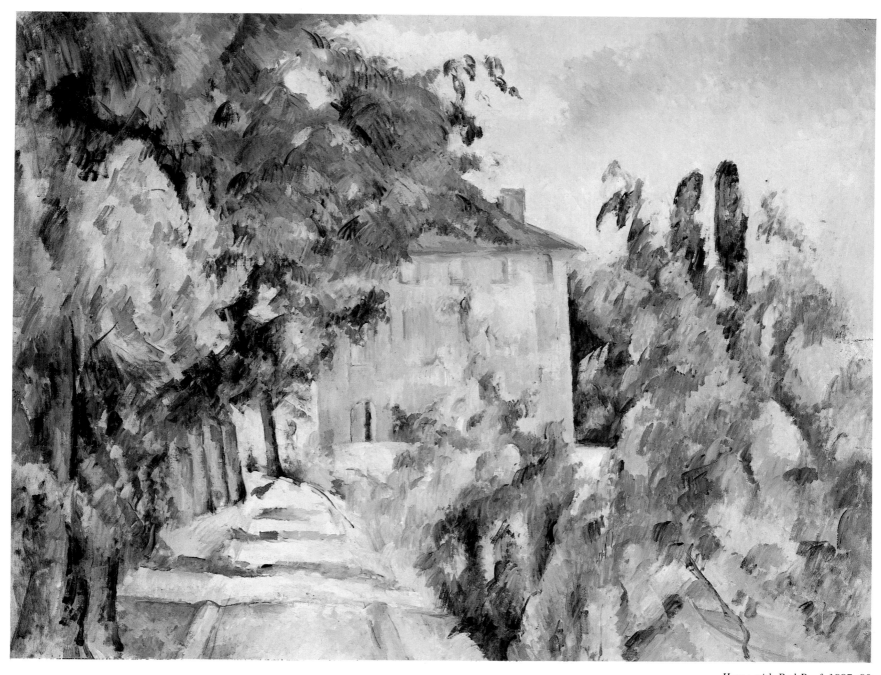

House with Red Roof. 1887–90

reticence in his praise, which seemed addressed to the personal friend rather than the artist, and finally the advice Zola gave him. All this showed Cézanne what was going on in Zola's mind. It was he, Cézanne, the failure, the "abortive genius," as Zola was to say later; it was he as much as Claude Lantier.

Cézanne was deeply hurt, both in his pride and in his friendship for Zola. Hiding immense pride under a modest exterior, Cézanne had, in spite of his moments of doubt and discouragement, a high opinion of his own talent, and his faith in his genius was absolute. His pride did not permit him to show his wound, to allow anyone to guess how much he felt himself hit through the figure of Claude Lantier. Shut up within himself, he knew how to keep the enigma of his acts and his thoughts and when, by chance, a secret escaped his vigilance, Cézanne could obstinately deny it against all evidence. Wishing at any price to hide the truth, he could maintain that *L'Oeuvre* had nothing to do with his break with Zola, just as he had refused to admit to his father that he had a mistress and a child.

It has often been maintained that Cézanne got along better with Zola while Zola was poor and that Cézanne disliked the pretentious environment of Médan. In spite of the affection with which he was treated by Zola and his wife, Cézanne may not have felt quite at his ease in these surroundings, too animated and luxurious for his taste. But do not his repeated visits to Médan show that the painter forgave Zola his way of life, just as the novelist forgave his friend the uncouthness of his dress and manners? Moreover, what importance could their differences of taste have had precisely at that time when Cézanne had retired to the Midi, and how could these differences have stopped an almost brotherly correspondence that had lasted for thirty years?

It is true, however, that all kinds of irritations must have prepared the ground for the break. The two friends had quarreled several times: after Cézanne's first trip to Paris when a certain coldness caused an interruption in their correspondence, and then, after the war of 1870 when Achille Emperaire, staying with Cézanne in Paris, informed some friends in Aix: "I found him completely deserted. . . . Zola, Solari, and the others, there is no question of them."

These two quarrels were probably followed by others, and doubtless all ended in the same way, by reconciliation and a return of affection. But it seems certain that it was not such a temporary misunderstanding that separated the two friends for good. It is in *L'Oeuvre* that one must seek the cause of this break. For, in acknowledging receipt of the book, Cézanne wrote from Gardanne on April 4, 1886:

My dear Emile,
I have just received *L'Oeuvre*, which you were good enough to send me. I thank the author of *Les Rougon-Macquart* for this kind token of remembrance and ask him to permit me to clasp his hand while thinking of bygone years.
Ever yours under the impulse of past times.
Paul Cézanne

Previously, Cézanne had always acknowledged receipt of Zola's books promptly, even if he had only read a few pages, and each time he had expressed his interest or anticipation of pleasure in reading them. In this letter, however, Cézanne does not mention the contents of the book, and it seems that the phrase, "I have just received" is there to excuse him from discussing it. Yet Cézanne may have heard the first chapters from Zola himself, and it is difficult to admit that he should not have read the rest, since *L'Oeuvre* had first appeared in serial form in *Le Gil Blas*, the more so as this *roman à clef* excited the curiosity of all those who had anything to do with the Impressionists. Besides, in February 1886

Cézanne had been at a literary evening with Pissarro where Zola's new novel was judged "absolutely bad" by some young poets. Thus, if Cézanne did not say a word about the novel itself in his letter to Zola, it seems obvious that he did not want to do so.

When thanking Zola for a new book, Cézanne had always written with simplicity and affection, as between friends, but this time he asks the permission to clasp the hand of the author of *Les Rougon-Macquart* while thinking of bygone years, and it is also "under the impulse of past times" that he signs his letter. Everything is for the past—for the present nothing, not a sign of interest, not a word of friendship.

The formal tone of this letter contrasts with that of the other letters, and its spirit of sadness and regret makes it seem like a letter of farewell, which in fact it was, for it marks the end of the correspondence between Cézanne and Zola.

The two friends never saw each other again. It does not seem, either, that Zola ever tried to renew his relations with Cézanne; like all the other friends of the painter, he thus conformed with Cézanne's desire to be left alone. But if the friendship between Zola and Cézanne was broken off, the ties that had united them for more than a quarter of a century were never completely cut. Unlike so many broken friendships, this one does not seem to have ended in bitterness and recrimination; neither one apparently bore any grudge or manifested any animosity.

When in 1891 Paul Alexis, one of Zola's closest friends, spent some time in Aix, Cézanne saw him frequently and showered him with canvases, although Alexis was nearsighted and had little taste for art. Might one not see in Cézanne's cordiality and generosity a gesture of friendship and affection that was not meant for Alexis alone? Doubtless the latter spoke to him at length of Zola, just as he sent a detailed report to Médan on everything Cézanne did, thought, and said.

As for Zola, he retained his affection for his old friend. His face lit up when anyone spoke of Cézanne, and when he himself mentioned the name or evoked their youth, it was with an obvious pleasure mingled with emotion. His daughter remembered with what joy he once showed her some of Cézanne's paintings when visiting Paul Alexis. However, when Gustave Coquiot interviewed him around 1896, Zola appears to have expressed himself somewhat unkindly about Cézanne:

Ah, yes, Cézanne. How I regret not having been able to push him. In my Claude Lantier I have drawn a likeness of him that is actually too mild, for if I had wanted to tell all. . . !

Ah, my dear Cézanne does not think enough of public opinion. He despises too much the most elementary things: hygiene, dress, language. And even all that, dress, self-respect, does not matter very much, after all, if my dear, great Cézanne had only had genius. You may imagine how much it cost me to be obliged to abandon him!. . . Yes, to start out together in the same faith, in the same enthusiasm, and arrive alone, attain glory alone, it is a great pain that weighs you down. Yet it seems to me, in spite of all, that in *L'Oeuvre* I have noted with the most attentive scruples all the efforts of my dear Cézanne. But what would you? There were those successive failures; good starts and then sudden stops; a brain that no longer thought, a hand that fell, powerless. Never anything carried through to the end with magnificent tenacity and force. All in all, no realization whatever!

If the general idea of this interview is correct, the actual wording seems reported rather too freely, for the undertone of false modesty and the philistine reproaches sound unlike Zola. However, there is no doubt that the novelist considered Cézanne a failure. He went even further; he now began to detach himself publicly from the efforts of all his former painter friends.

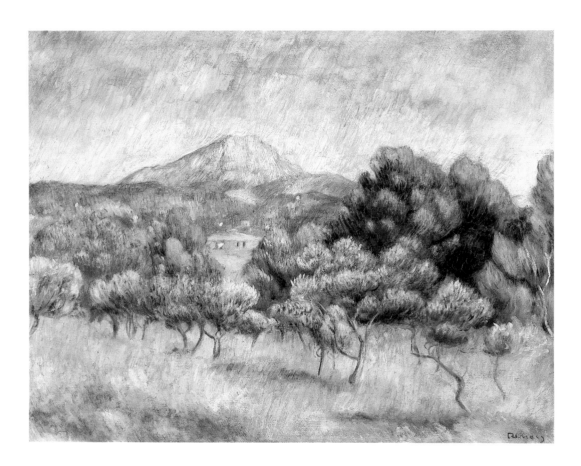

Auguste Renoir. *Mont Sainte-Victoire.* 1889

In May 1896 Zola took up once more the role of art critic, in a review of the official Salon that appeared in *Le Figaro*. It was this new article which revealed to the full extent the abyss that separated him from the Impressionists:

Suddenly the Salon of thirty years ago came back to me, these last few days when I visited the Salon. And what a heartthrob. I was twenty-six, I had just come to *Le Figaro*, which was still called *L'Evénement*. . . . I was then intoxicated with youth, with truth and the intensity of art, drunk with the need of asserting my beliefs with knockdown blows. And I wrote that Salon review of 1866, *Mon Salon*, as I called it with provocative conceit, in which I acclaimed Edouard Manet's talent, and the first articles of which produced such a violent storm, a storm that was to continue around me and that has not stopped for thirty years.

Yes, thirty years have passed and I have somewhat lost interest in painting. I had grown up virtually in the same cradle as Paul Cézanne; one is only now beginning to discover the touches of genius in this abortive great painter. I mixed with a group of young artists, Fantin, Renoir, Guillemet, and others whom life has dispersed and strewn on different stages of success. And in the same way I continued along my path, separating myself from the studios of my friends, taking my passion elsewhere. I think I have written nothing about painting for thirty years. . . . What a shock I felt in my breast when this whole past was resurrected for me by the thought that I was writing for *Le Figaro* again and that it would be interesting to talk about painting once more after a silence of almost a third of a century!

Let us assume that I slept for thirty years. Yesterday I was still pounding with Cézanne the hard pavement of Paris in the fever of conquering it. Yesterday I went to the Salon of 1866 with Manet, Monet, and Pissarro, whose paintings had been summarily rejected. And after a long night I awaken and go to the Salon. . . . O amazement! O unexpected and astounding wonder of life! O harvest whose seeds I saw and which astonishes me as though it were the most wild and unforeseen thing. What strikes me first is the clear, dominating tone. Everything is by Manet, Monet, Pissarro! Formerly when one of their canvases was hung in a room, it made a hole of light among the others. . . . It was the window open to nature, the famous open air that came in. And nowadays there is only open air, everyone followed my friends after having insulted them and me. Well, so much the better! Conversions are always pleasing.

What doubles my astonishment is the fervor of the converts, the abuse of the clear

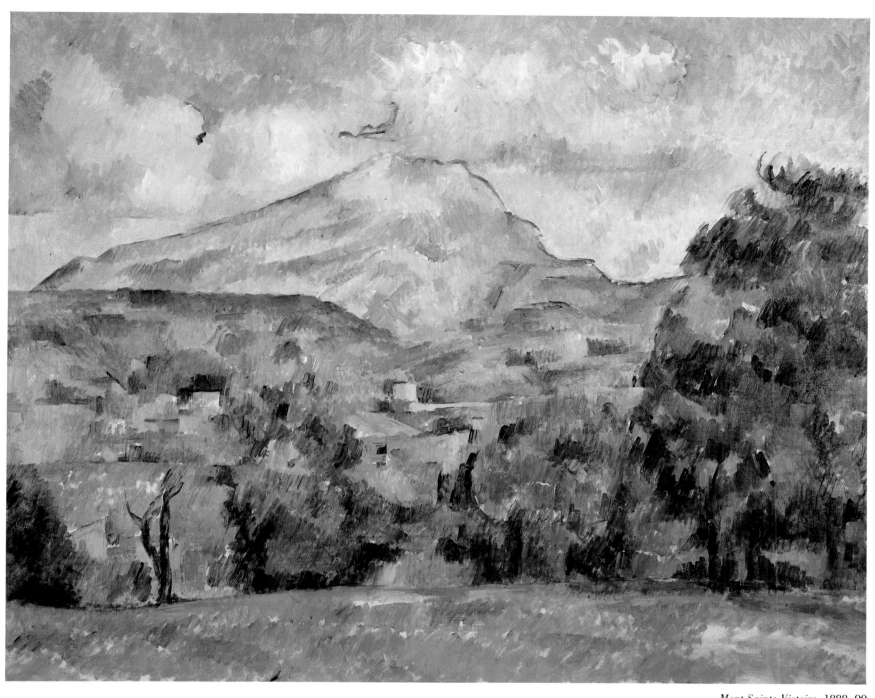

Mont Sainte-Victoire. 1888–90

tone, which makes certain works look like laundry discolored by extensive washing. New religions, when admixed with fashion, are terrible in that they exceed the bounds of common sense. And when I see this diluted, whitewashed Salon with its chalky insipidity, I almost begin to long for the black, bituminous Salon of yore. It was too black, but this one is too white. Life is more varied, warmer, and more flexible. And I who fought so violently for the open air and light tones, am little by little exasperated by this continuous procession of bloodless pictures, with dreamlike pallor, a premeditated green sickness aggravated by fashion, and I long for the artist of boldness and darkness!

But where my surprise turns to anger is in observing the insanity to which the theory of reflected light has led, in thirty years. Another of the victories won by us, the precursors! We maintained, very accurately, that the illumination of objects and figures is not simple; that under trees, for instance, nude flesh becomes green; that there is thus a continuous interchange of reflections that must be taken into account if one wishes to imbue a work with lifelike light. Light ceaselessly decomposes, breaks up, and scatters. . . . But as soon as it is dwelt upon, as soon as reason begins to play a role in it, caricature quickly results. And these are really disconcerting works, these multicolored women, these violet landscapes and orange houses which are being given us with scientific explanations that they are like that as the result of a certain reflection or decomposition of the solar spectrum. O! The ladies who have one blue cheek in the moonlight and the other one vermilion under a lampshade! O! The horizons with blue trees, red water, and green skies! It is dreadful, dreadful, dreadful!

. . . These bright canvases, these open windows of Impressionism, how well I know them—they are by Manet and because of them I was almost killed when I was young! These studies of reflection, this flesh with leaf-green tones, this water in which all prismatic colors dance, how well I know them, they are by Monet, and I defended them and was called insane! These decompositions of light, these horizons with blue trees, how well I know them, they are by Pissarro, and newspapers were once closed to me because I dared to say that such effects were found in nature.

And those are the canvases formerly rejected violently at each Salon; nowadays they are exaggerated, have become dreadful and countless! The seeds that I saw sown have sprouted, have borne fruit of a monstrous kind. I recoil in fright! Never have I been more aware of the danger of formulas, the pitiful end of schools when the founders have done their work and the masters have gone. Every movement becomes exaggerated, becomes a mere process and a lie as soon as it is taken up by fashion. There is no truth that is good in the beginning, for which theoretically one would shed one's blood, that does not become, through imitation, the worst of errors, the tare that must be ruthlessly mowed down.

I awaken and shudder. What! Was it really for this that I fought? For this bright painting, these spots, these reflections, this decomposition of light? Lord! Was I mad? But it is very ugly, I find it repulsive! Ah! The futility of discussions, of formulas and schools. And when I left the Salon of this year I asked myself whether the task I had once performed was a bad one.

No, I did my duty, I fought the good fight, I was twenty-six, I was with the young and the brave. That which I defended I would defend again, for it was the daring of the moment, the flag that had to be planted on enemy territory. We were right only because we represented enthusiasm and faith. The truth we established, however small, is accepted today. And if the road that was opened up has become trite, this is because we widened it in order that the art of a period might pass over it.

This article was called by Gustave Geffroy, Monet's intimate friend, "a kind of flourish of the trumpets of victory played like a funeral march." Some have seen in Zola's outcry: "Was it really for this that I fought?" a disowning of the old battles, but it is rather an avowal of his own incomprehension. Having once fought for something new that was the butt of ridicule, now, the battle won, Zola was left undecided, unsure of the position he should take. His heart and temperament had been with the innovators, but later on his reason had alienated him from an art he did not understand and that seemed to him to be careless and casual.

While legitimately proud of the role he once played as the mouthpiece of

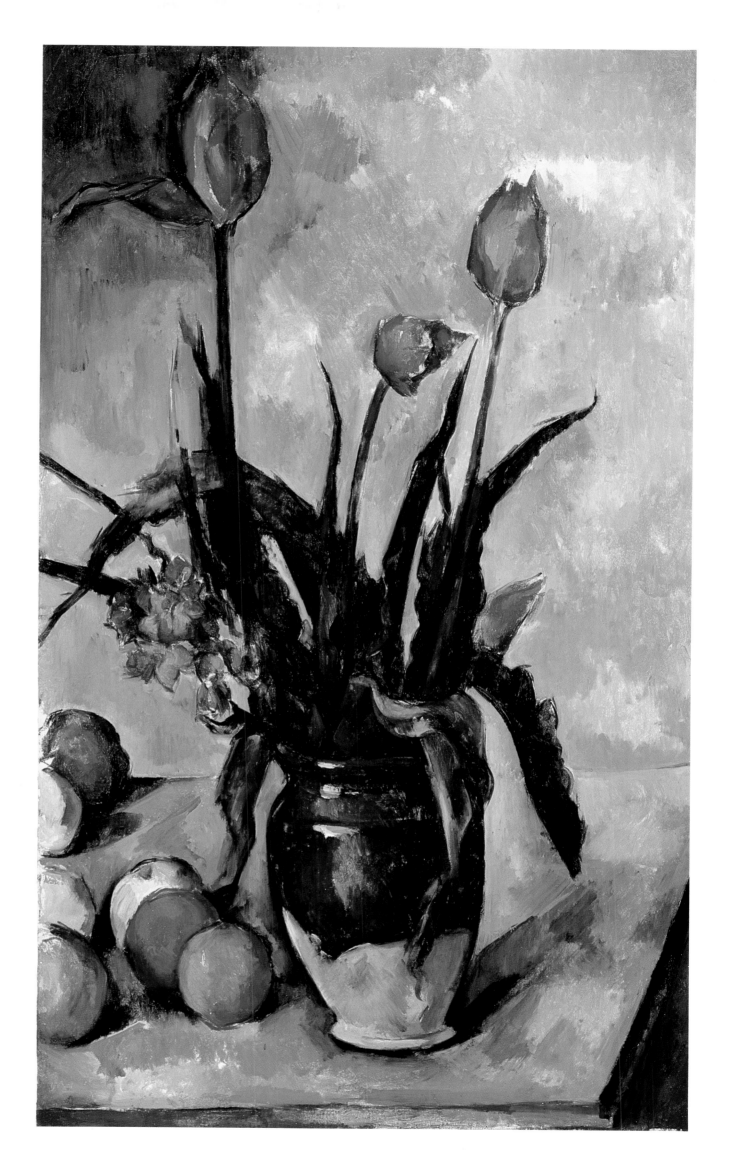

Tulips in a Vase. 1890–92

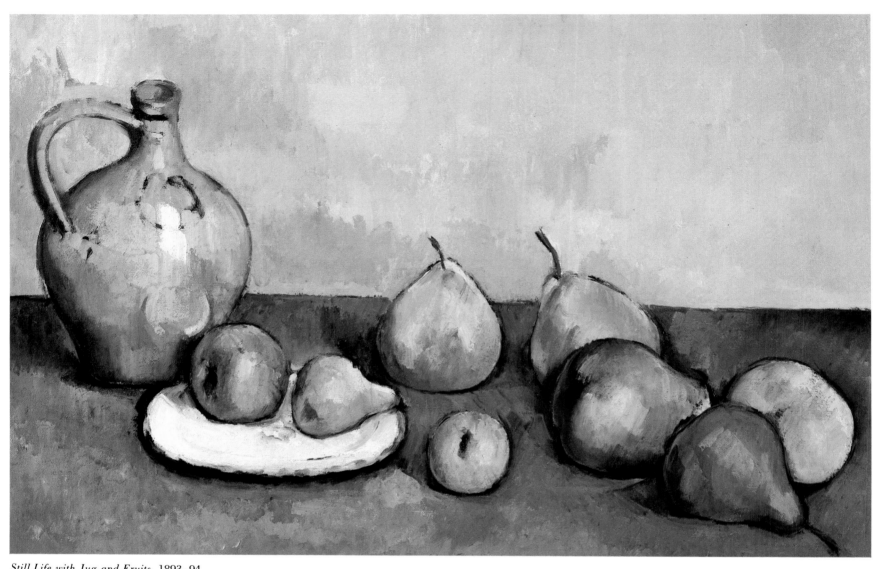

Still Life with Jug and Fruits. 1893–94

Still Life with Jug and Fruits on a Table. 1893–94

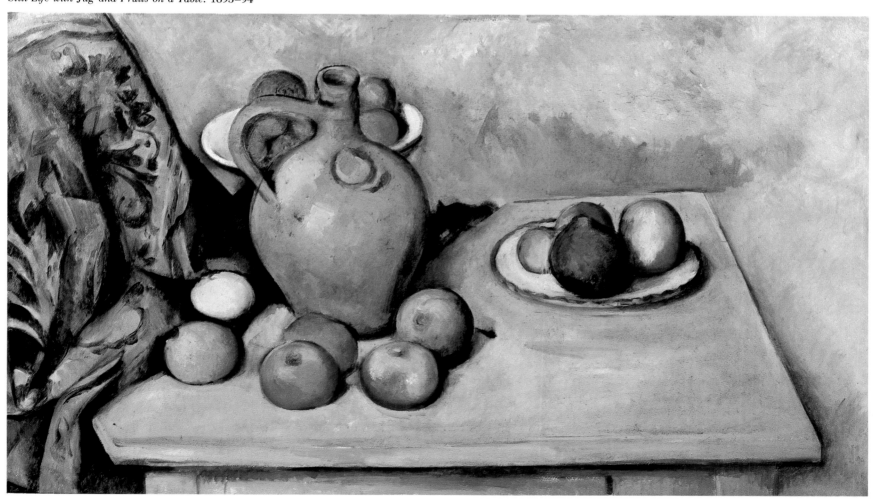

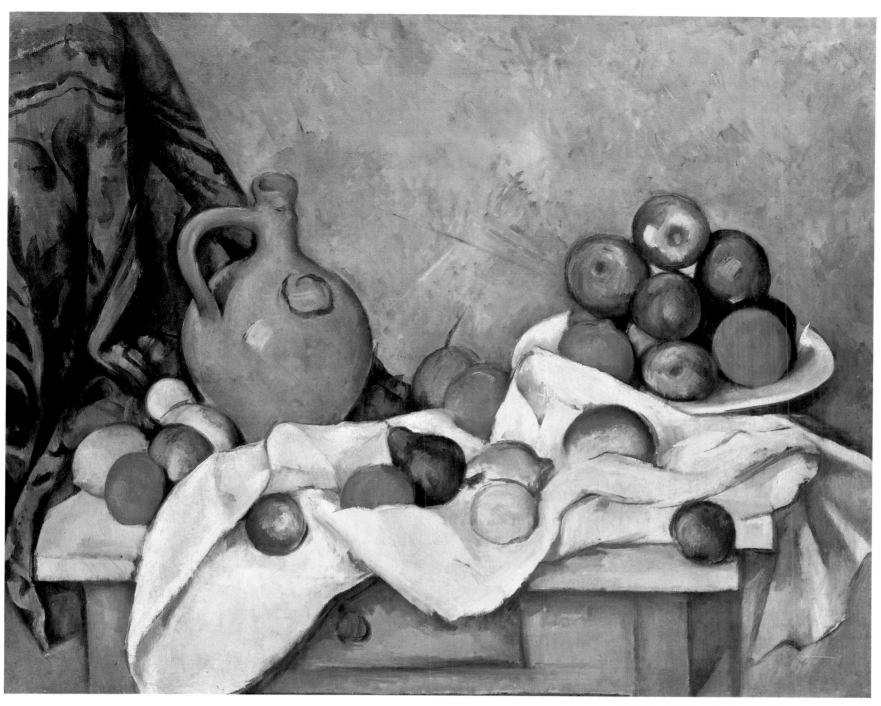

Still Life with Curtain, Jug, and Compotier. 1893–94

Though even some of his admirers accused Cézanne of lacking imagination, he showed a superb inventiveness when—using more or less the same objects—he assembled several series of still lifes in which each of these objects plays a completely different role. Without repeating the arrangements, he managed, quite to the contrary, to achieve every time a new balance and a new harmony of colors by shifting the familiar objects and regrouping them in an astonishing variety of compositions.

181

Manet and his group, Zola could not and did not know that the views he had so ardently and aggressively defended appeared rather "dated" some twenty years later. But Vincent van Gogh saw this clearly when, in 1883, he had read Zola's Salon reviews of 1866, assembled in the volume *Mes Haines*. Despite his boundless admiration for Zola as a novelist, van Gogh judged Zola's art criticism as a painter. As he wrote to a friend:

I am not among those who are furious at him for having written that book. Through it I am learning to know Zola, I am learning to know his weak side, to realize that his knowledge of the art of painting is insufficient, that it is, in this particular case, *prejudice* instead of being a *just judgment*. But I am far from being angry with a friend because he has some defects. On the contrary, I like him the better for them. That is why I am reading his articles on the Salon with a very special feeling. I believe that he is absolutely barking up the wrong tree, with the exception of the section concerning his appreciation of Manet. . . . Yet it is interesting to become acquainted with Zola's ideas on art. That is just as interesting, for example, as what a landscapist says of a portrait painter; in other words, that is not of his domain, and that is why it is superficial and full of errors. So, let him talk when he says that "this thing is not finished" or "this is not light enough." Let him talk. It only leads you to reflection, and I find it nevertheless original and full of life, even when it is erroneous and false and beside the point.

But Zola's former painter friends, who obviously had become similarly aware of his shortcomings as an art critic, did not judge his recent article in *Le Figaro* of May 1896 with van Gogh's mildness. Was he not proclaiming—rather than sharing their satisfaction with the progress achieved, rather than rejoicing in the slow and steadily growing influence of their work—was he not proclaiming that already their movement was turning into a lie? No wonder his latest pronouncement created great bitterness in the Impressionist camp. Not satisfied with dropping his support of Monet, Renoir, and Pissarro, who were about to win recognition, Zola had expressed his disillusionment and attacked the only one of their group who was still struggling, calling him an "abortive genius."

Two years after the publication of this article, however, when Joachim Gasquet visited Zola, the novelist spoke of Cézanne with "the most affectionate admiration." He always felt for Cézanne, "in spite of his sulkiness, all the friendship of a big fraternal heart."

"And I even," Zola told Gasquet, "begin to better understand his painting, which I have always liked but which for a long time I did not understand, for I thought it exaggerated, whereas actually it is unbelievably sincere and truthful." And in 1900 Zola supposedly said to Frank Harris that Cézanne was one of the greatest painters who had ever lived. But when Harris asked him why he had never written any books on the art of painting, the novelist replied quite openly that this was not his field and that he felt like an outsider.

Zola made no attempt to renew his friendship with Cézanne. When he went to Aix to stay for a few days with Numa Coste in 1896, the very year his article in *Le Figaro* was published, Zola did not get in touch with Cézanne. He apparently thought that after the years of separation a meeting might be painful, and that it was better to forget than to patch up a friendship that seemed fated to be broken.

Back in Paris, Zola wrote a few words to Numa Coste: "My short stay in Aix already seems like a dream, but a charming dream, in which I relived a little of my youth, and in which I saw you again, my dear friend, you who were part of that youth."

Cézanne, who also, and how much more, had been part of that youth, received a terrible shock when he learned that Zola had been in Aix, that they had been in the same town without meeting each other. His pain was profound and bitter, for he saw in this gesture of Zola's the sign that there were no more ties between

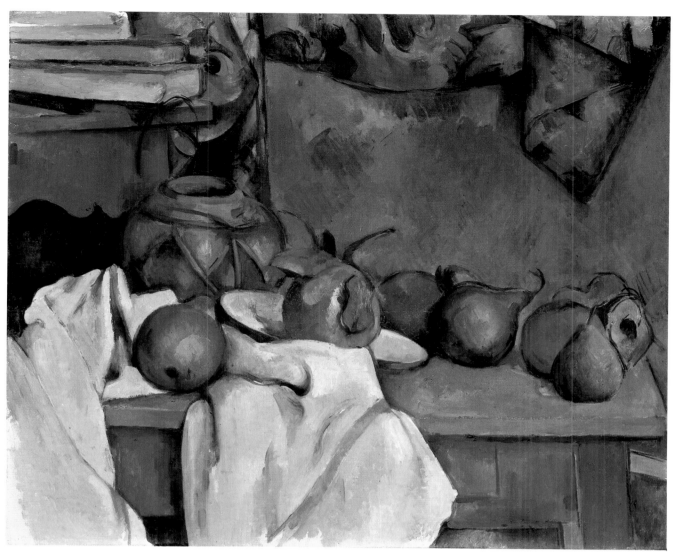

The Ginger Jar, also known as
Still Life with Pomegranate and Pears.
1890–93

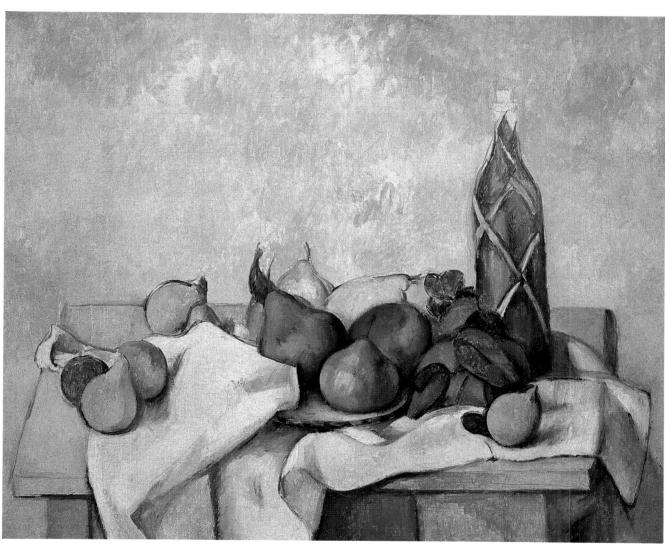

Still Life with Rum Bottle. c. 1890

The chestnut trees at the Jas de Bouffan
in winter. Photograph c. 1935

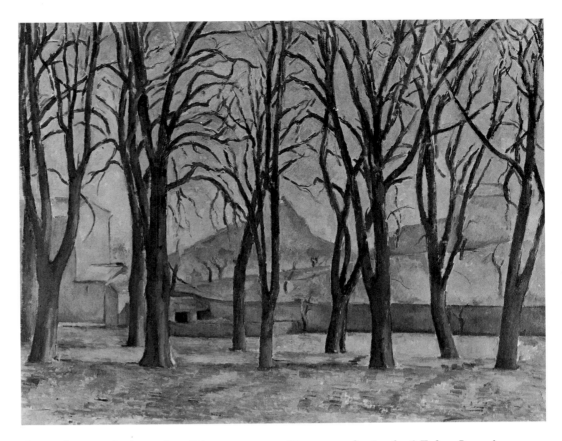

Chestnut Trees at the Jas de Bouffan in Winter. 1885–86

them. It was obvious that Cézanne was still extremely fond of Zola. Just the same, if Gasquet can be trusted (which is not always the case) Cézanne once told him that "nothing is more dangerous for a painter than to let himself go to literature. I know what I am talking about. The damage that Proudhon did to Courbet, Zola might have done to me. . . . I appreciate that Flaubert, in his letters, strictly avoids speaking of an art of the technique of which he was ignorant. . . ."

Nevertheless, Cézanne never completely detached himself from Zola. This became evident during the Dreyfus scandal. Though the painter did not believe in the innocence of the captain and did not approve of Zola's role in the affair, he judged him with an indulgence rather surprising in a man with so unrestrained a temper. Questioned about Zola in 1898, Cézanne merely laughed and commented: "They took him in." Monet and Pissarro, however, forgot their grievances against the novelist and joined him in his fight for justice.

In 1899, at the height of the Dreyfus scandal, Cézanne had lunch in Paris with Maurice Le Blond and Joachim Gasquet. They tried to persuade him to accompany them to Zola's, where they were expected that afternoon. Cézanne replied evasively, but when, on leaving the table, they attempted to take Cézanne by the arm and make him go with them, he gave such screams of fright that they were obliged to let him go. Cézanne must have felt instinctively that an impromptu visit before strangers in an effort to repair the break would be unworthy of the friendship that had been theirs. Perhaps Cézanne was also afraid of showing his emotions, he who often had difficulty holding back his tears.

When, on a September morning in 1902, Cézanne learned from his gardener that Zola had died, asphyxiated by fumes from a defective chimney, he was shattered. He burst into tears and locked himself up in his studio for the rest of the day, alone with his grief. Death immediately effaced all real or imaginary grievances. Now, before his eyes, Cézanne saw his whole life from their childhood to the break, and always he found at his side the untiringly good and devoted friend, the support in difficult days, the enthusiast who in his youthful dreams had conceived fame only as shared with him. It was a part of himself that had ceased to be.

I SOLATION is what I am worthy of. Thus, at least, no one gets me in his clutches." This was to become Cézanne's guiding thought, although from time to time he emerged from his retreat. It was a retreat without stability and quiet. In Aix he largely lost touch with the outer world, except when, in 1889, Renoir with his wife and son reciprocated Cézanne's visit to La Roche-Guyon. Renoir rented Bellevue from Cézanne's brother-in-law, Maxime Conil, and spent several months there. The two friends occasionally painted together in the Arc valley or put up their easels in front of the picturesque pigeon tower of Bellevue. But it seems that Renoir's stay in Aix did not end on a harmonious note. Indeed, Cézanne became increasingly irritable, and the diabetes from which he began to suffer around 1890 accentuated his occasional outbursts. In any case, after a short stay at the Jas de Bouffan, Renoir informed Monet: "We had to suddenly leave Mother Cézanne because of the sordid stinginess prevailing in that house."

Like all recluses, Cézanne sometimes enjoyed talking. Overflowing with confidence, he then grew very expansive and exuberant. "It does me good," he would say. "I am happy to loosen up." It was at such a moment that Paul Alexis found the painter in 1891 and received his confidences. In a letter to Zola Alexis wrote:

. . . This town is dreary, desolate, and paralyzing. Coste, the only one I see fairly often, isn't much fun every day. . . . Fortunately, Cézanne, to whom I found my way back some time ago, puts some spirit and life into my daily round. He at least is vibrant, expansive, and alive. He is furious at the Ball, who, to make up for a stay of a year in Paris, last summer inflicted upon him five months of Switzerland and of table d'hôte . . . where he found little sympathy except from a Prussian. After Switzerland, the Ball, escorted by her bourgeois son, made off again to Paris, but by cutting her allowance in half she has been brought back to Aix. . . .

During the day Cézanne paints at the Jas de Bouffan where a workman serves as his model and where one of these days I shall go to see what he is doing.—Finally, to complete his portrait, converted, he believes and practices.

Zola apparently had asked all his friends for news of Cézanne, and Numa Coste wrote to him at about the same time:

How to explain that a rapacious and tough banker could produce a being like our poor friend Cézanne, whom I have seen recently? He is well and physically solid, but he has become timid and primitive and younger than ever. He lives at the Jas de Bouffan with his mother, who, for that matter, is on bad terms with the Ball, who in turn does not get on with her sister-in-law, nor they among themselves. So that Paul lives on one side, his wife on the other. And it is one of the most touching things I know to see this good fellow retain his childlike naiveté, forget the disappointments of the struggle, and obstinately continue, resigned and suffering, the pursuit of a work he cannot produce.

The condescension with which Zola and his friends treated Cézanne contrasts sharply with the ever-rising esteem expressed by his painter friends. In the fall of 1894 Cézanne went for a short while to Giverny, where he stayed at the inn but saw Monet frequently. On November 12 Monet wrote to Geffroy: "Day after tomorrow, Wednesday, will be my birthday (fifty-four years); you would give me

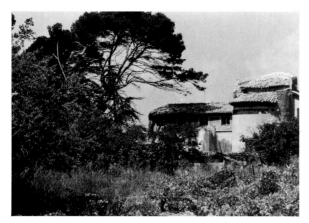

The Pigeon Tower at Bellevue. Photograph c. 1935

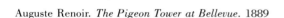

Auguste Renoir. *The Pigeon Tower at Bellevue.* 1889

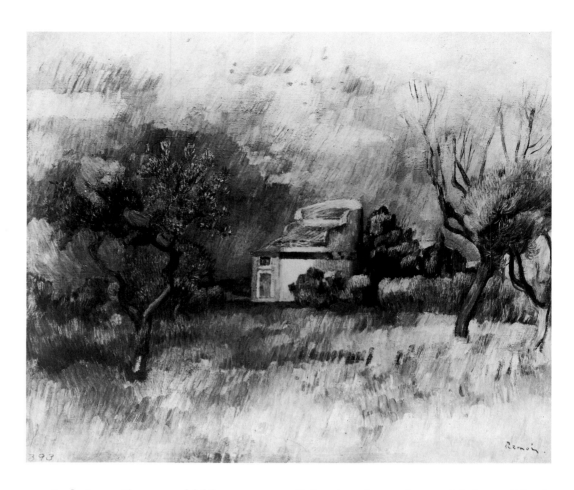

great pleasure if you could liberate yourself for that day and spend it here. I had hoped also to see Mirbeau but his wife is sick. But you will meet Cézanne, who arrived here a few days ago and who will be as happy to meet you as you'll be to get acquainted with him." At the birthday celebration, Monet introduced Cézanne to Clemenceau, Rodin, and Gustave Geffroy. Cézanne was deeply touched by the cordial manner in which he was treated; an affectionate handshake by Rodin in Monet's garden, for example, almost moved him to tears. According to Geffroy, for whom Cézanne showed a special liking, the painter was at that moment as sociable as could be and proved that he was enjoying himself by his laughter and his sallies. Eventually Cézanne also met the novelist and critic Octave Mirbeau through Monet.

It was during this visit to Giverny that Mary Cassatt for the first time ran into Cézanne. In a letter to one of her American friends she described her impressions:

The circle has been increased by a celebrity in the person of the first Impressionist, Monsieur Cézanne—"the inventor of Impressionism," as Madame D. calls him. . . . Monsieur Cézanne is from Provence and is like the man from the Midi whom Daudet describes; when I first saw him I thought he looked like a cutthroat with large red eyeballs standing out from his head in a most ferocious manner, a rather fierce-looking pointed beard, quite gray, and an excited way of talking that positively made the dishes rattle. I found later on that I had misjudged his appearance, for far from being fierce or a cutthroat, he has the gentlest nature possible, *comme un enfant* as he would say. His manners at first rather startled me—he scrapes his soup plate, then lifts it and pours the remaining drops in the spoon; he even takes his chop in his fingers and pulls the meat from the bone. He eats with his knife and accompanies every gesture, every movement of his hand, with that implement, which he grasps firmly when he commences his meal and never puts down until he leaves the table. Yet in spite of the total disregard of the dictionary of manners, he shows a politeness toward us that no other man here would have shown. He will not allow Louise to serve him before us in the usual order of succession at the table; he is even deferential to that stupid maid, and he pulls off the old tam-o'-shanter, which he wears to protect his bald head, when he enters the room. I am gradually learning that appearances are not to be relied upon over here. . . .

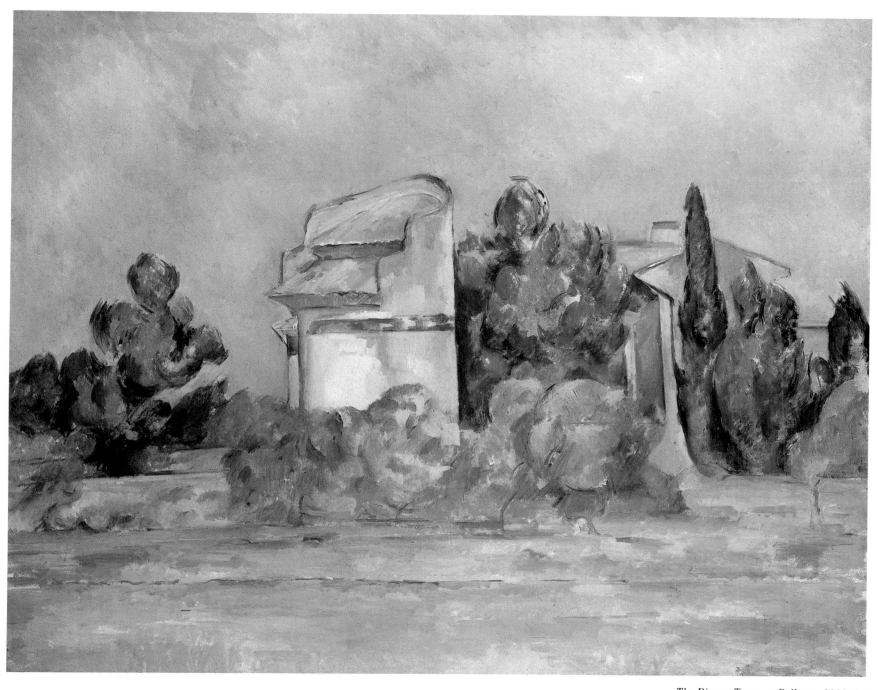

The Pigeon Tower at Bellevue. 1889–90

The conversation at lunch and at dinner is principally on art and cooking. Cézanne is one of the most liberal artists I have ever seen. He prefaces every remark with: *Pour moi* it is so and so, but he grants that everyone may be as honest and as true to nature from their convictions; he doesn't believe that everyone should see alike.

In Giverny Cézanne also met with the sympathy of Clemenceau, who found in the painter a good audience for his jokes. Cézanne, however, had little confidence in the statesman; he explained to Geffroy: "It is because I am too weak . . . and Clemenceau could not protect me! . . . Only the Church can protect me." And Monet wrote to a friend: "How unfortunate that this man should not have had more support in his existence. He is a true artist who has much too much self-doubt. He needs to be bolstered up. . . ."

Cézanne's touchiness and fear of people finally made him suspicious of even his most devoted friends. When Monet, precisely in an effort to bolster him up, on another occasion gathered a few friends in Giverny, among them Renoir and Sisley, he received Cézanne with the words: "At last we are here all together and are happy to seize this occasion to tell you how fond we are of you and how much we admire your art." Dismayed, Cézanne stared at his friend. "You, too, are making fun of me!" were his only words. He turned, took his coat, and left.

Cézanne departed from Giverny so abruptly that he abandoned a number of his unfinished canvases at the inn; Monet picked some of them up and sent them after him. From Aix Cézanne later wrote him: "So here I am back again in the South, which I ought, perhaps, never to have left, to fling myself once more into the chimerical pursuit of art. . . . May I tell you how grateful I was for the moral support I found in you and which served as stimulus for my painting."

As usual, despair followed periods of enthusiasm for Cézanne, and this moodiness hampered his work and kept him in a state of exasperation. Back in Paris in the spring of 1895 and hopeful of painting a picture that might at last receive a medal at the Salon, Cézanne asked Gustave Geffroy to pose for a portrait in his library. After having worked on this daily for three months, Cézanne suddenly sent for his easel, brushes, and paints with a note saying that the undertaking was definitely too much for him, that he had been wrong to begin it, and excused himself for abandoning it. At Geffroy's suggestion, Cézanne returned to work on this portrait for another week, but he no longer had faith in it and left for Aix.

Even in Aix Cézanne did not find the peace he sought. Before leaving Paris he had renewed his old friendship with Francisco Oller, whom he had first met more than thirty years before at the Atelier Suisse. After "numerous tokens of affection and southern warmth," Oller accepted Cézanne's invitation to accompany him to Aix. A few weeks later, however, Oller wrote to Pissarro: "My dear, Mr. Paul Cézanne is either a *canaille* or he is mad. He has played on me the dirtiest trick you could imagine."

This is what had happened: Cézanne and Oller had agreed to meet on the train for Aix at the third-class carriages. Unable to find Cézanne there—for the very good reason that he had taken a first-class compartment—Oller did not get on the train at all. With still no Cézanne in view, he decided to take the next train. Arrived in Aix, he sent word of his presence to the Jas de Bouffan, and Cézanne replied without delay. "If this is so, please come right away. I am expecting you."

The two painters thereupon saw each other for a couple of weeks, but when Oller began to give his friend some advice on painting, Cézanne burst forth with this letter:

Sir,

The highhanded manner you have adopted toward me for some time and the rather brusque tone you permitted yourself to use, at the moment you took leave, are not calculated to please me.

I am determined not to receive you in my father's house.

The lessons that you take the liberty of giving me will thus have borne their fruits. Good-bye.

P. Cézanne

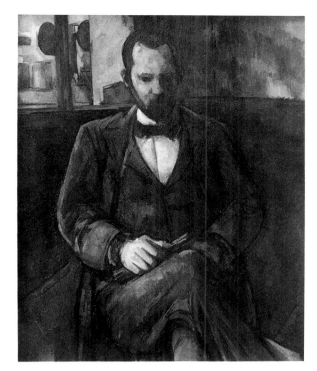

Portrait of Ambroise Vollard. 1899

Oller forwarded this letter to Pissarro, doubtless to ask him to intercede in this painful incident. "I saw Oller yesterday," Pissarro wrote his wife from Paris in January 1896. "He spoke to me a great deal about Cézanne, whose behavior, it seems, has been incredible. He was even worse than with Renoir. He brought Oller to Aix and stuck him there in extraordinary circumstances. I shall tell you about that verbally, it is too long.... Dr. Aguiard has come to Paris for a few days. He has seen Cézanne; he is sure that he is sick. In short, poor Cézanne is incensed with all of us, even with Monet, who, after all, has been very nice to him."

Oller also reported to Pissarro disparaging remarks Cézanne had made about him. "Pissarro is an old fool, Monet a cunning fellow, they have nothing in them.... I am the only one with temperament, I am the only one who can paint a red!..." When Dr. Aguiard assured him that Cézanne was not responsible for his fits of rage, Pissarro exclaimed in a letter to his son Lucien: "Is it not sad and a pity that a man endowed with such beautiful temperament should have so little balance?"

The strange thing about all this is that the year 1895 was to offer Cézanne for the first time in many decades some real satisfaction. A young dealer, Ambroise Vollard, had opened in December 1895 a large one-man show of Cézanne in Paris, and though the critics were rather hostile, for many young painters and a few avant-garde collectors this had proved to be the artistic event of the year. But even this success could not dispel Cézanne's somber mood, and in April 1896 Numa Coste wrote from Aix to Zola:

I have seen recently and still often see Cézanne and Solari, who have been here for some time.... Cézanne is very depressed and is often the prey of melancholy thoughts. He has some self-satisfaction, however, and his work is having sales to which he has not been accustomed. But his wife must have made him do quite a lot of foolish things. He has to go to Paris or return from there according to her orders. To have peace, he has had to give up all he has, and confidential remarks dropped by him reveal that he has only got left a monthly income of about a hundred francs. He has rented a cabin at the quarry above the dam and spends the greater part of his time there.

In Aix Cézanne still lived with his aged mother at the Jas de Bouffan. Her advanced age had little by little deprived her of physical and mental health. Her son cared for her in the most affectionate way.

At the Jas de Bouffan, Cézanne found the solitude he desired. He often worked in the garden, which at every season offered him new and striking aspects: in summer the shady row of chestnuts whose heavy foliage partly hid the house, in winter the bare branches of the trees, which allowed the distant silhouette of Mont Sainte-Victoire to be seen and to reflect itself in the pool. Besides these landscapes, Cézanne also painted still lifes and above all, portraits. He used some peasants and day laborers at the Jas as models for the different paintings of Cardplayers and of men smoking. A peasant woman was

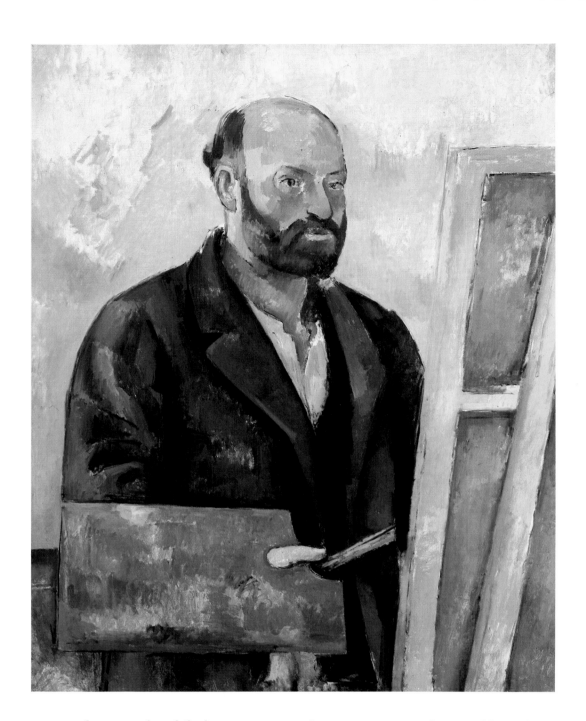

Self-Portrait with Palette. c. 1890

portrayed as a cook, while her son appears in a painting seated at a table with a skull in front of him. Whenever Cézanne's wife and son were in Aix, they too posed for him. To sit for the painter was not an easy matter; he often demanded uncomfortable poses and insisted that they be held for hours on end. His wife was one of the few who consented to go through with this ordeal repeatedly. On many occasions Cézanne also did self-portraits.

Cézanne worked very slowly and needed a week of daily sessions just to sketch on the canvas the contours of the model, a few shadows, and some indications of color. For his still lifes he was obliged to use paper flowers and artificial fruit, for real flowers wilted and fruit rotted before the work was far advanced. One hundred sittings for a portrait—such as he requested from Vollard—were nothing unusual, and even then he was not always satisfied with the result. When he had no model, Cézanne occasionally copied illustrations from his sister's magazines and thus painted a version of El Greco's *Lady in Ermine*.

Since working with Pissarro at Pontoise, Cézanne's knowledge of technique had greatly developed. He applied his colors less thickly as his brushes more easily expressed his vision. But his canvases still are sometimes covered, at least in part, with several layers of paint that bear witness to long and painful efforts. The technique differs widely in his paintings; in some the limpidity of tone corresponds to the thinness of the pigment and only the dark tones are composed

OPPOSITE:
Madame Cézanne in the Conservatory. 1891–92

190

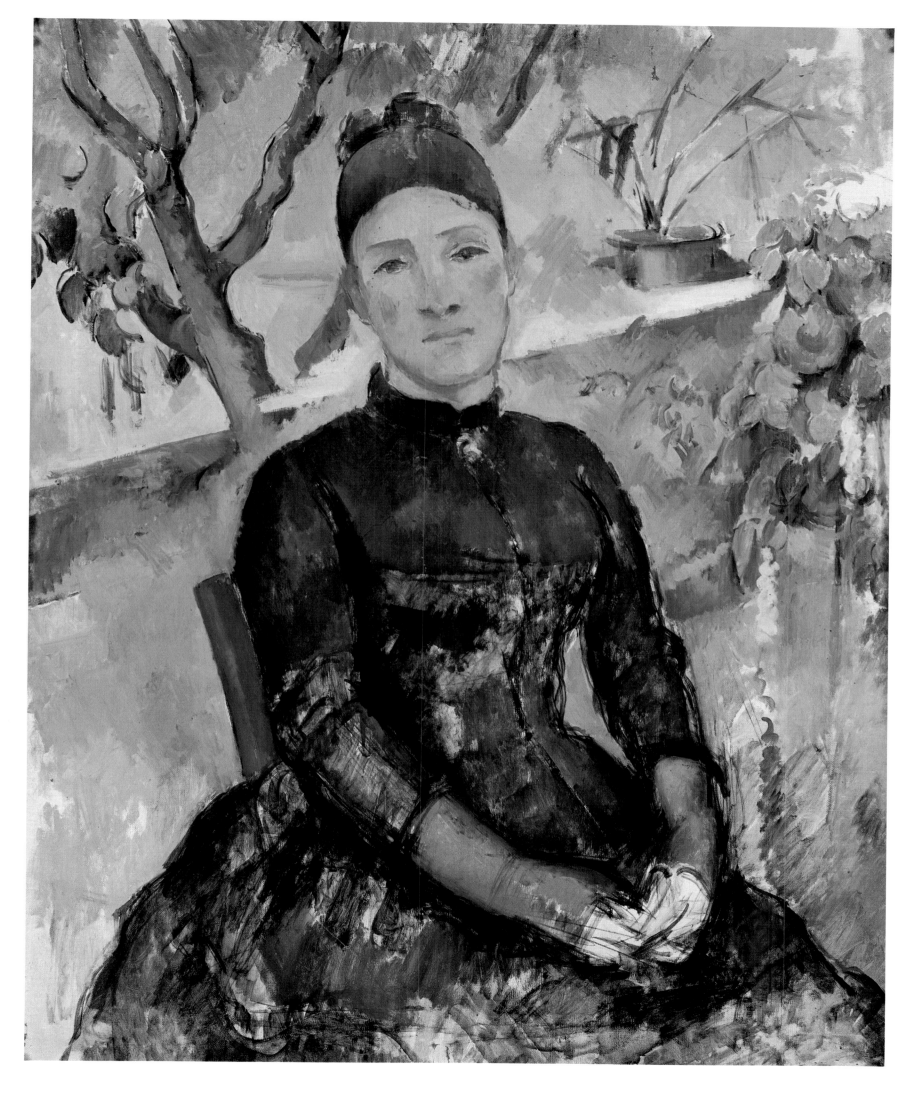

by a multitude of touches of color. In others Cézanne used the opposite method. The brushstrokes are not always the same, either; sometimes they are short and wide, while in other works they are long and narrow. The direction of the brushstrokes varies from painting to painting. Cézanne's technique was visibly dictated by the nature of the subject, by the lighting, and possibly also by his mood.

But Cézanne considered technique subordinate to sensitivity. He once remarked: "Technique grows in contact with nature. It develops through circumstances. It consists in seeking to express what one feels, in organizing sensations into personal esthetics." And he told Renoir: "It took me forty years to find out that painting is not sculpture." To this Renoir commented: "That means that at first he thought he must force his effects of modeling with black and white and load his canvases with paint, in order to equal, if he could, the effects of sculpture. Later, his study brought him to see that the work of the painter is so to use color that, even when it is laid on very thinly, it gives the full result."

Cézanne summed up his feelings about technique in these words: "I believe in the logical development of everything we see and feel through the study of nature and turn my attention to technical questions later; for technical problems are for us only the means of making the public feel what we painters feel and of making ourselves understood. The great masters whom we admire can have done nothing else."

After the death of Cézanne's mother in 1897, Marie Cézanne looked after her brother's affairs. In order to settle the estate, and at the insistence of Maxime Conil, the Jas de Bouffan had to be sold in November 1899 for 100,000 francs. In spite of his share of 33,000 francs, Conil, the following month, sold to Vollard two paintings that Cézanne must have given him, and the next year he was threatened by foreclosure. Conil, apparently, was constantly debt ridden; he seems to have been a chronic gambler, a circumstance that helped him go through his wife's considerable inheritance (and eventually to leave his children penniless).

Nothing is known of the reasons that induced the painter to agree to the sale of the Jas de Bouffan, which remains puzzling because it was perfectly within his means to buy up the shares of the two others. Perhaps he felt that he had fully explored all the possibilities of the beautiful estate? It seems more likely, however, that he wished to escape the many memories—both happy and unhappy—attached to the place; also he may have considered it much too big for his modest life-style, especially since his wife and son frequently resided in Paris and he found himself alone most of the time. Moreover, there might have been considerable expenses attached to the upkeep of the property and the exploitation of its vineyards, expenses he may have found hard to meet once his wife began exceeding her budget. It is probable, in any case, that his wife detested the Jas, from which she had been "banned" for many years, and where she was never welcome even after she and Cézanne had been married in 1886.

Still, leaving the Jas must have been a traumatic experience for the artist, since the place had always meant home to him. There was the vast salon that, in his exuberant youth, he had decorated with large wall paintings (all left behind), and, more important, there was the parklike garden with its alley of magnificent old chestnut trees reflected in the limpid pool. There were the greenhouse and the low wall beyond which, on clear days, Sainte-Victoire was visible; there were fields of various oats, barley, and wheat[14] stretching to distant hills, one of these, on the other side of town, called Les Lauves; there was the elongated farm

Tree-lined Path, Chantilly. 1888

complex where he had watched the laborers play cards. There was also that priceless seclusion so essential to him, and the recollection of seasonal changes—the bare branches forming elaborate designs against the windswept sky in winter; the trees decked out in tender green gauze in spring; the stillness of the trembling heat accented by the incessant singing of the cicadas in the summer; the vineyards turned purple and dead leaves rustling on the ground in the fall. Never one to adapt easily to new environments, Cézanne had found in the familiarity of the many aspects of the Jas both reassurance and isolation, the perfect ingredients for his work. Their loss was great. (It is said that before leaving, he made a bonfire of many belongings, among them quite a few of his works.)

Henceforth Cézanne went to live in Aix on the Rue Boulegon, where his housekeeper, Madame Brémond, took care of him. Now that he could no longer work at the Jas de Bouffan, he returned to the cabin in the Bibémus quarry, which he had rented a few years before in search of new motifs. He also rented a small room in the Château Noir, halfway between Aix and Le Tholonet. He went often to work there, returning every night to the Rue Boulegon, leaving his canvases and materials in one place or the other. Cézanne even offered to buy the property of Château Noir, but the owner refused to sell. Thus, for a few years after 1899, Cézanne had no place he could call his own in his beloved country around Aix.

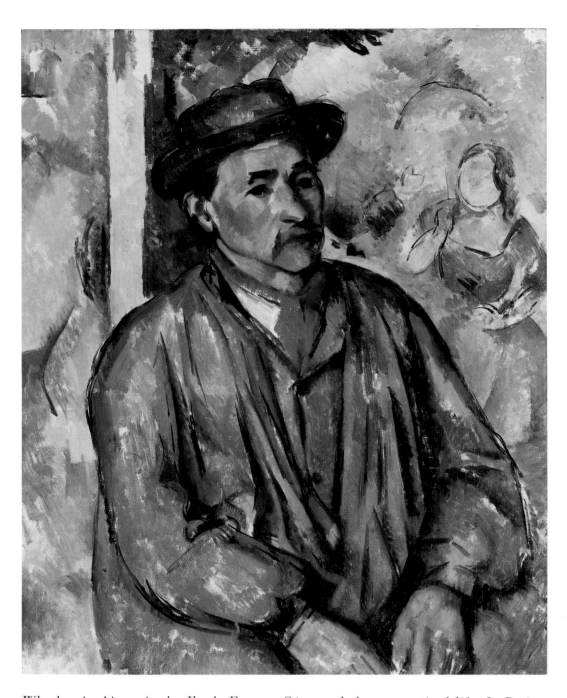

Peasant in a Blue Smock. c. 1897

Whether in Aix or in the Ile-de-France, Cézanne led a very retired life. In Paris he went to the Louvre to draw; the city was probably too animated for him to work in the streets or on the quais. The sketches he made in the museums were doubtless supposed to take the place of studies on the motif, or even more, from the living model. He began to copy ancient and modern sculpture in the Louvre, especially the works of Puget, in which he felt the "breath of the mistral." He also copied plaster casts in the Trocadéro Museum. Among the painters, Rubens and Poussin particularly attracted him, and Cézanne's sketchbooks are filled with drawings after Rubens, whose work, like Puget's, offered him subjects rich in color and movement.

In Paris, Cézanne now tried to avoid all personal contacts. Paul Signac, for example, walking one day on the Seine quais with Guillaumin, perceived Cézanne coming toward them. Ready to greet him, they saw him making gestures, begging them to pass him by; amazed and deeply moved, Guillaumin and Signac crossed the street and went on in silence. Another time, when Cézanne saw Claude Monet, he lowered his head and plunged into the crowd.

Pissarro, too, respected Cézanne's desire for solitude, though in 1898 he encouraged the young painter Louis Le Bail to call on Cézanne when the latter was working at Montgeroult near Pontoise. The two men soon became friends, and one day Cézanne asked his young colleague for permission to work at his

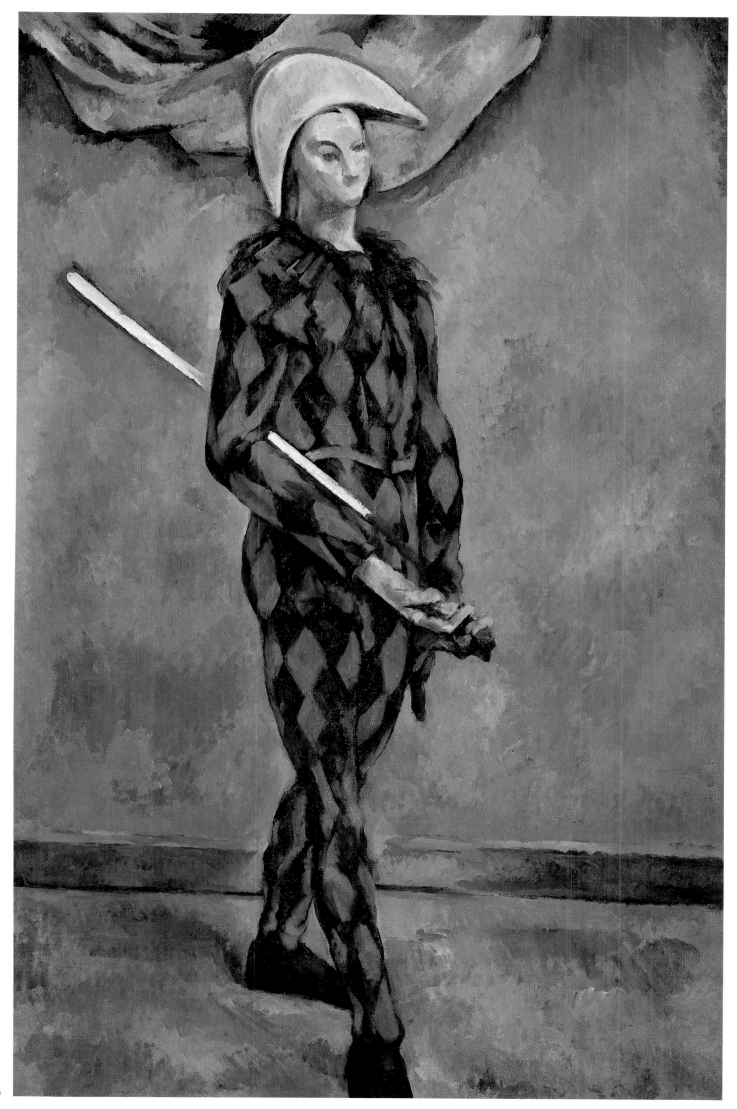

Harlequin. 1889–90

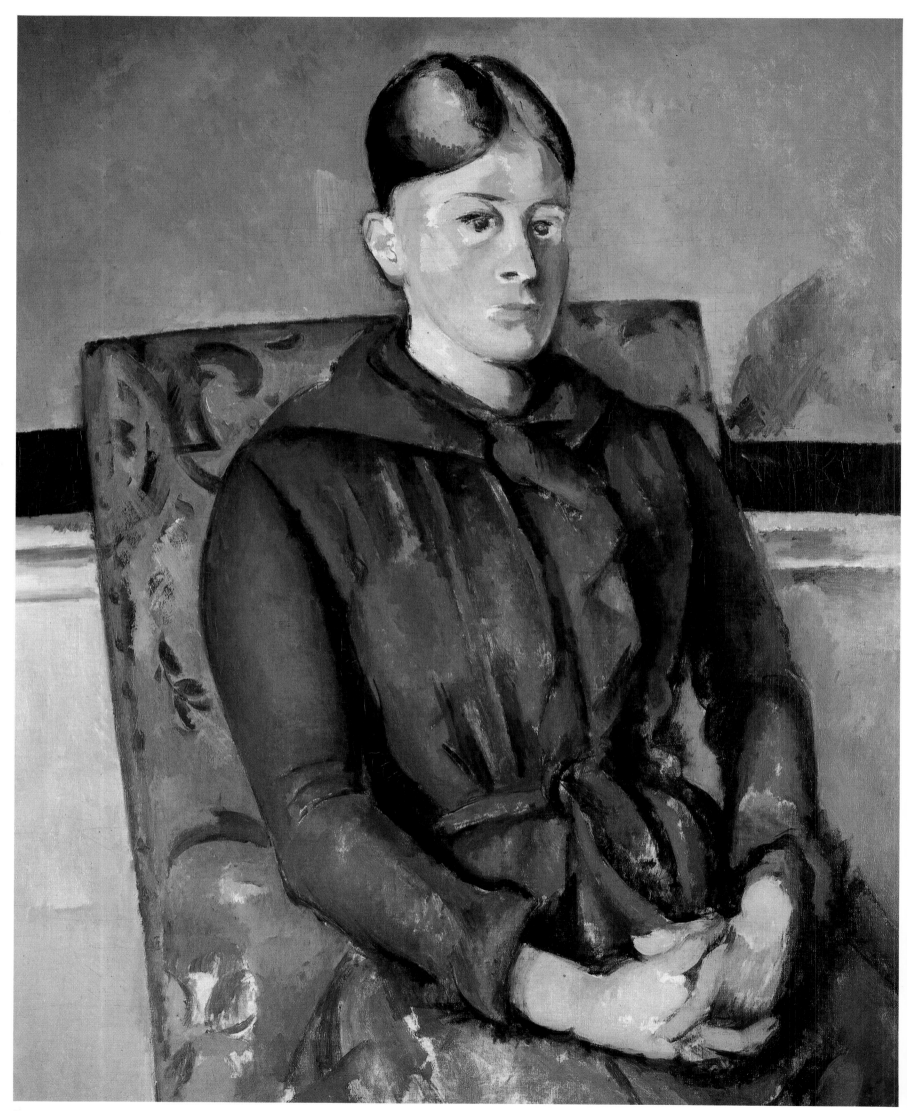

Portrait of Madame Cézanne in a Yellow Armchair. 1893–95

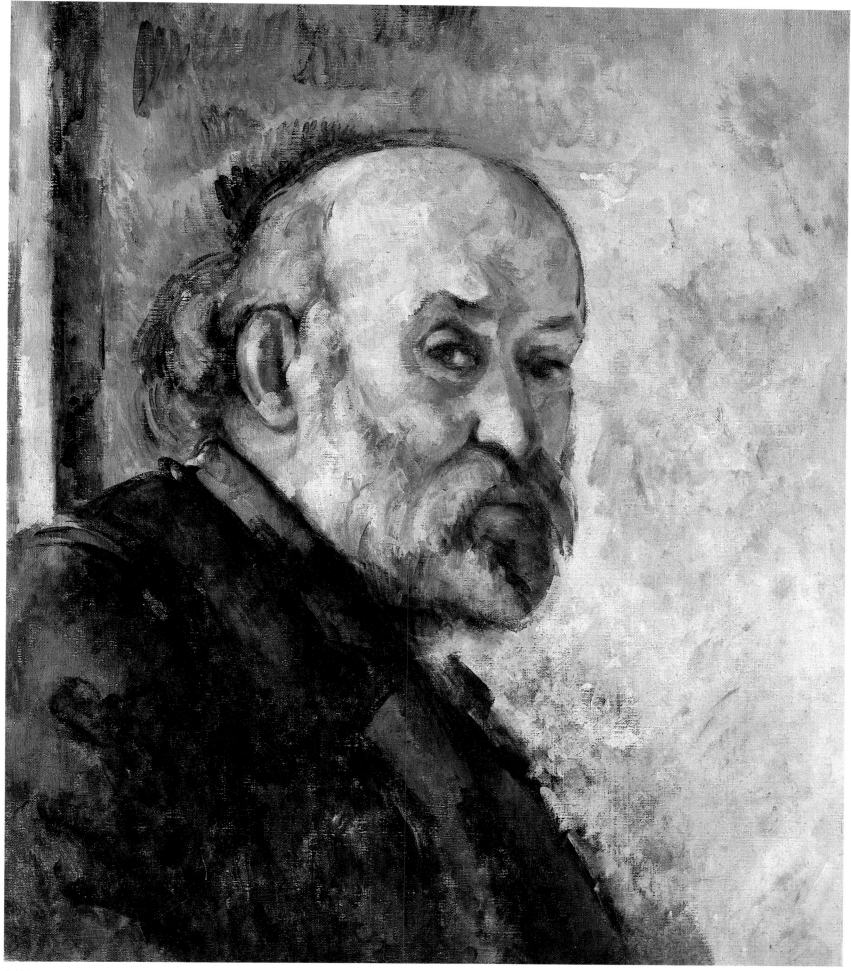

Self-Portrait. c. 1895

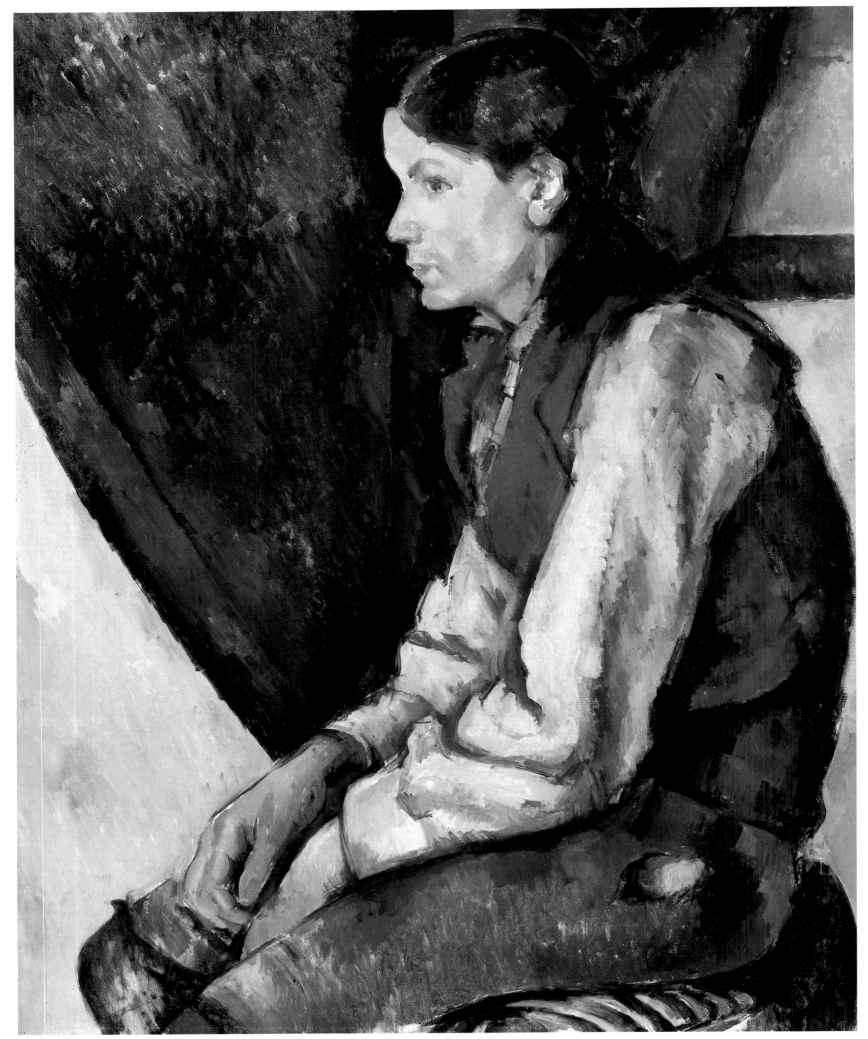

Boy in a Red Waistcoat. 1888–90

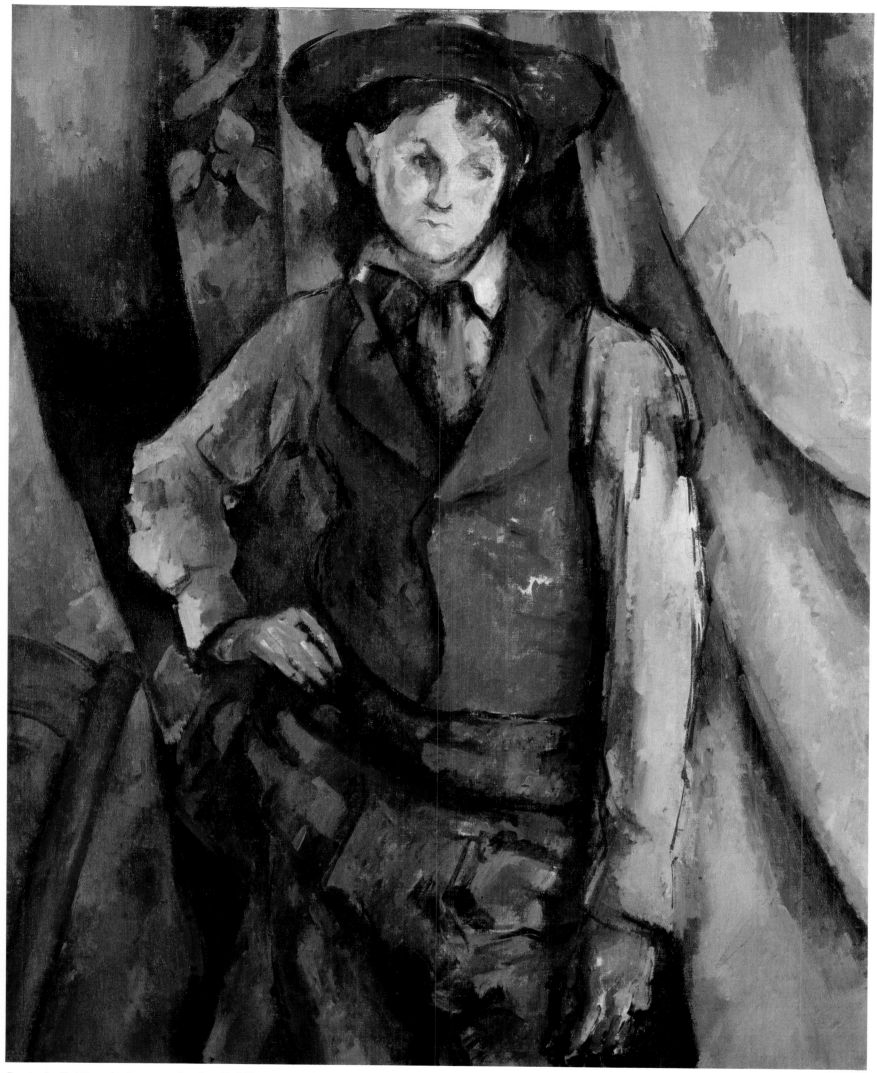

Boy in the Red Vest, also known as *Boy in a Red Waistcoat*. 1888–90

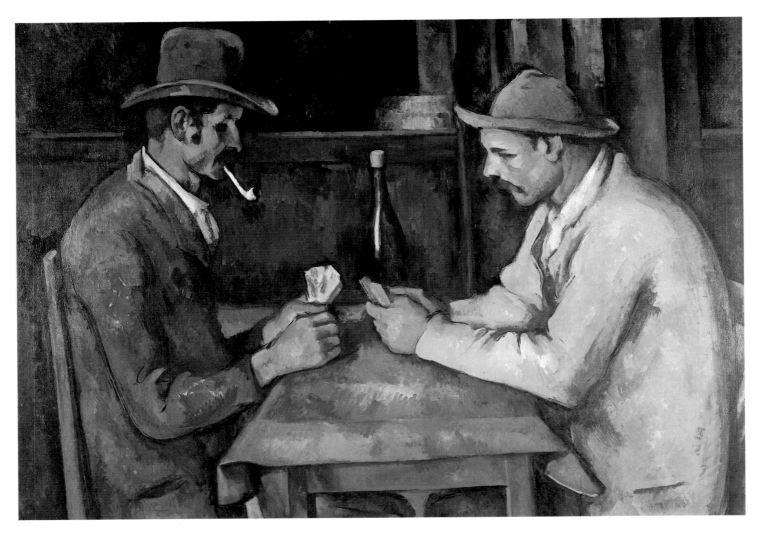

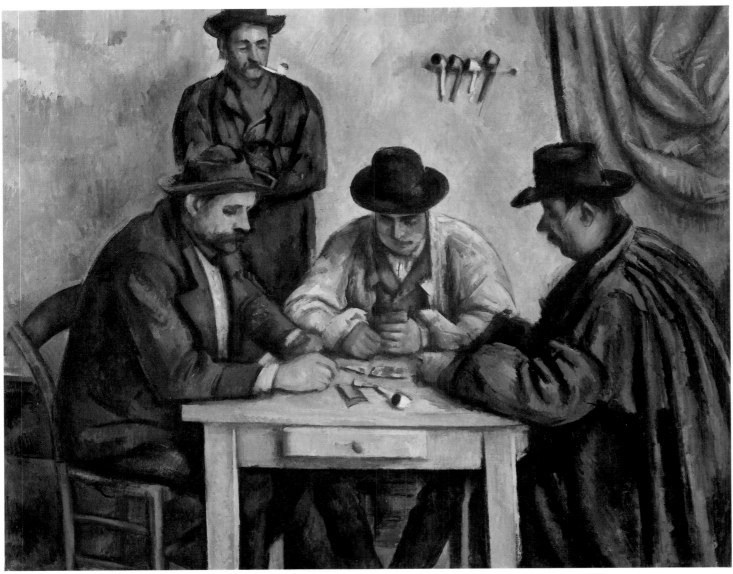

side on a motif that Louis Le Bail had discovered. Whereas the young man's canvas was already well advanced, Cézanne impetuously began a large painting. A young peasant girl passing by stopped to look at the two canvases and, pointing to Le Bail's, could not help saying, "That one is really beautiful." Cézanne was much upset by this candid remark. When, the next day, Le Bail felt that Cézanne was avoiding him and asked for an explanation, the old painter replied: "You should pity me; truth comes from the mouths of children."

Cézanne told Louis Le Bail that he would have been glad to earn 6,000 francs a year with his paintings. Vollard was not very liberal, but Cézanne was flattered that he accepted all his canvases, even the unfinished or torn ones. Thus the painter sold his work regularly and this through his son, to whom Cézanne gave ten percent. The young man also got ten percent from Vollard, a fact fully known to his father. "The boy is much smarter than I am," Cézanne said admiringly. "I have no practical sense." Young Cézanne even tried to intervene in his father's choice of subjects, urging him, for example, to paint women instead of men, as they were much more salable. But Cézanne's fear of women had grown with age. Although he did propose to work with Le Bail in his Paris studio where they might then have female models, this project was never carried out. The friendly relations of the two men came to a sudden end after a characteristic incident.

Cézanne had asked his young colleague to call him every day at three o'clock after his nap; Le Bail, taking him at his word, and finding Cézanne asleep, entered his room after having knocked several times to wake him. The next day Louis Le Bail received this letter:

Monsieur:
The rather discourteous manner with which you take the liberty of entering my room is not calculated to please me. In the future please see that you are announced.

Please give the glass and the canvas that were left in your studio to the person who comes for them.

Cézanne's friends eventually understood that he wished them to respect the isolation into which he withdrew more and more. Thus, Auguste Renoir, who was very fond of Cézanne, came to Aix with a young painter to see his friend; at the last minute, however, he hesitated and finally left Aix without calling on him, fearing, as he explained to his companion, an unexpected reaction on Cézanne's part.

His longing for solitude was partially explained by Cézanne in a letter to the Florentine painter and collector, Egisto Fabbri, who had written him in 1899:

I have the good fortune to own sixteen of your paintings. I understand their aristocratic and austere beauty—for they represent what is most noble in modern art. And often when looking at them, I have felt the urge to tell you what emotions they arouse in me. I know, however, that you are importuned by many people and I may appear very indiscreet if I ask permission to come and see you. Nevertheless, I like to think that one day I shall have the pleasure and the honor of making your acquaintance; and however it may be, Monsieur, please accept this expression of my profound admiration.

To this letter the painter answered: "I find myself unable to resist your flattering desire to make my acquaintance. The fear of appearing inferior to what is expected of a person presumed to dominate every situation is doubtless the excuse for the necessity I feel of living in seclusion."

OPPOSITE, ABOVE:
Two Cardplayers. 1892–93

OPPOSITE, BELOW:
The Cardplayers. 1890–92

201

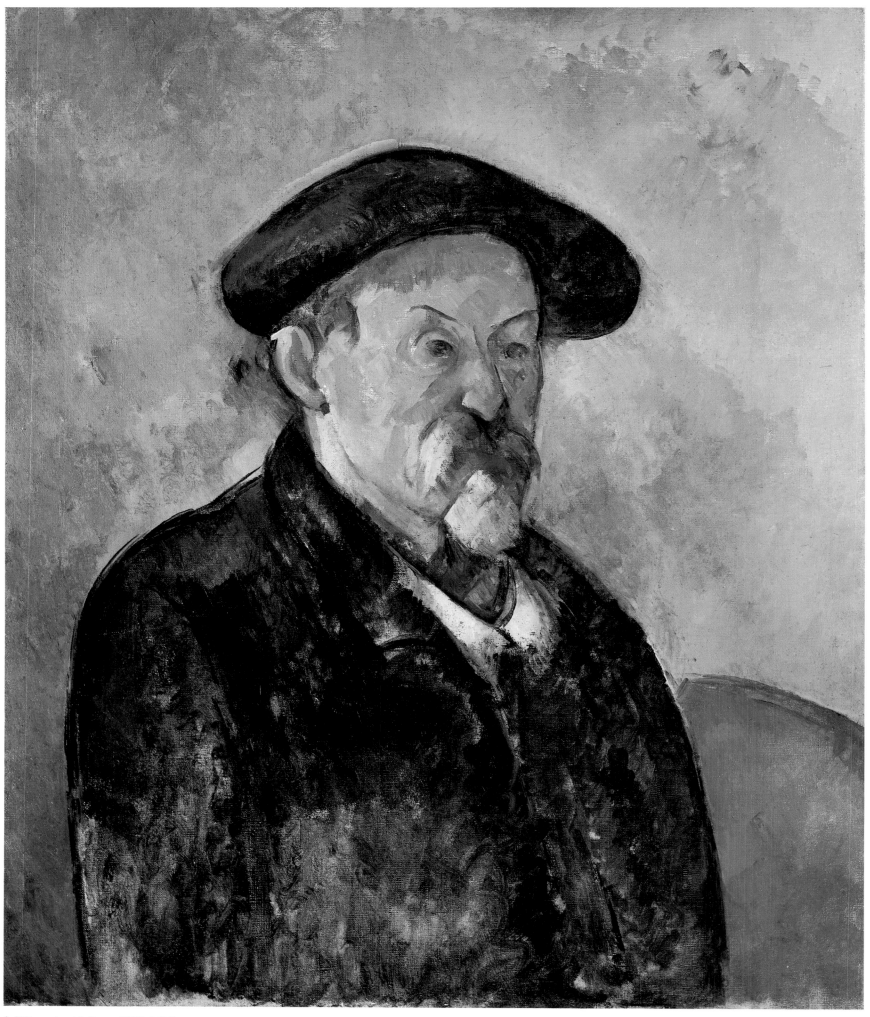

Self-Portrait with Beret. 1898–1900

Cézanne Attracts Attention in Paris

NOTWITHSTANDING Cézanne's complete isolation, his works had slowly begun to attract attention in Paris. As early as 1888 J.-K. Huysmans, who had been convinced by Pissarro of Cézanne's value, spoke of the "too much ignored painter" in an article for *La Cravache*, in which he further stated that Cézanne "contributed more than the late Manet to the Impressionist movement." The following year Huysmans devoted a whole chapter to Cézanne in his book *Certains*.

In 1889 a painting by Cézanne appeared in the Paris World's Fair, at the insistence of Chocquet, who had refused some other loan unless a canvas by his friend be included in the exhibition. At the end of the same year, Octave Maus invited Cézanne to show in Brussels with the young Belgian group of Les XX. In spite of his decision not to exhibit anymore because, as he explained to Maus, "the many studies I made have given only negative results," Cézanne accepted. Sisley and van Gogh having also been invited, Cézanne informed the organizer of the exhibition: "In view of the pleasure of finding myself in such good company, I do not hesitate to modify my resolve." Thus three canvases of Cézanne were hung at the Brussels exhibition of 1890.

When Paul Alexis tried in January 1892 to obtain Cézanne's participation in the Salon des Indépendants, which had been founded some years before on the principle of no jury and no awards; the painter at first accepted but then changed his mind. In that same year, Georges Lecomte, a friend of Pissarro's, dealt sympathetically with Cézanne in his book, *L'Art Impressionniste*, and the painter Emile Bernard published a short biographical sketch of the artist. A year later, in a study of Impressionism, Gustave Geffroy called Cézanne "the precursor of this art" and even reproduced, probably for the first time, one of his canvases.

But in spite of all this, Cézanne was still almost unknown in Paris and the critic Mellerio could write: "Cézanne seems to be a fantastic figure. Although still living, he is spoken of as though he were dead. A few examples of his work are owned by a small number of collectors." Indeed, Cézanne had not exhibited in Paris since 1877, with the exception of the two canvases that had been forced on the official exhibitions of 1882 and 1889.

However, Cézanne's influence was beginning to make itself felt in the works of the new generation. In 1892 the painter Maurice Denis stated at the Salon that it was from "Monet, Degas, Cézanne, Pissarro, and Renoir, unknown to the public of the openings, that the younger artists borrowed both their art and their vision. . . ."

A little later, Gustave Geffroy wrote:

For a long time, Cézanne has had a curious artistic fate. He might be described as a person at once unknown and famous, having only rare contact with the public yet considered influential by the restless and the seekers in the field of painting; known only by a few, living in savage isolation, reappearing, then disappearing suddenly from the sight of his intimate friends. All the little-known facts about his life, his almost secret productivity, the rare canvases, which ateem to follow none of the accepted rules of publicity, all these give him a kind of strange renown, already distant; a mystery surrounds his person and his work. Those who are in search of the unfamiliar, who like to discover things that have not yet been seen, speak of Cézanne's canvases with a

knowing air, giving information like a password. . . . What did his canvases look like? Where could some of them be seen? Reply was made that the preceding week a canvas had been seen at Tanguy's, the dealer in the Rue Clauzel, but that it was necessary to hurry to find it for there were always collectors quick to pounce upon these prizes, which were few and far between.

Georges Lecomte substantiated this when he stated that canvases by Cézanne were only seen by chance and in a few houses of Cézanne's friends: Zola had, among others, a landscape, Paul Alexis a still life, Duret and Huysmans a sketch each. It was also known that a few of Cézanne's paintings were to be found at Chocquet's, at Dr. Gachet's in Auvers, at Murer's in Rouen, that Pissarro owned some, that others belonged to Rouart and to the painters Caillebotte and Schuffenecker. Since the founding in 1890 of the new *Mercure de France*, Albert Aurier regularly mentioned in his art column any painting by Cézanne shown at Tanguy's, especially praising "a still life [pears on a napkin] that is simply an incomparable masterpiece." Aurier particularly admired the *Portrait of Achille Emperaire*.

The dark little shop of *père* Tanguy was the one place where Cézanne's works could be studied or bought. This humble dealer gave the only information available on the painter, and his narrow shop became the rendezvous of all those interested in this artist who would have been taken for a myth had it not been for his canvases in which the new generation sought advice and guidance. To be the only one in Paris to handle Cézanne's work gave a kind of celebrity to Tanguy in the eyes of the younger painters. Bernard later remembered:

One went there as to a museum, to see the few sketches by the unknown artist who lived in Aix, dissatisfied with his work and with the world, who himself destroyed these studies, objects of admiration though they were. The magnificent qualities of this true painter appeared even more original because of their author's legendary character. Members of the Institute, influential and avant-garde critics, visited the modest shop in the Rue Clauzel, which thus became the fable of Paris and the conversation of the studios. Nothing seemed more disconcerting than these canvases, where the most outstanding gifts were coupled with a childlike naiveté; the young felt the genius, the old the folly of the paradox; the jealous saw only impotence. Thus the opinions were divided, and one passed from profound discussions to bitter jeers, from insults to exaggerated praise; Gauguin, confronted with their daubed appearance, exclaimed: "Nothing looks more like a daub than a masterpiece!" Elimire Bourges cried out: "It's the painting of a sewage collector!" Alfred Stevens couldn't stop laughing.

Imperturbably, *père* Tanguy listened—perhaps often without understanding much—and remained silent. He never tired of showing his treasures. At the request of his visitors, according to Bernard, he went to fetch *the Cézannes!*

One saw him disappear into a dark room and reappear a moment later, carrying a package of modest size, carefully tied up; on his thick lips a mysterious smile, damp emotion shining in his eyes. Feverishly he untied the strings and, using the back of a chair as an easel, he exhibited the paintings one after the other, in religious silence. The visitors remarked upon them, pointed out certain parts, became enthusiastic over the color, the subject matter, and the style; then, when they had finished, Tanguy talked about the artist: "Papa Cézanne," he would say, "is never satisfied with what he does, he always gives up before having finished. When he moves, he is careful to forget his canvases in the house he is leaving; when he paints outdoors, he abandons them in the country. Cézanne works very slowly, the least thing costs him much effort, there is nothing accidental in what he does." Naturally, the curiosity of his visitors was aroused. Whereupon Tanguy would say with a rapt expression: "Cézanne goes to the Louvre every morning."

Even those who went to Tanguy's to make fun of Cézanne rarely left his shop without a kindly feeling for the good man. An American critic, taken there by some painters in 1892, related: "*Père* Tanguy is a short, thickset, elderly man, with a grizzled beard and large, beaming, dark blue eyes. He has a curious way of first looking down at his picture with all the fond love of a mother, and then looking up at you over his glasses, as if begging you to admire his beloved children. . . . I could not help feeling, apart from all opinions of my own, that a movement in art that can inspire such devotion must have a deeper final import than the mere ravings of a coterie."

Among those who visited Tanguy's more or less regularly were Vincent van Gogh and Maurice Denis, Paul Signac and Georges Seurat, Emile Bernard and Paul Gauguin, Jacques-Emile Blanche and Ambroise Vollard. Signac, encouraged by Pissarro, even acquired a painting by Cézanne. Denis later explained that what interested the young painters in Cézanne was that he reduced nature to pictorial elements and eliminated all others. All of Cézanne's admirers, however, regretted the silence that surrounded him; he lived, as Geffroy put it, "on the margin of life."

Interest in the Impressionists was suddenly awakened by the death of Gustave Caillebotte. On March 11, 1894, Renoir wrote to Henri Roujon, director of Fine Arts:

As executor of the estate of the painter Gustave Caillebotte, who died on February 21, 1894, I have the honor to inform you that M. Caillebotte, according to his will, bequeaths to the Luxembourg museum and to the Louvre, or to the Luxembourg museum only, a collection of about sixty works by MM. Degas, Cesanne [*sic*], Manet, Monet, Renoir, Pissarro, Sisley, Millet, and one drawing by Gavarny. This collection is still at Petit Gennevilliers [Caillebotte's country home near Argenteuil]. I shall have it brought to Paris and shall then have the honor to ask you for an audience so that I can personally inform you of the details of this donation.

The pictures were subsequently stored at 11, Boulevard Clichy, Caillebotte's Parisian studio, while the frames were kept in Renoir's studio, 13, Rue Girardon at Montmartre. Meanwhile Renoir was forced, for reasons of health, to go temporarily to the south of France. But he was back in time for a May 2 meeting with Gustave Caillebotte's brother, Martial, and Roujon where it was decided that the heirs of the painter would retain, yet keep at the disposition of the government, whatever works of the collection would not be accepted. This meant that quite early in the negotiations there was question of disregarding Caillebotte's specific condition that the collection should be accepted in its totality. Indeed, Léonce Benedite, curator of the Luxembourg museum, immediately stated that the bequest should be either accepted entirely or entirely rejected.

In July Renoir discovered yet another dozen paintings that had belonged to Caillebotte, of which six were added to the bequest. Subsequently, Martial Caillebotte found six more canvases through which the total number of works by Pissarro was increased by five to eighteen and that of Sisley by one to nine. Despite Caillebotte's provision that his collection should remain undivided, the state did not dare accept the bequest as a whole. Renoir, as executor, was forced to yield unless the gift were to be rejected; after long debates, only a fraction of the collection entered the Luxembourg museum, the bequest having been reduced from sixty-six works to thirty-eight. Of four paintings by Manet, two were accepted (then estimated at 13,000 francs); of seven pastels by Degas, all were accepted (estimated at 28,500 francs); of sixteen paintings by Monet, only

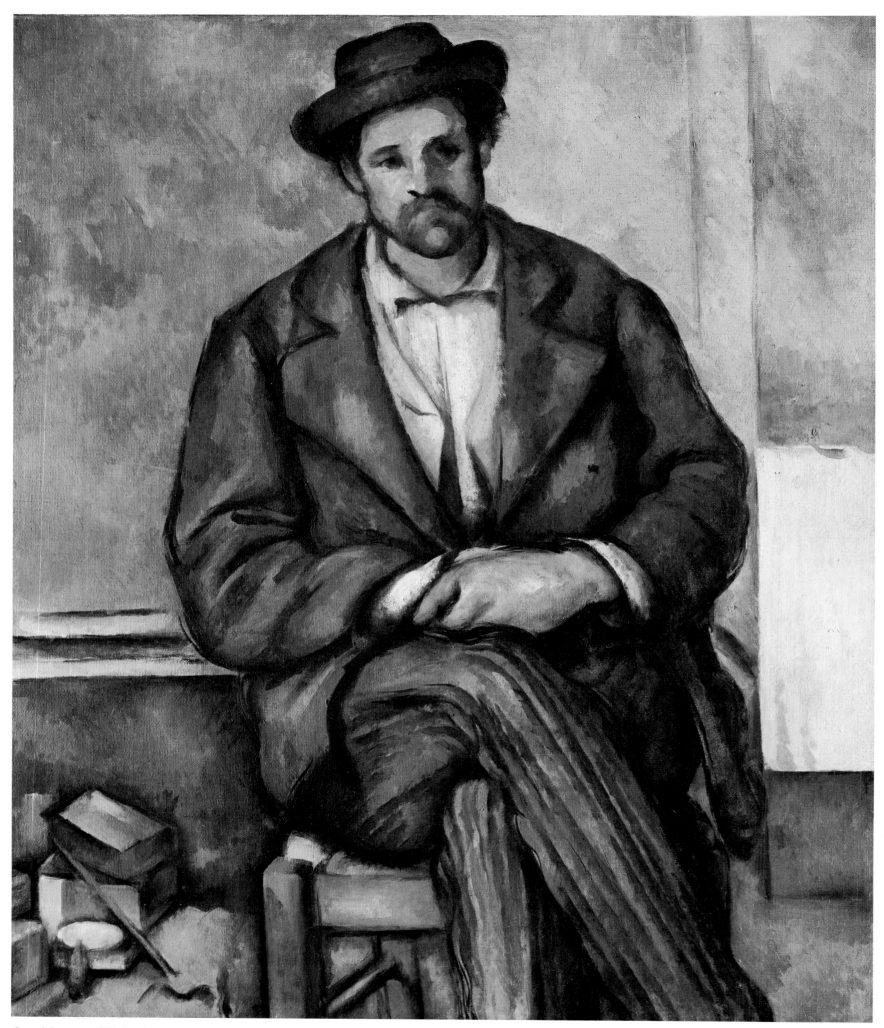

Seated Peasant. 1898–1900

eight were accepted (estimated at 46,000 francs); of eight paintings by Renoir, six were accepted (estimated at 30,000 francs); of eighteen paintings by Pissarro, only seven were accepted (estimated at 13,000 francs); of nine paintings by Sisley, six were accepted (estimated at 8,000 francs); and of five paintings by Cézanne, only two were accepted (estimated at 1,500 francs). These two were *Courtyard at Auvers* and *L'Estaque.*

In proportion to the total number of their works in the collection, Pissarro and Cézanne received the most humiliating treatment, the others having at least half or more of their paintings accepted.

Yet that was not the end of the affair. When the truncated Caillebotte bequest was finally hung in a separate room at the Luxembourg museum early in 1897, the Academy of Fine Arts, valiant upholder of the sacred principles of academic art and guardian over holy French traditions, voted eighteen to ten a strong protest against the legacy. On February 28, 1897, it sent the following letter to M. Rambaud, Minister of Public Instruction: "Though not fearing more than absolutely necessary the consequences of an act over which the good taste and the common sense of the public will probably triumph immediately, the members of the Academy of Fine Arts consider it their duty to inform you of the vivid regret that they have unanimously [?] felt when they saw a collection of paintings that in every respect are undeserving of such hospitality hung a few days ago on the walls of the National Museum of the Luxembourg." The letter was signed by Roty, President; Frémiet, Vice-President; and Count Henri Delaborde, Perpetual Secretary of the Academy. The Minister, as was the custom in such cases, did not answer.

The Caillebotte bequest aroused other vehement protests against "the profanation" of a museum consecrated to "pure" art and that, by exhibiting Impressionist work, became a dangerous place where "young men could be distracted from serious efforts." In the Senate and the press, objections were voiced against this donation, which was considered to be "a heap of rubbish, the exhibition of which in a national museum publicly dishonors French art."

Cézanne's name, however, was never mentioned in these indignant outcries, perhaps because it was thought that too much honor would be done him even by a derogatory reference.

Gustave Caillebotte's death was closely followed by two important events in the history of Impressionism: the sales of the Duret and Tanguy collections. In March 1894 Duret, the art critic and Zola's friend, sold his paintings, including three works by Cézanne, at quite good prices. A few weeks later, Tanguy's stock of paintings was sold at auction, following his death; six canvases by Cézanne sold for between forty-five and two hundred fifteen francs; all of them were acquired by an as yet unknown art dealer, Ambroise Vollard. Gustave Geffroy availed himself of this opportunity to publish in *Le Journal* a long and laudatory article on Cézanne.

The time seemed ripe for an exhibition of Cézanne's work, to give the public a chance to see for the first time a retrospective exhibit of this much-discussed painter. It was Vollard, a young Creole, recently established in the Rue Laffitte, who, at the insistence of Pissarro (joined by Monet, Renoir, and Guillaumin), undertook the organization of a one-man show. After numerous difficulties he managed to submit his project to Cézanne's son, who prevailed upon his father to send from Aix some 150 canvases. The large number of works intended by the artist himself to represent his efforts between 1868 and 1894, shows clearly enough that Cézanne did not consider his paintings merely as rough sketches, as had so often been claimed.

The exhibition opened in November 1895. Vollard, in his small shop, could

not show all of Cézanne's canvases at once. Nevertheless, this exhibition aroused great interest and lively discussions. Needless to say there were still those who spoke of the "nightmarish sight of these atrocities in oil, which exceed the amount of practical joking legally permissible today." But Pissarro told his son Georges: "Vollard is having a Cézanne exhibition; it is really wonderful; there are still lifes, very beautiful landscapes, very strange bathers of extraordinary sobriety. It looks as though it were done in two tones; it is very effective. . . . The collectors are stupefied; they don't understand anything about it, but nevertheless he is a first-class painter of astonishing subtlety, truth, and classicism."

And to his eldest son, Lucien, Pissarro wrote:

How rarely do you come across true painters, who know how to balance two tones. I was thinking of H., who looks for noon at midnight, of Gauguin, who, however, has a good eye, of Signac, who also has something—all of them more or less paralyzed by theories. I also thought of Cézanne's show in which there are exquisite things, still lifes of irreproachable perfection, others, *much worked on* and yet unfinished, of even greater beauty, landscapes, nudes, and heads that are unfinished but yet grandiose, and so *painted*, so supple. . . . Why? Sensation is there! Curiously enough, while I was admiring this strange, disconcerting aspect of Cézanne, familiar to me for many years, Renoir arrived. But my enthusiasm was nothing compared to Renoir's. Degas himself is seduced by the charm of this refined savage. Monet, all of us. . . . Are we mistaken? I don't think so. The only ones who are not subject to the charm of Cézanne are precisely those artists or collectors who have shown by their errors that their sensibilities are defective. They properly point out the faults we all see, which leap to the eye, but the charm—that they do not see. As Renoir said so well, these paintings have I do not know what quality, like the frescoes of Pompeii, so crude and so admirable! Degas and Monet have bought some marvelous Cézannes; I exchanged a poor sketch of Louveciennes for an admirable small canvas of bathers and one of his self-portraits.

In another letter Pissarro mentioned that Renoir and Degas were so enthusiastic about a drawing of some fruit that they drew lots for it.

Pissarro lost no opportunity to win over those who were still not convinced of his friend's qualities. He was incensed when a dealer claimed that Cézanne had always been influenced by Guillaumin. "Then how do you expect outsiders to understand anything!" he exclaimed to Lucien. "This monstrosity was expressed at Vollard's. Vollard was blue. Aren't these babblers amusing? You wouldn't believe how difficult it is for me to make certain collectors, who are friends of the Impressionists, understand how precious Cézanne's qualities are. I suppose centuries will pass before these are appreciated."

This time the press contained some respectful and sympathetic articles on Cézanne who, as Thadée Natanson wrote in the *Revue Blanche*, "assumes in the French school the position of the new master of still life." And Arsène Alexandre published an article by the significant title, "Claude Lantier," which appeared in *Le Figaro* on December 9, 1895:

When *L'Oeuvre*, the romantic epic of painting, appeared, with its exaggeration of types, its willful distortion of facts, and its lyricism, it seemed to describe very simple things, and some moderately well informed critics wrote that Claude Lantier, the chief character in the novel, the neurotic and miserable painter who ends by hanging himself in front of his picture, was a portrait of Cézanne. This was all that was necessary for the public, who were interested in the anecdotes and unpublished facts of artistic life, to spread the strangest ideas about the painter who could and moreover would do nothing to contradict them. One might have doubted whether, like Homer, Cézanne really existed.

The opportunity has arisen for stating that he really does exist, and even that his existence has not been useless to some people. . . . Today it has suddenly been

discovered that Zola's friend, the mysterious man from Provence, the painter simultaneously incomplete and inventive, sly and uncivilized, is a great man.

Great man? Not altogether, if one remains aloof from the enthusiasms of a season, but one of the strangest temperaments, from whom a great deal in the new school has been borrowed, knowingly or not. The interesting thing about this exhibition is the influence he exerted on artists who are now well known: Pissarro, Guillaumin, and later, Gauguin, van Gogh, and others.

M. Thiébault-Sisson, one of Zola's friends, wrote an article in *Le Temps* that seems to reflect the opinion of Cézanne current in Zola's circle. His conclusions could just as well apply to Claude Lantier: "Incapable of judging himself, he is unable to draw from a concept all the profit that more resourceful people drew from it; too unfulfilled, in a word, to realize completely what he had been the first to discover and give his full measure in definitive works."

Cézanne suffered profoundly from the lack of understanding with which his art met. He did not even enjoy the favorable comments published on his work. Thus, in April 1896 he wrote to a young poet:

I curse the Geffroys and the few rascals who, to write an article for fifty francs, drew the attention of the public to me. All my life I have worked to be able to earn my living, but I thought that one could do good painting without attracting attention to one's private life. To be sure, an artist wishes to raise himself intellectually as much as possible, but the man must remain obscure. Pleasure must reside in study. If it had been given me to succeed, I should have remained in a corner with my few studio companions with whom we used to go out for a pint. I still have a good friend[15] from those days—well, he has not been successful, despite his being devilishly more of a painter than all the daubers with medals and decorations who make you sick. And at my age you want me still to believe in something! Moreover, I am as good as dead. You are young, and I can understand that you wish to succeed. But as for me, all I can do in my position is to eat humble pie, and were it not that I am passionately fond of the contours of my country, I should not be here.

Indeed, the Vollard exhibition and the enthusiasm of some young admirers drew public attention to Cézanne, and at the sale of the Chocquet collection after his widow's death in 1899, thirty-two of his canvases sold for over 51,000 francs, the average price being about 1,600 francs; *House of the Hanged Man*, acquired by Camondo at the urging of Monet, brought as much as 6,200 francs. Most of Cézanne's paintings were bought by Durand-Ruel, to whom Monet had pointed out that it was high time he began to take an interest in Cézanne, the only Impressionist not represented in his stock. It is true that Monet had not hesitated to set an example. At the sale of Count Armand Doria's collection, which preceded the Chocquet auction, one of Cézanne's landscapes had been knocked down for 6,750 francs. This bid caused quite some excitement and the public, suspecting a maneuver, loudly demanded the buyer's name, whereupon the latter rose and declared: "It is I, Claude Monet," and the sale went on without further incident.

At the end of 1899 Vollard informed Gauguin with satisfaction: "I have purchased all of Cézanne's paintings that were in his studio. I have already held three or four exhibitions of them; they are beginning to catch on with the public." The same year Cézanne decided at last to send three canvases to the Salon des Indépendants. Due to the intervention of Roger Marx, three more of his works were hung prominently at the big centennial exhibition of 1900 in Paris, much to the consternation of the public and the official artists. In 1901 Cézanne again exhibited in Brussels with Les XX as well as with the Indépendants in Paris,

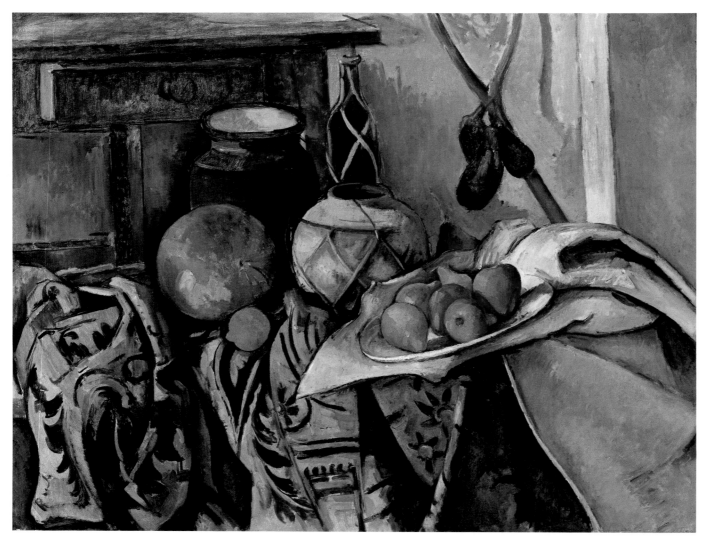

*Still Life
with Ginger Jar
and Eggplants.
1893–94*

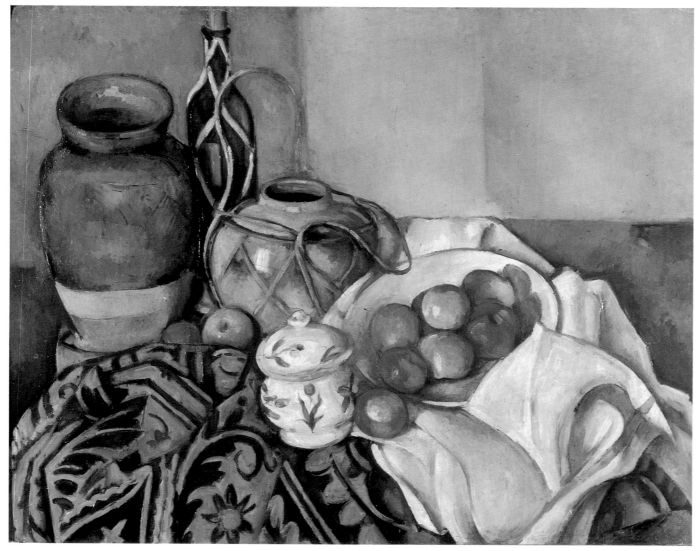

*Still Life with Olive Jar,
Ginger Pot, Rum Bottle,
Sugar Pot, Blue Rug,
and Apples. 1893–94*

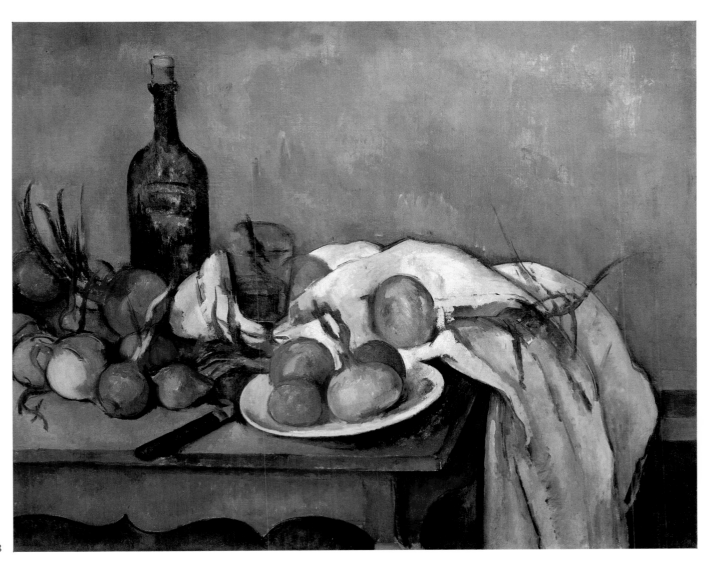

Still Life with Onions. 1896–98

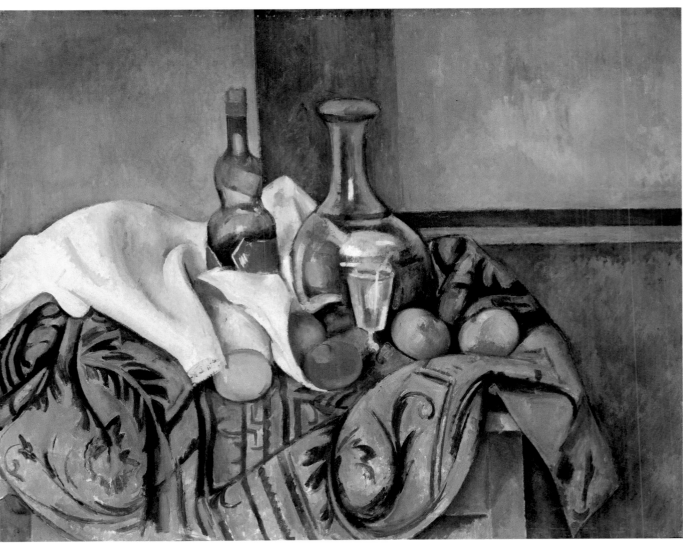

*Still Life with Peppermint Bottle
and Blue Rug.* 1893–95

while Maurice Denis showed at the same time at the Salon a large canvas entitled *Homage to Cézanne*, representing a group of painters and friends [among them Redon, Vuillard, Bonnard, and Vollard] gathered around a still life by the master. Denis could not portray Cézanne himself because at that time he had not yet met him. His *Homage to Cézanne* is one of the first public manifestations in which the new generation of artists expressed their gratitude, admiration, and respect for the "hermit of Aix." But these young artists were not as yet followed by the general public in their appreciation of the old painter.

"Although he is no longer scoffed at as in former years," Gustave Geffroy stated, "he is still regarded with surprise by certain people who do not make the effort to understand the decorative sense, amplitude of form, brightness of color that make of this painter a sort of Venetian, possessor of a new style, of a personal gravity."

And another critic wrote in 1901: "Cézanne is not known to the masses . . . but for a number of years painters have been following him attentively. Many of them owe to him the revelation of what one might call the intrinsic beauty of painting. In Cézanne the interest of the subject is not in its story . . . but rather in the production of visual delight."

However unwillingly, Cézanne decided to exhibit again at the Salon des Indépendants in 1902, when he wrote to Vollard:

I have received from Maurice Denis a letter that describes as a desertion my not taking part in the exhibition of the Indépendants. I have replied to Monsieur Denis, telling him that I am asking you to place at his disposal the pictures that you are able to lend him and to choose the ones that are calculated to do least harm.

It seems to me that I find it difficult to dissociate myself from the young people who have shown themselves to be so much in sympathy with me, and I do not think that I shall in any way harm the course of my studies by exhibiting.

The battle for recognition was slowly being decided in favor of the solitary painter who never made any attempt to answer his critics. Although Manet's work had long been given its just due, and Monet, Pissarro, and Renoir were slowly being recognized as masters, Cézanne alone had not yet imposed himself. Despite the fact that the number of his admirers was constantly increasing, he was still being attacked in the daily press. One of the most vigorous campaigns ever launched against him was occasioned by the sale, in March 1903, of Zola's collection after the novelist's death. Ten of Cézanne's early works, to the surprise of the *Gazette de l'Hôtel Drouot*, obtained bids far above the official estimates. While a landscape by Monet brought 2,805 francs; two paintings by Guillemet, 300 and 600 francs respectively; two canvases by Pissarro, 500 and 920 francs each; and a large painting by Debat-Ponsan (a famous Salon painter), 350 francs, Cézanne's work sold as follows:

The Abduction [reproduced p. 50] 4,200 francs
Still Life with Black Clock 3,000 francs
Corner of a Studio 2,050 francs
Paul Alexis Reading to Zola [reproduced p. 49] 1,050 francs
View of L'Estaque 1,050 francs
Portrait [reproduced p. 56] 950 francs
Still Life 900 francs
Study 720 francs
Nymph and Tritons [reproduced p. 40] 680 francs
Portrait of a Woman 600 francs

On the occasion of this sale, Henri Rochefort, a political adversary of Zola, published on March 9, 1903, an article in *L'Intransigeant* on "The Love of Ugliness," in which he dealt with the novelist's collection. After mentioning the hilarity caused by the work of "an ultraimpressionist named Cézanne," Rochefort went on to say:

The crowd was particularly amused by the head of a man, dark and bearded, whose cheeks were sculptured with a trowel and who seemed to be the prey of an eczema. The other paintings by the same artist all had an air of defying no less directly Corot, Théodore Rousseau, and also Hobbema and Ruysdael.

Pissarro, Claude Monet, and the other more eccentric painters of the plein air and of pointillism—those who have been called "confetti painters"—are academicians, almost members of the Institute, by comparison with this strange Cézanne whose productions Zola had picked up.

The experts in charge of the sale themselves experienced a certain embarrassment, in cataloguing these fantastic things and attached this reticent note to each one of them: "Work of earliest youth!"

If M. Cézanne was still being nursed when he committed these daubs, we have nothing to say; but what is to be thought of the head of a literary school as the squire of Médan considered himself to be, who propagates such pictorial madness? And he wrote Salon reviews in which he pretended to rule French art!

Had the unfortunate man never seen a Rembrandt, a Velázquez, a Rubens, or a Goya? For if Cézanne is right, then all those great brushes were wrong. Watteau, Boucher, Fragonard, and Prud'hon no longer exist and nothing remains as supreme symbol of the art dear to Zola but to set fire to the Louvre.

We have often averred that there were pro-Dreyfus people long before the Dreyfus case. All the diseased minds, the topsy-turvy souls, the shady and the disabled, were ripe for the coming of the Messiah of Treason. When one sees nature as Zola and his vulgar painters envisage it, naturally patriotism and honor take the form of an officer delivering to the enemy plans for the defense of his country.

The love of physical and moral ugliness is a passion like any other.

The repercussions of this article were considerable, especially in Aix, where people were convinced that the Parisians "admired" Cézanne's work only to make fun of Aix. In his hometown, Cézanne was considered an eccentric who, son of an honorable banker, wasted his time and money at "painting" instead of living like other people. Many were openly delighted to see that there was still someone in Paris who was not afraid to tell the truth. Three hundred copies of *L'Intransigeant* were ordered and, at night, slipped under the doors of all those who had evinced some sympathy for the painter.

All the vicious talk that reached his ears naturally upset Cézanne. Threatening letters and anonymous insults were addressed to him at the Rue Boulegon. His family and few friends were maligned. It was hinted that he ought to relieve of his presence the city he was dishonoring. When his son wrote to him from Paris asking whether he should send him a copy of Rochefort's article, Cézanne answered bitterly: "It is unnecessary to send it to me; every day I find it under my door, not counting the copies of *L'Intransigeant* sent by mail."

The slanders published about him strengthened Cézanne's hatred of journalism and particularly of art criticism. He despised with equal fervor both attacks on and praise of his art, and when the painter Emile Bernard wished to devote a new study to his work, Cézanne wrote him in 1904: "Talks on art are almost useless. The work that produces progress in one's own profession is sufficient compensation for not being understood by imbeciles." And in another letter

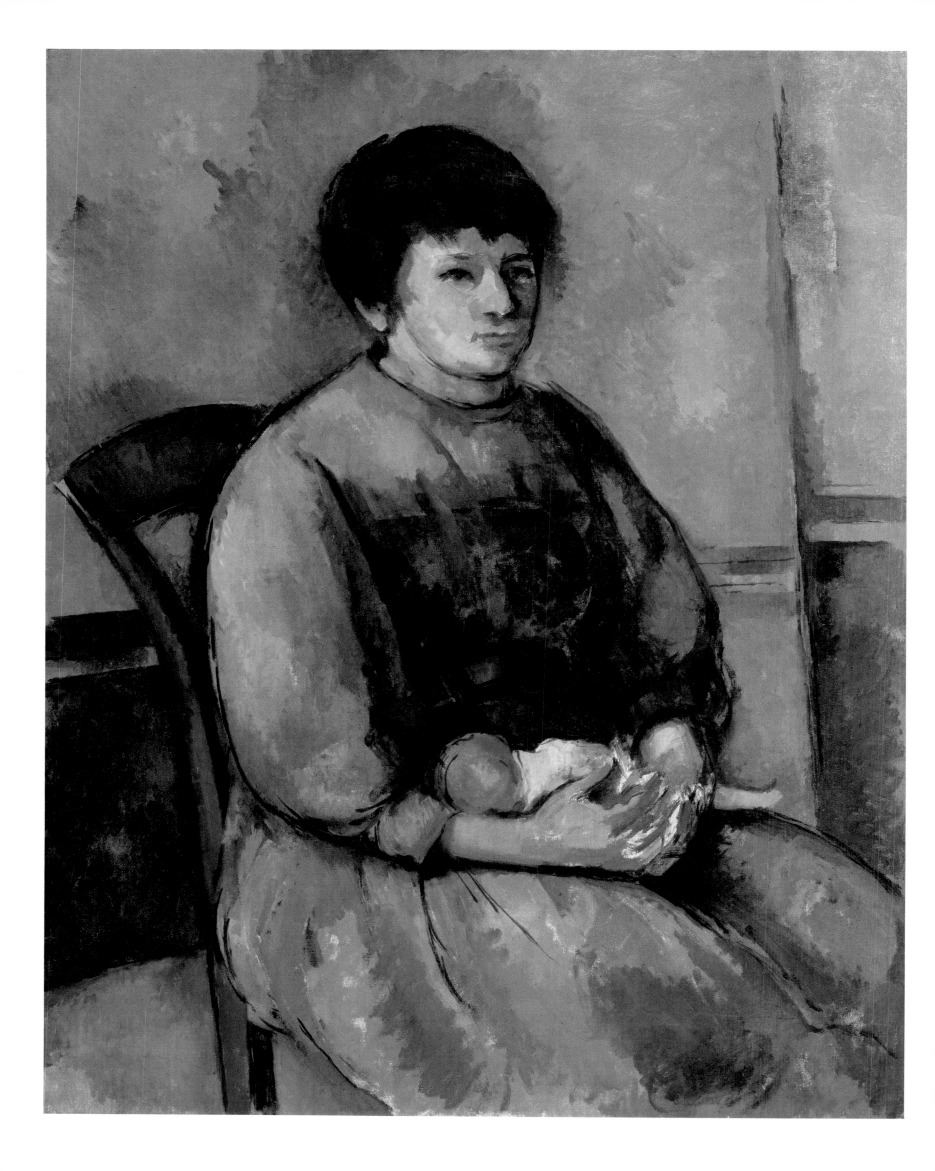

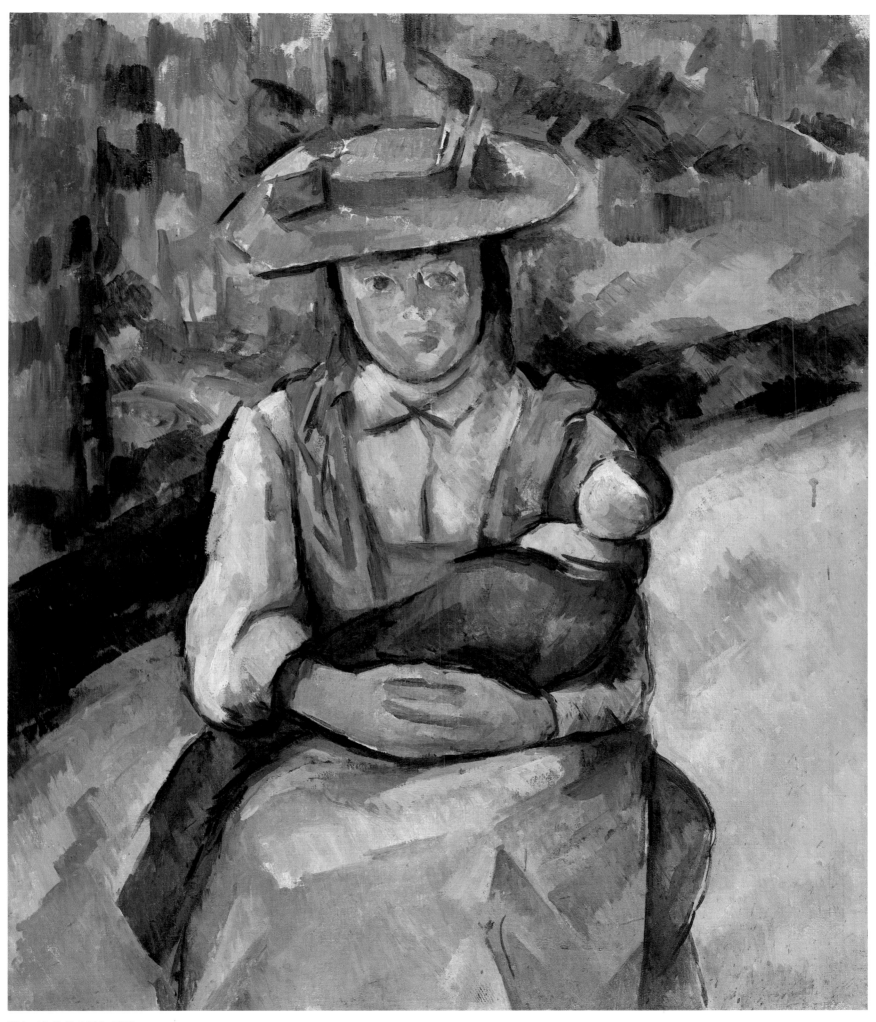

Girl with Doll. 1902–1904

OPPOSITE:
Girl with Doll. c. 1902

215

Cézanne advised Bernard: "Do not be an art critic, but paint; therein lies salvation."

Cézanne continued to exhibit, however, and in the summer of 1903 seven of his canvases (mostly loaned by Durand-Ruel) were shown in the Impressionist section of the Vienna Secession; in the same year three of Cézanne's paintings were shown in Berlin (where Durand-Ruel had lent twelve of Chocquet's Cézannes to the Berlin dealer Cassirer during the winter 1900–1901; none was sold). In 1904 Cézanne sent no less than nine canvases to Brussels and asked Vollard to send a group of his pictures to the Salon d'Automne, an association that had just been founded and in which all the artists who were members took turns at jury duty. The French author Jules Renard saw Cézanne's work at this exhibition and noted in his diary: "At the Salon d'Automne. . . . Cézanne, barbarian. One must first have admired a great many famous daubs before liking this carpenter of color. . . . The lovely life of Cézanne, all spent in a village in the South. He did not even come to his own exhibition. He would like to be decorated. That is what all these poor old painters want who, after an admirable life see at last, when they are near death, art dealers get rich on their work."

When Roger Marx reviewed Cézanne's contribution to the Salon d'Automne in favorable terms, the painter wrote him from Aix on January 23, 1905:

I have read with interest the lines that you were kind enough to write about me in the two articles in the *Gazette des Beaux-Arts*. I thank you for the favorable opinion that you express on my behalf.

My age and my health will never allow me to realize the dream of art that I have been pursuing all my life. But I shall always be grateful to the intelligent amateurs who had—despite my own hesitations—the intuition of what I wanted to attempt for the renewal of my art. To my mind one does not substitute oneself for the past, one merely adds a new link to its chain. With the temperament of a painter and an ideal of art—that is to say a conception of nature—sufficient means of expression would have been necessary to be intelligible to the general public and to occupy a decent position in the history of art.

And at about the same time Cézanne wrote to a young friend: "I am still working, without worrying about criticism and critics, as a true artist should do. My work must prove that I am right."

In 1905 Cézanne sent ten paintings to the Salon d'Automne and again the same number in 1906. But he did not exhibit his work only in Paris during the last years of his life. In Aix a Société des Amis des Arts had been formed around the turn of the century with Cézanne's old fellow student, Villevieille, as president. As a member of the society, Cézanne exhibited in 1902 a landscape of the Jas de Bouffan and a still life, and in 1906 a view of Château Noir. In the little catalogues of these exhibitions Cézanne had himself listed as "Pupil of Pissarro." Thus the old painter whose name was beginning to be honored in the art world paid a debt of gratitude to the man who had guided his early efforts and given him boundless encouragement, the magnificent example of a high artistic conscience, and deep kindness.

Thanks to all these exhibitions, the public was now able to study and appreciate Cézanne's art. Yet the painter and his work continued to be maligned, especially after Rochefort's article had reminded the critics that Cézanne had been Zola's friend.

"Cézanne, for a short time victor, with Zola, may now definitely be classed with the vanquished," wrote Max Nordau with ill-concealed satisfaction, and in 1904 an anonymous critic of *La Lanterne* spoke of the painter as though he were

dead: "Cézanne was nothing but a lamentable failure; perhaps he had some ideas but he was quite incapable of expressing them." And later the same expert wrote: "Why are they still bothering us with M. Paul Cézanne? Has his cause really not been heard? Do not all those who have seen his works consider him a complete failure? So much the worse for the dealers who, at Zola's word, thought they could make a killing with his works."

Calling Cézanne "victor with Zola," insinuating that it was the novelist who had pushed the painter's work, was a complete distortion of the truth. All that Zola had written about Cézanne was, in 1867, that he "respected" his strong and individual talent; in 1877, that he was the greatest colorist among the Impressionists; in 1880, that the painter was still trying to find himself; and sixteen years later, that Cézanne was an "abortive genius." But in spite of this evidence, and in spite of the fact that nobody ever dared suggest that Manet, whom Zola had so frequently praised, owed his fame to Zola, the journalists began to insist that "Cézanne has Zola to thank for his reputation."

Now that Zola was dead, Cézanne became the victim of his friendship. After having suffered so much from his friend's lack of understanding, Cézanne was haunted at the end of his life by Zola's ghost, always called forth to attack him.

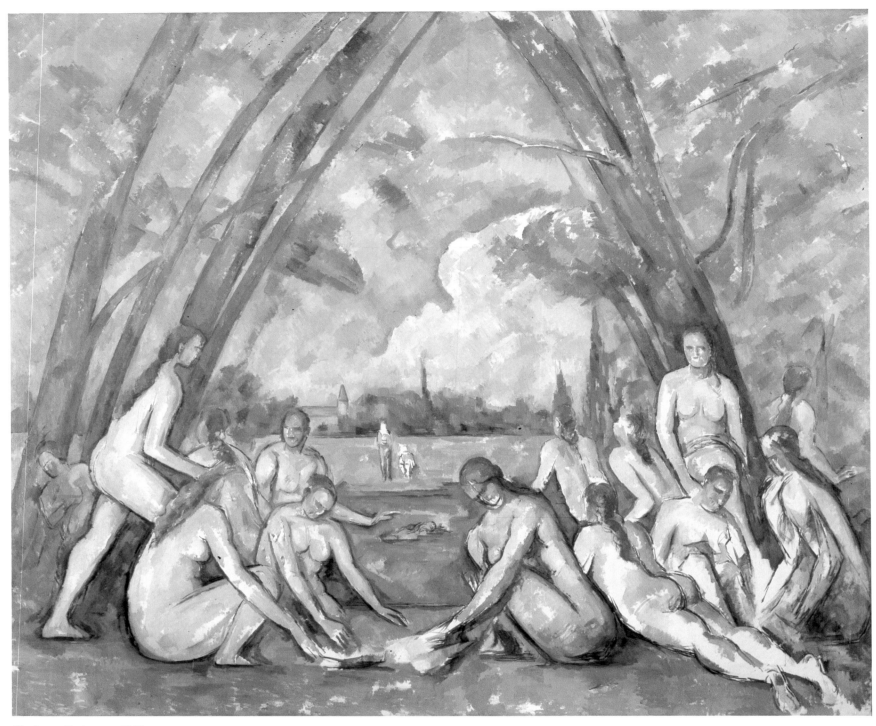

The Large Bathers. c. 1906

Cézanne and His Admirers

THE EXHIBITIONS and criticisms drew the attention of the younger generation to the old painter, but, curiously enough, it was at first chiefly writers and poets who entered his solitary life. His friend Phillipe Solari presented to him his son Emile, who was Zola's godson and who intended to become a novelist. Together Cézanne and Emile took long walks and even climbed Sainte-Victoire. In 1896 through another schoolmate, Henri Gasquet, Cézanne met the latter's son, the poet Joachim Gasquet, who became for a while Cézanne's closest friend. Joachim Gasquet in turn introduced some of his youthful colleagues, such as Edmond Jaloux, Xavier de Magallon, and Louis Aurenche, to Cézanne. They were joined around 1900 by the poet Léo Larguier and the painter Charles Camoin, who were then doing their military service in Aix.

With these young people Cézanne, so timid and suspicious by nature, came out of his shell, touched by the sincere respect and admiration they vouchsafed him. One now sometimes saw him on the terraces of the cafés on the Cours Mirabeau, surrounded by these young writers, or met him at the Hôtel de la Croix de Malte where he went to eat with them when he did not invite them to the Rue Boulegon.

"If I was interested in being with you," Cézanne explained in 1902 to Louis Aurenche, "it was egotism, since I found myself with new friends in the wastes of this good town of Aix. I was unable to open my heart to anyone here."

But despite his pleasure at finding himself surrounded by youthful admirers who tried to compensate him for the contempt he had been shown by his own generation, the friendship of these young men caused the old painter almost as much anxiety as real enjoyment. Although he was often happy and cordial with them, Cézanne could not master his occasional fits of rage, his sudden and offensive reactions. He could, for example, make a terrible scene when someone touched him by accident, but at other times he permitted intentional contact. A fear of persecution, which from time to time obscured his judgment, caused him to speak ill of those who were not present. Almost all of those who knew him during the last years of his life report that Cézanne made unpleasant remarks about all the others. Thus he said cruel and unjustified things—eagerly snapped up by his interlocutors—about Gasquet, Geffroy, Gauguin, Zola, the young painters he knew, and even the art of Claude Monet. In spite of the fact that Cézanne referred to Zola as "a phrasemaker," to Monet as a "blackguard," and to Renoir as a "whore," one must not attach undue importance to these epithets, especially since at the same time Cézanne often spoke very warmly and with real emotion of his former comrades. It is true that Pissarro thought Cézanne's friendship had cooled at the time of the Dreyfus affair, but after Pissarro's death in 1903 Cézanne never let an occasion pass to render homage to this artist who was his friend from the beginning, who had never lost confidence in his genius, and whom he considered his master.

The young men who met Cézanne in Aix, though they were not always conscious of his genius, were without exception struck by something in the old painter that led them to feel his greatness. Edmond Jaloux, who lunched with Cézanne at Gasquet's, later remembered:

Suddenly the door opened. Someone came in with an exaggerated air of prudence and discretion. He had the face of a petit bourgeois or a well-to-do peasant, sly and rather formal. He was slightly round-shouldered and had a tanned complexion, a high forehead, long dishevelled white hair, small, piercing, and ferretlike eyes, a slightly red Bourbon nose, a short, drooping moustache, and a military goatee. That was Paul Cézanne. . . . I can hear his speech, nasal, slow, meticulous, with something careful and caressing about it. I can hear him discourse on art or nature with subtlety, dignity, and profundity.

Louis Aurenche, who also met Cézanne in Gasquet's house, had a similar impression:

Dressed in a dark jacket, with a black silk string tie tightly knotted, holding his hat in his hand, Cézanne seemed to me extremely unhappy. He remained stiff after the first step, silent, intimidated, almost confused. His globular eyes stared anxiously at one after the other of us. With a completely feminine grace, Madame Gasquet took us up to him and introduced each one of us in turn. At every introduction Cézanne bowed deeply, stammering a few unintelligible words; then a long silence fell. At table, Cézanne answered mainly his neighbor, Madame Gasquet, and sometimes I saw him interrupt himself suddenly and blush. Imagining that a slightly crude word might have shocked one of the guests, he remained silent a long moment. He left us before three o'clock so as not to be late for vespers at Saint-Sauveur.

As to Gasquet's own relations with the painter, not much is known, in spite of the book of souvenirs he published many years later. It seems certain, however, that after one or even several quarrels, the two men avoided each other, and that on Cézanne's part a fairly pronounced disdain took the place of a sincere friendship. It may have been that Gasquet was lacking in tact and showed a too evident desire to obtain some of Cézanne's canvases. Though the painter was often happy to present his works to the few friends who admired them, he did not appreciate a too obvious wish to receive them as presents. Thus when the young painter Hermann-Paul quite innocently asked the price of a canvas, he got the unexpected answer: "I have no reason to make a gift of them to anyone."

Cézanne ceased to see Gasquet, not only because of his suspicion of the poet's motives, but also, as he explained to a young painter, because: "I have no business in their salon, I am always saying *Nom de Dieu!*" However, he remained on good terms with several of Gasquet's friends, such as Léo Larguier and Louis Aurenche, who often came to dine at 23, Rue Boulegon. Léo Larguier in particular, who spent two years in Aix, was a regular Sunday visitor. He has told in his recollections of Cézanne that the painter was, contrary to the legend, better and more comfortably dressed than most people in Aix and was, moreover, very cordial. During dinner Cézanne would tell the most innocent stories and, when he had finished, drop his hands and exclaim with a sigh: "Life is frightening." He admitted to the young soldier that he considered himself "a weakling," that he found Larguier "very well balanced," and asked him to come often since he gave him "moral support." The same moral support Cézanne found in Charles Camoin, a young painter from Marseilles who, like Larguier, was doing his military service in Aix, and became one of Cézanne's favorite companions. This shy young man would listen with such ardent admiration that Cézanne willingly spoke to him of his art, feeling himself understood by this colleague who was so full of goodwill. In the letters he later wrote to Camoin, Cézanne gave him advice on painting in a particularly affectionate and paternal tone.

The same cannot be said of Cézanne's relations with the young painter Emile Bernard, who came to Aix early in 1904 and stayed there for a month. Bernard, who had published a pamphlet on Cézanne twelve years before, was very well received by the old painter and even invited to come and work in a room below

his own studio. While he painted there he used to hear Cézanne walking up and down in his studio and frequently interrupting his work, descending into the garden, then rushing up again.

Together, Cézanne and Bernard visited the museum of Aix or took long walks into the beautiful countryside. They also painted side by side. They had long discussions on art and continued these discussions in a fairly consecutive correspondence. However, Cézanne's letters to Bernard do not always show the same cordiality as those he wrote Camoin. Indeed, the old painter seems often tired of Bernard's numerous questions on his artistic theories and somewhat resentful of having to answer them with abstract thoughts. "The man of letters expresses himself in abstractions," he wrote Bernard, "whereas the painter gives concrete shape to his sensations and perceptions by means of drawing and color."

It was apropos of one of Bernard's letters that Cézanne wrote to his son: "I can scarcely read his letter but I think it is right, though the good man absolutely turns his back in practice on what he expounds in his writings. His drawings are merely old-fashioned rubbish, which stem from his dreams of art suggested not by the emotion of nature, but by what he has been able to see in museums, and more still by a philosophic mind, which comes from the too great knowledge he has of the masters he admires."

Camoin and Bernard were not the only ones to visit Cézanne in Aix. Other painters, such as Maurice Denis, K.-X. Roussel, and Hermann-Paul made the pilgrimage to Aix to render Cézanne the homage of their admiration. They came to see him in his studio or accompanied him to the motif, listening to his theories on art. "What we sought in his work and his words," Maurice Denis later admitted, "was that which seemed opposed to Impressionist realism, and the confirmation of our own ideas, those which were *dans l'air*. Cézanne was a thinker, but he did not always think the same thing every day. All those who approached him made him say what they wanted to hear. They interpreted his thought."

However, even those who approached Cézanne without preconceived ideas were astonished by the ease with which he seemed to contradict himself. A young artist, Francis Jourdain, heard him say: "Impressionism, it's no longer necessary. It is nonsense!" and then promptly pay a moving tribute to Pissarro, whom he designated as the true master, the incontested leader of the Impressionists. After remarking, before his large canvas of *Bathers*, done without models, that "painting is in here" and tapping his forehead, Cézanne surprised his young visitor by insisting that his purpose had always been to convey the real distance between the eye and the object, and that true progress could only be based on nature. Their admiration notwithstanding, those who called on the aging Cézanne sometimes had to admit that consistency was not the greatest virtue of his remarks.

Cézanne's position in Aix had remained somewhat ambiguous, and if he desired so ardently to be accepted at the official Salon or to be decorated with the red ribbon of the Legion of Honor, it was doubtless to prove to his compatriots that his art was more than the pastime of an old maniac. But neither of these dreams were to be fulfilled; on the contrary, fate seemed determined to deny even the least satisfaction to his pride. When, in 1905, Monet, who was already world-famous, declared his admiration for Cézanne in an interview, saying that he considered him one of the great painters of the epoch, his words were published with a footnote specifying: "The review *L'Art et les Artistes* is open to all sincere opinions, it is free of any bias, and it is not to be held responsible for the esthetic judgments of its contributors." Exposed to such sly insults (directed, in this instance, not only against Cézanne but also against Monet), it is not

surprising that, after innumerable such experiences, after the protests unleashed by the Caillebotte bequest, after the calumnies at the time of the Zola sale, after so many daily vexations, Cézanne finally believed that there was some plot against him and became suspicious even of good news. Thus the announcement that one of his paintings had been hung in the Berlin National Gallery had the unfortunate consequence of making him fear that such a gesture by the Germans might forever close to him the doors of the French museums. However, in 1906, when the German collector, Karl Ernst Osthaus, founder of the Folkwang Museum, came with his wife to see Cézanne in Aix, they were very well received at the Rue Boulegon. Osthaus wrote of his visit:

When the door was opened we entered an apartment that in no way betrayed the exceptional qualities of its inhabitant. There were no pictures anywhere on the walls. Cézanne received us without formality. Standing, we told him that we had been glad to take the opportunity of a trip south to bring him the homage of our respect, that our admiration for his art dated from far back, and that we hoped very much to buy one of his works.

Cézanne put us several questions about our collection. The names represented gained us his esteem. He became communicative and began to expound his thoughts on painting.

He explained his ideas in front of several canvases and sketches, which he fetched from all over the house. They showed masses of brush, rocks, and mountains all intermingled. The principal thing in a painting, he said, was to find the distance. It was there that one recognized the talent of a painter.

And saying this, his fingers followed the limits of the various planes on his canvases. He showed exactly how far he had succeeded in suggesting the depth and where the solution had not yet been found; here the color had remained color without becoming the expression of distance.

Then he spoke to us of painting in general. Was it courtesy towards his German interlocutors that caused him to place Holbein at the head of the list of all the masters? In any case, he did so with such emphasis that it was not permissible to question his convictions.

"But one cannot equal Holbein," he exclaimed, "that is why I took Poussin as an example!"

Of the moderns, Cézanne spoke warmly of Courbet. He admired Courbet's unlimited talent, which mastered all difficulties. "Great as Michelangelo," he said, but with this restriction: "He lacks the elevation!"

He only mentioned van Gogh, Gauguin, and the Neo-impressionists. "They make things a little too easy for themselves," he said. Finally, he delivered an enthusiastic eulogy of his comrades of former years. In the pose of a great orator, raising his finger in the air, he exclaimed: "Monet and Pissarro, the two great masters, the only ones!"

Before saying good-bye to us, Cézanne urged us to come to see him after lunch in his studio in the country, where he was working on a painting. When we arrived, he was awaiting us. He had us enter the simple two-story house that contains, in addition to a few bare rooms, only the large studio, which is also bare. On his easel was a still life he had just begun and the chief work of his old age, the *Bathers*. The tall shafts of the trees were already bending, forming an arch under which the bathing scene was unfolding. We spoke of the painting of nudes. Cézanne then complained of the narrow provincial attitude that prevented him from having a female model. "An old invalid poses for all these women," he explained.

After this visit, the collector, on the way home, stopped in Paris and purchased two canvases from Vollard, one of them related to the landscape of bushes and rocks he and his wife had admired at Rue Boulegon. The painter had also promised to send some works to Germany, a promise he was not able to keep.

Only on his return to Paris, where Herr Osthaus spoke of the courteous reception given him by Cézanne, did he learn that the artist was considered, even by some of his admirers, as perfectly impossible to approach. According to rumor it was better to avoid him if one ever ran into him.

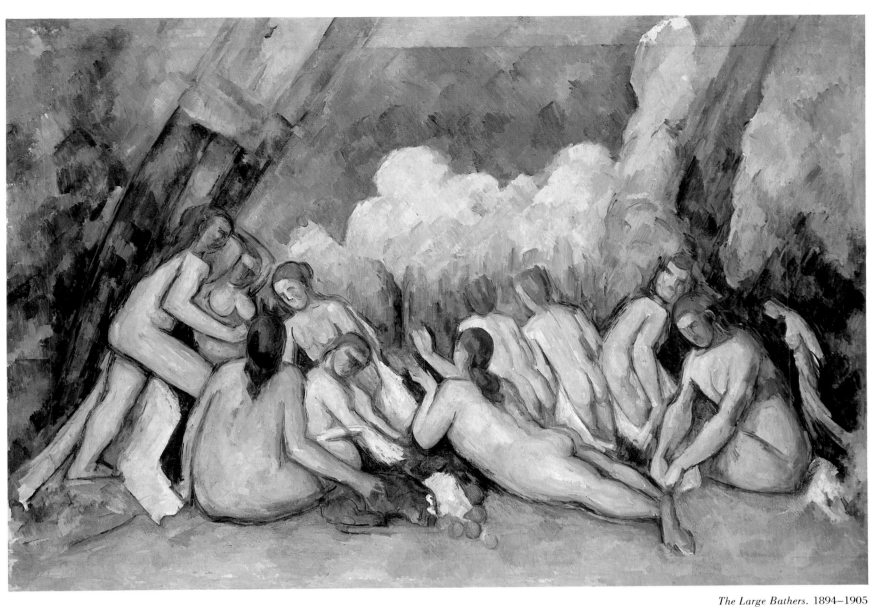

The Large Bathers. 1894–1905

Cézanne's Theories about Art

THE YOUNG artists who sought Cézanne's advice in Aix were sure of a cordial reception. He was always ready to speak of his work and would ask whether the others had made the same observations on nature. "I think the young painters are much more intelligent than the others," he wrote to his son. "The old ones see in me only a dangerous rival."

Realizing that it was too late for him to form pupils, Cézanne decided to leave to posterity what might be called a system of painting. Despite his frequently expressed contempt for theories, he now did not hesitate to formulate some of his own, glad to be sought after and to have his advice esteemed. "I owe you the truth about painting," he wrote, a year before his death, to Emile Bernard, "and I shall tell it to you." And to Charles Camoin he promised: "I shall speak to you about painting better than anyone else."

If Cézanne had recognized his own words and gestures in Claude Lantier, as well as his difficulty in realizing his sensations, Lantier did not express Cézanne's ideas. What Cézanne thought about art, the theories he communicated to his young painter friends, he had found expressed by Balzac in the short novel *Le Chef-d'oeuvre inconnu* [*The Unknown Masterpiece*] and he had not hesitated to identify himself with its chief character, the painter Frenhofer. The spiritual similarity between Cézanne and Frenhofer is such that one cannot determine whether Cézanne found in Frenhofer an echo of his own ideas or whether he gathered these ideas from Balzac's character.

For example, Frenhofer speaks of this "mass of ignorant people who fancy they can draw correctly because they carefully make a sharp line." He then explains his own method:

I have not coldly outlined my figure and emphasized each minor anatomical detail, for the human body is not limited by lines. . . . Nature comprises a series of curves that interlace. Strictly speaking, drawing does not exist. . . . Line is the means by which man takes account of the effect of light on objects; but there is no line in nature, where everything is full: it is in modeling that one draws, that is to say, one detaches things from their environment—the daylight alone gives the body its appearance! . . . Perhaps it would be better not to draw a single line, but rather to begin a figure in the middle, starting with the protuberances that receive the most light and proceeding thence to the darker parts. Is that not the method of the sun, the divine painter of the universe?

Cézanne, like Frenhofer and all the Impressionists for that matter, denied the existence of line in nature. "Pure drawing is an abstraction," he said. "Drawing and color are not separate and distinct, as everything in nature has color." And Cézanne remarked to Emile Bernard: "While one paints, one draws; the more the color harmonizes, the more precise becomes the drawing. When the color is rich, the form is at its height. The contrasts and relations of tone comprise the secret of drawing and form," for "the form and contour of objects are conveyed to us through the opposition and contrast resulting from their individual colors."

Frenhofer's theory that one should attack a figure by starting with the most illuminated protuberances is found again in the advice Cézanne gave Emile Bernard, to whom he wrote: "In an orange, an apple, a ball, a head, there is a

Jean-Baptiste Pigalle. *Love and Friendship*

OPPOSITE:
Drawing after Pigalle's
Love and Friendship. 1879–82

Auguste Préault. *Clémence Isaure*

culminating point and this point is always—despite the tremendous effect of light and shade and sensation of color—the closest to our eye. The edges of objects recede to a center placed on our horizon."

For a better grasp of his model, Cézanne advised Bernard to "see in nature the cylinder, the sphere, the cone, putting everything in proper perspective, so that each side of an object or a plane is directed toward a central point. Lines parallel to the horizon give breadth, that is, a section of nature. . . . Lines perpendicular to this horizon give depth. But nature, for us men, is more depth than surface, whence the necessity of introducing in our vibrations of light— represented by reds and yellows—a sufficient quantity of blue to give the feeling of air."

This theory, which preoccupied Cézanne during his last years, is the outcome of his study of planes and volumes. In Cézanne's work, however, one finds neither cylinders, cones, nor parallel and perpendicular lines, the line never having existed for Cézanne except as a meeting place for two planes of different color. One might thus be permitted to see in this theory an attempt to express his consciousness of structure beneath the colored surface presented by nature. It was this awareness of form that detached Cézanne from his Impressionist friends. But nowhere in his canvases did Cézanne pursue this abstract concept at the expense of his direct sensations. He always found his forms in nature and never in geometry.

It was chiefly Emile Bernard who, by his numerous questions and long discussions, pushed Cézanne to formulate theories. As he wrote his son: "With Bernard one can develop theories indefinitely, for he has the temperament of a logician." But Cézanne did not much like this temperament, which led to interminable controversies, sometimes interrupted by sudden rages of the old painter. When Bernard asked too many questions, Cézanne, instead of answering, would say: "I am not in the habit of reasoning so much." And when the young man continued his queries in his letters, Cézanne complained that he spoke of so many different things all related to art that he could not "follow his reasoning."

"I am sorry not to have him in my power," Cézanne wrote about Bernard in 1906 to his son, "so as to infuse into him the idea that is so healthy, so comforting, and the only correct one of the development of art through contact with nature."

This was the best piece of advice he thought himself capable of giving to young painters, besides urging them not to neglect the old masters. "Go and study Veronese and his technique in the Louvre," he told Louis Le Bail, while speaking of the vibration of color. He also liked to hold forth about Chardin, the brothers Le Nain, Poussin, Rubens, and particularly Delacroix, in whose honor he dreamed of painting an *Apotheosis* uniting Pissarro, Monet, Chocquet, and himself. Ultimately, he considered himself closest to the French school of the eighteenth century, yet at the same time he feared that the young painters might pursue their study of the old masters to the detriment of the observation of nature, and this danger he constantly exhorted them to avoid. "Since you are now in Paris," he wrote to Camoin, "and the masters of the Louvre are attracting you, make, if you feel like it, some studies after the great decorative masters Veronese and Rubens, but just as you would do after nature—a thing I was only able to do incompletely myself. But you do well to study above all from nature."

Cézanne's advice would have been incomplete if he had not shown his method of work, brush in hand, avoiding all the dangerous abstractions he so disliked. He could say, for instance, to Louis Le Bail as they were starting off together to the

Drawing after Préault's
Clémence Isaure. 1880–83

Pierre Puget. *Hercules*

TOP:
Drawing after Puget's *Hercules*. 1884–87

motif: "We are going to put our absurd theories into practice." He cared little for theory if it was not justified in the work. And he insisted: "I do not want to be right in theory but in nature." For, as he said in a letter to Emile Bernard, theories "are always easy; it is only the proof of what one thinks that presents serious obstacles." Thus, while painting a portrait, Cézanne once exclaimed: "If I make a success of this fellow, the theory will have been right!" However, Cézanne would not have hesitated to reject any theory if in its realization he did not find complete satisfaction. "All things, particularly in art," Cézanne wrote to Camoin, "are theory developed and applied in contact with nature." And another time he told him: "I have nothing to hide in art. Primary force alone, *id est* temperament, can bring a person to the end he must attain."

One rainy day, Louis Le Bail watched Cézanne compose a still life: a napkin, a glass containing a little red wine, and peaches. "The cloth was very slightly draped upon the table, with innate taste," he later remembered. "Then Cézanne arranged the fruits, contrasting the tones one against the other, making the complementaries vibrate, the greens against the reds, the yellows against the blues, tipping, turning, balancing the fruits as he wanted them to be, using coins of one or two sous for the purpose. He brought to this task the greatest care and many precautions; one guessed that it was a feast for the eye to him."

When he had finished, Cézanne explained to his young colleague: "The main thing is the modeling; one shouldn't even say modeling, but modulating."

Questioned by a young artist on what, in his opinion, was the most necessary study for a beginner, he replied without hesitation: "Copy your stovepipe." And he gave his reasons for attaching the greatest importance to a profound knowledge of the play of light on a form and the means of expressing this form by

Diana the Huntress. After the Antique

LEFT:
Drawing after *Diana the Huntress.* 1882–85

Still-life objects and a patterned rug used by Cézanne for compositions in his Lauves studio. Photograph c. 1935

reproducing that play: the most luminous point, the gradation of light, halftone, shadow, reflection.

To Renoir, Cézanne once remarked that good painting required that "the angle of the shadow be equal to the angle of light." And Emile Bernard noted how Cézanne painted a still life: "He started with the shadow and with a brushstroke, then covered it with another, larger one, then a third, until all the spots of tones, forming a kind of screen, modeled the object in color." To give him an idea of his approach, Cézanne advised Bernard "to begin lightly and with almost neutral tones. Then one must proceed by steadily climbing the scale and tightening the chromatics." In order to accomplish this, Cézanne, instead of mixing a lot of

Guillaume Coustou. *Bust of the Priest de la Tour*

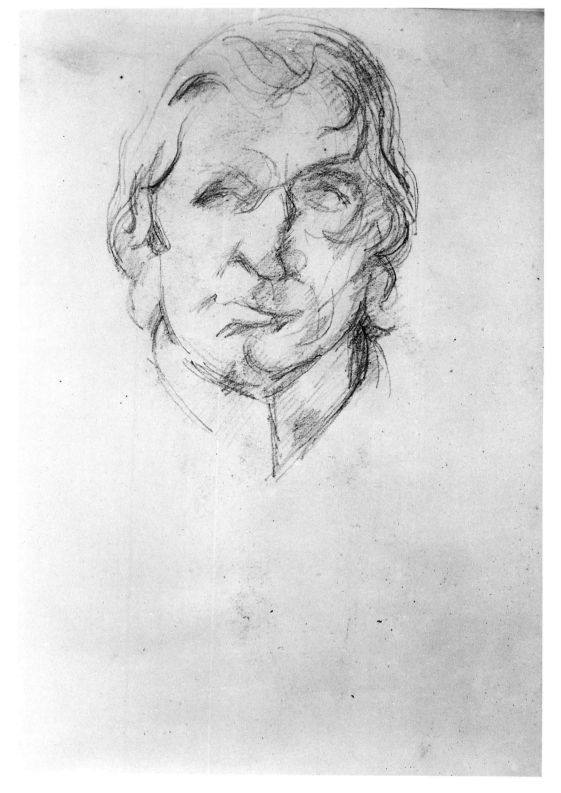

Drawing after Coustou's
Bust of the Priest de la Tour.
1884–87

colors, had ready on his palette an entire scale of tone gradations.

Cézanne's palette, according to Bernard and memos found in the painter's notebooks, consisted of the following:

YELLOW: brilliant yellow, Naples yellow, chrome yellow, yellow ocher

RED: raw Sienna, vermilion, red ocher, burnt Sienna, madder lake, carmine lake, burnt lake

GREEN: Veronese green, viridian, green earth

BLUE: cobalt blue, ultramarine, Prussian blue

BLACK: peach black

From about 1890 on, watercolor played an important role in Cézanne's work. Since this medium does not permit any correction of brushstrokes, Cézanne, who for so long had been unwilling to part with a canvas until he had gone over it

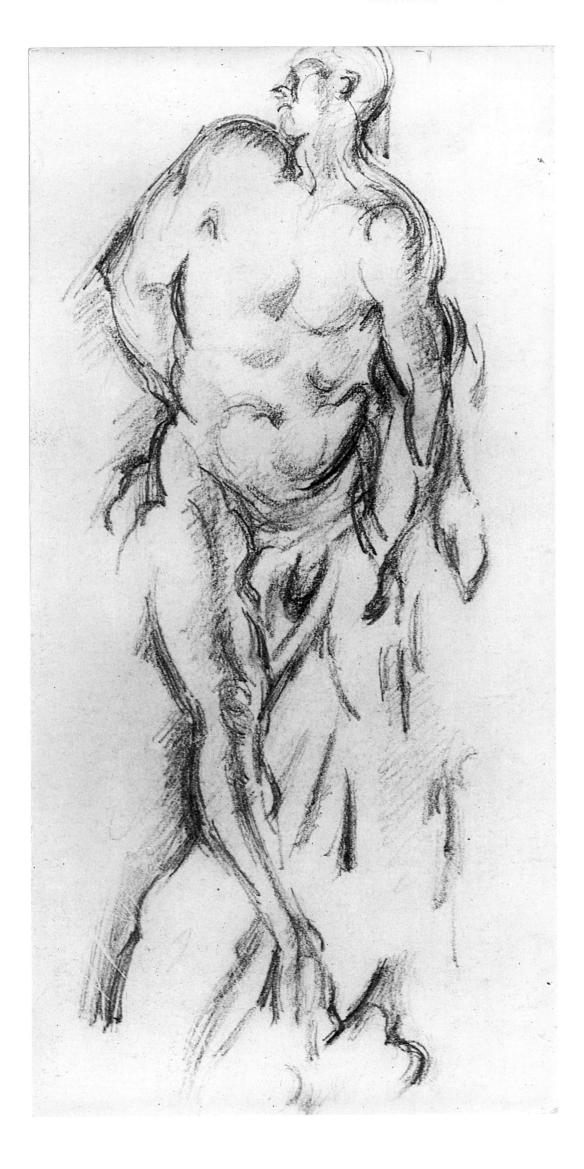

Pierre Puget. *Milo of Crotona*

Drawing after Puget's *Milo of Crotona*. 1895–98

Mars Borghese. Roman marble copy after Greek bronze original of the 5th century, B.C.

Drawing after *Mars Borghese.* 1892–95

time and again, must have acquired a complete confidence in the spontaneous reaction of his sensibility before taking up watercolors. In general he did not use this medium to add color to his drawings but as a self-sufficient means of expression, in which all lines and forms spring from color alone. Never before had the technique of watercolor been used with such purity or been so reduced to its essence.

Cézanne, who filled notebook after notebook with sketches, sometimes hasty, sometimes developed, was not, strictly speaking, a draftsman; that is to say, drawing does not seem to have been an end in itself to him. When he took up his pencil it was, so to speak, for his personal use, to retain forms and movements, to fix an idea, to exercise his eye. He hardly ever did preliminary sketches,

232

Michelangelo. *Slave*

Drawing after Michelangelo's *Slave*. 1885–88

since his watercolors and canvases are not the products of a long, abstract reflection but the result of direct observation, which did not allow such preparations. That which meant most to Cézanne was precisely the color that is lacking in drawings.

The draftsman Cézanne, who, in studies of objects of little color (sculpture, skulls, etc.) endeavored to render the form by a range from pure white to black, proceeded in a completely different fashion in the presence of nature: he hardly ever tried to suggest depth, a task that devolves on color; he was satisfied with indicating the contours, setting off all their purity. The bare trees become living arabesques, the roofs of L'Estaque form nothing more than a mosaic of geometric figures. But even when Cézanne consciously renounced color, he generally could

233

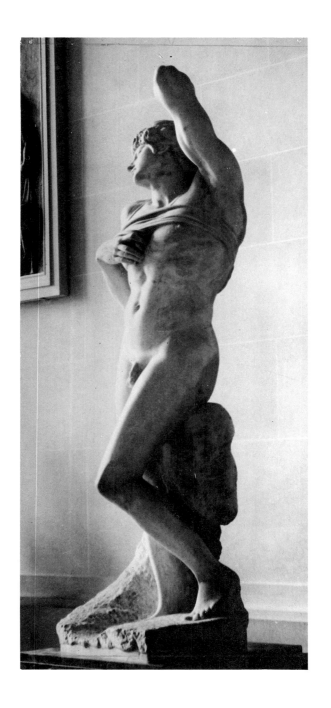

not help substituting patches and strokes of the pencil for it, indicating the different values. Some of his drawings look as though they had been made one day when the painter had forgotten his paint box. While in his watercolors he was satisfied with a very light pencil sketch without much detail (the brush would later fix with precision the joint of a branch or the roundness of a trunk), these drawings are all composed of little dashes in different directions, each one seemingly representing a brushstroke. The color appears to be "invented" by the pencil.

However, drawings without color are found less and less in the work of Cézanne's old age, precisely because color became increasingly the dominant element in his art. In the watercolors or oils the drawing is no longer even the scaffolding, the frame for the color; it is hardly more than an indication of masses. It has no longer the right to encroach upon the domain of color; the strokes of the pencil have no plastic value, so that the color may freely weave

OPPOSITE, ABOVE LEFT:
Antoine Coysevox.
Bust of Marie Serre

OPPOSITE, BELOW LEFT:
Michelangelo. *Slave*

OPPOSITE:
Drawing after Coysevox's
Bust of Marie Serre. c. 1900

RIGHT:
Drawing after Michelangelo's
Slave. 1884–87

that astonishing and dense texture presented by the last works of Cézanne.

Watercolor was for Cézanne a means that permitted him quickly to retain colored impressions or to enliven his studies, still lifes as well as portraits, landscapes, and groups of bathers. Sometimes he was satisfied to add color to a sketch, dashes of violet blue doubling contours, a few spots indicating the nature of the object. It was these studies which inspired Rilke to write: "They are very beautiful; they reveal as much assurance as the paintings and are as light as the others are massive. Landscapes, brief pencil sketches upon which, here and there, as though to emphasize or to confirm, falls a trace of color, casually; a succession of dashes, admirably arranged with a sureness of touch, like the echo of a melody."

Besides these, as it were, highlighted drawings, Cézanne executed watercolors in a technique reminiscent of his oil paintings. Proceeding only with very light spots of color, he covered the white sheet with several successive layers. To prevent the wet spots running into each other, this procedure demands that each one dry completely before the next one is applied. It is thus a very slow method, which Cézanne used, however, without sacrificing the spontaneous charm of the medium, endowing his watercolors with a luminous beauty never before attained. For unlike oils, the various layers of watercolor as used by Cézanne remain transparent; they do not imprison forms or define them but rather indicate their shapes in such a loose way that each patch seems to move when looked at. The richness of tones and nuances of these works is equaled only by the simplicity with which Cézanne uses this complicated procedure to fix the roundness of a few apples on a white plate or to give a dreamlike atmosphere to a scene of bathers.

The influence of oils on Cézanne's watercolors corresponds to a reciprocal influence of his watercolor technique on his oil painting. He placed large strokes without hesitation, giving to the canvas itself, which often appears, the role of the white paper, that is to say, as a bond between the scattered touches. However, in his very last years, Cézanne made use of a technique that one might call "impasto" if this term were not reminiscent of his early works or of his Auvers period, for this new impasto often is one of the first layer. Cézanne worked with a full brush on canvases often hardly prepared and that rapidly absorbed the oil of the pigment, thus robbing the color of its brilliance. All preliminary drawing seems to have disappeared and the canvas is covered with a dense tissue of spots that, from close to, offer the eye nothing but a mosaic of tones.

In his last years, Cézanne had found that sureness which permitted him to work more or less spontaneously. When, for example, he began a new canvas, he drew with a brushful of ultramarine diluted with a lot of turpentine, sketching with vigor, without hesitation. His paintings are in general only covered with a single layer of pigment, and the canvas often shows through. It was apropos of these bare spots that Cézanne wrote to Emile Bernard in 1905: "Now, being old, nearly seventy years, the sensations of color, which give light, are the reason for the abstractions that prevent me from either covering my canvas or continuing the delimitation of objects when their points of contact are fine and delicate; from which it results that my image or picture is incomplete. . . ."

"It is very painful to have to register," Cézanne told Emile Bernard, "that the improvement which manifests itself in the understanding of nature, as regards the form of the painting and the development of the means of expression, should be accompanied by old age and a weakening of the body."

Jean-Baptiste Pigalle. *Mercury*

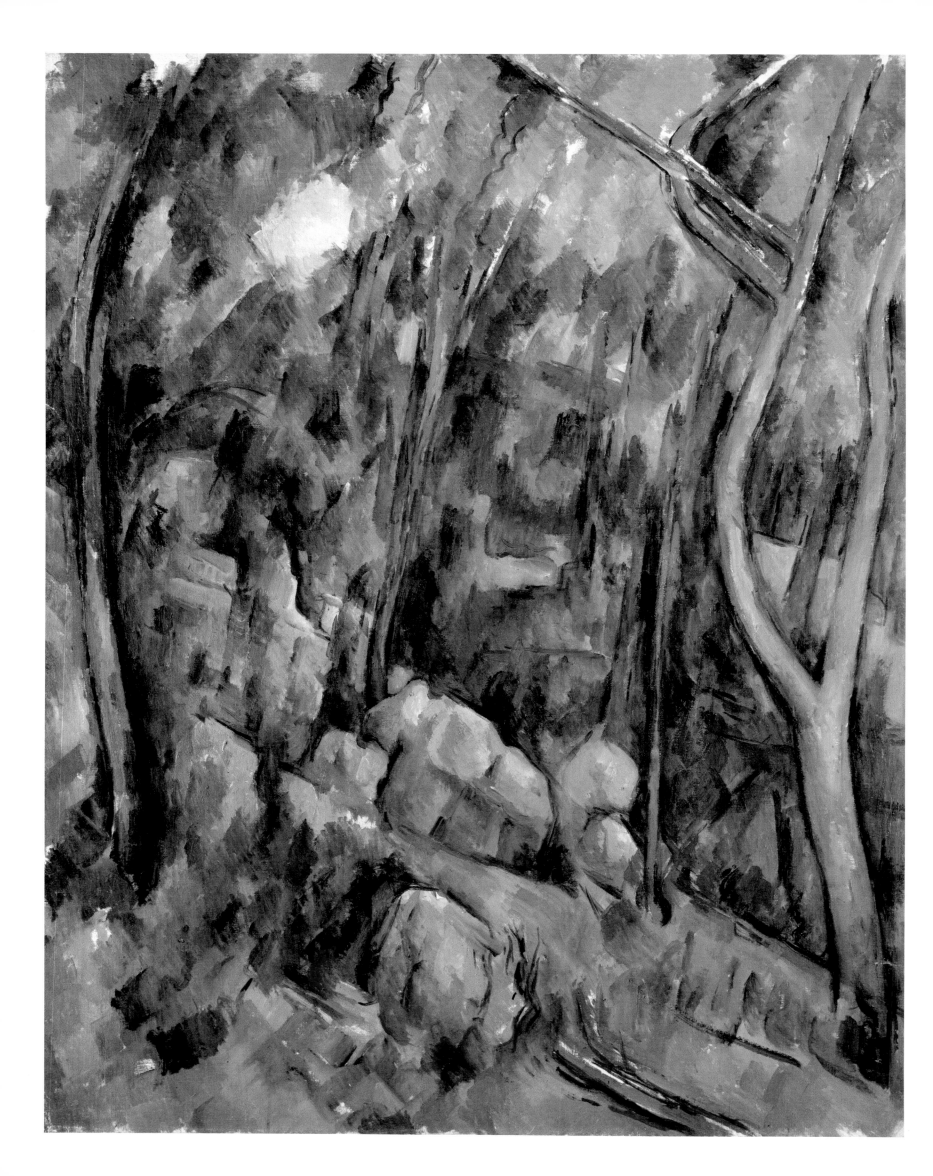

The Last Motifs at Aix [16]

As CEZANNE grew old his world became ever more restricted. He was not yet fifty when, at his father's death, he inherited substantial wealth: 1,600,000 francs to be divided among the banker's four heirs, his widow and his three children. Cézanne now could at last have undertaken trips abroad, to Italy and Spain for example, which he had never visited and whose museums contained treasures that meant a great deal to him. Yet he did nothing to change the rhythm of his simple life and, rather than venture farther away from Aix, actually confined himself still more to its immediate surroundings. These never lost their attraction for him. Aix itself held scant fascination for him—and its provincial inhabitants even less. He remained a loner in the midst of a region where every stone, every tree, every brook was familiar to him since his youth. He never grew tired of its colors and harmonious shapes, its light and distant vistas dominated by Mont Sainte-Victoire.

In 1896 Cézanne sojourned with his wife and son at Talloires on Lake Annecy, possibly because Madame Cézanne, in compensation for the boring cures at Vichy, exacted this concession from her husband. It was from Talloires that the painter wrote to his longtime friend Solari: "When I was in Aix, it seemed to me that I should be better elsewhere; now that I am here I miss Aix. Life for me is beginning to be of a sepulchral monotony. . . . I paint to divert myself; it is not very amusing, but the lake is very nice with the big mountains all round. . . . It is not worth our country, though—without exaggeration—it is fine. But when one was born down there, it is no use, nothing else seems to mean anything."

In Aix, Cézanne had taken the habit of hiring a carriage to drive him to the motifs, which were all situated in the surroundings of the city, preferably in spots far from the roads and on heights, so that the painter could see in time anyone who came to interrupt his work. Yet Cézanne could not always paint where he wished, as he sometimes did not receive permission to work on private properties, either because of his reputation of being a little touched, or because he was too timid to insist.

"The world does not understand me," he sometimes told his coachman, with whom he liked to chat when, on the hills, he got out of the carriage and walked to lessen the horse's load. "And I do not understand the world," he continued. "That is why I have withdrawn from it." And it would frequently happen that, deep in his thoughts, Cézanne forgot to climb back into the carriage when they had reached the top of the hill; meditating or talking to the driver, he reached their destination on foot.

When in a mood for company, Cézanne liked to go for walks with his friend Philippe Solari, talking all the time and explaining to him his ideas on art and on nature. At other times he would invite him to dinner at the Rue Boulegon and their heated discussions on art would sometimes stop the passersby in the street. "The poor man," wrote Cézanne to Solari's son, speaking of his father, "I have saturated him with theories on painting. He must have a good constitution to have withstood it."

For some time already Cézanne had avoided L'Estaque, and he gave his reasons in a letter to his goddaughter, Paule Conil, who was spending her vacation near there: "I remember perfectly the once so picturesque coast of

Forked pine tree near the caves above Château Noir.
Photograph c. 1935

OPPOSITE:
*The Forest with Forked Pine Tree
near the Caves above Château Noir.*
1900–1904

239

The old road of Le Tholonet with umbrella pines. n.d.

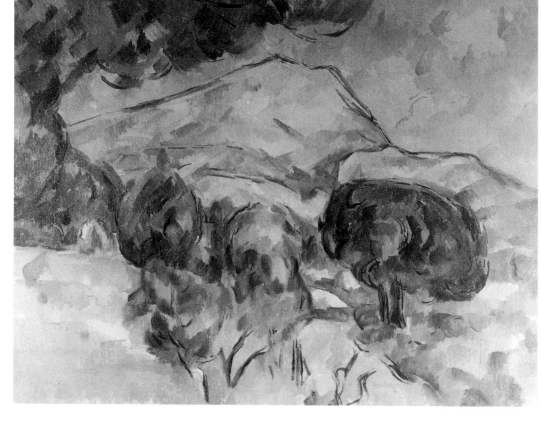

Mont Sainte-Victoire above the Road of Le Tholonet (with Umbrella Pines). c. 1904

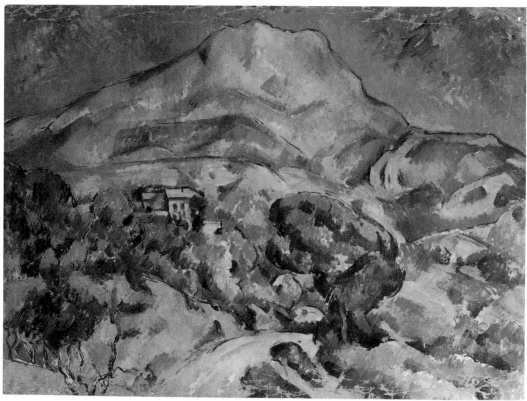

Mont Sainte-Victoire above the Road of Le Tholonet. 1896–98

L'Estaque. Unfortunately, what is called progress is nothing but the invasion of bipeds who will not rest until they have transformed everything into hideous quais with gas lamps, and—what is even worse—electric lights. What times we live in!"

After his mother's death in 1897 the Jas de Bouffan was disposed of in order to divide the proceeds among the painter and his two sisters, and Cézanne began to look for new places around Aix. He worked at the Bibémus quarry and in the area of Le Tholonet, where he felt drawn to Château Noir and its wooded slope, which afforded a close view of Sainte-Victorie.

In 1901 Cézanne had rented living quarters in a narrow street in Aix, 23, Rue

Boulegon, not far from the splendid town hall and its beautiful square. There was a small garden with a tree behind the house where he would occasionally work. Cézanne needed a larger space, yet it was not easy to find a place where he could paint undisturbed out-of-doors. It was at this time that he approached the owner of Château Noir, which stood uninhabited most of the year, with an offer to buy the property, a proposal that was turned down.

What was then the "Petite Route du Tholonet" leads from Aix eastward in the direction of Sainte-Victoire. The road bends frequently, rises and falls, until, after about a mile, at a sharp turn, the view is suddenly free over an undulating landscape that reaches the foot of the commanding gray rock. After one more gentle curve a small, slowly mounting path to the left of the road disappears into the forest. From a slight elevation near the path, one can look down over the road and see the two umbrella pines that cast their shadows on it, with Mont Sainte-Victoire looming over the whole scene. From here Cézanne painted two views of the mountain, of those pines, and of the road that loses itself in the distance.

The path, strewn with pine needles, leads through the woods toward the so-called Maison Maria. On the way, where the trees are less densely clustered, there are glimpses of Château Noir, with Sainte-Victoire beyond. Yet it was from the broadening path in front of Maison Maria, where the ground sloped down on one side and rose on the other, that Cézanne had a better view of the building, or rather of its west wing, which he painted repeatedly from that vantage point.

Situated halfway between Aix and the village of Le Tholonet, Château Noir had been built in the second half of the nineteenth century somewhat above the road near the bottom of the wooded hill that rises behind it. It consists of two separate buildings, set at a right angle to each other; the higher, main building looks south, down on the road and into the valley that leads to the distant village of Palette on the highway to Nice. A series of pillars extends from this main building to the west wing. They were to be part of an orangerie, which was never finished. They rise into the sky, supporting nothing, and lend the complex an incongruous aspect of ruins. Incongruous, too, is the style of the buildings, with their narrow Gothic windows and steep roofs. Between them lies the court that Cezanne's room overlooks; at its center there is still a gnarled pistachio tree surrounded by stones, and a heavy stone lid—probably for a well—that had been abandoned there, which Cézanne represented in a watercolor.

Legend has it that the complex, which was planned to be twice as large as it is, was built by a coal merchant who had it painted black. Other tales assert that he was an alchemist who had intimate commerce with the devil—hence the designation "Château du Diable," by which the strange structure was also known. But even the less forbidding name of "Château Noir" is a misnomer, for there is nothing black about it, nor is it a château; it is built of the beautiful yellow stone from the nearby Bibémus quarry, which also furnished the material for most of the patrician houses and the churches of Aix. In Cézanne's paintings it is always the glow of the orange-gold facade of the west wing, livened by the large red barn-door (now faded), as seen from the Maison Maria, that dominates the unruly blue-green vegetation.

The path from the Maison Maria, now wider and more level, continues straight to another bend where a number of stone blocks lie helter-skelter, a stone wheel standing erect among them. At this site an oil mill was to be erected, yet the blocks are still waiting to be set into place. Like so many other projects, this too was abandoned, and trees and bushes have grown freely among the blocks. Some of the trees have died, choked by the surrounding forest, and their trunks litter the ground. Next to this spot is an ancient cistern, for there was a spring below,

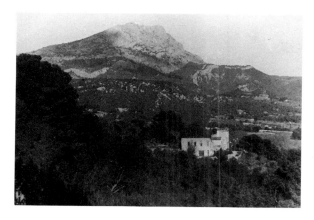

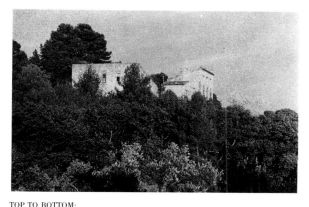

TOP TO BOTTOM:
Château Noir seen from a neighboring hill. Photograph c. 1935

Mont Sainte-Victoire seen from the terrace of Château Noir. Photograph c. 1950

View of Château Noir. Photograph c. 1935

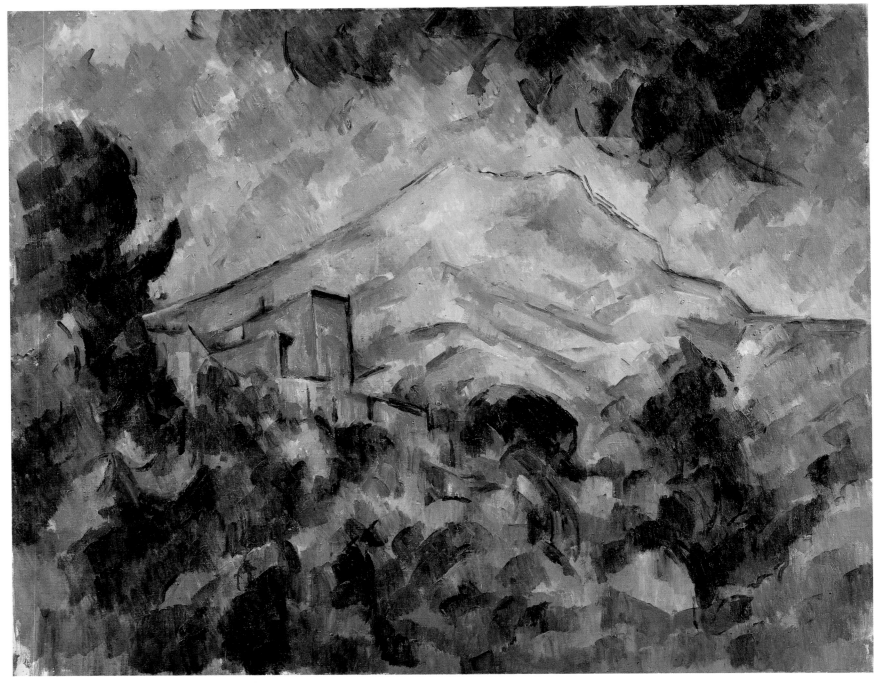

Mont Sainte-Victoire and Château Noir. 1904–1906

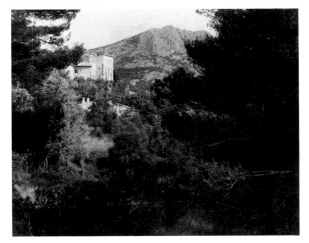

Mont Sainte-Victoire and Château Noir.
Photograph c. 1935

242

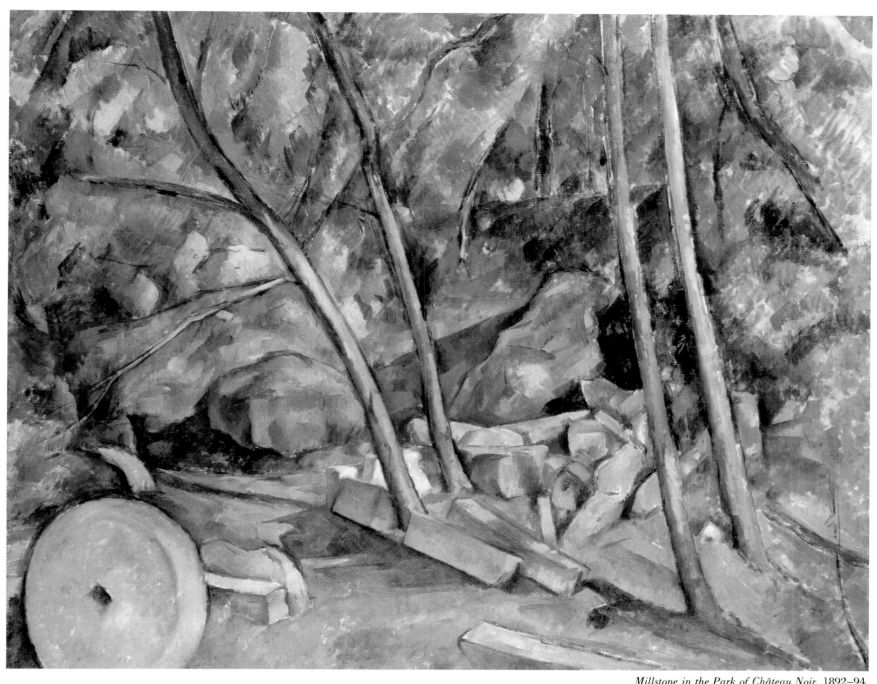

Millstone in the Park of Château Noir. 1892–94

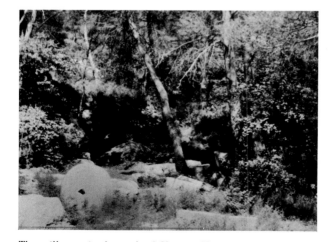

The millstone in the park of Château Noir.
Photograph c. 1935

as attested by an irregular row of oak trees; from three wooden poles joined together above it, a chain used to dangle with a bucket that could be lowered into the cool depth. Cézanne liked to put up his easel here to paint the cistern, the abandoned mill, the rocks and the trees behind them.

Beyond this spot the path narrows again and, passing a small well, soon reaches the broad, sun-drenched terrace that surrounds Château Noir on three sides. To the left of the west wing Cézanne could ascend to his room on the inner court, for—because of the rising ground—that court is level with the second floors of the two buildings. When he followed the terrace to the east, he reached a shady grove where the view toward Sainte-Victoire was unhampered, with not a house in sight, nothing but vineyards, fields dotted with dark cypresses, woods, and hills, behind which rises the mountain, its massive, chopped-off cone barring the horizon.

Cézanne painted Château Noir only from a distance, as it emerges above the treetops. He usually preferred to work in the forest, climbing up the fairly steep hill through the thickets, skirting large boulders that seem to have been stopped by a mysterious force as they tumbled down the slope. Here the sky is hidden by the branches and the air is fresh and fragrant, enlivened by the tireless song of the cicadas. As he reached the top, Cèzanne came to a spot where a chain of huge rocks is strung along the ridge of the hill. Crushing and surmounting each other, they form caves half hidden by vegetation. It was not an easily accessible place, and he was certain not to be disturbed. After the more or less well kept grounds of the Jas, here Cézanne discovered nature untouched by human hand, yet with an almost intimate atmosphere; a sequestered spot where, amid the jumble of stones, the shrubs had gained a precarious foothold in the wilderness. The light filtered gently through the branches of the pines.

The bizarre forms of the rocks are sometimes difficult to "read," and many of the watercolors that Cézanne painted at the caves have been hung upside down. Yet he faithfully traced their irregular shapes, the surfaces full of crevices, grooves, and hollows, the nooks invaded by shadows. A recent forest fire has denuded the upper part of the hill, and the rocks are now bare, exposed to the sun; all the wild vegetation is gone, and so is the secluded beauty of the spot.

Behind the rocky ridge, which continues to the east well beyond the Château Noir property, lies a high plateau taken over by brambles because the packed ground and the mistral discourage most other growth. To the northwest, the distant Tour de César points its slim needle into the sky. This plateau—as well as the ridge itself—extends in the direction of Sainte-Victoire to the nearby Bibémus quarry.

Moderate slopes lead up to the plateau for much of its length, but at this point it is edged with cliffs that overlook the valley. After the winter rains the soaked soil turns orange, and the evergreen laurels, thyme, and rosemary glisten with moisture. From far below, vapor rises like smoke behind every swelling, every undulation of the ground, while Mont Sainte-Victoire disappears under low-hanging clouds. In the distance, to the left, the ocher chapel of the Domaine Saint-Joseph stands out against the dark firs of the slope. Farther away, the straight rows of sycamores that lead from the Château du Tholonet toward Palette cut across the plain, which is dotted with isolated farms, rain-drenched vineyards, and olive or almond groves. According to local legend, the reddish earth takes its color—which is particularly vivid after rainfall—from the blood with which it was drenched when Marius defeated the Teutons at the foot of Sainte-Victoire, a hundred years before Christ.

Provence is rich with ancient quarries, some of them going back to Roman times. Though quite a few are being reexploited now, many have lain unused for

centuries. Their intricate cubic forms, the strange shapes of their weathered stones—usually the result of man's intervention—offer striking and picturesque effects under cloudless blue skies. Stone from these quarries is usually distinctive, and the real lover of Provence can distinguish the porous gray product of Rognes from the discreetly veined slabs of Tavel or the white blocks of Lacoste, rich in fossilized creatures of the sea. But the stone from Bibémus is still different: it has a soft ocher color, as though the rays of the sun had been captured in it. This is why so many stately residences on the Cours Mirabeau of Aix, their facades withering under the persistent mistral, maintain the rich yellow that forms such a warm contrast to the cold splendors of marble.

At Bibémus, as in most Provençal quarries, the stone is excavated without the aid of superstructures, and there is nothing to signal these extensive work sites to the passerby. Even those who explore the country into its farthest, most secret corners can easily pass them without noticing, or suspecting, the presence of their fascinating, sunken architectures.

Bibémus is reached by a once-much-traveled road over which the stone from the quarry was carried to Aix. This road crosses the high plateau to the north of Château Noir. The quarry itself is an immense complex of large holes cut into the ground, often in layers that form strange steps. Beyond and below Bibémus (and north of Le Tholonet) lie the Gorges des Infernets, where Emile Zola's father had designed the dam that provides Aix with water. In their youth, Zola and Cézanne used to come here to hunt, or to swim in the dammed-up waters, but it was not until almost forty years later—in the middle nineties—that the painter returned to the area to work at Bibémus. He rented a small, completely isolated one-room shack (a *cabanon*) and began to look for motifs.

The quarry had been abandoned for some time, and trees and bushes had taken root among the ocher rocks. In the distance, the ever-present Mont Sainte-Victoire rises into the sky. The scenery is quite different from that of the caves near Château Noir, for the space is wide open, exposed to the sun and winds, and the shapes of the rocks were not formed by nature but bear the marks of human industry. Yet it appears as though no plan presided over the exploitation of the quarry, where the stone has been extracted here and left untouched there. Between deep cavities and shallow furrows, solitary blocks remain standing, scarcely tampered with. It is a vast field of seemingly accidental forms, as if some prehistoric giant, constructing a fantastic playground, had piled up cubes and dug holes and then abandoned them without leaving a hint of his intricate plan. And nature has since spread a carpet of plants over the turrets, the square blocks, the sharp edges, the clefts, the caves, the tunnels and arches, thus reclaiming the site that had been wrested from her.

Wherever he turned, Cézanne found enticing aspects whose basic elements were always ocher rocks and more or less timid vegetation. He made numerous paintings at Bibémus, but few watercolors, which he executed mostly in the more protected setting of the not-too-distant caves just above Château Noir.

Eventually, however, Cézanne felt the need for a place of his own. It may have been a desire not so much for a change of scenery as for a studio where he could work on his large compositions of bathers, one of the major concerns of his last years. As it turned out, he was to find both: a house where he was at ease and new landscape subjects. In November 1901, Cézanne acquired a property of modest size halfway up the hill of Les Lauves, to the north of Aix and overlooking the town. The plain, two-story structure he built there—it was ready in September 1902—contains small rooms on the ground floor, while the second floor is taken up almost entirely by a large studio, more than twenty-three by twenty-five feet and a little over thirteen feet high, its north wall made up of a

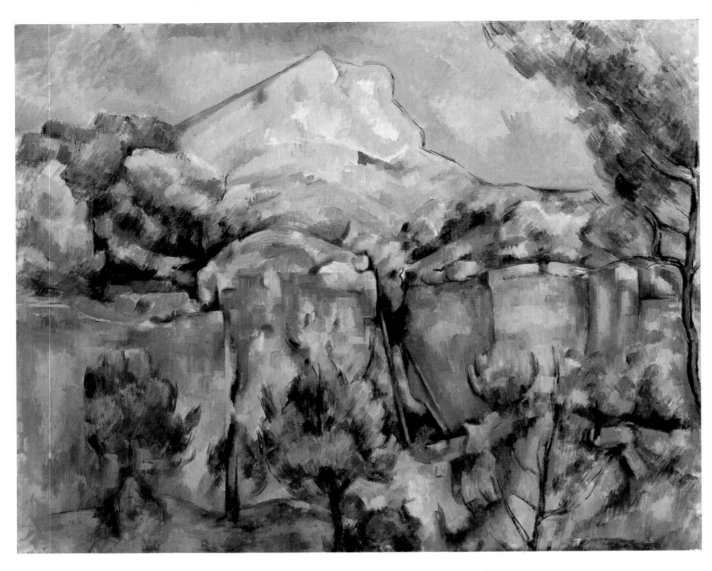

Mont Sainte-Victoire
Seen from
Bibémus Quarry.
c. 1897

Maison Maria
with a View
of Château Noir.
c. 1895

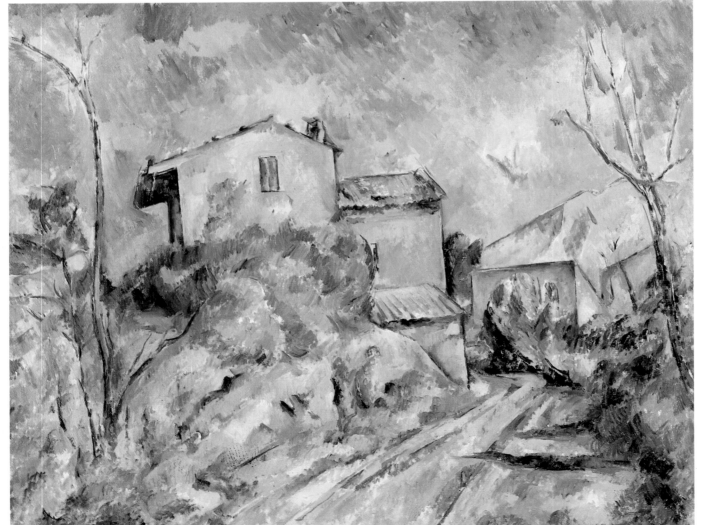

The Maison Maria
in the park of Château Noir.
Photograph c. 1935

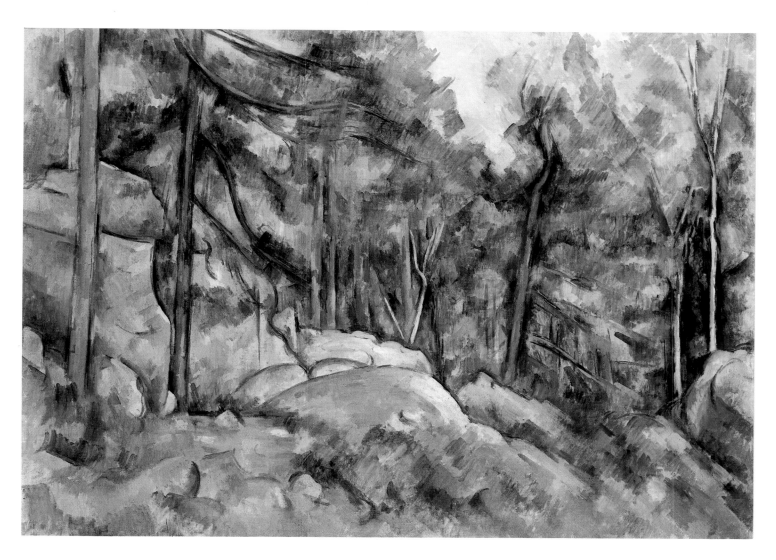

Forest Interior.
1898–99

Château Noir.
1900–1904

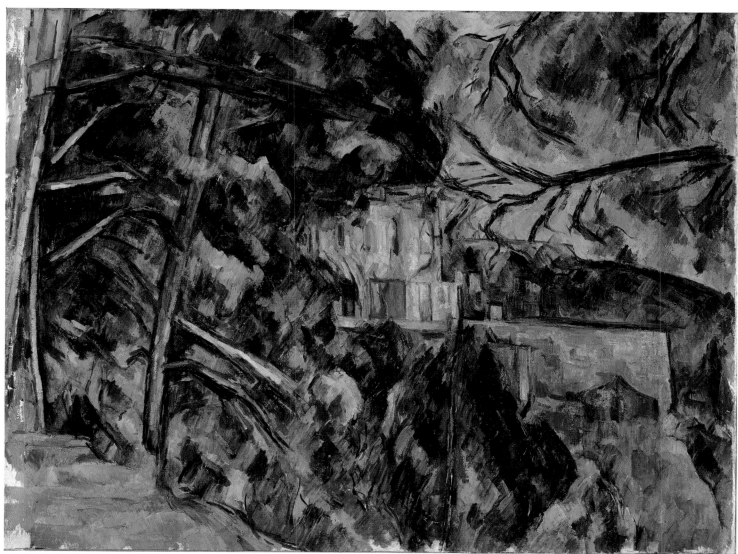

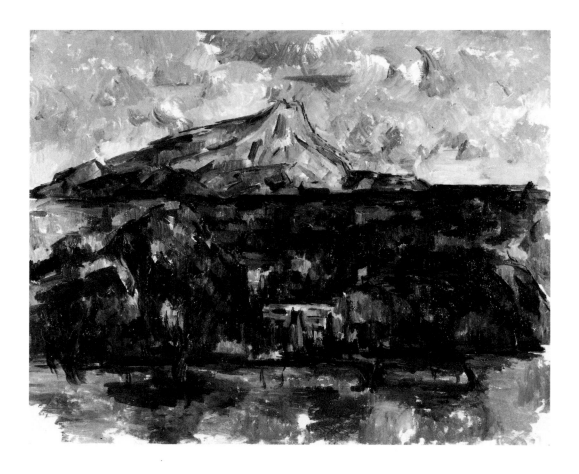

Mont Sainte-Victoire Seen from Les Lauves. 1904–1906

huge window next to which there is a long, narrow slit through which big canvases can be moved. On the opposite wall are two tall windows (the third lights the stairwell) that afford a magnificent view of Aix and, in the far distance, the misty blue mountain range, the Chaîne de l'Etoile, with its protruding, square Pilon du Roi.

There is a twenty-foot-wide terrace in front of the studio, bordered by a low wall, separating it from a small garden that descends toward a narrow canal. An old gardener, Vallier, took care of the grounds. Behind the studio a wooded plot, belonging to a neighbor, provided a green curtain for the large window.

It must have been while the studio was being constructed that Cézanne, inspecting the progress of the work, began to venture farther up the still unsettled hill. Climbing the fairly steep road beyond the studio to the crest of Les Lauves, he found a new, exhilarating panorama stretching away to his right. From here Sainte-Victoire, remote but imposing, no longer appeared as the chopped-off cone that he had contemplated from Château Noir or Bibémus, but as an irregular triangle, its long back gently rising to the abrupt, clifflike front that tapered off to the horizontal extension of the Mont du Cengle. At his feet extended a vast, undulating plain with a quilted pattern of fields and clusters of trees, interrupted by occasional farm buildings. It was a welter of horizontals and verticals, a dense conglomerate of color patches over which his eyes could roam at will and which was so wide that he had to turn his head to the right and left to take all of it in. Sometimes he even had to add strips of linen to his canvas—or paper to his sheet—when he tried to encompass the whole breadth of the view in a painting or a watercolor.

Above this immense stretch, Sainte-Victoire seemed to float ethereally in the southern light, hanging there like a glorious symbol of Provence. Cézanne's almost obsessive fascination with the mountain drew him again and again to this spot, where many of his last landscapes were painted. Here he paid ultimate homage to the mountain, which, no longer squatting beneath the infinity of the skies, appears pointed toward heaven, in as solitary splendor as ever, though possibly still more majestic.

The artist was sixty-three years old when at last he could move for the first time into a studio built to his specifications. He furnished it sparsely but brought along many of the objects (quite a few are still there) that he liked to use for still-life compositions. Among them were four or five skulls, a blue ginger pot, old bottles, green olive jars, various containers and crockery, as well as a rather ugly rug or table cover made of some kind of heavy felt. It had rusty brown and deep green and red tints, its geometric design set in squares, the whole surrounded by a lighter, flower-patterned border. Cézanne used it also for a backdrop, like a curtain, and it provided a lively prop for portraits as well as for many still lifes, among them those with several skulls. Though dirty and faded, this rug was still in the studio a few years before the war; souvenir hunters and moths have since got the better of it.

While little attached to possessions, Cézanne seems to have cared for these rather common objects, which he kept for many years and on which he could always rely. He also took to the studio a small wooden table with scalloped apron that he had already used for over a decade and on which he liked to assemble still lifes. It is still there. Preserved also are the white plaster putto, *L'Amour*, attributed to Puget, and a—now decapitated—plaster of a *Flayed Man*, both frequently represented by the artist. On the walls hung assorted lithos or photographs of works by Signorelli, Rubens, Delacroix, and Forain; others were kept in large folders. In a corner, leaning against the wall, still stands an immense ladder that Cézanne needed for work on the large bathers, for which a special extensible easel also still exists. Among the few pieces of furniture was a small chest that served for paints, brushes, and similar paraphernalia.

Cézanne never really lived at the studio but continued to reside in Aix. He went up to start work very early in the morning, sometimes rising at five o'clock to escape the heat. While the studio was not too far from his home, the walk was uphill and there was no shade on the Chemin des Lauves. The painter generally left again by eleven, but occasionally he had food sent up so as not to interrupt his work. Around four in the afternoon, once the hot weather had subsided, he might have a carriage take him to outlying motifs. Cézanne loved that time of day for painting *sur le motif*; then the heat no longer vibrates over the fields; by six o'clock the shadows grow longer, the air becomes limpid and crystalline, the distance takes on a peculiar sharpness, and the foreground glows under the rays of a leisurely disappearing sun. It is an unforgettable hour of harmony and peace. Those who have wandered over the countryside of Aix in the footsteps of the artist call it "the hour of Cézanne."

When he drove or walked back from his studio, Cézanne skirted the massive Hôpital Saint-Jacques at the foot of Les Lauves, then went through the most ancient sector of the town, passing the cathedral of Saint-Sauveur (where a new "idiot of an abbé, who works the organ and plays wrong," prevented him from attending Mass) and the imposing old Law Faculty (where he had once studied) before reaching the square in front of the town hall; turning left at the quaint clock tower, he found himself in the Rue Paul Bert, which leads to the Rue Boulegon.

When it was too hot or when the Lauves crest was swept by the mistral, Cézanne could work under a linden tree on the terrace in front of his studio. The vegetation of his garden did not yet block the view of the Aix rooftops, against which stood out the elegant silhouette of the tower of Saint-Sauveur. On the low parapet of the terrace rows of potted plants were assembled; there, in the dappled shade, he not only painted watercolors of the splendid panorama of the town, but also repeatedly had his gardener, Vallier—and sometimes other willing peasants—sit for him.

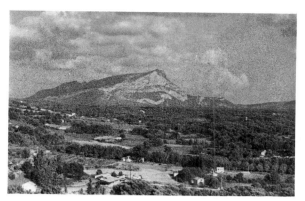

Mont Sainte-Victoire seen from Les Lauves, above Cézanne's studio. Photograph c. 1935

OVERLEAF, CLOCKWISE FROM TOP LEFT:
Cézanne's Lauves studio. Photograph c. 1904

View of Aix with the Cathedral of Saint-Sauveur, from Cézanne's Lauves studio. Photograph c. 1935

A corner of Cézanne's Lauves studio. Photograph c. 1930

Skull, bottles, and patterned rug used by Cézanne for still-life compositions in the Lauves studio; the rug no longer exists. Photograph c. 1935

Still-life objects still preserved in Cézanne's Lauves studio on the table with the scalloped apron. Photograph c. 1935

249

O N SEPTEMBER 26, 1902, shortly after he had moved into his new studio, Cézanne wrote his final last will and testament. His dispositions were quite simple:

I commend my soul to God. I hereby bequeath on a preferential basis to my son, Paul Cézanne, the entire share disposable by me of the possessions that will be left on the day of my death; consequently, my wife—if she survives me—will have no legal right to any life interest [usufruct] whatever concerning the properties that will constitute my estate on the day of my death.[17]

These are my intentions. I am revoking all other wills or dispositions in case of my death that I may have made previous to this instrument, which shall be the only valid one.[18]

Paul Cézanne

This will is handwritten and—according to French custom—was established without witnesses. But it was doubtless deposited with a notary and a copy may have been entrusted to the artist's son.

Having thus taken care of the future, Cézanne could continue to devote himself to the present, in other words, his work. He seems to have gradually abandoned such outlying motifs as Château Noir and Bibémus quarry, painting instead more frequently in the immediate vicinity of his Lauves studio or in the studio itself where, besides the large canvas of bathers, he continued to execute many portraits and still lifes of fruits, flowers, or skulls. He proceeded very slowly; a single canvas could take him several months if not years, as revealed by some letters to Vollard about a painting of a bunch of roses. The artist first wrote on January 23, 1902: "I continue working at the bouquet of flowers, which will doubtless take me until about the 15th or 20th of February." But early in April, Cézanne wrote again to announce: "I find myself obliged to postpone sending you the picture of your roses to a later date. Although I should have greatly liked to send something to the Salon of 1902, I am putting off the execution of this plan again this year. I am not satisfied with the result I have obtained. On the other hand, I shall not give up this study, which will have caused me to make, as I like to believe, not unproductive efforts."

A year later, however, in January 1903, the painter mentioned in a letter to Vollard: "I have had to drop your flowers, with which I am not very satisfied."

One can understand how, in such conditions, Cézanne could only do his still lifes from artificial flowers.

In his later years Cézanne suffered from poor health. His diabetes became aggravated by nervous strain from overwork. To this were added recurrent bouts of depression. Yet, in spite of his frequent moods of discouragement, Cézanne knew his own value, and although in general his opinion was that "the feeling of one's own strength makes one modest," he did not hesitate, when the occasion arose, to express himself openly. "There is only one living painter—myself!" he declared, and another time he interrupted a political argument by stating: "There are two thousand politicians in every legislature, but there is a Cézanne only every two centuries." This awareness of his superiority, however, did not prevent Cézanne from saying often that he was still far removed from the goal that as an artist he dreamed of attaining. "I have a lot of work to do," he wrote to Louis Aurenche. "It is what happens to everyone who is someone."

Cézanne's last will and testament, dated Aix, September 26, 1902

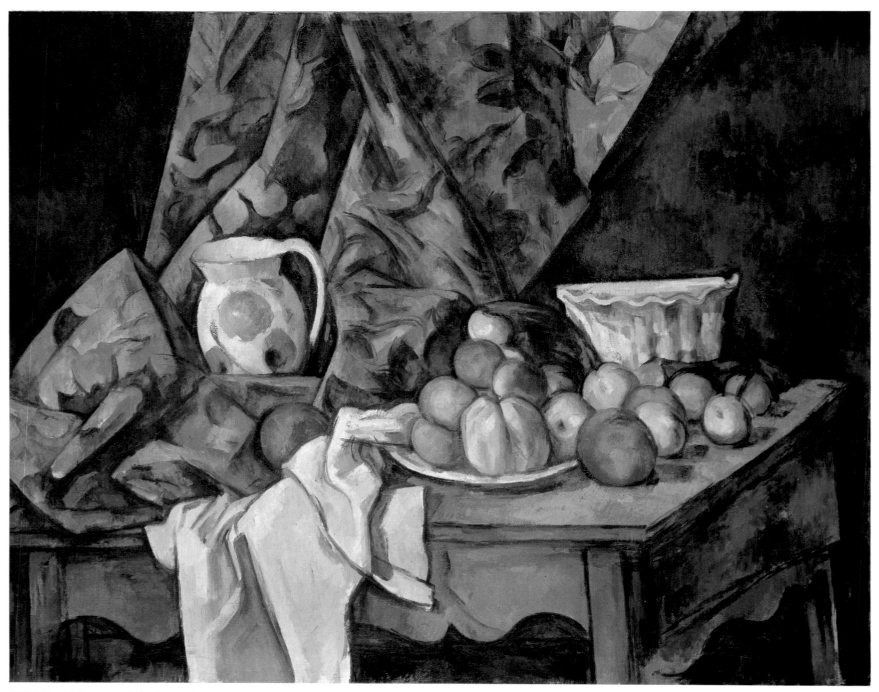

Still Life with Apples and Peaches. c. 1905

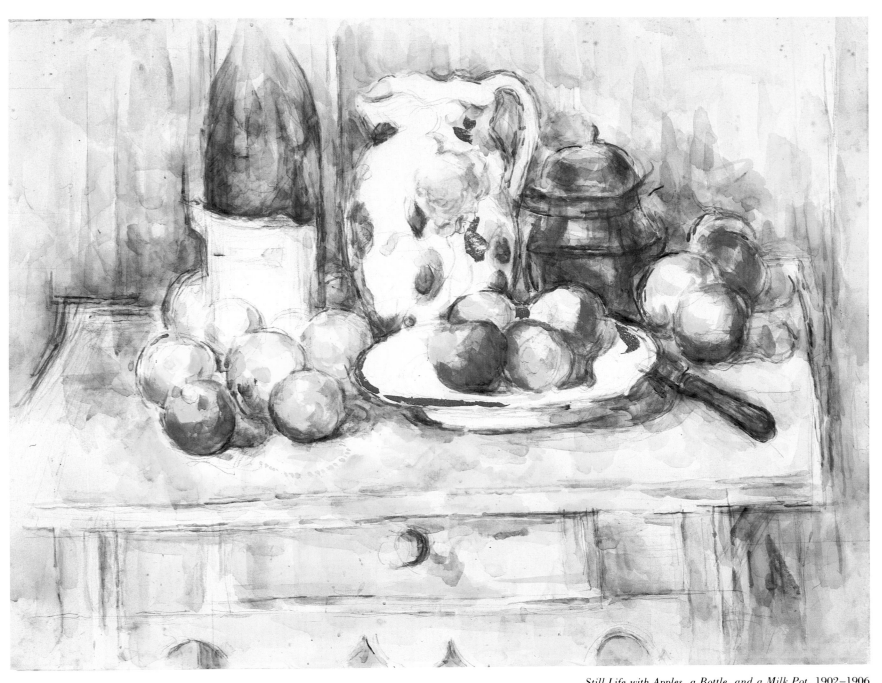

Still Life with Apples, a Bottle, and a Milk Pot. 1902–1906

When the painter Louis Le Bail asked him which were his favorite paintings,
Cézanne replied: "Mine, if I had managed to achieve what I am still seeking."
And in 1903, Cézanne informed Vollard: "I am working obstinately; I am
beginning to see the promised land. Shall I be like the great leader of the
Hebrews or shall I be able to enter it? . . . I have made some progress. Why so
late and with such difficulty? Is art indeed a priesthood that demands the pure in
heart, completely dedicated to it?" To a young friend he explained: "My painting
is getting along so-so. I sometimes have magnificent bursts of enthusiasm and
even more often painful disappointments. That is life."

Strangely enough, Cézanne seems to have been rather indifferent toward the
condition of his own works, whether abandoned in the course of execution or
already more or less finished. Just the same, among the piles of canvases
accumulated in his studio were also views from the North, which the artist had
obviously taken to Aix with the intention of pursuing work on them. When two
young painters, R. P. Rivière and J. F. Schnerb, visited him in Aix in January
1905, they found him much less misanthropic than his reputation made him out
to be. They were admitted to his studios and noticed that "in the corners
canvases were lying about, still on their stretchers or rolled up. The rolls had
been left on chairs and had been crushed. His studios, the one in the Rue
Boulegon and the one . . . in the country, were in great disarray, in an unstudied
disorder. The walls were bare, the light was crude. Half-empty paint tubes, silk
brushes stiff with colors long since dried, remnants of meals that had become
subjects of still lifes covered the tables. In a corner stood a collection of parasols
such as landscape painters use, their coarse armatures doubtless provided by
some local merchant and their pikes shod by some neighborhood blacksmith; next
to them were game bags to take victuals out into the fields."

Cézanne's physical condition deteriorated considerably throughout 1906. In
almost all his letters to his son—his only confidant—he complained about his
health. "Being in pain exasperates me so much," he wrote, "that I cannot get
over it and it forces me to live a retired life; that is what is best for me." Illness
and old age accentuated the morbid traits in his character, and what was once

only sensitivity and suspicion turned sometimes into a real persecution mania. More than ever before he feared getting into the clutches of others, and especially those of priests and art dealers.

Cézanne's temperament led him always to waver between the extremes. Kind and generous, even extravagant, he frequently seemed unconscious of the value of money. He was often sent unfortunates who could be sure that they would not leave his house without generous alms. And he gave not only because he did not know how to refuse but also for the pleasure of giving, to see the joy of the country children to whom he would throw a few sous when they ran after his carriage. It even seems that his sister, who, with Madame Brémond, looked after his household, was careful not to let him go into town with anything but a very small sum of money in his pocket, although, for that matter, he did not often go.

Toward the end of May 1906, a bust of Zola by Philippe Solari, left unfinished at the sculptor's death, was unveiled at the Bibliothèque Méjanes in Aix, in the presence of a large crowd. Among those attending the ceremonies were noted, in the reserved section, near Madame Zola, the members of the Municipal Council; the director of the Aix Academy; the director of the library; the senator Louis Leydet, a former schoolmate of the painter; Emile Solari, son of the sculptor; and Paul Cézanne.

It was the mayor of the town, Monsieur Cabassol, son of Louis-Auguste Cézanne's partner in the bank Cézanne & Cabassol, who made the first speech and pointed out the considerable role played by the town of Aix in the novels of the master. Paul Cézanne, visibly moved, heard the mayor evoke the youth of Zola, heard him speak about the Jas de Bouffan, of which Zola had described in *L' Oeuvre* "the mosquelike whiteness, in the center of the vast grounds." Cézanne listened as the mayor told how in 1858 Zola had parted from Cézanne ("since become the great modern painter we know," in the words of the orator), and, hearing him speak of the three inseparables, his youth arose before his eyes.

Cézanne's emotion became even more profound when the mayor was followed by their old friend, Numa Coste, who paid tribute to the memory of the departed and described the days of their youth together:

We were then at the dawn of life, filled with vast hopes, desirous of rising above the social swamps in which impotent jealousies, spurious reputations, and unhealthy ambitions lie stagnant. We dreamed of the conquest of Paris, the possession of that intellectual home of the world, and outdoors, in the midst of arid and lonely spaces, by the shaded torrents or at the summit of marmorean escarpments, we forged the armor for this gigantic struggle.... When Zola had preceded the group to Paris, he sent his first literary efforts to his old friend, Paul Cézanne, at the same time letting all of us share his hopes. We read these letters amidst the hills, in the shade of the evergreen oaks, as one reads the communiqués of a campaign that is beginning.

The painter, always so easily moved, could not resist this flood of memories. Tears came to relieve the nostalgia that had taken possession of him, and the other guests saw that the old man was crying, no longer able to hide his emotion.

Numa Coste, continuing his address, now spoke of the later Zola. "As he often said," Coste remembered, "one thinks one has revolutionized the world, and then one finds out, at the end of the road, that one has not revolutionized anything at all.... Men remain the ephemeral creatures they have been since they appeared on earth."

But what does it matter whether the world has been revolutionized or not, as long as one has worked with all one's might to attain an end, as long as one has succeeded in adding a new link to the chain of the past? Had not Cézanne, like

Pierre Bonnard. *Portrait of Ambroise Vollard.* c. 1914

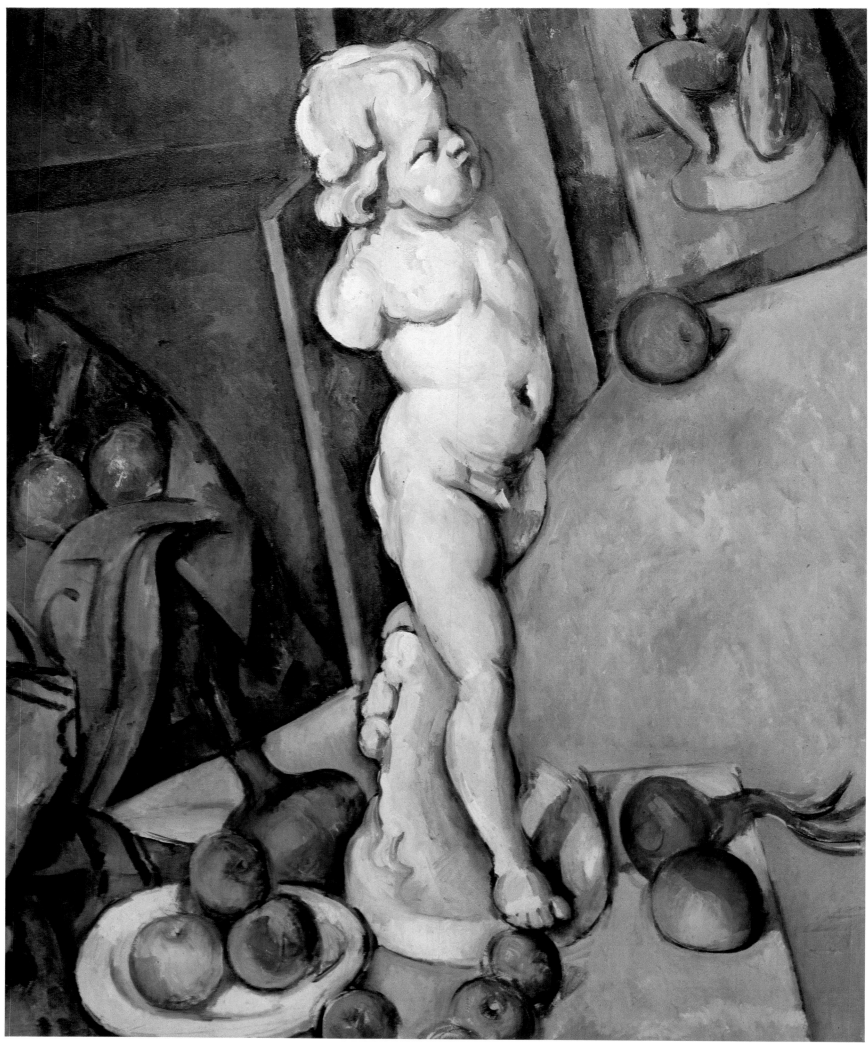

Still Life with Putto. c. 1895

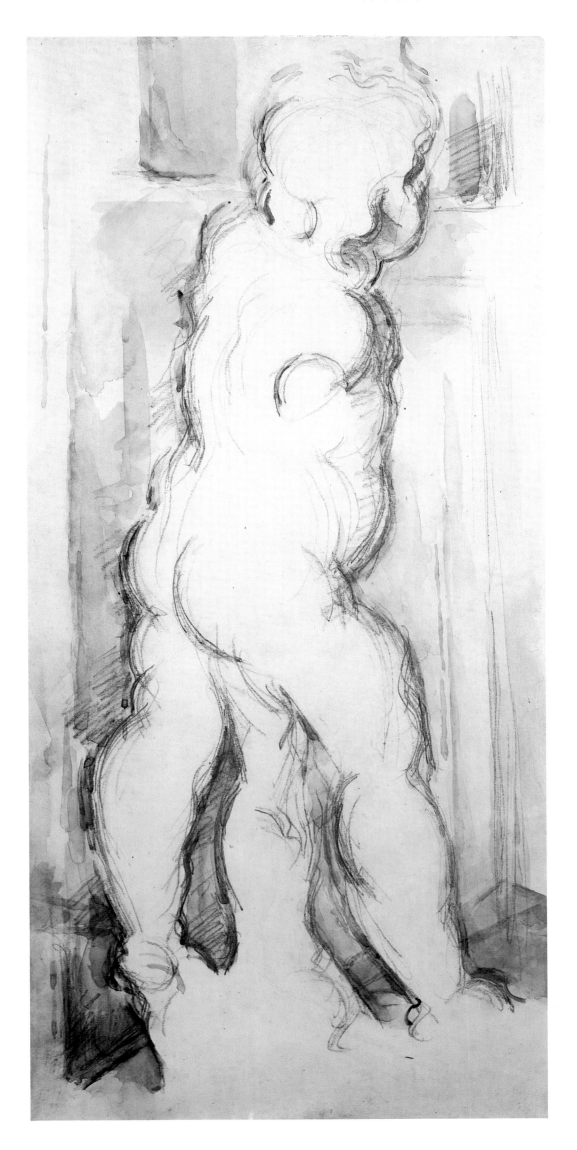

A watercolor *(left)* and a drawing *(below)* of a plaster cast of a *putto (above)* attributed to Pierre Puget, still in Cézanne's Lauves studio

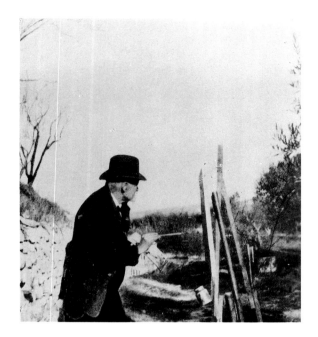

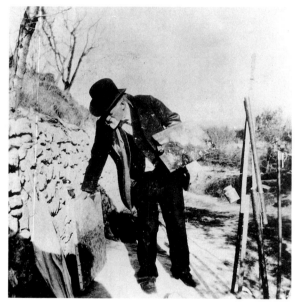

Paul Cézanne at work on the hill of Les Lauves.
Photographs taken by K.-X. Roussel, 1906

Zola, lived a life completely dedicated to work, so absorbed by the artistic effort that even the oldest friendship, the most profound affection of his life, had had to be thrown aside?

Through the tears that veiled his eyes, Cézanne saw Madame Zola embrace Numa Coste in grateful emotion when he had finished his speech by extolling the "work that consoles and makes one forget the sorrows."

Work consoles and makes one forget the sorrows. Cézanne had expressed the same thought when he wrote to Gustave Caillebotte on the death of his mother, advising him to devote his time and his energies to painting "as being the surest way of distracting our sadness."

During the summer of 1906, when the heat became particularly unbearable (perhaps his diabetes caused him to suffer more acutely from it), Cézanne began to look for shade. He had to give up going to his Lauves studio and only took short walks in the morning. In the afternoon, in his carriage, he went to a secluded spot on the Route des Milles, where the Arc River flows not very far from the Jas de Bouffan, and near the property of Montbriant, once owned by his brother-in-law. But soon he preferred to have his coachman take him to another familiar place in the Arc valley, scene of many of his youthful escapades. His carriage followed narrow, cobbled streets, crossed the Place des Prêcheurs to the Route de Nice; before reaching the village of Palette, the coachman would turn right and drive over the old, strangely pointed, single-lane bridge of Les Trois Sautets. On the far side, on the bank of the river and beneath large trees that formed a vault over the quiet waters—sometimes rippled, ever so slightly, by a dragonfly—Cézanne found coolness and isolation; close by he also found a place to leave his painter's gear.

The artist's frequent letters to his son permit to follow his daily existence during his last months. Although his failing health put serious obstacles in the way of work, Cézanne continued indefatigably his "research."

In the month of August, suffering greatly of the heat, Cézanne wrote:

It oppresses my brain considerably and prevents me from thinking. I get up early in the morning and hardly live my normal life except between five and eight o'clock. At that time the heat becomes stupefying and exerts such a cerebral depression that I cannot even think about painting. . . . I regret my advanced age, in view of my color sensations. . . . It is unfortunate not to be able to produce many examples of my ideas and sensations; long live the Goncourts, Pissarro, and all those who have the love of color, representative of light and air.

A little later he excused himself:

If I forget to write to you it is because I am losing my sense of time to a degree. . . . My nervous system must be very much enfeebled, I live somewhat as in a void. Painting is what means most to me. I am very annoyed at the cheek with which my compatriots seek to compare themselves with me as an artist and try to lay their hands on my studies. You should see the messes they make. . . . I am going up to the studio; I got up late, after five o'clock. I am still working with pleasure, but sometimes the light is so horrible that nature seems ugly to me.

And on September 8 he wrote his son:

I must tell you that as a painter I am becoming more lucid before nature, but with me the realization of my sensations is always painful. I cannot attain the intensity that is unfolded before my senses. I do not have the magnificent richness of coloring that

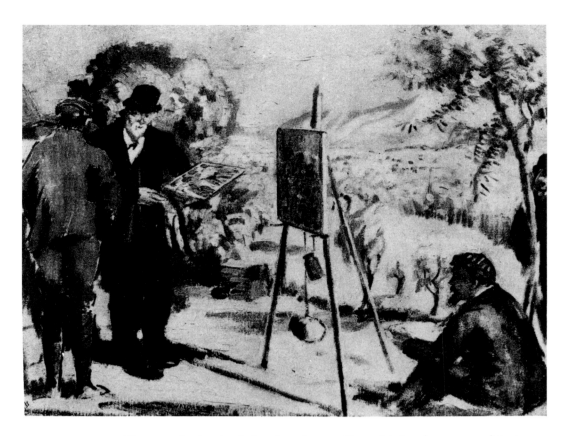

Paul Cézanne on the hill of Les Lauves. Photograph taken by Emile Bernard, 1905

LEFT:
Maurice Denis. *Cézanne Painting a View from Les Lauves.* 1906. At left, from the back, is K.-X. Roussel; at right, seated on the ground, is Denis himself making a sketch for this canvas.

animates nature. Here on the bank of the river the motifs multiply, the same subject seen from a different angle offers subject for study of the most powerful interest and so varied that I think I could occupy myself for months without changing place, by turning now more to the right, now more to the left.

But four weeks later, as he informed his son, Cézanne had a falling-out with the coachman, who had "raised the price of the carriage to three francs return, when I used to go to Château Noir [which is farther away] for five francs. I fired him." Weather permitting, he now went on foot to the outskirts of the town, carrying his watercolor equipment on his back. Fortunately, by then the terrific heat had lessened, and he could soon return to Les Lauves.

"As the banks of the river are now a bit cool," he wrote on October 13, "I have left them and climb up to the Quartier de Beauregard where the path is steep, very picturesque but rather exposed to the mistral. At the moment I go up on foot with only my bag of watercolors, postponing oil painting until I have found a place to put my baggage; in former times one could get that for thirty francs a year. I can feel exploitation everywhere."

To reach the Quartier de Beauregard, Cézanne took the Route de Vauvenargues that runs along the bottom of a shady vale northeast of Aix, in the direction of the Tour de César. To the right rises the high plateau with the Bibémus quarry; to the left the ground mounts toward the Beauregard section. The artist would climb a winding lane at left, up to the top where the tall pines and thickets of short cork oaks of the protected slope give way to fields and meadows with sparse trees and a few isolated houses. It is almost an hour's walk from Aix. When the mistral blows here, it sweeps over the flat lands and sways the trees. From some spots, vegetation permitting, Mont Sainte-Victoire can be glimpsed beyond the village of Saint-Marc. (In earlier years Cézanne had done a watercolor from there.)

The fall finally brought relief. "The weather is magnificent, the country superb," Cézanne exclaimed, but soon his fears took possession of him again, and he continued: "As for me, I must remain alone. The meanness of people is such that I should never be able to get away from it—it is theft, complacency, infatuation, violation, the seizing of your work. And yet nature is beautiful. I still

The Château de Fontainebleau. 1904—1905

Landscape. c. 1890
(possibly later)

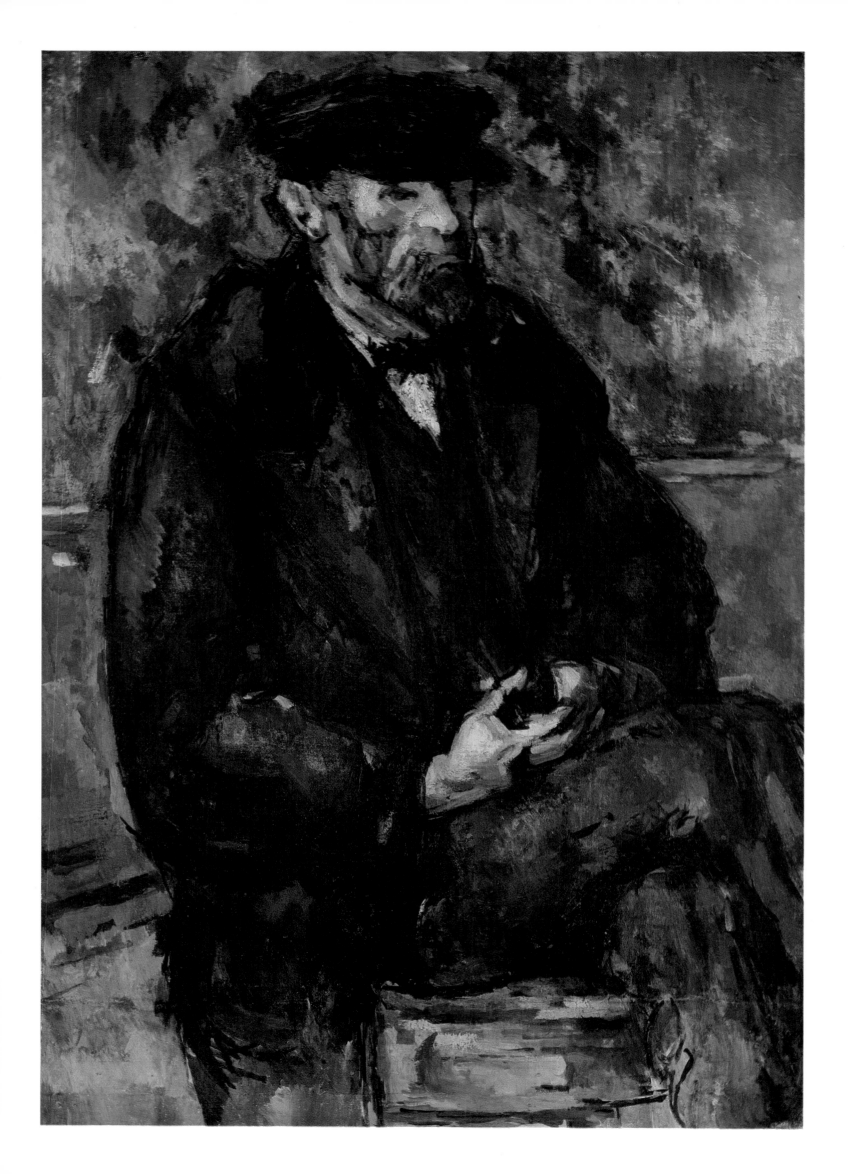

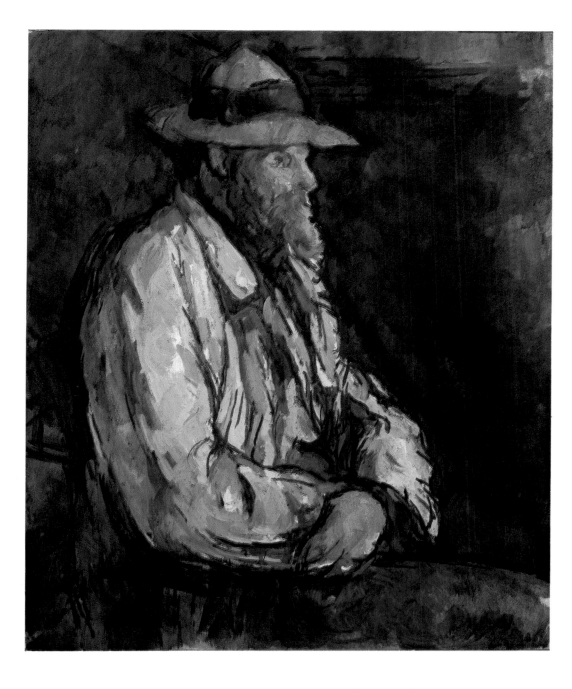

Portrait of the Gardener Vallier. 1906

see Vallier, but I am so slow at realizing my ideas that it makes me very sad."

A little later he wrote: "Sketches, paintings, if I were to do any, would be merely constructions after nature, based on methods, sensations, and developments suggested by the model."

In the last letter to his son, on October 15, he said: "In order to give you news as satisfactory as you desire, I would have to be twenty years younger. I repeat, I eat well, and a little moral satisfaction—but only work can give me that—would mean a lot to me. All my compatriots are hogs compared with me."

This letter also contains a phrase he used again and again: "I continue to work with difficulty, but in spite of that something is achieved." A few weeks earlier, Cézanne had written to Emile Bernard: "I am old and ill, and I have sworn to die painting rather than to waste away vilely in the manner that threatens old men who allow themselves to be dominated by passions that coarsen their senses."

Life, which had brought Cézanne so many disappointments, now gave him a first and last satisfaction: a death as he had desired it. The rainy season having set in, a violent thunderstorm overtook the painter on Monday, October 15, while he was working on a landscape a few hundred yards above his Lauves studio. He remained exposed to the rain for several hours until he was picked up by a laundry cart and brought back to the Rue Boulegon; it took two men to carry him to his bed. At dawn the following day he arose and descended to the small garden to work on a portrait of his gardener, Vallier. He returned in a state of

OPPOSITE:
The Sailor. 1902–1906

263

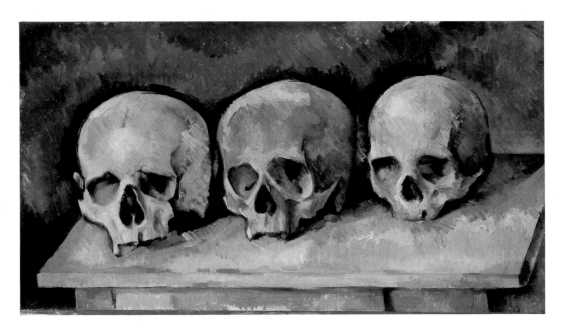

Three Skulls. c. 1900

Pyramid of Skulls. 1898–1900

collapse; yet from his bed he still wrote a line to his color merchant, on Wednesday, the 17th:

It is now eight days since I asked you to send me ten burnt lakes and I have had no reply. What is the matter?

A reply, and a quick one, I beg of you.

Paul Cézanne

On Saturday the painter's sister Marie wrote anxiously to her nephew: "You know your father, it is a long story. . . ." And she insisted: "I repeat that I find your presence here necessary." Two days later, on October 22, Madame Brémond telegraphed to wife and son: "Both come immediately, father very ill." They were too late.

Cézanne died at nine o'clock on the morning of October 23, 1906. Gossip had it that his wife didn't make it in time to Aix because she was unwilling to cancel a

fitting at her dressmaker's. The artist was buried in the family tomb at Aix, which was eventually "taken over" by the Conils (Cézanne's sister Marie chose to be interred with a friend, a woman who preceded her in death; Cézanne's widow and son repose in a Paris cemetery).

Within five weeks of the painter's death, Hortense Cézanne and her son seem to have removed from the Lauves studio all paintings, watercolors, and drawings found there. They subsequently were to declare that the artist, before his death, and they themselves afterward, had sold an unspecified number of his works for a total of 24,500 francs. Cézanne's estate thus found itself reduced to eighteen paintings gathered at the Rue Boulegon, of which an inventory was established on November 28 by one Lucien Exel, official expert, and Henri Pontier, director of the Aix museum and an old enemy of Cézanne who had sworn that during his lifetime no work by Cézanne would ever enter the museum (an oath he religiously kept).

Among the eighteen paintings recorded in the inventory were six landscapes of the surroundings of Aix, six views of Mont Sainte-Victoire (probably all seen from Les Lauves), three figure pieces (one of these possibly representing Vallier), two pictures painted on the banks of the Seine at Valvins, and one large composition of bathers. The estimated total value was about 5,700 francs, or an average of less than 320 francs each, including the large canvas of bathers.

These evaluations were in sharp contrast to the prices Hortense Cézanne and her son obtained in their dealings with Vollard, which, as a matter of fact, involved such large sums that the dealer had to associate himself with his rivals, the Bernheim-Jeunes, to raise the necessary amounts and even then had to pay in several installments. Some time before March 11, 1907, (that is, less than five months after the artist's death), Vollard and the Bernheim-Jeunes acquired seventeen "studies" from the estate for 165,000 francs, followed by the purchase of 187 watercolors (no watercolors had appeared in the Rue Boulegon inventory) for 62,000 francs and twelve more "studies" for 48,000 francs. These transactions—which may have included some of the works listed in the inventory—netted 275,000 francs, not even counting the amount of 24,500 francs mentioned in the inventory as having been obtained for sales made before the taking of the inventory.

It is difficult to understand why Cézanne's heirs were in such a hurry to dispose of his works, especially if one considers that they also inherited the artist's share of his father's and mother's fortunes, roughly half a million francs, as well as his share from the sale of the Jas de Bouffan. Indeed, according to what is known, the painter had lived on the income from his wealth without ever touching the principal (in addition, his son would eventually inherit half of the estate of his maiden aunt, Marie).

It is not impossible that the artist's widow and son feared that the relatively "high" prices they obtained for his works would not prevail and therefore decided to take advantage of the artist's modest posthumous vogue. On the other hand, Hortense Cézanne was an inveterate gambler, seen more frequently in casinos than in art galleries, and her son, a good-natured man whose astuteness his father had so greatly admired, showed more gifts for losing money in all kinds of schemes than in earning any. Their combined efforts eventually succeeded in reducing to practically nothing the fortune amassed by Louis-Auguste Cézanne and passed on to the painter. At one point the latter's son was so riddled with debts that he had to approach Vollard for a not inconsiderable loan. Vollard provided the amount but would not hear of a loan, explaining that he had made enough money with Cézanne's work to be able to *give* the required sum to the artist's son.

Cézanne's widow sold her share of the Lauves studio for 2,500 francs to her son, who subsequently disposed of it to a local writer, Marcel Provence. After his death the studio was threatened by real-estate developers. A committee of American admirers of Cézanne thereupon raised the relatively modest sum necessary for its acquisition. The very day in 1954 that its purchase was concluded, it was turned over to Aix officials to preserve it for all time. The studio is now open to the public.

It seems superfluous to add that since Cézanne's death his fame has never stopped increasing and his position as the "father of modern art" has been steadily fortified. The saddest epitaph for him was provided—not too surprisingly —by his widow, who once told Henri Matisse (one of Cézanne's most fervent admirers among the next generation, but who had been too timid and too respectful to visit him in Aix):

You understand, Cézanne didn't know what he was doing. He didn't know how to finish his pictures. Renoir and Monet, they knew their craft as painters. . . .[19]

Hermann-Paul. *Caricature of Cézanne.* 1904

Notes

1. The name *Cézanne* or *Césane* has been found in the records of the town hall of Briançon as early as 1650 and in those of Aix-en-Provence since around 1700. Paul Cézanne's grandparents had left Aix for a neighboring township, Saint-Zacharie, where Louis-Auguste Cézanne, the painter's father, was born June 28, 1798.
2. These expressions appear in the text in English.
3. On the Free Municipal School for Drawing, Aix, see Bruno Ely, "Cézanne, l'Ecole de Dessin et le Musée d'Aix," in *Cézanne au Musée d'Aix,* ed. D. Coutagne (Aix-en-Provence, 1984).
4. The picture is now attributed to Titian.
5. Zola even mentioned by name several members of the jury, praising Daubigny's attitude, reproaching Corot for cowardice, and saying that Théodore Rousseau was severe; as for the others, he refused to acknowledge their right to judge their colleagues. This passage was omitted by Zola when he collected his articles in a pamphlet, *Mon Salon* (later incorporated in the volume *Mes Haines*). In a note Zola explained: "I believe I should excise this part of the article. I have been shown that there is little basis for a number of details of whose veracity I had been previously assured. The general spirit was undoubtedly true; but not knowing where the inaccurate begins, I find it simpler to erase it all and to stick only to my opinions in matters of art."
6. In the Salon des Refusés there was, however, a canvas entitled *Pig's Feet,* signed Graham.
7. *Le Nain jaune* (March 31, 1867).
8. The Commune was crushed by the French army on May 28, 1871.
9. At that time, Guillaumin was employed by the Department of Bridges and Highways and painted only in his spare time.
10. See W. S. Meadmore, *Lucien Pissarro—Un coeur simple* (Constable & Co., 1962), pp. 25–27.
11. Essential sections of this letter were first quoted in the 1936 edition of the present book after the author had discovered it among Zola's papers at the Bibliothèque Nationale in Paris; they were of course included in all subsequent editions and translations. This did not prevent Robert J. Niess from referring to this document in his *Zola, Cézanne, and Manet—A Study of L'Oeuvre* (Ann Arbor: The University of Michigan Press, 1968) as an "unpublished letter" (p. 81).
12. One recognizes a takeoff on the names of Valabrègue and of Achille Emperaire, whose name actually is inscribed in large letters on his portrait by Cézanne.
13. "Each one is carried away by his own desire."
14. These fields were eventually replaced by vineyards planted by the new owner. In recent times the vineyards were forced to yield to ugly housing developments and a superhighway that practically runs beneath the north wall of the property. This highway has considerably lowered the natural water level of the sector with the result that the roots of the centenary chestnut trees of the Jas can't reach the water and are now beginning to tumble.
15. Possibly an allusion to Achille Emperaire.
16. This chapter is taken from John Rewald's "Cézanne's Last Motifs at Aix," in *Cézanne: The Late Work,* ed. William Rubin (New York: Museum of Modern Art, 1977), and is used by permission of the Museum of Modern Art.
17. This clause strongly contradicts the contentions of Sidney Geist, according to whom Cézanne was, until the very end, so deeply in love with his wife that he included a "hidden" image of her in his ultimate large composition of bathers.
18. See Robert Tiers, "Le testament de Paul Cézanne et l'inventaire des tableaux de sa succession, rue Boulegon à Aix, en 1906," *Gazette des Beaux-Arts* (November 1985).
19. See Marie-Alain Couturier, O. P., *Se Garder Libre,* Journal, 1947–1954 (Paris, 1962) [conversation with Matisse, Nice, June 23, 1951], p. 116.

Biographical Outline

1839 January 19, birth of Paul Cézanne, 28, Rue de l'Opéra, Aix-en-Provence. February 22, baptism at the church of Sainte-Madeleine. His father is Louis-Auguste Cézanne, dealer and exporter of felt hats established in Aix.

1841 July 4, birth of Marie Cézanne, 55, Cours Mirabeau, Aix.

1844 January 29, marriage of Louis-Auguste Cézanne and Anne-Elisabeth Aubert, mother of his children, in Aix.

c. 1844 – 1849 Paul Cézanne at Primary School, Rue des Epinaux in Aix.

1848 June 1, establishment of the Bank Cézanne & Cabassol in Aix. Louis-Auguste Cézanne runs unsuccessfully for the municipal council under the short-lived Second Republic.

1849 Granet's bequest of his paintings and watercolors enters the Aix museum, subsequently becomes accessible to Cézanne (at date unknown).

c. 1849 – 1852 Paul Cézanne at the Ecole Saint-Joseph in Aix.

1852 – 1858 Cézanne at the Collège Bourbon in Aix; friendship with Emile Zola and Baptistin Baille.

1854 June 30, birth of Rose Cézanne, 14, Rue Matheron, Aix.

1857 First inscription at the Free Municipal School for Drawing, Aix.

1858 February, Zola leaves Aix for Paris but returns there for his summer vacations. July, Cézanne fails at the baccalaureate; passes the examination on November 12. From November 1858 to August 1859, Cézanne works at the Free Municipal School for Drawing, Aix.

1859 Cézanne studies law at the University of Aix. His father acquires the Jas de Bouffan. Zola again spends his vacations in Aix. From November 1859 to August 1860, Cézanne once more works at the Free Municipal School for Drawing; obtains a second prize for a painted figure study. Cézanne dreams of becoming a painter. At about this time he is called for military service, but his father buys him a substitute.

1860 Cézanne continues his law studies more and more reluctantly. His father agrees to his departure for Paris, where Zola impatiently awaits Cézanne, but the latter's teacher at the municipal drawing school advises against the trip. From November 1860 to the spring of 1861, Cézanne again works at the municipal drawing school.

1861 Abandons his law studies. From April to the fall, first sojourn in Paris, Rue Coquillière, later Rue des Feuillantines. Visits the Salon. Meets Pissarro at the Atelier Suisse. Paints portrait of Zola. Returns discouraged to Aix in September; enters his father's bank. From November 1861 to August 1862, works once more at the Free Municipal School for Drawing.

1862 Quits his father's bank. Takes up painting again. Friendship with Numa Coste. Returns to Paris in November. Apparently fails in examinations for the Ecole des Beaux-Arts.

1863 In Paris probably during the entire year. Cézanne's father pays short visit to son in January. Exhibits at the Salon des Refusés; visits the exhibition with Zola. Works at the Atelier Suisse, where he meets Guillemet, Oller, and Guillaumin. November 20, requests a student permit as pupil of Chesneau to make copies at the Louvre; his address: 7, Rue des Feuillantines.

1864 Rejected at the Salon. Copies painting by Delacroix. April 19, begins copy of Poussin's *Arcadian Shepherds* at the Louvre. Returns to Aix in the summer. August, in L'Estaque, a fishing village near Marseilles.

1865 Spends most of the year in Paris, 22, Rue Beautreillis. Oller, "pupil of Cézanne," lives at the same address. Rejected at the Salon. Works at the Atelier Suisse. Returns to Aix during the summer; friendship with Valabrègue, Marion, and the German musician Morstatt; Guillemet works at La Rochelle, Pissarro at La Varenne-Sainte-Hilaire. Zola publishes *La Confession de Claude*, dedicated to Cézanne and Baille; a review of the book says that Cézanne admires Ribera and Zurbarán.

1866 Guillemet spends January in Aix. Cézanne returns to Paris in February, again lives at Rue Beautreillis. Is complimented by Manet on his still lifes. Rejected at the Salon despite intervention of Daubigny; writes a letter of protest to the Director of Fine Arts. Zola publishes aggressive and unorthodox Salon reviews in *L'Evénement*; has to suspend series of articles later issued as pamphlet dedicated to Cézanne. July, with Zola, Valabrègue, Baille, Solari, etc., at Bennecourt on the Seine. Plans huge paintings. From August to December, in Aix; informs Guillemet that he has painted "a good picture." Guillaumin considers him superior to Manet. October, invited by Joseph Gibert to visit the Bourguignon Collection of old masters recently bequeathed to the Aix museum and first installed in the former chapel of the White Penitents, where Cézanne goes to see it and considers everything bad, which he finds "very consoling." Guillemet spends October and November in Aix, obtains higher allowance for Paul from his father. November, Cézanne attempts to paint a large *Soirée de Famille*, a project he abandons. Cézanne begins to show interest in working out-of-doors.

1867 From January to June, in Paris, Rue Beautreillis. Rejected at the Salon. Zola defends Cézanne in the press. Cézanne spends summer in Aix. A painting exhibited in Marseilles has to be withdrawn so as not to be torn to pieces by the crowd. Returns to Paris in the fall. 1867–68, becomes acquainted with fellow Provençal Adolphe Monticelli at the Café Guerbois in Paris.

1868 Rejected at the Salon. February 13, obtains renewed student permit as pupil of Chesneau to make copies at the Louvre (no subject specified); Cézanne's address still 22, Rue Beautreillis. From May to December, in Aix, works at the Jas de Bouffan. Friendship with Alexis. Often paints in company of Marion. Excursion to Saint-Antonin at the foot of Mont Sainte-Victoire.

1869 Spends most of the year, if not all, in Paris. Rejected at the Salon. At about this time meets Hortense Fiquet, born 1850. Zola begins work on the *Rougon-Macquart* series. Cézanne reads Stendhal's *Histoire de la peinture en Italie*.

1870 In the spring a caricature of Cézanne by Stock appears in a Paris weekly. May 31, Cézanne is witness at Zola's wedding in Paris; lives at 53, Rue Notre-Dame-des-Champs. July 18, declaration of the Franco-Prussian War. Cézanne works in Aix, later in L'Estaque, where he lives with Hortense Fiquet. They are joined for a while by Zola. Cézanne avoids the draft. September 4, proclamation of the Third Republic. Cézanne's father retires from the bank, is nominated member of the municipal council of Aix. November 18, Cézanne himself is elected member of the commission for the Free Municipal School for Drawing but does not participate in the work of this commission, which is dissolved on April 19, 1871. Honoré Gibert becomes curator of Aix museum.

1871 Armistice signed January 28. Paris Commune from March 18 to May 28. Cézanne leaves L'Estaque in March, apparently returns to Aix. Is back in Paris in the autumn, impatiently awaited by Zola. Lives at 5, Rue de Chevreuse, the same house as Solari. December, moves to 45, Rue de Jussieu, opposite the Halle aux Vins, where Emperaire stays shortly with him.

1872 January 4, Hortense Fiquet gives birth to a son recognized by his father and christened Paul Cézanne. Cézanne is apparently again rejected by the Salon jury; April, joins Manet, Pissarro, Renoir, Jongkind, and forty-five others to request a special hall for the Refusés. With Hortense and their infant moves to Pontoise, where Cézanne works at Pissarro's side and sees Guillaumin frequently. He lives at the Hôtel du Grand Cerf at Saint-Ouen-l'Aumône, across the river from Pontoise. Copies a landscape by Pissarro. In the spring, Dr. Gachet buys a house at Auvers-sur-Oise, not far from Pontoise. Late in 1872, Cézanne and his small family leave Pontoise and settle in Auvers-sur-Oise, where they remain throughout the next year.

1873 Friendship with Dr. Gachet. Duret becomes interested in Cézanne's work. Zola publishes *Le Ventre de Paris*, in which appears a painter, Claude Lantier, resembling Cézanne.

1874 Cézanne in Auvers. Participates in the first Impressionist group show, April 15 to May 15; exhibits three paintings; sells *House of the Hanged Man* for 100 francs to Count Doria. Exhibition produces deficit; group dissolved at December 17 meeting, in which Cézanne does not participate. Pissarro paints Cézanne's portrait. Cézanne returns to Aix in June but is back in Paris in the fall at 120, Rue de Vaugirard.

1875 In Aix part of the year. Through Renoir meets Victor Chocquet after the latter bought a canvas of his at *père* Tanguy's. Paints Chocquet's portrait. August, with Pissarro and Guillaumin, joins L'Union Artistique, directed by one Alfred Meyer. Lives in Paris, 15, Quai d'Anjou, neighbor of Guillaumin, in whose company he sometimes works. According to Renoir's friend Rivière, a watercolor of the Jas de Bouffan is rejected by the Salon jury.

1876 February, Cézanne introduces Monet to Victor Chocquet. In Aix and L'Estaque for the greater part of the year. Rejected at the Salon. Does not join the Impressionists for their second group show; is defended by Monet and elected member of new Impressionist association. End of August, leaves Aix for Paris; works with Guillaumin at Issy-les-Moulineaux.

1877 Probably in and around Paris most of the year; lives at 67, Rue de l'Ouest. With Pissarro and Guillaumin resigns from Meyer's Union Artistique; April, participates in the third group show of the Impressionists with sixteen works, mostly still lifes and landscapes; also exhibits his portrait of Chocquet, who retires from Customs Service. Is praised by Renoir's friend Rivière but mocked by all the other critics. Works with Pissarro in Pontoise; appears shortly in Auvers, Chantilly, Fontainebleau; also works in Issy near Paris. Suffers from an attack of bronchitis. Zola spends the summer in L'Estaque.

1878 Cézanne back in Aix at the beginning of the year; works in Aix and L'Estaque during the entire year. Has difficulties with his father and is helped financially by Zola. Rejected at the Salon. Is ready to show with the Impressionists, but no group exhibition is organized that year. Zola buys a house in Médan. 1878–79, Cézanne sees Monticelli; Hortense and her son live at 32, Rue Ferrari, Marseilles, not far from Monticelli. September, Cézanne is racked for one month by a bronchitis attack. Reads Stendhal's *Histoire de la peinture en Italie* for the third time.

1879 Works in L'Estaque. Is rejected at the Salon despite intervention of Guillemet, now jury member. March, returns to Paris; from April to December, is in Melun. In autumn pays visit to Zola in Médan.

1880 Spends January to March in Melun. Probably again rejected at the Salon. From March to December, is in Paris, 32, Rue de l'Ouest. Zola mentions Cézanne in an article in which he begins to detach himself from his painter friends. August, Cézanne pays visit to Zola in Médan, where he meets Huysmans. Renoir does Cézanne's portrait. Rose Cézanne buys property on May 1, 1880, for 16,500 francs.

1881 Rose Cézanne marries Aix lawyer Maxime Conil on February 26, 1881. Cézanne in Paris until April at Rue de L'Ouest. Probably again rejected at the Salon. From May to October, with Pissarro in Pontoise; lives at 31, Quai de Pothuis. There meets Gauguin. June, Cézanne's sister Rose comes to Paris with her husband. At about this time the roof of the Jas de Bouffan is covered with new tiles; it was probably on that occasion that a studio for the painter was built under the roof. October, Cézanne visits Zola in Médan. Returns to Aix in November. Is caricatured in a short novel by Duranty, published posthumously.

1882 Sees Monticelli; works in L'Estaque with Renoir, whom he nurses in February during an attack of pneumonia. March, Victor Chocquet's wife inherits fortune from her mother; they retire to Yvetot in Normandy. From March to October, Cézanne in Paris, 32, Rue de l'Ouest. Is admitted to the Salon as "pupil" of Guillemet; exhibits a portrait of a man, which according to Rivière was a self-portrait. Spends five weeks in the fall at Zola's in Médan. Also visits Chocquet at Hattenville (Normandy) and works with Pissarro near Pontoise. Returns to Aix in October, works at the Jas de Bouffan. Makes his last will, which he entrusts to Zola.

1883 Works mostly in and around Aix. Is probably again rejected at the Salon. Apparently in Paris for

Manet's funeral on May 4. In L'Estaque from May to November; sees Monticelli often. December, meets Monet and Renoir in the south. Gauguin buys two paintings by Cézanne from *père* Tanguy.

1884 Short trip from L'Estaque to Aix to see Valabrègue; their friendship has cooled. Works mostly in and around Aix. Is rejected at the Salon, again despite intervention of Guillemet. The young Signac buys a landscape by Cézanne at *père* Tanguy's. From June to October, severe cholera epidemic at Marseilles prompts young maid to leave the Jas de Bouffan; Cézanne presents her with a painting.

1885 Probably again rejected at the Salon. Works in L'Estaque and Aix until May; suffers from severe neuralgia in March. Has mysterious love affair. Visits Renoir with Hortense Fiquet and their son in La Roche-Guyon during June and July. Short stays in Villennes and Vernon; possibly short visit with Monet at Giverny; sees Zola briefly in Médan, returns to Aix in August. Works in Aix and Gardanne during rest of the year. Zola writes *L'Oeuvre [His Masterpiece]*.

1886 Cézanne in Paris during February; spends most of the year in Gardanne with Hortense Fiquet and their son. March, Zola publishes *L'Oeuvre;* Cézanne, deeply hurt, breaks with him. Probably again rejected at the Salon. April 28, marries Hortense Fiquet in Aix in the presence of his parents; religious ceremony, April 29, at the church Saint-Jean-Baptiste, with Marie Cézanne and Maxime Conil as witnesses. Cézanne's father dies on October 23, aged eighty-eight; the painter inherits sizable fortune: 1,600,000 francs divided among Louis-Auguste's widow and his three children, Marie, Paul, and Rose Conil. December 2, the artist's sister Rose buys property (probably Bellevue) for 38,000 francs.

1887 Cézanne is probably in Aix most of the year.

1888 In Paris, 15, Quai d'Anjou, two and a half flights up; the apartment has a mirror over the fireplace that is wider than the mantelpiece; Cézanne paints there. Works in Chantilly, Alford (on the banks of the Marne), and in the outskirts of Paris. Huysmans publishes short article on Cézanne in *La Cravache;* from this time on, Cézanne's name appears every now and then in various Symbolist periodicals; Aurier and Fénéon mention him occasionally.

1889 In Paris, Quai d'Anjou. Chocquet maneuvers to have Cézanne's *House of the Hanged Man* shown at the Paris World's Fair. June, pays short visit to Chocquet in Hattenville, Normandy. Spends latter part of the year in Aix; Renoir comes there, rents Bellevue from Maxime Conil. Cézanne is invited to exhibit with the Belgian group Les XX in Brussels. He is mentioned in *Le Moderniste*, periodical of Les XX (editor-in-chief, Aurier).

1890 In Paris, Quai d'Anjou; later, Avenue d'Orléans; has a studio, Rue du Val de Grâce. January, shows three canvases with Les XX in Brussels; Signac mentions Cézanne's works in *Le Moderniste*. Cézanne spends five months during the spring and summer with his wife and son in Switzerland (Neuchâtel, Berne, Freyburg, Vevey, Lausanne, Geneva). During the fall in Aix, works at the Jas de Bouffan, probably at his *Cardplayers* series. Begins to suffer from diabetes.

1891 Spends the beginning of the year in Aix, where he sees Alexis frequently. April, death of Chocquet at Yvetot, Normandy. Cézanne considers exhibiting at the Salon des Indépendants but changes his mind. Obliges his wife and son to settle in Aix; later leaves for Paris. At about this time becomes a devout Catholic.

1892 Georges Lecomte gives lecture on Cézanne in Brussels, published in *L'Art Moderne*, February 21. Cézanne in Aix and in Paris, 2, Rue des Lions-Saint-Paul. Works in Fontainebleau forest at Samois and Alfort. At about this time acquires house in nearby village of Marlotte. The painter Emile Bernard publishes a pamphlet on Cézanne.

1893 Cézanne in Aix and in Paris, Rue des Lions-Saint-Paul. Works again in Fontainebleau forest. Death of Caillebotte; bequest of his collection to the Luxembourg museum and the Louvre. Death of *père* Tanguy.

1894 In Aix and Paris; March, auction sale of Théodore Duret's collection, containing three paintings by Cézanne, which obtained fair prices. September 7–30, Cézanne at Hôtel Baudy in Giverny; at celebration of Monet's fifty-fourth birthday (November 14), Cézanne meets Clemenceau, Rodin, Gustave Geffroy, also Mary Cassatt. Leaves suddenly for Aix. At the auction of *père* Tanguy's estate, Cézanne's canvases bring between 45 and 215 francs; are bought by new and unknown dealer, Ambroise Vollard, who in January has opened a small gallery in Paris, Rue Laffitte. Vollard follows Pissarro's advice and seeks out Cézanne's son to organize a one-man show of his father's work. Cézanne lives in Paris, Rue des Lions-Saint-Paul; works at Avon, Barbizon, Mennecy (Forest of Sénart). Plans to paint an *Apotheosis of Delacroix*.

1895 In Paris from January to June, Rue Bonaparte. Paints portrait of Geffroy. Spends the fall in Aix; excursions to Bibémus quarry and Mont Sainte-Victoire with Solari and the latter's son. Conflict with Pissarro's friend, the painter Oller. September, plagued by financial troubles, Conil sells property. November, Cézanne begins to pay rent for the *cabanon* at Bibémus quarry. November, Vollard opens Cézanne's first one-man show; the painter sends him some 150 works. With the truncated Caillebotte bequest, two of five paintings by Cézanne enter the Luxembourg museum. Founding of the Société des Amis des Arts in Aix; Cézanne becomes a member.

1896 In Aix until June; works at Bibémus quarry. April, introduced to poet Joachim Gasquet, son of one of his former schoolmates. Through him meets Edmond Jaloux and Louis Aurenche. Zola spends some days at Numa Coste's in Aix but does not see Cézanne. In Vichy during June, then in July and August at Talloires, on the Lac d'Annecy. Spends fall and winter in Paris, living in Montmartre, Rue des Dames. Zola, in a new article, calls Cézanne an "abortive genius."

1897 Cézanne suffers from influenza during entire month of January; in Paris, 73, Rue Saint-Lazare, until April. Spends May in Mennecy, near Corbeil. After Cézanne leaves, Vollard buys from the artist's son the entire contents of his studio. From June until the end of the year, Cézanne in Aix; works frequently in nearby Le Tholonet and at the Bibémus quarry. October 25, death of Cézanne's mother, aged eighty-two. Two of Cézanne's paintings are hung in the Berlin National Gallery but banned by the kaiser. During the Dreyfus affair, Cézanne disapproves of Zola's stand.

1898 Spends first part of the year in Aix; works at Château Noir. Returns in the summer to Paris, 15, Rue Hégésippe-Moreau. Works in Montgeroult and in Marines, near Pontoise, sometimes in

company of the young painter Louis Le Bail. Also works in Marlotte on the edge of Fontainebleau forest and in nearby Montigny-sur-Loing. Death of Achille Emperaire.

1899 Spends most of the year in and around Paris. April 23, death of Chocquet's widow. The Italian collector Egisto Fabbri, who owns sixteen canvases by Cézanne, meets the artist in May. Paints portrait of Vollard in his studio, Rue Hégésippe-Moreau. Returns to Aix in the fall. November 25, in order to settle the estate of Louis-Auguste Cézanne and at the insistence of Maxime Conil, the Jas de Bouffan has to be sold for 75,000 francs, much to the regret of Cézanne, who then tries to buy the domain of Château Noir, halfway between Aix and Le Tholonet. His offer is rejected. Exhibits three paintings at the Salon des Indépendants. At the sale of the Chocquet collection in July, Cézanne's paintings average 1,700 francs; Isaac de Camondo, on Monet's advice, buys *House of the Hanged Man* for 6,200 francs; Monet himself had paid 6,750 francs for a Cézanne landscape at the Doria sale in May. (In March 1900, a still life was to bring 7,000 francs at a Paris auction.) Durand-Ruel buys many of Cézanne's paintings at the Chocquet sale. December, Vollard holds yet another Cézanne exhibition. Vollard informs Gauguin in Tahiti that he has bought the entire contents of Cézanne's studio.

1900 Cézanne spends the year in Aix. Due to the intervention of Roger Marx, three of Cézanne's paintings are shown at the Centennial Exhibition in Paris. October, Durand-Ruel sends twelve paintings by Cézanne to Cassirer, not all of which are for sale; Cassirer's exhibition is first in Germany; *all* pictures are returned to Paris in January 1901.

1901 Cézanne spends the year in Aix; he rents an apartment, 23, Rue Boulegon. Maurice Denis exhibits at the Salon a *Homage to Cézanne*. Cézanne shows two paintings at the Salon des Indépendants and one in Brussels with the group La Libre Esthétique. May–June, Hogendijk (or his family) lends four paintings by Cézanne to an International Exhibition at The Hague. November 18, Cézanne buys some land for 2,000 francs on the Chemin des Lauves, on a hill dominating Aix, to build a studio. Frequently meets the poet Léo Larguier and the painter Charles Camoin, both doing their military service in Aix. Conil is threatened with foreclosure.

1902 January, Vollard pays short visit to Cézanne at Aix; Gaston Bernheim-Jeune also comes to Aix as "fellow artist"; buys pictures from the artist's son. July. Jules Borély visits Cézanne at Aix. Cézanne works in Aix and Le Tholonet while his studio is being constructed. Apparently spends several weeks on Gasquet's estate in Eguilles near Aix, but soon afterward their friendship cools. Upon the insistence of Maurice Denis, exhibits three paintings at the Salon des Indépendants. Shows two paintings in Aix with the Société des Amis des Arts. September, settles in his new Lauves studio. In the fall visits the Larguier family in the Cévennes. September 26, Cézanne makes his final last will and names his son as his exclusive heir (after his widow has obtained her legal share). September 29, death of Zola in Paris.

1903 Cézanne spends the year in Aix; works in his new studio. March 7, sale of Zola's collection; ten works by Cézanne average 1,500 francs, but the painter is violently attacked in the press. Seven paintings by Cézanne are exhibited at the Secession in Vienna and three in Berlin. November 12, death of Pissarro in Paris.

1904 Cézanne spends most of the year in Aix; is visited there by Emile Bernard, with whom he corresponds after his departure. Bernard prepares a new article on Cézanne. Sojourn in Paris; works in Fontainebleau forest. Exhibits nine paintings with La Libre Esthétique in Brussels and others at the Salon d'Automne in Paris. October, Pissarro's widow sells three paintings by Cézanne to Bernheim-Jeune for 15,000 francs. The Galerie Cassirer in Berlin organizes second one-man show of Cézanne; October–November, Impressionist exhibition at the Galerie Emil Richter in Dresden with one or more works by Cézanne. Camoin, Francis Jourdain, and the painter-dealer Bernheim-Jeune visit Cézanne in Aix.

1905 In early spring or summer, exhibition of Cézanne watercolors at Vollard's. Cézanne in Aix during almost the entire year. Is visited by R. P. Rivière and Jacques Schnerb in January. In Fontainebleau briefly during the summer. Shows ten paintings at the Salon d'Automne. Monet expresses publicly his admiration for Cézanne as "one of the masters of today." Durand-Ruel includes ten paintings by Cézanne in large Impressionist exhibition at the Grafton Galleries in London.

1906 Cézanne in Aix; January, Maurice Denis and K.-X. Roussel catch Cézanne after Sunday mass at Saint-Sauveur Cathedral and spend the entire day with him. March, Vollard exhibits a dozen of Cézanne's works. Cézanne is visited in April by the German collector Karl Ernst Osthaus, who buys two paintings for his museum. Exhibits a *View of Château Noir* with the Société des Amis des Arts in Aix; lists himself in the catalogue as "élève de Pissarro"; the work (a watercolor?) is priced at 150 francs. July, works near Cabanon de Jourdan. Suffers an attack of bronchitis in August. Works near the bridge of Les Trois Sautets and at Le Gour de Martelly, both on the Arc River; does watercolors there. October, also does watercolors in the Beauregard sector, though incommoded by the mistral. Is again visited by Camoin. Shows ten paintings at the Salon d'Automne. Dies in Aix, 23, Rue Boulegon, on October 23.

List of Illustrations

23: *Portrait of Louis-Auguste Cézanne Reading* L'Evénement *(The Artist's Father)*. Autumn 1866. 78¾ × 47¼″. National Gallery of Art, Washington, D.C. From the Collection of Mr. and Mrs. Paul Mellon, Upperville, Virginia

24: *Male Nude*. 1862. Pencil, 23¾ × 15⅜″. Private Collection, Paris. Photograph Maurice Poplin, Villemomble, France

25: Achille Emperaire. *Male Nude*. 1846. Pencil, 24⅜ × 18⅜″. Musée Granet, Aix-en-Provence. Photograph Bernard Terlay, Musée Granet

Achille Emperaire. *Figure Study* (after a plaster cast from the Antique). 1847. Pencil, 28¾ × 21¼″. Musée Granet, Aix-en-Provence. Photograph Bernard Terlay, Musée Granet

27: The Cathedral of Saint-Sauveur, Aix-en-Provence. Photograph Henry Ely, Aix-en-Provence, c. 1900

28: The Bridge of Les Trois Sautets near Aix-en-Provence. Photograph Henry Ely, Aix-en-Provence, c. 1900

30: *Male Nude*. 1863–66. Charcoal, 19¹¹⁄₁₆ × 11¹³⁄₁₆″. Private Collection. Photograph courtesy Sotheby's, New York

31: *Seated Male Model*. 1865–67. Black chalk, 9⅞ × 12¾″. Private Collection. Photograph courtesy Sotheby's, New York

32: *Study for* The Autopsy. c. 1865. Charcoal, 11½ × 16¾″. The Art Institute of Chicago. Mr. and Mrs. Tiffany Blake Fund

33: *Portrait of Emile Zola*. 1862–64. 10¼ × 8¼″. Present whereabouts unknown. Photograph Maurice Poplin, Villemomble, France

34: Marie Cézanne. Anonymous photograph, c. 1861

35: Paul Cézanne. Anonymous photograph, c. 1861

36: *Rocks in the Forest (Fontainebleau?)*. 1865–68. 16⅛ × 13″. Private Collection

37: Gustave Courbet. *Snow Effect in a Quarry*. c. 1870. 17⅛ × 24″. Bridgestone Museum of Art, Tokyo

40: *Nymph and Tritons*. c. 1867. 9½ × 13½″. Private Collection

41: *The Judgment of Paris*. 1862–64. 6 × 8¼″. Private Collection

44: *Portrait of Uncle Dominique as a Monk*. c. 1866. 25½ × 21¼″. From the Private Collection of the Honorable and Mrs. Walter Annenberg, Palm Springs. Photograph Wildenstein & Co., New York

45: Antoine-Fortuné Marion. *Two Dogs*. 1869. 6½ × 8⁹⁄₁₆″. Musée Granet, Aix-en-Provence

Antoine-Fortuné Marion. *The Church of Saint-Jean-de-Malte, Aix-en-Provence*. c. 1866. 25½ × 21¼″. Fitzwilliam Museum, Cambridge, England. Photograph Morgan Photographs, New York

Antoine-Fortuné Marion. *Rocky Landscape near Aix*. c. 1866. Private Collection, Aix-en-Provence

46: The salon of the Jas de Bouffan with Cézanne's murals still in place, c. 1900. Photograph Bibliothèque Nationale, Paris

47: Antoine-Fortuné Marion. Anonymous photograph, c. 1866

48: *The Negro Scipion*. c. 1867. 42⅛ × 32⅝″. Museu de Arte, São Paulo. Photograph Luiz Hossaka, São Paulo

49: *Paul Alexis Reading to Zola*. 1869–70. 20½ × 22″. Private Collection, U.S.A. Photograph Wildenstein & Co., New York

50: *The Abduction*. 1867. 32½ × 46″. By permission of the Provost and Fellows of Kings College, Cambridge, England. Keynes Collection. Photograph courtesy the Fitzwilliam Museum, Cambridge

51: *Preparation for the Funeral*, also known as *The Autopsy*. 1869. 19¼ × 31½″. Private Collection. Photograph Galerie Beyeler, Basel

52: *The Murder*. c. 1870. 25¾ × 31½″. Walker Art Gallery, Liverpool

53: *Portrait of Antony Valabrègue*. 1869–70. 23¾ × 19¾″. J. Paul Getty Museum, Pacific Palisades. Photograph Galerie Beyeler, Basel

55: *Marion and Valabrègue Leaving for the Motif*. Autumn 1866. 15⅜ × 12¼″. Private Collection, Paris. Photograph Vizzavona, Paris

56: *Self-Portrait*. c. 1866. 17¾ × 16⅛″. Private Collection, Paris. Photograph Vizzavona, Paris

57: *The Rue des Saules in Montmartre.* 1867–68. 12⅜ × 15½″. Present whereabouts unknown

Motif for *The Rue des Saules in Montmartre.* Photograph J. R., c. 1935

58–59: Cézanne's letter of protest to Count de Nieuwerkerke of April 19, 1866, with the latter's negative reply written across the upper left corner. Document courtesy the late Ambroise Vollard

63: *Overture to Tannhäuser.* c. 1866. 22⁷⁄₁₆ × 36¼″. The Hermitage, Leningrad

65: *A Painter at Work.* 1874–75. 9½ × 13½″. Private Collection. Photograph Galerie Beyeler, Basel

66: *Factories in Front of the Mont du Cengle.* 1867–69. 16⅛ × 21⅝″. Present whereabouts unknown. Photograph Feilchenfeldt, Zurich

68: *Afternoon in Naples,* also known as *The Wine Grog.* 1876–77. 14⅝ × 17¾″. Australian National Gallery, Canberra. Photograph Wildenstein & Co., New York

71: *La Colline des Pauvres near Château Noir, with a View of Saint-Joseph.* 1888–90. 25⅝ × 31⅞″. The Metropolitan Museum of Art, New York

72: *Portrait of a Man.* c. 1866. 32⅛ × 26″. Oskar Reinhart Collection, "Am Römerholz," Winterthur, Switzerland

76: *The Temptation of Saint Anthony.* c. 1877. 18½ × 22″. Musée d'Orsay, Paris. Photograph Service Photographique des Musées Nationaux, Paris

80: *Still Life with Bread and Eggs.* 1865. 23¼ × 29⅞″. Cincinnati Art Museum. Gift of Mary Johnston

81: *Still Life with Green Jug and Tin Kettle.* 1867–69. 24¾ × 31½″. Musée d'Orsay, Paris. Photograph Service Photographique des Musées Nationaux, Paris

84: Stock. Caricature of Paul Cézanne with the two paintings rejected by the Salon jury of 1870. From an unidentified Paris newspaper

85: *Portrait of Achille Emperaire.* c. 1868. 78¾ × 48″. Musée d'Orsay, Paris. Photograph Bernheim-Jeune, Paris

86: Achille Emperaire. *Nude.* n.d. Sanguine drawing, 6 × 4⅜″. Private Collection, New York. Photograph Eric Pollitzer, New York

Achille Emperaire. *Self-Portrait.* n.d. Pencil, 12¾ × 9⅝″. Musée Granet, Aix-en-Provence. Photograph Bernard Terlay, Aix-en-Provence

Achille Emperaire. *Still Life with Pitcher and Fruits.* n.d. 10½ × 13¾″. Musée Granet, Aix-en-Provence. Photograph Bernard Terlay, Aix-en-Provence

87: *Bathers.* c. 1870. 13 × 15¾″. Private Collection

89: *The Village of the Fishermen, L'Estaque.* c. 1870. 16½ × 21⅝″. Private Collection. Photograph Bernheim-Jeune, Paris

90: *Melting Snow, L'Estaque,* also known as *The Red Roofs.* c. 1870. 28¾ × 36¼″. Private Collection, Switzerland. Photograph Walter Drayer, Zurich

Landscape (near L'Estaque?). c. 1870. 21⅛ × 25⅝″. Städeliches Kunstinstitut und Städtische Galerie, Frankfurt. Photograph Ursula Edelmann, Frankfurt

92: Paul Cézanne (center) with Camille Pissarro (at right) in the region of Auvers. Anonymous photograph, c. 1874

94: *Quai de Bercy—La Halle aux Vins, Paris.* 1872. 28¾ × 36¼″. Private Collection

95: La Halle aux Vins, Paris. c. 1900. From an old postcard

La Halle aux Vins, Paris. c. 1900. From an old postcard

96: Camille Pissarro. *Les Mathurins, Pontoise.* 1875. 20½ × 32″. Present whereabouts unknown. Photograph Durand-Ruel, Paris

Les Mathurins, Pontoise. 1875–77. 22⅞ × 28″. Pushkin Museum, Moscow. Photograph Vizzavona, Paris

97: *Snow Effect, Rue de la Citadelle, Pontoise.* 1873. 15 × 18⅛″. This painting was lost during World War II, a casualty of the pillage of the Château de Rastignac, Dordogne, by the S.S. Division *Das Reich,* 1944.

The Mill on the Banks of La Couleuvre near Pontoise. 1881. 28½ × 35⁷⁄₁₆″. National-Galerie, East Berlin. Gift of Wilhelm Staudt, 1897

Camille Pissarro. *The Rue de la Citadelle, Pontoise in Winter.* 1873. 21¼ × 29″. Formerly Collection Florence Gould. Photograph Wildenstein & Co., New York

The mill on the banks of La Couleuvre near Pontoise. From a turn-of-the-century postcard. Courtesy Rodo Pissarro

98: *View of Auvers-sur-Oise—The Fence.* c. 1873. 17½ × 13⅝″. Collection Mr. and Mrs. Nathan L. Halpern. Photograph Otto Nelson, New York

99: *The Road*, also known as *The Wall.* 1875–76. 19⅝ × 25⅝″. Private Collection. Photograph courtesy the Metropolitan Museum of Art, New York

The group of houses that appears in the center of the painting reproduced on page 98. Photograph J. R., c. 1935

100: Camille Pissarro. *Portrait of Paul Cézanne.* c. 1874. Pencil, 7⅝ × 4⅜″. Musée du Louvre, Paris

101: Camille Pissarro. *Portrait of Cézanne.* 1874. Etching, 10⅝ × 8¼″. Photograph Bibliothèque Nationale, Paris

102: Camille Pissarro. *Road of the Hermitage, Pontoise, under the Snow.* c. 1874. 18¼ × 15⅜″. Private Collection, Cambridge, Massachusetts. Photograph courtesy E. V. Thaw & Co., New York

103: *House and Tree near the Road of the Hermitage, Pontoise.* 1873–74. 25⅝ × 21¼″. Private Collection. Photograph courtesy Christie's, New York

Camille Pissarro. *The Road of the Hermitage, Pontoise.* 1874. 18 × 15″. Private Collection. Photograph courtesy E. V. Thaw & Co., New York

104: *Self-Portrait.* c. 1875. 25¼ × 20⅞″. Musée d'Orsay, Paris. Gift of J. Laroche. Photograph Service Photographique des Musées Nationaux, Paris

105: Photograph of Paul Cézanne. c. 1875. Photograph F. Brouchican, Aix-en-Provence

107: *Bathers.* 1874–75. 15 × 18⅛″. The Metropolitan Museum of Art, New York. Bequest of Joan Whitney Payson, 1975

108: *Women Picking Fruit.* 1876–77. 6⅛ × 8⅞″. Private Collection

109: *Bathers.* 1875–77. 5½ × 7½″. Private Collection

Bather with Arms Spread. 1877–78. 13 × 9⁷⁄₁₆″. Private Collection, Zurich. Photograph courtesy Phillips Gallery, New York

111: *The Fishermen.* c. 1875. 21¼ × 32″. Private Collection

114: *The Eternal Feminine*, also known as *The Triumph of Women.* c. 1877. Watercolor, 6⅞ × 9″. Private Collection, Zurich

115: *The Eternal Feminine*, also known as *The Triumph of Women.* c. 1877. 17 × 20⅞″. Private Collection. Photograph Wildenstein & Co., New York

116: *Portrait of Victor Chocquet.* 1876–77. 18 × 14½″. Private Collection. Photograph Schechter Lee, New York

117: *House of the Hanged Man, Auvers-sur-Oise.* c. 1873. 21⅝ × 26″. Musée d'Orsay, Paris. Photograph E. B. Weill, Paris

118: *Still Life with Open Drawer.* 1877–79. 13 × 16⅛″. Private Collection, Switzerland. Photograph Acquavella Galleries, New York

The Plate of Apples. 1878–79 (possibly earlier). 17⅞ × 21⅝″. From the Private Collection of the Honorable and Mrs. Walter Annenberg, Palm Springs. Photograph Wildenstein & Co., New York

119: *Still Life with Compotier.* 1879–80. 18⅛ × 21⅝″. Private Collection

120: *Madame Cézanne in a Red Armchair*, also known as *Madame Cézanne in a Striped Skirt.* c. 1877. 28½ × 22″. Museum of Fine Arts, Boston. Bequest of Robert Treat Paine II, 1944. Photograph © Museum of Fine Arts, Boston. All Rights Reserved

122 ABOVE: *The Artist's Son.* c. 1878. Pencil, 4⅞ × 4⅜″. Private Collection, Paris. Photograph Atelier 53, Paris

122 BELOW: *The Artist's Son.* c. 1878. Pencil, 4¼ × 2⅞″. Private Collection, Paris. Photograph Atelier 53, Paris

123: Cézanne's civil certificate of marriage, Aix-en-Provence, April 28, 1886

Certificate of the religious wedding of Paul Cézanne and Marie Hortense Fiquet in the Church of Saint-Jean-Baptiste of the parish of the Jas de Bouffan, on April 29, 1886

124: *Self-Portrait.* 1878–80. 24 × 18½″. The Phillips Collection, Washington, D.C.

125: Auguste Renoir. *Portrait of Paul Cézanne*. 1880. Pastel, 21¾ × 17¼″. British Railroad Pension Fund. On Loan to the Victoria and Albert Museum, London

126: *Portrait of the Artist's Son, Paul*. 1888–90. 25⅜ × 21¼″. National Gallery of Art, Washington, D.C. Chester Dale Collection

127: *Seven Apples*. 1877–78. 6¹¹⁄₁₆ × 14³⁄₁₆″. Collection Mr. and Mrs. Eugene Victor Thaw, New York

128: *Portrait of Louis Guillaume*. 1879–80. 22 × 18½″. National Gallery of Art, Washington, D.C. Chester Dale Collection

130: *The Oise Valley*. c. 1880. 28⅜ × 35⅞″. Private Collection, France. Photograph Jacqueline Hyde, Paris

131: *The Seine at Bercy, Copy after Guillaumin*. 1876–78. 23¼ × 28⅜″. Kunsthalle, Hamburg. Photograph Kleinhempel, Hamburg

Armand Guillaumin. *The Seine at Bercy*. 1873–75. 22⅛ × 28½″. Kunsthalle, Hamburg. Photograph Kleinhempel, Hamburg

132: *Village behind Trees, Ile de France*. c. 1879. 25⅝ × 18⅛″. Private Collection. Photograph Will Brown, courtesy Philadelphia Museum of Art

133: Armand Guillaumin. *Village behind Trees, Ile de France*. c. 1879. 24 × 19¾″. Private Collection. Photograph courtesy Christie's, New York

134: *Self-Portrait with Olive Wallpaper*. 1880–81. 13¼ × 10¼″. National Gallery, London. Purchased by the Trustees of the Courtauld Fund, 1925

136: *Young Girl with Unbound Hair*. 1873–74. 4⅜ × 6″. Private Collection

137: *Four Bathers*. c. 1880. 13¾ × 15½″. Private Collection, Switzerland. Photograph Acquavella Galleries, New York

138: *Four Bathers*. 1877–78. 15 × 18⅛″. Private Collection

141: *Five Bathers*. 1879–80. 13⅝ × 15″. Detroit Institute of Arts. Robert H. Tannahill Bequest

143: *Young Woman Sewing*. 1881. Page from a sketchbook. Pencil, 5 × 8⁹⁄₁₆″. Collection Mr. and Mrs. Eugene Victor Thaw, New York

Camille Pissarro. *Young Woman Sewing*. 1881. Gouache over pencil on linen, 9⅞ × 7⅞″. Takashi Gallery Inc., Tokyo. Photograph courtesy Sotheby's, New York

144: *View of L'Estaque and the Château d'If*. 1883–85. 28 × 22¾″. Fitzwilliam Museum, Cambridge, England. Anonymous loan

145: *View of L'Estaque*. 1882–83. 23½ × 28⅞″. Private Collection

View of L'Estaque. Photograph J. R., c. 1935

146: *Farmhouses near the Jas de Bouffan*. 1877–80. Double page of a sketchbook. Pencil, 6 × 18⅝″. From the Collection of Mr. and Mrs. Paul Mellon, Upperville, Virginia

Farmhouses near the Jas de Bouffan. Photograph J. R., c. 1935

147: *Saint-Henri and the Gulf of Marseilles*. c. 1883. 25⅝ × 31⅞″. Philadelphia Museum of Art. Bequest of Mr. and Mrs. Carroll S. Tyson, Jr.

View of Saint-Henri and the Gulf of Marseilles. Photograph J. R., c. 1935

148: Tall trees at the Jas de Bouffan. Photograph J. R., c. 1935

L'Estaque Seen through the Pines. 1882–83. 28½ × 35⁷⁄₁₆″. Collection Reader's Digest, Pleasantville, New York. Photograph Otto Nelson, New York

149: *Tall Trees at the Jas de Bouffan*. 1885–87. 28¾ × 23¼″. Private Collection

150: *Mont Sainte-Victoire near Gardanne*. 1886–90. 24⅝ × 35⅞″. National Gallery of Art, Washington, D.C. Presented to the United States government in memory of Charles A. Loeser

Chestnut Trees and Farmhouse at the Jas de Bouffan. c. 1885. 25¾ × 32″. Private Collection. Photograph Otto Nelson, New York

151: *Gardanne*. c. 1886. 31½ × 25¼″. The Metropolitan Museum of Art, New York. Gift of Dr. and Mrs. Franz H. Hirschland, 1957

152: *Farmhouse near Gardanne*. 1886–90. 23 × 28¼″. Private Collection

View of Gardanne. c. 1935. Photograph J. R., c. 1935

Farmhouse near Gardanne. Photograph J. R., c. 1935

153: *Houses in Provence (Vicinity of L'Estaque)*. 1879–82. 25½×32″. National Gallery of Art, Washington, D.C. From the Collection of Mr. and Mrs. Paul Mellon, Upperville, Virginia

154: *The Gulf of Marseilles, Seen from L'Estaque*. c. 1885. 31½×39¼″. Mr. and Mrs. Martin A. Ryerson Collection. ©The Art Institute of Chicago. All Rights Reserved

Red Roofs, L'Estaque. 1883–85. 25⅝×31⅞″. Private Collection

155: *The Gulf of Marseilles, Seen from L'Estaque*. c. 1885. 28¾×39½″. The Metropolitan Museum of Art, New York. Bequest of Mrs. H. O. Havemeyer, 1929. The H. O. Havemeyer Collection

156: *Portrait of Madame Cézanne*. c. 1885. 18⅛×15″. Private Collection

157: *Mont Sainte-Victoire, Seen from Bellevue*, also known as *The Viaduct*. 1882–85. 25¾×32⅛″. The Metropolitan Museum of Art, New York. Bequest of Mrs. H. O. Havemeyer, 1929. The H. O. Havemeyer Collection

View of Mont Sainte-Victoire and the Arc valley with viaduct. Photograph J. R., c. 1935

160: *The Blue Vase*. 1889–90. 24⅜×20⅛″. Musée d'Orsay, Paris. Photograph E. B. Weill, Paris

162: *Provençal Landscape*. c. 1886. Pencil, 8⅞×11¹³⁄₁₆″. Private Collection, Germany

L'Estaque and the Gulf of Marseilles. 1882–85. Pencil, 8⅞×11¹³⁄₁₆″. Private Collection, Germany

163: *Lamenting Woman*. c. 1873. Detail of a study sheet. Pencil and watercolor, 5¾×6¼″. Private Collection, New York

165: *Still Life, Flowers in a Vase*. 1885–88. 18¼×27⅞″. Private Collection. Photograph courtesy Sotheby's, New York

Still Life with Pomegranate and Pears on a Plate. 1885–90. 10⅝×14⅛″. Private Collection

168: *Self-Portrait in a White Turban*. 1881–82. 21⅞×18⅛″. Neue Pinakothek, Bayerische Staatsgemaldesammlungen, Munich. Photograph Joachim Blauel, Artothek, Munich

170: *Orchard*. c. 1890. 24¼×20½″. Academy of Fine Arts, Honolulu

172: *The Forest*. 1890–92. 28¾×36¼″. Collection The White House, Washington, D.C. Photograph The National Geographic Society, courtesy The White House Historical Association, Washington, D.C.

173: *House with Red Roof*. 1887–90. 28¾×36¼″. Private Collection

176: Auguste Renoir. *Mont Sainte-Victoire*. 1889. 20⅞×25¼″. Yale University Art Gallery, New Haven. The Katharine Ordway Collection. Photograph Gert T. Mancini, New Haven

177: *Mont Sainte-Victoire*. 1888–90. 25⅝×31⅞″. Private Collection

179: *Tulips in a Vase*. 1890–92. Oil on paper mounted on board, 28½×16½″. Norton Simon Art Foundation, Pasadena. Photograph A. E. Dolinski Photographic, San Gabriel

180: *Still Life with Jug and Fruits*. 1893–94. 17×24¾″. Private Collection

Still Life with Jug and Fruits on a Table. 1893–94. Oil on paper mounted on panel, 16⅛×28⅜″. Private Collection, Switzerland. Photograph courtesy E. V. Thaw & Co., New York

181: *Still Life with Curtain, Jug, and Compotier*. 1893–94. 23¼×28½″. Collection Mrs. John Hay Whitney, New York. Photograph Eric Pollitzer, New York

183: *The Ginger Jar*, also known as *Still Life with Pomegranate and Pears*. 1890–93. 18¼×21⅞″. The Phillips Collection, Washington, D.C. Gift of Gifford Phillips in memory of his father, James Laughlin Phillips, 1939

Still Life with Rum Bottle. c. 1890. 23⅝×28¾″. Private Collection, New York. Photograph courtesy E. V. Thaw & Co., New York

184: The chestnut trees at the Jas de Bouffan in winter. Photograph J. R., c. 1935

Chestnut Trees at the Jas de Bouffan in Winter. 1885–86. 29¹⁄₁₆×36⅝″. Minneapolis Institute of Arts

186: The Pigeon Tower at Bellevue. Photograph J. R., c. 1935

Auguste Renoir. *The Pigeon Tower at Bellevue*. 1889. Present whereabouts unknown

187: *The Pigeon Tower at Bellevue*. 1889–90. 25¼×31½″. The Cleveland Museum of Art. The James W. Corrigan Memorial

189: *Portrait of Ambroise Vollard*. 1899. 39½×32″. Musée du Petit Palais, Paris. Photograph Maurice Poplin, Villemomble, France

190: *Self-Portrait with Palette.* c. 1890. 36¼×28¾″. The E. G. Bührle Foundation, Zurich. Photograph Walter Drayer, Zurich

191: *Madame Cézanne in the Conservatory.* 1891–92. 36¼×28¾″. The Metropolitan Museum of Art, New York. Bequest of Stephen C. Clark, 1960

193: *Tree-lined Path, Chantilly.* 1888. 32¼×26″. Private Collection. Photograph courtesy E. V. Thaw & Co., New York

194: *Peasant in a Blue Smock.* c. 1897. 31½×25″. Kimbell Art Museum, Fort Worth

195: *Harlequin.* 1889–90. 39⅜×25⅝″. From the Collection of Mr. and Mrs. Paul Mellon, Upperville, Virginia

196: *Portrait of Madame Cézanne in a Yellow Armchair.* 1893–95. 31⅞×25⅝″. Private Collection, New York. Photograph Christie's, New York

197: *Boy in the Red Vest*, also known as *Boy in a Red Waistcoat.* 1888–90. 35¼×28½″. From the Collection of Mr. and Mrs. Paul Mellon, Upperville, Virginia

198: *Boy in a Red Waistcoat.* 1888–90. 32×25⅝″. Museum of Modern Art, New York. Fractional gift of David Rockefeller

199: *Self-Portrait.* c. 1895. 18⅛×15¾″. Private Collection

200: *Two Cardplayers.* 1892–93. 38⅛×51¼″. Private Collection. Photograph Chauderon, Lausanne

The Cardplayers. 1890–92. 25⅝×31⅞″. The Metropolitan Museum of Art, New York. Bequest of Stephen C. Clark, 1960

202: *Self-Portrait with Beret.* 1898–1900. 25×20″. Museum of Fine Arts, Boston. Charles H. Bayley Fund and partial gift of Elizabeth Paine Metcalf

206: *Seated Peasant.* 1898–1900. 21½×17¾″. From the Private Collection of the Honorable and Mrs. Walter Annenberg, Palm Springs. Photograph courtesy Wildenstein & Co., New York

210: *Still Life with Ginger Jar and Eggplants.* 1893–94. 28¾×36¼″. The Metropolitan Museum of Art, New York. Bequest of Stephen C. Clark, 1960

Still Life with Olive Jar, Ginger Pot, Rum Bottle, Sugar Pot, Blue Rug, and Apples. 1893–94. 25¾×32⅛″. Private Collection. On extended loan to the Kunsthaus, Zurich

211: *Still Life with Onions.* 1896–98. 26×32¼″. Musée d'Orsay, Paris. Photograph Service Photographique des Musées Nationaux, Paris

Still Life with Peppermint Bottle and Blue Rug. 1893–95. 25⅞×32¼″. National Gallery of Art, Washington, D.C. Chester Dale Collection

214: *Girl with Doll.* c. 1902. 37¾×28⅜″. Private Collection. Photograph courtesy the Metropolitan Museum of Art, New York

215: *Girl with Doll.* 1902–1904. 28¾×23⅝″. Private Collection

218: *The Large Bathers.* c. 1906. 82×98″. Philadelphia Museum of Art. The W. P. Wilstach Collection

223: *The Large Bathers.* 1894–1905. 53½×75¼″. National Gallery, London. Purchased in 1964 with the aid of the Max Rayne Foundation and a special Exchequer Grant

224: Drawing after Pigalle's *Love and Friendship.* 1879–82. Page from a sketchbook. Pencil, 8³⁄₁₆×5³⁄₁₆″. Formerly Collection R. von Hirsch, Basel

225: Jean-Baptiste Pigalle. *Love and Friendship.* Marble. Musée du Louvre, Paris. Photograph J. R., c. 1935

226: Auguste Préault. *Clémence Isaure.* Marble. Luxembourg Gardens, Paris. Photograph J. R., c. 1935

227: Drawing after Préault's *Clémence Isaure.* 1880–83. Page from a sketchbook. Pencil, 8¼×4¾″. Kunstmuseum, Basel

228: Drawing after Puget's *Hercules.* 1884–87. Page from a sketchbook. Pencil, 4⅝×7⅝″. Private Collection

Pierre Puget. *Hercules.* Marble. Musée du Louvre, Paris. Photograph J. R., c. 1935

229: Drawing after *Diana the Huntress.* 1882–85. Page from a sketchbook. Pencil, 7⅝×4⅝″. Collection A. Chappuis, Tresserve, France

Diana the Huntress. After the Antique. Marble. Musée du Louvre, Paris. Photograph J. R., c. 1935

Still-life objects and a patterned rug used by Cézanne for compositions in his Lauves studio. Photograph J. R., c. 1935

230: Guillaume Coustou. *Bust of the Priest de la Tour*. Terra-cotta. Musée du Louvre, Paris. Photograph J. R., c. 1935

Drawing after Coustou's *Bust of the Priest de la Tour*. 1884–87. Page from a sketchbook. Pencil, 8½ × 5″. From the Private Collection of the Honorable and Mrs. Walter Annenberg, Palm Springs

231: Drawing after Puget's *Milo of Crotona*. 1895–98. Page from a sketchbook. Pencil, 9⁵⁄₁₆ × 6″. From the Collection of Mr. and Mrs. Paul Mellon, Upperville, Virginia

Pierre Puget. *Milo of Crotona*. Marble. Musée du Louvre, Paris. Photograph J. R., c. 1935

232: *Mars Borghese*. Roman marble copy after Greek bronze original of the 5th century B.C. Musée du Louvre, Paris. Photograph J. R., c. 1935

Drawing after *Mars Borghese*. 1892–95. Page from a sketchbook. Pencil, 7¹⁵⁄₁₆ × 4¹³⁄₁₆″. Kunstmuseum, Basel

233: Drawing after Michelangelo's *Slave*. 1885–88. Pencil, 17⅝ × 11⅝″. Detroit Institute of Arts

Michelangelo. *Slave*. 1513–16. Marble. Musée du Louvre, Paris. Photograph J. R., c. 1935

234: Antoine Coysevox. *Bust of Marie Serre*. Marble. Musée du Louvre, Paris. Photograph J. R., c. 1935

Drawing after Coysevox's *Bust of Marie Serre*. c. 1900. Page from a sketchbook. Pencil, 8¼ × 4¹³⁄₁₆″. Kunstmuseum, Basel

Michelangelo. *Slave*. Marble. Musée du Louvre, Paris. Photograph J. R., c. 1935

235: Drawing after Michelangelo's *Slave*. 1884–87. Page from a sketchbook. Pencil, 8⅛ × 4¹⁵⁄₁₆″. Formerly Collection Robert von Hirsch, Basel

236: Drawing after Pigalle's *Mercury*. c. 1890. Page from a sketchbook. Pencil, 8⅛ × 4¹⁵⁄₁₆″. Formerly Collection Robert von Hirsch, Basel

237: Jean-Baptiste Pigalle. *Mercury*. Marble. Musée du Louvre, Paris. Photograph J. R., c. 1935

238: *The Forest with Forked Pine Tree near the Caves above Château Noir*. 1900–1904. 35¾ × 28⅛″. National Gallery, London. Purchased 1963

239: Forked pine tree near the caves above Château Noir. Photograph J. R., c. 1935

240: The old road of Le Tholonet with umbrella pine. n.d. Anonymous photograph

Mont Sainte-Victoire above the Road of Le Tholonet (with Umbrella Pines). c. 1904. 28⅞ × 36¼″. Cleveland Museum of Art. Leonard C. Hanna, Jr., Collection

Mont Sainte-Victoire above the Road of Le Tholonet. 1896–98. 30¾ × 39″. The Hermitage Museum, Leningrad

241: Château Noir seen from a neighboring hill. Photograph J. R., c. 1935

Mont Sainte-Victoire seen from the terrace of Château Noir. Photograph J. R., c. 1950

View of Château Noir. Photograph J. R., c. 1935

242: *Mont Sainte-Victoire and Château Noir*. 1904–1906. 25¾ × 31⅞″. Bridgestone Museum of Art, Tokyo. Ishibashi Foundation

Mont Sainte-Victoire and Château Noir. Photograph J. R., c. 1935

243: *Millstone in the Park of Château Noir*. 1892–94. 28¾ × 36¼″. Philadelphia Museum of Art. Bequest of Mr. and Mrs. Carroll S. Tyson, Jr.

The millstone in the park of Château Noir. Photograph J. R., c. 1935

246: *Mont Sainte-Victoire Seen from Bibémus Quarry*. c. 1897. 25⅝ × 31⅞″. Baltimore Museum of Art. The Cone Collection, formed by Dr. Claribel Cone and Miss Etta Cone of Baltimore

Maison Maria with a View of Château Noir. c. 1895. 25⅝ × 31⅞″. Kimbell Art Museum, Fort Worth

The Maison Maria in the park of Château Noir. Photograph J. R., c. 1935

247: *Forest Interior*. 1898–99. 24 × 31⅞″. The Fine Arts Museum of San Francisco. Gift of the Mildred Anna Williams Fund

Château Noir. 1900–1904. 29 × 38″. National Gallery of Art, Washington, D.C. Gift of Eugene and Agnes Meyer

248: *Mont Sainte-Victoire Seen from Les Lauves*. 1904–1906. 25⅝ × 32″. Nelson-Atkins Museum of Art, Kansas City. Nelson Fund

249: Mont Sainte-Victoire seen from Les Lauves, above Cézanne's studio. Photograph J. R., c. 1935

250: Cézanne's Lauves studio. Photograph Bernheim-Jeune, c. 1904

View of Aix with the Cathedral of Saint-Sauveur, from Cézanne's Lauves studio. Photograph J. R., c. 1935

A corner of Cézanne's Lauves studio. Anonymous photograph, c. 1930

Skull, bottles, and patterned rug used by Cézanne for his still-life compositions in the Lauves studio. Photograph J. R., c. 1935

Still-life objects still preserved in Cézanne's Lauves studio on the table with the scalloped apron. Photograph J. R., c. 1935

251: Cézanne's last will and testament, dated Aix, September 26, 1902. Document courtesy Robert Tiers, Avignon

252: *Still Life with Apples and Peaches.* c. 1905. 32 × 39⅝". National Gallery of Art, Washington, D.C. Gift of Eugene and Agnes Meyer

253: *Still Life with Apples, a Bottle, and a Milk Pot.* 1902–1906. Watercolor, 19⅛ × 24⅞". Dallas Museum of Art. The Wendy and Emery Reves Collection

254: Cézanne in front of his *Large Bathers.* Photograph taken in the Lauves studio by Emile Bernard, 1904

255: Pierre Bonnard. Portrait of *Ambroise Vollard.* c. 1914. Etching, 13⅝ × 9½". The Museum of Modern Art, New York

256: *Still Life with Putto.* c. 1895. Oil on paper mounted on panel, 27½ × 22½". Courtauld Institute Galleries, University of London

257 LEFT: *Putto.* 1900–1904. Pencil and watercolor, 18½ × 8⅝". Collection Mr. and Mrs. Eugene Victor Thaw, New York

257 ABOVE RIGHT: Plaster cast of a *putto* attributed to Pierre Puget, still in Cézanne's Lauves studio. Photograph J. R., c. 1954

257 BELOW RIGHT: *Putto.* c. 1890. Drawing after plaster cast attributed to Puget. Pencil, 19⁹⁄₁₆ × 12⁹⁄₁₆". British Museum, London

258: Paul Cézanne at work on the hill of Les Lauves. Photographs taken by K.-X. Roussel, 1906

259: Maurice Denis. *Cézanne Painting a View from Les Lauves.* 1906. 20⅛ × 25¼". Collection J. F. Denis, Alençon

Paul Cézanne on the hill of Les Lauves. Photograph taken by Emile Bernard, 1905

260: *The Château de Fontainebleau.* 1904–1905. Watercolor, 17⅜ × 21⅝". Collection Stephen Hahn, New York. Photograph Bruce C. Jones

261: *Landscape.* c. 1890 (possibly later). Watercolor, 19 × 12½". Private Collection, Switzerland

262: *The Sailor.* 1902–1906. 42¼ × 29⅜". National Gallery of Art, Washington, D.C. Gift of Eugene and Agnes Meyer

263: *Portrait of the Gardener Vallier.* 1906. 25⅝ × 21¼". Private Collection, Switzerland

264: *Three Skulls.* c. 1900. 13¾ × 24". The Detroit Institute of Arts. Bequest of Robert H. Tannahill

Pyramid of Skulls. 1898–1900. 15⅜ × 18⅜". Private Collection, Switzerland

266: Hermann-Paul. *Caricature of Cézanne.* 1904. Pen and ink

Selected Bibliography

Adhemar, Hélène, ed. *Cézanne dans les musées nationaux*. Paris: Ed. des Musées Nationaux, 1974. Exhibition catalogue.

Adriani, Götz. *Cézanne Watercolors*. New York: Harry N. Abrams, 1983.

Andersen, Wayne V. *Cézanne's Portrait Drawings*. Cambridge, Mass., and London: The MIT Press, 1970.

Badt, Kurt. *Die Kunst Cézannes*. Munich: Prestel-Verlag, 1956; *The Art of Cézanne*. Translated by Sheila Ann Ogilvie. Berkeley: University of California Press, 1965.

——— . *Das Spätwerk Cézannes*. Constance: Universitätsverlag, 1971.

Barskaya, A. *Paul Cézanne*. Leningrad: Aurora, 1975.

Berhaut, Marie. "Le legs Caillebotte. Vérités et contre-vérités." *Bulletin de la Société de l'Histoire de l'Art Français*, Année 1983 [1985], pp. 209–239.

Bernard, Emile. "Paul Cézanne." *Hommes d'Aujourd'hui*, vol. 8, no. 387 (1892).

——— . *Sur Paul Cézanne*. Paris: R. G. Michel, 1925.

——— . *Souvenirs sur Paul Cézanne, une conversation avec Cézanne*. Paris: R. G. Michel, 1926.

Berthold, Gertrude. *Cézanne und die alten Meister*. Stuttgart: W. Kohlhammer, 1958.

Beucken, Jean de. *Un Portrait de Cézanne*. Paris: Gallimard, 1955.

Camoin, Charles. "Souvenirs sur Paul Cézanne." *Amour de l'Art*, January 1921.

Cézanne, Paul. *Correspondance*. Edited by John Rewald. Paris: Bernard Grasset, 1937. English translation, *Letters*. Edited by John Rewald. London: Bruno Cassirer, 1941. *Letters*. Revised and augmented edition. Edited by John Rewald, and translated by Seymour Hacker. New York: Hacker Art Books, 1984.

Chappuis, Adrien. *Album de Paul Cézanne*. 2 vols. Paris: Berggruen, 1966.

——— . *The Drawings of Paul Cézanne: A Catalogue Raisonné*. Greenwich, Conn.: New York Graphic Society; London: Thames and Hudson, 1973.

Coquiot, Gustave. *Paul Cézanne*. 5th edition. Paris: Ollendorf, 1919.

Coutagne, Denis. *Cézanne au Musée d'Aix*. Aix-en-Provence, 1984. Exhibition catalogue.

Denis, Maurice. "Cézanne." *Burlington Magazine*, January and February 1911, pp. 207–219; 275–280.

——— . *Théories*. Paris: Bibliothèque de l'Occident, 1912.

Doran, P. M., ed. *Conversations avec Cézanne*. Paris: Macula, 1978.

Dorival, Bernard. *Cézanne*. Paris: Tisné, 1948.

Duranty, Edmond. *Le Pays des Arts*. Paris: Charpentier, 1881.

Elder, Marc. *Chez Claude Monet à Giverny*. Paris: Bernheim-Jeune, 1924.

Feist, Peter H. *Paul Cézanne*. Leipzig: E. A. Seemann, 1963.

Fry, Roger. *Cézanne, A Study of His Development*. New York: Macmillan, 1927.

Gasquet, Joachim. *Cézanne*. Paris: Bernheim-Jeune, 1921.

Geffroy, Gustave. *Claude Monet, sa vie, son oeuvre*. 2 vols. Paris: Crès, 1924.

Gowing, Lawrence. *Cézanne*. London: Arts Council of Great Britain, 1954. Exhibition catalogue.

Guerry, Liliane. *Cézanne et l'expression de l'espace*. Paris: Flammarion, 1950; 2nd edition. Paris: Albin Michel, 1966.

Huyghe, René. *Cézanne*. Paris: Editions d'Art et d'Histoire, 1936.

Jaloux, Edmond. "Souvenirs sur Paul Cézanne." *Amour de l'Art*, December 1920, pp. 285–286.

Johnson, Erle. See Loran, Erle.

Larguier, Léo. *Le Dimanche avec Paul Cézanne*. Paris: L'Edition, 1925.

Loran, Erle [Erle Johnson]. "Cézanne's Country." *The Arts*, April 1930, pp. 535–541.

——— . *Cézanne's Composition*. Berkeley: University of California Press, 1943.

Mack, Gerstle. *Paul Cézanne*. New York: Alfred A. Knopf, 1935.

Marschutz, Leo. See Rewald and Marschutz.

Meier-Graefe, Julius. *Entwicklungsgeschichte der modernen Kunst*. Vol. 3. Stuttgart: Jul. Hoffmann, 1904.

——— . *Paul Cézanne*. Munich: R. Piper & Co., 1910; fifth edition. Munich: R. Piper & Co., 1923; *Cézanne*. Translated by J. Holroyd-Reece. London: Ernest Benn Ltd., 1927.

——— . *Cézanne und sein Kreis*. Munich: R. Piper & Co., 1918; second edition. Munich: R. Piper & Co., 1920; third edition. Munich: R. Piper & Co., 1922.

Neumeyer, Alfred. *Cézanne's Drawings*. New York and London: Yoseloff, 1958.

——— . *Paul Cézanne, Die Badenden*. Stuttgart: Philip Reclam, 1959.

Novotny, Fritz. *Cézanne*. Vienna: Phaidon, 1937; London: Phaidon, 1961.

——— . *Cézanne und das Ende der wissenschaftlichen Perspektive*. Vienna: Anton Schroll & Co., 1938.

Perruchot, Henri. *La vie de Cézanne*. Paris: Hachette, 1956.

Pissarro, Camille. *Letters to His Son Lucien*. Edited by John Rewald. New York: Pantheon, 1943.

Ponente, Nello. *Paul Cézanne*. Bologna: Capitol, 1980.

Ratcliffe, Robert. *Cézanne's Working Methods and Their Theoretical Background*. Doctoral thesis, University of London (unpublished), 1961.

Reff, Theodore. "Cézanne's Constructive Stroke." *Art Quarterly*, vol. 25, no. 3 (Autumn 1962), pp. 214–227.

——— . "Cézanne, Flaubert, St. Anthony, and the Queen of Sheba." *The Art Bulletin*, vol. 44, no. 2 (June 1962), pp. 113–125.

——— . "Cézanne and Hercules." *The Art Bulletin*, vol. 48 (March 1966), pp. 35–44.

——— . "Cézanne's 'Cardplayers' and Their Sources." *Arts Magazine*, vol. 55, no. 5 (November 1980), pp. 104–117.

Rewald, John. "Cézanne au Louvre." *Amour de l'Art*, October 1935, pp. 283–288.

_____ . *Cézanne et Zola*. Paris: A. Sedrowski, 1936; *Cézanne, sa vie, son oeuvre, son amitie pour Zola*. Paris: Albin Michel, 1939.

_____ . "A propos du catalogue raisonné de l'oeuvre de Paul Cézanne et de la chronologie de cette oeuvre." *La Renaissance*, March–April 1937, pp. 53–56.

_____ . *Paul Cézanne, A Biography*. New York: Simon & Schuster, 1939.

_____ . *Cézanne, Geffroy et Gasquet, suivi de Souvenirs sur Cézanne de Louis Aurenche et de lettres inedites.* Paris: Quatre Chemins-Editart, 1959.

_____ . *Paul Cézanne Sketchbook, 1875–1885*. New York: Harcourt Brace Jovanovich, 1982.

_____ . *Paul Cézanne: The Watercolors*. Boston: New York Graphic Society; London: Thames and Hudson, 1983.

_____ . *Studies in Impressionism*. London: Thames and Hudson; New York: Harry N. Abrams, 1985–86.

Rewald, John, and Marschutz, Leo. "Cézanne au Château Noir." *Amour de l'Art*, January 1935, pp. 15–21.

Rey, Robert. *La renaissance du sentiment classique*. Paris: Les Beaux-Arts, 1931.

Rilke, Rainer Maria. *Lettres sur Cézanne*. Paris: Corréa, 1944.

Rishel, Joseph. *Cézanne in Philadelphia Collections*. Philadelphia: Philadelphia Museum of Art, 1983. Exhibition catalogue.

Rivière, Georges. *Le Maître Paul Cézanne*. Paris: Floury, 1923.

_____ . *Cézanne*. Paris: Floury, 1933; Paris: Floury, 1942.

Rivière, R., and Schnerb, J. F. "L'atelier de Cézanne." *La Grande Revue*, December 25, 1907, pp. 811–817.

Rubin, William, ed. *Cézanne: The Late Work*. With contributions by T. Reff, L. Gowing, L. Brion-Guerry, J. Rewald, F. Novotny, G. Monnier, D. Druick, and G. H. Hamilton. New York: Museum of Modern Art, 1977.

Schapiro, Meyer. *Cézanne*. New York: Harry N. Abrams, 1952.

_____ . "The Apples of Cézanne: An Essay on the Meaning of Still-life." *Art News Annual*, vol. 34 (1968), pp. 34–53; *Modern Art: Selected Papers*. New York: George Braziller, 1978, pp. 1–38.

Schniewind, Carl O. *Paul Cézanne Sketchbook*. 2 vols. New York: Curt Valentin, 1951.

Scolari, Margaret, and Barr, Alfred H., Jr. "Cézanne in the Letters of Marion to Morstatt, 1865–68." *Magazine of Art*, February, April, May 1938, pp. 84–89; 220–225; 288–291.

Sherman, H. L. *Cézanne and Visual Form*. Columbus: Ohio State University, 1952.

Shiff, Richard. *Cézanne and the End of Impressionism*. Chicago: University of Chicago Press, 1984.

Venturi, Lionello. *Cézanne, son art, son oeuvre*. 2 vols. Paris: Paul Rosenberg, 1936.

_____ . *Cézanne*. Geneva: Skira, 1978.

Vollard, Ambroise. *Paul Cézanne*. Paris: Vollard, 1914; *Paul Cézanne, His Life and Art*. Translated by Harold L. van Doren. New York: Crown Publishers, 1937.

Zola, Emile. *Correspondance (1858–1871); Oeuvres complètes*. Paris: François Bernouard, 1928.

_____ . *L'Oeuvre*. Notes and commentary by Maurice LeBlond. Paris: François Bernouard, 1928.

Index

Page numbers are in roman type. Page numbers on which illustrations appear are in *italic* type. All works are by Cézanne unless otherwise noted.